Drawing on a wide range of perspectives and methods of analysis, the contributors in this book offer a nuanced look into the myriad ways minority women influence, and are influenced by, the political world. This is a necessary addition to our examination of institutions, voters, and elections, as it requires us to consider the power of identity and the growing influence of women of color.

Kathleen Dolan, *University of Wisconsin Milwaukee, USA*

Pulling together original and thoughtful contributions from leading experts in the field on the role of women of color in politics and using a mix of methodological and theoretical approaches, the contributors to this edited volume delve deeply into the reality of the political experiences of Black, Latina, Asian American, and Native American women. The book is essential reading for those interested in truly understanding modern U.S. politics and the role played by women of color as candidates and in the general public.

Melissa Michelson, *Menlo College, USA*

DISTINCT IDENTITIES

Minority women in the United States draw from their unique personal experiences, born of their identities, to impact American politics. Whether as political elites or as average citizens, minority women demonstrate that they have a unique voice that more often than not centers on their visions of justice, equality, and fairness.

In this volume, Drs. Nadia E. Brown and Sarah Allen Gershon seek to present studies of minority women that highlight how they are similar and dissimilar to other groups of women or minorities, as well as variations within groups of minority women. Current demographic and political trends suggest that minority populations – specifically minority women – will be at the forefront of shaping U.S. politics. Yet, scholars still have very little understanding of how these populations will behave politically. This book provides a detailed view of how minority women will utilize their sheer numbers, collective voting behavior, policy preferences, and roles as elected officials, to impact American politics.

The scholarship on intersectionality in this volume seeks to push beyond disciplinary constraints to think more holistically about the politics of identity.

Nadia E. Brown is an Associate Professor in the Department of Political Science & African American Studies and Research Center at Purdue University. Her scholarship on intersectionality seeks to push beyond disciplinary constraints to think more holistically about the politics of identity and Black women's politics more specifically.

Sarah Allen Gershon is an Associate Professor of Political Science at Georgia State University. Her research focuses on the incorporation of traditionally underrepresented groups (including women, and racial and ethnic minorities) into the American political system. In seeking to explain the challenges faced by these groups, Dr. Gershon's work emphasizes the role of communication, campaigns and political attitudes.

Routledge Series on Identity Politics
Series Editor: Alvin B. Tillery, Jr.,
Rutgers University

Group identities have been an important part of political life in America since the founding of the republic. For most of this long history, the central challenge for activists, politicians, and scholars concerned with the quality of U.S. democracy was the struggle to bring the treatment of ethnic and racial minorities and women in line with the creedal values spelled out in the nation's charters of freedom. In the midst of many positive changes, however, glaring inequalities between groups persist. Indeed, ethnic and racial minorities remain far more likely to be undereducated, unemployed, and incarcerated than their counterparts who identify as white. Similarly, both violence and work place discrimination against women remain rampant in U.S. society. The Routledge series on identity politics features works that seek to understand the tension between the great strides our society has made in promoting equality between groups and the residual effects of the ascriptive hierarchies in which the old order was rooted.

DISTINCT IDENTITIES

Minority Women in U.S. Politics

Edited by
Nadia E. Brown and
Sarah Allen Gershon

 Routledge
Taylor & Francis Group

NEW YORK AND LONDON

First published 2016
by Routledge
711 Third Avenue, New York, NY 10017

and by Routledge
2 Park Square, Milton Park, Abingdon, Oxon, OX14 4RN

Routledge is an imprint of the Taylor & Francis Group, an informa business

Library of Congress Cataloging in Publication Data
A catalog record for this book has been requested

ISBN: 978-1-138-95883-8 (hbk)
ISBN: 978-1-138-95884-5 (pbk)
ISBN: 978-1-315-66101-8 (ebk)

Typeset in Bembo
by Wearset Ltd, Boldon, Tyne and Wear

For Brian M. Lawrence and Nile Elizabeth Brown-Lawrence. For Matt, Madelyn, Henry, Charlotte, Nancy, George, Susannah, Patrick, and William.

CONTENTS

FIGURES

TABLES

ACKNOWLEDGMENTS

When we first began to talk about this book, we were assistant professors. Our desire to work on this book came from observations regarding the literature on American political behavior. As many scholars in this field do, we frequently discussed the need for more work concerning the intersection of race, gender, and ethnicity in American political behavior. Coming from different methodological backgrounds, we wanted to edit a book that brought together scholars who utilized a variety of empirical and theoretical approaches to study minority women in American politics.

We would not have been able to complete this book without the assistance of several people. First, we would like to thank the scholars who contributed chapters to this volume for their commitment to this project and tireless work perfecting their chapters. Nadia and Sarah thank Michael Kerns, Lillian Rand, and Jennifer Knerr at Routledge who saw the importance of this project at the onset. We profoundly thank Alvin Tillery for his initial support of this project and his unwavering mentorship throughout this process. Nadia and Sarah are extremely grateful to Ian Thomas and Richard Gardiner who served as our graduate research students who helped to ensure that the book was formatted correctly and ready for submission. We also wish to thank the political psychology group organized by Angie Bos and Monica Schneider. Our attendance at the October 2014 conference at the College of Wooster helped to solidify contributors to this volume as well as provided a space for us to discuss the project. Lastly, we are indebted to our respective institutions – Purdue University and Georgia State University.

Nadia would like to thank her department head, Rosalee Clawson, for her support, encouragement, and mentorship. Rosie has been a consistent advocate and sponsor for Nadia. She is greatly appreciative of all that Rosie has done (and

continues to do) to make Nadia feel valued and appreciated at Purdue University. Nadia also wishes to thank Venetria Patton, her former African American Studies program chair, for her guidance and support. Venetria has proven to be a powerful ally and mentor for the Black women faculty at Purdue University. Nadia is deeply appreciative of Alvin Tillery, Jane Junn, Evelyn Simien, Valeria Sinclair-Chapman Shayla Nunnally, and S. Laurel Weldon for their continued mentorship over the past several years. She also wishes to express sincere gratitude to her church family at St. John's United Church of Christ in Saint Louis, MO who provided spiritual support and guidance during the long recovery process from her car accident and encouraged her to work on this book project. Finally, Nadia is eternally grateful to have the fortunate opportunity to work with Sarah as a co-author. Over the years, Sarah has proven to be a conscientious scholar and devoted friend. Nadia has grown intellectually because of this partnership with Sarah by learning how to approach scholarly questions from different perspectives and methodologies, being exposed to useful literatures outside of her own expertise, and taking advantage of new scholarly opportunities that Sarah introduced to her. Working with Sarah has been a sincere pleasure.

First, Sarah must thank Kim Fridkin and Pat Kenney for their continued guidance and for encouraging her interests in the politics of race, ethnicity, and gender. Sarah is also indebted to her department chair, Carrie Manning, for her incredible support and mentorship over the past several years. She would like to express her gratitude to Bob Howard for his advice in negotiating the publication process with this book. Sarah would like to thank the many excellent scholars in the field of identity politics that she has encountered over her career who are too numerous to list here. She is truly grateful for their inspiration, inclusion, and support. Finally, Sarah is thankful for the opportunity to work with Nadia Brown. Sarah is grateful for Nadia's encouragement and friendship over the past several years. Throughout their collaborations, Nadia has challenged and inspired Sarah, expanding her approach to the study of political behavior. Working with Nadia on this book has been a wonderful experience.

We both sincerely thank our families for their consistent love and encouragement. This project and partnership has survived the birth of four children, one wedding, one car accident, two promotions with tenure, and one institutional move. We would not have been able to accomplish our academic goals in the midst of these life changes without the unwavering support of our families.

1

INTRODUCTION

Nadia E. Brown and Sarah Allen Gershon

> We have to build things that we want to see accomplished, in life and in our country, based on our own personal experiences ... to make sure that others ... do not have to suffer the same discrimination.
>
> Rep. Patsy T. Mink

The quote by Patsy Mink – the first Asian American Congresswoman (D-HI), the first Asian American to seek the Democratic Party nomination for president, co-author of the Title IX Amendment of the Higher Education Act, Assistant Secretary of State for Oceans and International Environmental and Scientific Affairs, Chairwoman of the Honolulu City Council, and posthumous winner of the Presidential Medal of Freedom – demonstrates that minority women in the United States draw from their unique personal experiences to impact American politics. Mink's raced/gendered identities alongside her identities as a third generation Japanese-American, mother, wife, and lawyer influenced her progressive politics. She was the consummate advocate for women's rights, minority rights, and protector of marginalized communities. Like Mink, the women present in this volume also pull from their multiple identities as women of color to influence American politics. Whether as political elites or as citizens, minority women demonstrate that they have a unique voice that more often than not centers on their visions of justice, equality, and fairness. Furthermore, the studies of minority women in this edited volume also show that this population is committed to creating an America that is better tomorrow than it is today. Similar to Patsy Mink, many of the women of color in this book have faced adversity but choose to use these setbacks as building blocks rather than stumbling blocks. Here, we pay homage to Mink's legacy, using minority women as a focal point to demonstrate how far America has progressed and where there is still room left for growth.

While we can readily point to influential women of color who were the first to achieve various political offices or the growing influence of minority women as mass citizens in American politics, scant few political science studies have researched both these avenues of minority women's politics in one scholarly volume. Additionally, the majority of studies only address one particular group of women of color – i.e., African Americans, Latinas, Asian American, or Native women. In this volume, we present studies of minority women that highlight how they are similar and dissimilar to other groups of women of color as well as nuances and variations within groups of minority women. As such, we present a more comprehensive picture of how minority women behave politically by focusing on their policy preferences, political behavior, and impact as political elites.

To be clear, we are not arguing that all minority women have similar raced/gendered experiences because of their marginalized status as women in a patriarchal society or as racial minorities in a country founded on White supremacy. Nor are we are arguing that minority women are always placed at a disadvantage in American society. Instead, we seek to elucidate how being a woman of color leads to unique political experiences, viewpoints, and behaviors. While the term "women of color" is problematic because it marks minority women as the other and Whites as identity free, this catch-all term for minority women is the best descriptor for describing this population. While the term denotes all non-White persons, it is used frequently for Black women who were the first to theorize feminist ideologies that were different than White women (Collins 1990; hooks 1984). Additionally, while research on women of color is small, in proportional terms research on African American women as political actors outweighs scholarship on Latinas and Asian American women. In a response to this scholarly oversight, we include several chapters on Asian American women, Latinas, and we have one chapter on Native women in American politics, as well as work across groups of women of color.

Why Study Minority Women in U.S. Politics?

For decades, feminist scholars and women of color academics have argued that minority women have been understudied in American politics (Junn and Brown 2008). Indeed, the subfield of women and politics within political science is marked by a willingness to ignore and marginalize the experiences of women of color. Jeane Kirkpatrick's *Political Woman* (1974) ushered in the study of women in politics within the discipline. This canonical text did not meaningfully address differences in political experiences and behavior of ethnic/minority women. Unfortunately, the trajectory laid forth by Kirkpatrick has largely continued into the present study of women in politics despite the challenge from minority women – as both scholars and activists – to include different perspectives within feminist scholarship. Rather than wait for the mainstream discipline of political

science to embrace minority women as legitimate subjects of study and scholarly examination, brave women of color academics began to write and publish their own scholarship that prioritized their unique race/gendered experiences. Take for example, Marianne Githens and Jewel Prestage's (1977) *A Portrait of Marginality* that places special emphasis on the role of Black women in American politics. The authors conclude that women are not socialized to become political actors, but more specifically, that politics are accessed using male-based criteria that place women at a disadvantage. Prestage (1977) finds that Black women are underrepresented in state legislatures which leads her to conclude that this population is doubly disadvantaged – both as women and as Blacks.

Yet, as the chapters in this edited volume elucidate, women of color are not necessarily doubly disadvantaged and there is much work to be done in understanding the experiences of minority women across groups and time. As Christina Bejarano (2013) forcefully argues, women of color can and often do use their identities as women and as members of a racial/ethnic minority for their benefit which increases their chances for winning elected office. *The Latina Advantage* convincingly disputes theories of double jeopardy (Beale 1979), or multiple jeopardy (King 1988), to argue that women of color are not uniformly politically disadvantaged because of their identities as minority women. Yet, mainstream political science scholarship as well as the subfield of women and politics often starts from the supposition that minority women are placed at a political disadvantage. Many scholars begin with this premise, often ignoring the work of minority women scholars who have showcased the dynamism of women of color in American politics (Jordan-Zachery 2014). Indeed, the academic erasure of women of color in women and politics scholarship greatly alters our collective understanding of politics, produces normative narratives about who can be legitimate subjects of inquiry, and has political consequences for how knowledge is produced (Alexander-Floyd 2012). As a result, silencing the voices of women of color or starting a research project by asking questions that assume that gender/race is always a hindrance for minority women produces an incomplete picture of this population.

In this volume, we seek to center the politics of minority women as a way to provide a fuller and richer depiction of these women's politics. The importance of paying specific attention to women of color is often touted as a signal to the growing diversity in the United States. This segment of the U.S. population has proven to be a vital part of American politics and, with recent minority growth in the mass population, will continue to shape the future of American politics. Women vote at higher rates than men, but their electoral preferences and behavior varies significantly within racial and ethnic categories. For example, while women make up 53 percent of the electorate, it was minority women who forcefully turned out in 2008 and 2012 for President Obama. Furthermore, it was women of color who widened the gender gap in the 2012 election. Ninety-six percent of Black women supported President Obama, as did 76

percent of Latinas and 66 percent of all other non-Hispanic women of color. This is compared to only 42 percent of White women. Research indicates that minority women are more politically active than their male counterparts and at times out-participate White women (Bejarano 2014; Brown 2014). This modern racialized gender gap should motivate both political parties to actively seek the minority women's vote.

The racial demographics are rapidly changing in America. According to the 2010 Census, non-White Hispanics are 16 percent of the population, Blacks are 12 percent, Native Americans, Asians, and Pacific Islanders are 6 percent, and multiracial individuals are 3 percent of the nation's population. Indeed, the fastest growing populations in the U.S. are Latinos, multi-ethnics, and those of Asian descent. The demographic and political trends suggest that minority populations – specifically minority women – will be at the forefront of shaping U.S. politics. Yet, scholars still have very little understanding of how these populations will behave politically. It is our goal to provide a more detailed view of how minority women will utilize their sheer numbers, collective voting behavior, policy preferences, and roles as elected officials to impact American politics.

The Importance of Intersectionality in Studying Minority Women in Politics

Intersectionality refers to the various forms of oppression that are interrelated and cause intersections between systems of domination that result in unique practices of discrimination (Crenshaw 1989). For example, racism, sexism, homophobia, classism, and other forms of bigotry do not act independently of one another. Yet, multiple forms of discrimination operate together to form systemic injustice and sociopolitical inequality. Feminist scholars have used intersectionality as an analytical tool to theorize about identity and oppression (Nash 2008). However, Crenshaw (1989) insists that intersectionality is best used as a heuristic to do things rather than as theory of identity (Carbado et al. 2013). As a result, we cannot conflate intersectionality with identity politics. Instead, we use intersectionality as an analytical tool to examine the process of identity creation, provide an understanding of social forces, to investigate how material realities are structured by interdependent systems of domination. Intersectionality as an analytical tool reduces essentialism by calling attention to the process that leads to gendered hierarchies, racial inequality, and biological determinism (Hawkesworth 2006). We are not arguing that identities are static in our use of intersectionality, but rather highlighting how intersectionality as an analytical tool allows feminist researchers to examine the power relations that maintain forms of oppression.

Minority women experience structural inequality based on their race and gender as interdependent, interactive, and dynamic rather than independent and static. The experiences of women of color are mediated by interlocking systems

of domination that are constructed by race, gender, class, sexuality, nationality, and ability (Baca Zinn and Thornton Dill 1996). These systems of power dictate the allocation of political resources. Additionally, women of color's access to and relationship with the state and benefits of citizenship differs significantly from that of other groups. While women of color share similar experiences with their racial/ethnic male counterparts and White women, they have experiences that uniquely position them in lower social, political, and economic strata due to the confluence of race/ethnicity and gender (Chow et al. 1996; Landry 2006). Discrimination is not static and racism and sexism are experienced differently among women of color. Understanding the complexities of both the multiplicity and fluidity of identity necessitates that scholars disavow a binary approach to identity politics. As Simien (2007, 264) explicates,

> political science as a discipline historically has had limited relevance and prescriptive utility for individuals and groups that confront interlocking systems of oppression, as it has largely ignored the intersection (or interaction) of race, class, and gender in American politics.

Furthermore, the inequalities within identity must be made plural and viewed through often contradictory, socially embedded, and mutually constitutive forms. These inequalities may influence the participation and representation of minority women. Thus we argue that the gendered and racialized identities of minority women will impact their behavior, experiences, and outlook within American politics.

Given the population's uneven distribution of incomes, histories of political incorporation, length of time in America, national origins, and differing generational attitudes, this book places specific focus on sub-group, intraracial, and inter-racial analyses. We move beyond White women as the default category in women and politics literature to complicate how we understand the experiences of minority women in U.S. politics (Junn and Brown 2008). For example, Asian Americans – could not become naturalized citizens until the passage of the McCarran–Walter Act (1952); African Americans were denied access to voting until the passage of the 1965 Voting Rights Act (VRA); and Latinos, who were also uniformly granted suffrage with the 1965 VRA, were ultimately unable to exercise this right in several states until Section 5 was extended to states with large Latino populations in 1982. Understanding the differences in when communities of color were given unrestricted access to the ballot muddles the neat construction that women were uniformly given the right to vote with the 1920 ratification of the 19th amendment. Thus, women of color did not equally gain suffrage when women were granted the right to vote. Minority women's history of marginalization and discrimination has had lasting impact on their present-day politics. As a result of minority women's unequal access to the American

government, differing patterns of political behavior, policy preferences, and political mobilization are apparent. These byproducts of racialization and gendered hierarchies prohibit a uniform comparison of groups between minority women with White women, minority men, and White men.

We argue that intersectionality is a useful method for asking and answering new scholarly inquiries that recognize deficiencies in existing scholarship on women and/or racial minorities. While we challenge scholars to move beyond the deficit model of minority women's politics, as either double jeopardy or multiple jeopardy models, we maintain that the structural barriers that shape the lives of women of color have material consequences for the politics of this population. We must understand the limitations, barriers, and sociopolitical constructions that often disadvantage women of color, yet understand how these unique factors also create opportunities for minority women.

Chapter Outline and Rationale

The chapters in this volume fall into four categories: mass behavior and attitudes, voter evaluations of minority women candidates, the mass media's coverage of minority women, and the road to office for women of color. The data and methods employed by the contributors of this volume are varied and multifaceted. From national surveys, elite interviews, historical analysis, experiments, content analysis, and policy case studies, the diverse data sources provide poignant and substantive findings and theoretically significant conclusions about the role of minority women in U.S. politics. Rather than approaching the study of women of color in American politics through a homogenous lens, this edited volume uniquely allows for the wide-ranging and assorted questions about participation and representation in ways that best present the full range of experiences, attitudes, and behavior of minority women. Our chapters explicitly speak to one another and provide readers the unique opportunity to consider minority women's politics in its multiple dimensions.

The first several chapters center on intersectionality, mass political behavior, and attitudes in the U.S. In this section, the authors explore how identity shapes the political behaviors and attitudes of women of color in the U.S. As the American electorate continues to diversify and the number of minority women in the population grows, identifying the forces shaping political attitudes and participation among women of color is critical. The diverse set of studies presented in this section illustrates the importance of taking an intersectional approach to the study of political behavior. Holman's work in Chapter 2 illustrates the power of intersectional analyses, demonstrating the variance in predictors of political participation among women of different racial and ethnic backgrounds. The remaining chapters in Part I focus on the attitudes and behaviors of Blacks, Latinos, and Asian Americans individually. In Chapter 3, Capers and Watts Smith find variance in the group consciousness and policy attitudes among native and foreign-born

Blacks in the U.S. Ford Dowe (Chapter 4) also explores Black attitudes in the U.S., focusing on the unique attitudes and behaviors of African American women. In Chapter 5, Harvie expands our limited scholarly knowledge of gendered differences in the Asian American population, illustrating the unique attitudes and behaviors of Asian American women, compared with their male and non-Asian peers. Finally, VanSickle-Ward and Pantoja (Chapter 6) explore Latino foreign policy attitudes, finding a clear gender gap on these issues and highlighting the unique forces that shape policy support among Latinas and Latinos.

In Part II, the authors continue to focus on mass attitudes with chapters that examine voter evaluations of minority women running for office. As many of these authors note, the gender politics literature includes a great deal of research concerning voter support for women, yet this research largely explores support for *White* female candidates. As the chapters in this section illustrate, exploring how identity shapes voter attitudes towards Latina, Black, and Asian women running for office is critical. Chapter 7 explores support for Black women candidates. Johnson Carew's work explores how race, gender, and skin tone shape voter expectations regarding African American women's traits, ideology, and viability. In Chapter 8, Sriram uses the recent election of Representative Tulsi Gabbard as a starting point to explore how Southeast Asian voters react to the competing cues of nationality and religion when evaluating female candidates for office. Finally, Cargile explores the role of voter and candidate identity in shaping stereotypes of Latina/o candidates for political office in Chapter 9.

Scholars have often noted the critical role of the media in politics (Gershon 2012; Kahn and Kenney 1999, 2002). As the educator and informer of the public, the press serves an important function in American democracy and clearly shapes political attitudes towards candidates and office holders. Thus, studying how the press treats women of color is important for our understanding of the challenges minority women face in seeking and holding higher office. Part III explores the role of the mass media in covering elite minority women. In Chapter 10, Ward utilizes a qualitative content analysis to track media coverage of African American women running for office in the 2012 election, illustrating the unique challenges these women face from the press.

The last section of the book contains research that largely explores the road to office for women of color in America. In Chapter 11, Sanbonmatsu explores the pathway to office for minority women, finding that women of color disproportionately achieve political office in non-traditional ways (e.g., appointment to vacant seats). Chapters 12 and 13 focus on office holding among Latinas specifically. Bejarano (Chapter 12) finds that Latina candidates are most successful at the state level in certain circumstances, such as in single-member districts, liberal areas, and among large Latino electorates. Relying on an examination of Latina/o elected officials since 1990, Ramírez and Burlingame (Chapter 13) illustrate the increases in Latina office holding in recent

years, particularly in comparison to their Latino male and non-Latino female peers. In Chapter 14, Filler and Lien examine Asian Pacific American men and women holding elective office in the U.S. The authors present a complex picture of the pathways to office for Asian Pacific American women, illustrating the impact of family and professional socialization in shaping the political careers of these office holders. Chapter 15 presents a unique look at press coverage of one of the most prominent women in politics – the First Lady. As Gillespie demonstrates in her research, Michelle Obama is subject to coverage that is uniquely racialized, when compared with that of her peers. Greer (Chapter 16) presents a historical analysis of the presidential candidacies of Charlene Mitchell and Shirley Chisholm, illustrating the challenges these women faced in campaigning for the highest office in the U.S. The remaining chapters explore the experiences of women in leadership roles. Prindeville and Broxton (Chapter 17) draw on a unique set of in-depth interviews to explore the experiences of Native American women office holders in the U.S., focusing in particular on their role in tribal politics. Finally, Williams (Chapter 18) explores minority women's legislative priorities through a case study of support for reproductive legislation among Black male and female legislators in Georgia.

Taken together, this diverse set of essays offers readers a few things. First, the work included in this volume clearly illustrates the different ways in which identity shapes politics. As the authors of these chapters indicate, the experiences, attitudes, and behaviors of women of color are distinct. The need for an intersectional approach to the study of political behavior in the U.S. is apparent throughout the work presented in this volume. Second, the diverse set of methods employed throughout the chapters highlights the value of different tools for analyzing the political experiences of women of color in the U.S. Rather than competing with one another, the qualitative and quantitative research in this book is complementary, revealing the value of different approaches in this field of study.

Conclusion

The epigraph of this chapter sets the frame for this edited volume, we maintain that women of color add a distinct perspective to American politics that is derived from their identities. The unique intersectional location that women of color inhabit impacts how they operate within and view American politics. Our goal is to advance scholarly understanding of diversity among and between minority women. Because personal backgrounds influence political behavior (Brown 2014), we purport that gendered and racial/ethnic group memberships are structured in ways that produce both political commonality and difference among this population of women.

References

Alexander-Floyd, Nikol G. 2012. "Disappearing Acts: Reclaiming Intersectionality in the Social Sciences in a Post-Black Feminist Era." *Feminist Formations*, 24(1): 1–25.

Baca Zinn, Maxine and Bonnie Thornton Dill. 1996. "Theorizing Difference from Multiracial Feminism." *Feminist Studies*, 22: 321–31.

Beale, Frances. 1979. "Double Jeopardy: To Be Black and Female." In *The Black Woman*, edited by Toni Cade, 90–100. New York, NY: American Library.

Bejarano, Christina E. 2013. *The Latina Advantage: Gender, Race, and Political Advantage.* Austin, TX: University of Texas Press.

Bejarano, Christina E. 2014. *The Latino Gender Gap.* New York, NY: Routledge.

Brown, Nadia. 2014. *Sisters in the Statehouse: Black Women and Legislative Decision Making.* New York, NY: Oxford University Press.

Carbado, Devon W., Kimberle Williams Crenshaw, Vickie M. Mays, and Barbara Tomlinson. 2013. "Intersectionality: Mapping the Movements of a Theory." *Du Bois Review: Social Science Research on Race*, 10(2): 303–12.

Chow, Ester Ngan-ling, Doris Wilkinson, and Maxine Baca Zinn. 1996. *Race, Class, & Gender: Common Bonds, Different Voices.* Thousand Oaks, CA: Sage Publications.

Collins, Patricia Hill. 1990. *Black Feminist Thought: Knowledge, Consciousness and the Politics of Empowerment.* New York, NY: Routledge.

Crenshaw, Kimberle Williams. 1989. "Demarginalizing the Intersection of Race and Sex: A Black Feminist Critique of Antidiscrimination Doctrine, Feminist Theory, and Anti-Racist Politics." In *Feminist Legal Theory: Readings in Law and Gender*, edited by K. T. Bartlett Kennedy and R. Kennedy, 57–80. San Francisco, CA: West View Press.

Gershon, Sarah. 2012. "When Race, Gender, and the Media Intersect: Campaign News Coverage of Minority Congresswomen." *Journal of Women, Politics & Policy*, 33(2): 105–25.

Githens, Marianne and Jewel Prestage. 1977. *A Portrait of Marginality: The Political Behavior of the American Woman.* New York, NY: David McKay.

Hawkesworth, Mary. 2006. *Feminist Inquiry: From Political Conviction to Methodological Innovation.* New Brunswick, NJ: Rutgers University Press.

hooks, bell. 1984. *Feminist Theory from Margin to Center.* Boston, MA: South End Press.

Jordan-Zachery, Julia. 2013. "Now You See Me, Now You Don't: My Political Fight Against the Invisibility/Erasure of Black Women in Intersectionality Research." *Politics, Groups, and Identities*, 1(1): 101–9.

Jordan-Zachery, Julia. 2014. "I Ain't Your Darn: Black Women as the Help in Intersectionality Research." *National Political Science Review*.

Junn, Jane and Nadia Brown. 2008. "What Revolution? Incorporating Intersectionality in Women and Politics." In *Political Women and American Democracy*, edited by Karen Beckwith, Christina Wolbrecht, and Lisa Baldez, 64–78. New York, NY: Cambridge University Press.

Kahn, Kim Fridkin and Patrick J. Kenny. 1999. *The Spectacle of US Senate Campaigns.* Princeton, NJ: Princeton University Press.

Kahn, Kim Fridkin and Patrick J. Kenney. 2002. "The Slant of the News: How Editorial Endorsements Influence Campaign Coverage and Citizens' Views of Candidates." *American Political Science Review*, 96(02): 381–94.

King, Deborah. 1988. "Multiple Jeopardy, Multiple Consciousness: The Context of a Black Feminist Ideology." *Signs: Journal of Women in Culture and Society*, 14(1): 42–72.

Kirkpatrick, Jeane. 1974. *Political Woman*. New York: NY: Basic Books.

Landry, Bart. 2006. *Race, Gender, and Class: Theory and Methods of Analysis*. Upper Saddle River, NJ: Prentice Hall.

Nash, Jennifer C. 2008. "Re-Thinking Intersectionality." *Feminist Review*, 89(1): 1–15.

Prestage, Jewel Limar. 1977. "Black Women State Legislators: A Profile." In *A Portrait of Marginality: The Political Behavior of the African American Woman*, edited by Marianne Githens and Jewel Prestage, 410–18. New York, NY: David McKay.

Simien, Evelyn. 2007. "Doing Intersectionality Research: From Conceptual Issues to Practical Examples." *Politics and Gender*, 3(2): 36–43.

PART I

Gender, Race, Ethnicity, and Mass Behavior

2

THE DIFFERENTIAL EFFECT OF RESOURCES ON POLITICAL PARTICIPATION ACROSS GENDER AND RACIAL GROUPS

Mirya R. Holman

Introduction

Scholars have long documented pervasive gender, race, and class differences in political participation, with women, the poor, and non-Whites generally participating at lower levels in most forms of political action. Generally, scholars have explained the gap via the resources available to these groups. In particular, varying levels of access to socioeconomic resources across gender, race, and class groups leads to suppressed participation. Early research on the topic demonstrated that women, racial minorities, and the poor suffer significant disadvantages when it comes to these resources, including lacking money, free time, education, and efficacy (Schlozman et al. 1994; Burns et al. 2001). Yet, there are also clear intersectional departures from these patterns; in fact, some groups of women that have, on average, less access to resources, participate more than other groups with more access to resources (Harvie, Chapter 5). For example, Black women participate in almost all forms of political participation at elevated rates as compared to White women and men and Black men (Ansolabehere and Hersh 2013; Farris and Holman 2014). My research suggests that the resource model of political participation, which was largely developed out of the experiences of White men, fails to explain the participatory experiences of members of intersectional groups.

Using intersectionality as both a paradigm and a methodology (Crenshaw 1989; McCall 2005), I posit that the traditional models of political participation should not apply evenly across intersectional groups because members of these groups do not experience the political system in the same ways, nor do these groups gain access to the polity and political decision-making power equally (Junn and Brown 2008; Brown 2014). Indeed, given that Black and Hispanic

women have faced a pervasive lack of resources for years, I expect that many traditional resources like income will matter much less in predicting the political participation of these women than for White women or the population overall.

Using data from the 2008 American National Elections Studies, I present an intersectional model of forms of political participation, with a focus on how race, gender, and class intersect to influence a variety of political actions. In particular, I examine the influence of traditional and new resources on reported levels of voting, contributing to political campaigns, and acts of protest both within each of these groups and across marginalized groups. By employing intercategorical and intracategorical analyses, I demonstrate the importance of understanding how many of the traditional factors associated with high levels of political participation do not operate in identical ways across intersectional groups.

My results provide new evidence for the importance of understanding intersectional patterns of repression and triumph in examining political engagement. In particular, these results demonstrate the importance of using an intersectional paradigm in approaching political participation. The factors traditionally associated with political participation do often influence the participation of intersectional groups, and many factors have inconsistent effects across intersectional groups. The results presented in this chapter draw attention to the need to examine central theories of political science through an intersectional approach, particularly given that finding differences across groups can help us understand *all* political participation in more meaningful ways.

Political Participation

Americans participate in a variety of political activities with the goal of influencing policy, supporting political actors, pursuing an ideological agenda, or engaging in democratic action. The most basic, low cost, and widespread of these activities is voting, but many alternative methods of participation exist, including donating to or working for campaigns, belonging to a political party, being involved in local political issues, protesting, and contacting political officials. Each of these activities requires a certain set of resources, skills, and interests; for example, donating to political campaigns requires more monetary resources, while contacting political officials requires efficacy and knowledge. Early research on the topic demonstrated that women, racial minorities, and the poor suffer significant disadvantages when it comes to these resources, including money, free time, education, and efficacy (Schlozman et al. 1994; Burns et al. 2001).

Research on political participation often focuses on a *resource-model* of participation, where variance in socioeconomic, social, and psychological factors often predicts whether an individual or group engages in political actions (Campbell et al. 1986; Burns et al. 2001; Thomas 2012). Within this context, certain groups (such as the wealthy, Whites, and men) hold more of the resources necessary to participate in politics and other groups (including racial

and ethnic minorities, women, and the poor) are systematically less likely to engage in political action. Yet, the resource model fails to tell the entire story of participation. For example, while women have systematically gained economic resources, joined the workforce, and are now the majority of college graduates in the United States, they still lag behind men in almost all forms of political participation outside the voting booth (Thomas 2012). And, while Black[1] women, as a group, do *not* have access to many socioeconomic resources, they participate at an equal rate to Black men and a higher rate than White women in many forms of political action (Ansolabehere and Hersh 2013; Farris and Holman 2014). Indeed, there are wide variations in the level of various forms of political participation across gender and race groups. For example, men are more likely to report donating to political causes and trying to influence someone else's vote, while Black men and women report higher levels of displaying political stickers and attending a political meeting. Hispanic men and women vote at lower rates, but Hispanic women vote at significantly higher rates than do Hispanic men. Despite these observable group differences and the incompatibility with central theories of political participation, scholars have yet to fully examine forms of political participation through an intersectional approach that takes gender, race, and class into account.

Resource Model of Political Participation

Various different personal resources are associated with higher levels of political participation. College and graduate levels of education encourages a variety of forms of political participation, including voting, working for campaigns, and joining political organizations (Wolfinger and Rosenstone 1980; Verba et al. 1997; APSA n.d.). Income and class also exert a strong effect on time to participate, money for political contributions, and personal efficacy (Burns et al. 1997; Leighley and Vedlitz 1999; Leighley and Nagler 2013).

Gender influences access to the resources necessary for political participation. While women lagged behind men in access to education for much of American history, women now make up the majority of college students and college graduates (Goldin et al. 2006). In addition, women have increasingly entered the workforce, moving from 14.6 percent of the workforce in 1967 to 43.2 percent in 2009 (DeNavas-Walt 2009), although women still make less than men do on average for the same work and hold fewer economic resources (Blau and Kahn 2001), with women of color additionally disadvantaged, making significantly less than White men for similar work (Cassese et al. 2015).[2] Younger women also fare better: for example, unmarried, childless women under 30 living in cities exceed the income of their male counterparts (Luscombe 2014). And, while women continue to occupy a variety of time-intensive social roles like motherhood and responsibility for taking care of the home (Burns 2007), their duties in this area have declined over time (Mattingly and Blanchi 2003).

Unlike White women, racial minorities – especially women of color – have not seen dramatic changes in access to the resources necessary for political participation over the last several decades. Blacks and Hispanics still have dramatically lower rates of high school and college graduation than do Whites, as well as lower median household incomes, and higher unemployment rates. Minority women operate in a "double-bind," where they suffer from both sexism and racism; because of historical and current disadvantages, female minority groups have access to even fewer of the resources traditionally associated with political participation (Brown 2014; Farris and Holman 2014). For example, Black women make 64 cents for each dollar earned by White men, while Hispanic women make 0.53 ("How Does Race Affect the Gender Wage Gap?" 2014; Cassese et al. 2015). Black and Hispanic women have also been largely left behind in many of the second wave of feminism's gains, including their low rates of access to managerial positions, maternity leave, and the ability to outsource child and household care (Folbre 2011).

Lack of access to many of these resources results in somewhat lower levels of participation for Blacks in politics. For example, scholars have shown that economic problems lead to Black disengagement with politics (Dawson 2001; Marschall and Stolle 2004), as can residing in areas with high levels of poverty (Cohen and Dawson 1993; Harris et al. 2005). Other scholars have noted that if socioeconomic status is accounted for, Blacks actually participate at elevated rates (Dawson 2001); thus, while the resource model helps explain levels of Black participation, it does not fully capture the variances in engagement.

Women, racial minorities, and the poor all have access to fewer of the resources that the dominant models of political science posit are necessary for political participation. Yet, these groups often participate at higher rates than expected. For example, women have registered to vote and turned out to vote at higher rates than have men in every national election over the past three decades (Brown 2014; Farris and Holman 2014). Research demonstrates the unique challenges and resources of intersectional groups of women participating in politics (Tate 1991; Junn 1997). Other scholars identify that the traditional resource model of participation may not work across gender and race groups (Leighley and Vedlitz 1999; Coffé and Bolzendahl 2010; Leighley and Nagler 2013; Brown 2014; Farris and Holman 2014).

Research also indicates that the same overall form of participation, such as volunteering for a political campaign, can take very different forms for men and women, especially women of color (Hardy-Fanta 1993; Freeman 2002; Brown 2014). Indeed, "the exclusive focus on participation in traditional electoral politics fails to grasp how and to what extent marginalized groups such as women actively participate in political life" (Stolle et al. 2005, 250). For example, Hardy-Fanta (1993) finds that Hispanic women focus on participatory (versus power-related) elements of politics more than Hispanic men.

Examining political participation in detail, scholars find that women's visibility increases through avenues of political participation outside traditional electoral forms (Hooghe and Stolle 2004; Stolle et al. 2005; Quintelier et al. 2011). Women's activism often takes the form of non-institutional participation and private activism, as opposed to direct contact, collective, or activism that requires private resources (Coffé and Bolzendahl 2010; Ford Dowe 2016).

Given that the traditional resource model of political participation seems ill suited to explain the levels of participation for non-White, non-male Americans, I turn to alternative theories of participation. Many of these theories have been developed by scholars of minority politics in attempts to understand the political experiences of non-Whites.

Psychological resources, including political interest, political efficacy, group consciousness, and civic duty, can encourage political participation (Aldrich 1993; Verba et al. 1997). Membership in groups and organizations can facilitate these psychological resources, mobilize, and teach civic skills (Putnam 1995; Burns et al. 1997). Minority owned businesses, churches, colleges, and institutions increase political knowledge, skills, resources, and mobilization (Tate 1991; Harris 1994; Calhoun-Brown 1996; Leighley and Vedlitz 1999; Alex-Assensoh and Assensoh 2001; Marschall 2001; McClerking and McDaniel 2005; Robnett and Bany 2011). In particular, politically active Black churches mobilize church attendants to political participation, teach civic skills, and provide voting shortcuts (Morris 1986; Harris 1994; Calhoun-Brown 1996; Harris et al. 2005; Austin 2006).

Scholars have documented how group identity and consciousness increases Black, Latino, and female political participation (Miller et al. 1981; Shingles 1981; Conover 1988; Tate 1991; Harris-Lacewell 2004; Valdez 2011). The presence of minorities on the ballot and in political office can also increase minority political engagement and efficacy (Tate 1991; Gay 2002; Harris et al. 2005; Barreto 2007; Leighley and Nagler 2013; Stout and Tate 2013), including after the 2008 election of Barack Obama (Merolla et al. 2013). In addition, women's representation increases the political participation of women in the general population (High-Pippert and Comer 1998; Banducci et al. 2004; Campbell and Wolbrecht 2006; Alexander 2012; Barnes and Burchard 2013).

Taken all together, research on gender, race, political participation, and resources demonstrates that intersectional groups, such as White women, Black women, and Hispanic women, may experience the same political activism in very different ways. In addition, the resources that members of these groups have access to may also vary in their effect on various forms of political activity. I employ both intercategorical and intracategorical analyses to evaluate the role of common factors in promoting political participation by intersectional groups, which allows me to test the following hypotheses:

Hypothesis 1: *White women, Black women, and Hispanic women will all participate in different political activities at varying rates.*

Hypothesis 2: *Socioeconomic resources will have a differential effect on political participation across intersectional groups. In particular, resources related to class will be more important for the political participation of White women than for Black or Hispanic women.*

Research Design and Methods

Many of the initial large studies of political behavior in the political science discipline focused on how access to resources influences how individuals are able to participate politically. However, many of these studies were developed out of largely observing the behavior of White men (Campbell et al. 1960; Burns et al. 2001); when the political participation of women or minorities received attention, these groups were evaluated in isolation from each other (Burns et al. 1997). The political behavior of gender and race groups varies from the patterns and theories developed in these early studies and demonstrates the need for an intersectional approach. Intersectionality, which is "*both* a normative theoretical argument *and* an approach to conducting empirical research" (Hancock 2007, 63, emphasis in the original), calls for scholars to acknowledge that categories of difference (such as race, class, gender, and sexual orientation) influence how people live, interact with others and institutions, and engage in strategies of survival (Crenshaw 1989; Simien and Clawson 2004; McCall 2005; García Bedolla 2007; Hancock 2007). Of particular importance in the research presented here is "the acknowledgement of difference" (Davis 2008, 70), or that these groupings may produce unique experiences so that conclusions drawn from one group cannot be applied to others.

This chapter uses, as its primary methodology, McCall's (2005) *intracategorical* (evaluating each group's participation in isolation) and *intercategorical* (comparing participation across groups) approaches (Hancock 2007; Farris and Holman 2014). By bringing attention to a group who exists at the crossroads of multiple categories of oppression, the *intracategorical* approach focuses on "particular social groups as neglected points of intersection" (McCall 2005, 1174). An intracategorical approach restricts analysis to the single group of interest, thus bringing attention to "a new or invisible group" (McCall 2005, 1782). I use the *intracategorical* method by examining the effect of various resources on the political participation of White women, Black women, and Hispanic women in isolation; this allows me to evaluate whether these traditional factors matter for each group on their own.

In addition to the intracategorical approach, I also use an *intercategorical* approach, which systematically compares across social categories to evaluate "relationships of inequality" (McCall 2005, 1785). This approach allows me to

examine whether traditional factors, like socioeconomic status, play an equal role in encouraging political participation across social groups. Using intracategorical and intercategorical approaches in combination allows me to examine the complex process of political participation while giving traditionally marginalized groups a voice in the scholarship.

In order to evaluate how political participation may vary across gender, race, and class groups, I examine self-reported participation measures from the 2008 American National Elections Study (ANES). The ANES is an election-year-based survey of political and social attitudes conducted by the Center for Political Studies at the University of Michigan and sponsored by grants from the National Science Foundation. The ANES contains slight oversampling of racial and ethnic minority groups, which provides large enough samples of intersectional groups for statistical analysis. In the dataset, once I account for missing variables, there are 594 White women, 319 Black women, and 245 Hispanic women who completed the survey. While using a single year of data limits the external validity of the data, these findings do offer an opportunity to evaluate the application of a traditional model of political participation across intersectional groups.

Findings

I first examine whether the intersectional groups in the ANES 2008 data present differences in levels and types of political participation. In particular, I evaluate the influence of these essential identities on reported levels of several different forms of political participation, including self-reporting of the following: voting in the 2008 election, trying to influence someone else's vote, donating to a political cause, working for a political party, and displaying a political sticker. These activities represent a wide swath of potential political activities that one could engage in and that require varying levels of resources.[3]

Table 2.1 provides information on the levels of various forms of participation for White women, Black women, and Hispanic women, as well as the overall composition measure of participation, providing evidence for Hypothesis 1.[4] There are significant group-based differences in participation in individual activities, as well as in overall participation levels. In addition, it is not simply White women – who have access to the most resources as a group – who participate in each activity at the highest level; for example, Black women's political participation exceeds that of White women in voting, working for a political party, and displaying a political sticker. I also find significant differences across the three groups in looking at a composite of political participation.[5]

What effect do traditional factors associated with political participation have on gender and race intersectional groups? To examine this question, I estimate political participation models of the same set of control variables (available in the appendix) for the sample overall, and for White women, Black women, and

TABLE 2.1 Political Participation Rates and Gender, Race, and Class

	White Women (%)	Black Women (%)	Hispanic Women (%)
Voted in the 2008 election*	81	82	70
Tried to influence someone's vote*	47	40	32
Work for a political party	5	7	3
Display a political sticker*	17	34	15
Donated to political causes*	14	8	6
Composite Political Participation Measure*	1.72	1.83	1.32

Source: Data from the American National Election Study (2008).

Note
* = $p < 0.05$, ANOVA test across the groups. Hispanic women only includes citizen respondents.

Hispanic women.[6] I focus on these three intersectional groups because they represent key intersections of race and gender in the United States and provide opportunities to analyze participation across groups that lack many traditional socioeconomic resources associated with higher levels of political participation. Results are presented in Table 2.2.

While some traditional indicators of political participation, such as education, have a significant positive effect across intersectional groups, many other factors do not. For example, while church attendance increases White women's participation, it does not similarly influence Black or Hispanic women's participation, and while age increases the participation of Black and Hispanic women, it does not similarly increase the participation of White women (Sweet-Cushman et al. 2013). The lack of significance for church attendance by Black and Hispanic women is somewhat surprising, given the research that has found Black and Hispanic churches encourage participation (Austin 2006); other scholars have found that Black and Hispanic women may benefit less from membership in churches than their male counterparts because of patriarchal structures and sexism in these churches (Hardy-Fanta 1993; Montoya et al. 2000; Dawson 2001; Coffé and Bolzendahl 2010; Robnett and Bany 2011; Mohamed 2015). Overall, the results in Table 2.2 provide preliminary support for Hypothesis 2 and demonstrate the need for an intersectional approach to understanding political participation.

In evaluating the effect of income on the political participation of intersectional groups, I find clear evidence in support of Hypothesis 2, which posits that resources will have a stronger effect on political participation among White women than among minority women. Figure 2.1 provides the marginal effects of gender, race, and social capital-related resources on political participation for White women, Black women, and Hispanic women, calculated using the grinter command in STATA. The slope of the line indicates the effect of

TABLE 2.2 Intersectionality and Overall Participation

	Overall Population	White Women	Black Women	Hispanic Women
	Political Participation	Political Participation	Political Participation	Political Participation
Age	0.012**	0.004	0.018**	0.013*
	(0.000985)	(0.00387)	(0.00559)	(0.00572)
Married	0.006	−0.120	−0.623**	−0.012
	(0.032)	(0.124)	(0.199)	(0.153)
Kids	−0.04*	−0.136*	−0.036	−0.061
	(0.016)	(0.06)	(0.08)	(0.075)
Education	0.154**	0.224**	0.221**	0.210**
	(0.01)	(0.039)	(0.054)	(0.048)
Church attendance	−0.066**	−0.07*	−0.059	−0.05
	(0.0081)	(0.030)	(0.0458)	(0.044)
Own home	0.010	−0.13	−0.016	−0.119
	(0.034)	(0.134)	(0.168)	(0.172)
Trust govt	−0.0003	0.001	−0.004	−0.0006
	(0.0006)	(0.002)	(0.003)	(0.003)
Income	0.075**	0.212**	0.221*	0.010
	(0.015)	(0.064)	(0.091)	(0.088)
Black	0.399**			
	(0.058)			
Hispanic	−0.032			
	(0.065)			
Gender	−0.036			
	(0.029)			
Constant	0.388**	0.341	0.172	0.0874
	(0.085)	(0.336)	(0.455)	(0.458)
N	7099	544	285	214
R^2	0.102	0.137	0.189	0.173

Note

OLS Regression analysis – unstandardized coefficients are presented, with standard errors in parentheses. Data from the American National Election Study (2008). Dependent variable is the composite of (self-reported): Voted in the 2008 Election, Donated to political causes, Working for a political party, Display a political sticker, Try to influence someone else's vote.

income on participation for each group, while the dashed lines indicate the 95 percent confidence interval; the effects are calculated with all controls from Table 2.2.

As the graphs in Figure 2.1 show, the resource-based model applies much better to White women then it does to Black women and especially Hispanic women. Indeed, given the insignificance of income for Hispanic women, these results show that low- and high-income Hispanic women participate at similar

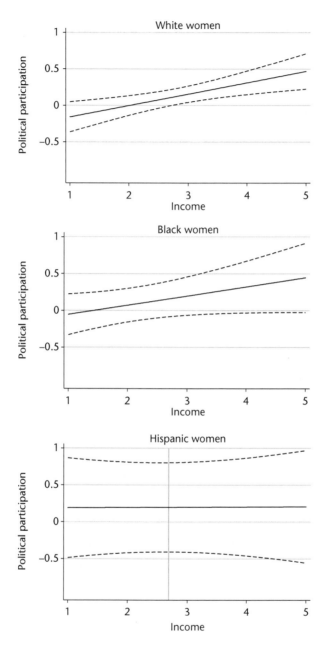

FIGURE 2.1 Intersectionality and Overall Participation

Note

Figure presents marginal effects of Race × gender × income, controlling for demographics in Table 2.2. Dashed lines give 95% confidence interval. Slope indicates the effect of income on participation for each intersectional group. Income is divided into quintiles. Political participation is the composite measure. Marginal effects calculated using the grinter command in STATA.

levels. High-income White women, however, participate at nearly a full point higher (on a five-point scale of the various forms of political participation) than do low-income White women. Going back to Table 2.2, among Black and Hispanic women, age has a positive effect on participation, so that a ten-year increase in age leads to a half-point increase in the political participation scale. And, while White and Hispanic women's marital status is insignificant, married Black women are less likely to engage in political participation.

Conclusion

The results presented here demonstrate the importance of considering intersectional groups when evaluating the factors that contribute to political participation. Using data from the 2008 ANES, I examine the traditional factors associated with political participation and show that these factors do not operate in the same way across intersectional groups or within each intersectional group. I find that while some factors – such as education – have even effects across the intersectional groups, other factors have individualized effects depending on the group. For example, while income has a strong positive effect on White and Black women's participation, the effect of income is insignificant for Hispanic women.

In using both intercategorical and intracategorical analysis in my research, I bring the rich tradition of intersectionality to discussions of how to motivate and encourage political participation, particularly by marginalized groups. These results are particularly important for the factors that encourage Hispanic women's political participation. Other scholars have documented the unique nature of Hispanic women's political participation (Fraga et al. 2006; Bejarano et al. 2011; Bejarano 2013, 2014; Brown 2014) and pointed out the need to understand how Hispanic women interact with the political system. Similarly, other scholars have focused attention on the unique experiences of Black women, demonstrating that political science must examine Black women as a unique group (Hemck and Welch 1992; Cole and Stewart 1996; Gay and Tate 1998; Farris and Holman 2014). Brown's (2014) work focuses on the ways in which White, Black, Latina, and Asian women participate in various forms of political participation and the factors that influence traditional and non-traditional participation. This line of inquiry provides much needed attention to how race and gender intersect to shape how individuals interact with systems where race and gender matter and limit access to the policy. Additional research should take these women's experiences as important and dedicate attention to understanding how and why we find the patterns of participation that we do.

My research is limited in a number of ways. First, while the ANES oversamples racial and ethnic minorities, the numbers of Black and Hispanic women in the sample are still very low. As a result, my conclusions are limited in their application to the U.S. population overall. Second, the quantitative nature of my research limits my ability to understand the micro-level processes going on

that have led to these overall patterns. Additional qualitative research would supplement my findings and provide much-needed detail to understanding how individuals decide to participate in politics. Third, by looking at a single point in time – 2008 – these results are dependent on what was happening at that point in time. And the 2008 election was a significant election, particularly with the primary candidacy of Hillary Clinton and the election of Barack Obama as the first Black president of the United States. These candidates and their campaigns could fundamentally shape how intersectional groups participate in politics. Despite these limitations, the results presented demonstrate the importance of intersectional considerations in evaluating political participation.

The results presented here provide new evidence for the importance of understanding intersectional patterns of repression and triumph in examining political participation. In general, I find that many of the traditional variables associated with the resource model of political participation do influence the participation of intersectional groups. However, the effect and significance of these variables varies across intersectional groups. The results presented in this chapter draw attention to the need to examine central theories of political science through an intersectional approach, particularly given that finding differences across groups can help us understand *all* political participation in more meaningful ways. In addition, by identifying key differences across intersectional groups, these results suggest ways to normatively use our understanding of political participation to increase democratic participation, particularly among marginalized groups.

Appendix Table available online at www.routledge.com/9781138958845.

Notes

1 Like other scholars, I use the term Black in this chapter to refer to people who are African descendants in the United States. Scholars often refer to Black Americans as African Americans, but I consider Black a more inclusive term because it includes those with African heritage that do not identify as Americans or with the history of African Americas (Waters 1994).
2 However, this is not true for Asian American women.
3 As previously noted, these are all self-reported behaviors. Scholars have consistently demonstrated that individuals overreport their political participation, but that there are few gender and race differences in the overreporting. Thus, while the overall rates of reporting may be inflated in these models, the underlying patterns should not vary based on race and gender groups.
4 All political participation measures explicitly reference the most recent campaign cycle; given the data are from 2008, all these questions ask about behavior during the 2008 election.
5 The composite is a count measure of the number of the political participation activities that each individual indicated engaging in; the measure's high cronbach's alpha ($\alpha = 0.0709$) indicates that the variables hold together into a singular composite measure.
6 Results in the model have been replicated using an ordinal logit model to account for the categorical nature of the dependent variables. Significance and the size of the coefficients do not change in using this alternative modeling strategy.

References

Aldrich, John H. 1993. "Rational Choice and Turnout." *American Journal of Political Science* 37 (1): 246–78.

Alexander, Amy C. 2012. "Change in Women's Descriptive Representation and the Belief in Women's Ability to Govern: A Virtuous Cycle." *Politics & Gender* 8 (4): 437–64.

Alex-Assensoh, Yvette, and A.B. Assensoh. 2001. "Inner-City Contexts, Church Attendance, and African-American Political Participation." *Journal of Politics* 63 (3): 886–901.

Ansolabehere, Stephen, and Eitan Hersh. 2013. "Gender, Race, Age and Voting: A Research Note." *Politics and Governance* 1 (2): 132–37.

APSA. n.d. "American Democracy in an Age of Rising Inequality." In *Task Force on Inequality and American Democracy*. Washington, D.C.: The American Political Science Association.

Austin, Sharon D. Wright. 2006. *The Transformation of Plantation Politics: Black Politics, Concentrated Poverty, and Social Capital in the Mississippi Delta*. Albany, NY: State University of New York Press.

Banducci, Susan A., Todd Donovan, and Jeffrey A. Karp. 2004. "Minority Representation, Empowerment, and Participation." *The Journal of Politics* 66 (2): 534–56.

Barnes, Tiffany D., and Stephanie M. Burchard. 2013. "'Engendering' Politics: The Impact of Descriptive Representation on Women's Political Engagement in Sub-Saharan Africa." *Comparative Political Studies* 46 (7): 767–90.

Barreto, Matt A. 2007. "Si Se Puede! Latino Candidates and the Mobilization of Latino Voters." *American Political Science Review* 101 (3): 425–41.

Bejarano, Christina E. 2013. *The Latina Advantage: Gender, Race, and Political Success*. Austin: University of Texas Press.

Bejarano, Christina E. 2014. "Latino Gender and Generation Gaps in Political Ideology." *Politics & Gender* 10 (1): 62–88.

Bejarano, Christina E., Sylvia Manzano, and Celeste Montoya. 2011. "Tracking the Latino Gender Gap: Gender Attitudes across Sex, Borders, and Generations." *Politics & Gender* 7 (4): 521–49.

Blau, Francine D., and Lawrence M. Kahn. 2001. *Understanding International Differences in the Gender Pay Gap*. National Bureau of Economic Research. www.nber.org/papers/w8200.

Brown, Nadia E. 2014. "Political Participation of Women of Color: An Intersectional Analysis." *Journal of Women, Politics & Policy* 35 (4): 315–48.

Burns, Nancy. 2007. "Gender in the Aggregate, Gender in the Individual, Gender and Political Action." *Politics and Gender* 3: 104–24.

Burns, Nancy, Kay Lehman Schlozman, and Sidney Verba. 1997. "The Public Consequences of Private Inequality: Family Life and Citizen Participation." *The American Political Science Review* 91 (2): 373–89.

Burns, Nancy, Kay Lehman Schlozman, and Sidney Verba. 2001. *The Private Roots of Public Action*. Cambridge, MA: Harvard University Press.

Calhoun-Brown, Allison. 1996. "African American Churches and Political Mobilization: The Psychological Impact of Organizational Resources." *The Journal of Politics* 58 (4): 935–53.

Campbell, Angus, Philip E. Converse, Warren E. Miller, and Donald E. Stokes. 1960. *The American Voter*. Vol. viii. Oxford, England: John Wiley.

Campbell, David E., and Christina Wolbrecht. 2006. "See Jane Run: Women Politicians as Role Models for Adolescents." *Journal of Politics* 68 (2): 233–47.

Campbell, Karen E., Peter V. Marsden, and Jeanne S. Hurlbert. 1986. "Social Resources and Socioeconomic Status." *Social Networks* 8 (1): 97–117.

Cassese, Erin C., Tiffany Barnes, and Regina Branton. 2015. "Racializing Gender: Public Opinion at the Intersection." *Politics & Gender* 11 (1): 1–26.

Coffé, Hilde, and Catherine Bolzendahl. 2010. "Same Game, Different Rules? Gender Differences in Political Participation." *Sex Roles* 62 (5): 318–33.

Cohen, Cathy J., and Michael C. Dawson. 1993. "Neighborhood Poverty and African-American Politics." *American Political Science Review* 87 (2): 286–302.

Cole, Elizabeth R., and Abigail Stewart. 1996. "Meanings of Political Participation Among Black and White Women: Political Identity and Social Responsibility." *Journal of Personality and Social Psychology* 71 (1): 130–40.

Conover, Patricia Johnston. 1988. "Feminists and the Gender Gap." *Journal of Politics* 50 (4): 985–1010.

Crenshaw, Kimberle. 1989. "Demarginalizing the Intersection of Race and Sex: A Black Feminist Critique of Antidiscrimination Doctrine, Feminist Theory, and Antiracist Politics." *University of Chicago Legal Forces*, 139–68.

Davis, Kathy. 2008. "Intersectionality as Buzzword: A Sociology of Science Perspective on What Makes a Feminist Theory Successful." *Feminist Theory* 9 (1): 67–85.

Dawson, Michael. 2001. *Black Visions*. Chicago, IL: University of Chicago Press.

DeNavas-Walt, Carmen. 2009. *Income, Poverty, and Health Insurance Coverage in the United States: 2009*. Washington, D.C.: U.S. Census Bureau.

Farris, Emily M, and Mirya R. Holman. 2014. "Social Capital and Solving the Puzzle of Black Women's Political Participation." *Politics, Groups, and Identities* 3 (2): 331–49.

Folbre, Nancy. 2011. "Feminism's Uneven Success." *Economix Blog*. December 19. http://economix.blogs.nytimes.com/2011/12/19/feminisms-uneven-success/.

Ford Dowe, Pearl. 2016. "African American Women: Leading Ladies of Liberal Politics." In *Distinct Identities: Minority Women in U.S. Politics*, edited by Nadia E. Brown and Sarah Gershon. London: Routledge.

Fraga, Luis Ricardo, Linda Lopez, Valerie Martinez-Ebers, and Ricardo Ramírez. 2006. "Gender and Ethnicity: Patterns of Electoral Success and Legislative Advocacy among Latina and Latino State Officials in Four States." *Journal of Women, Politics, and Policy* 28 (3/4): 121–45.

Freeman, Jo. 2002. *A Room at a Time: How Women Entered Party Politics*. Lanham, MD: Rowman & Littlefield.

García Bedolla, Lisa. 2007. "Intersections of Inequality: Understanding Marginalization and Privilege in the Post-Civil Rights Era." *Politics & Gender* 3 (2): 232–48.

Gay, Claudine. 2002. "Spirals of Trust? The Effect of Descriptive Representation on the Relationship Between Citizens and Their Government." *American Journal of Political Science* 46 (4): 717–32.

Gay, Claudine, and Katherine Tate. 1998. "Doubly Bound: The Impact of Gender and Race on the Politics of Black Women." *Political Psychology* 19 (1): 169–84.

Goldin, Claudia, Lawrence F. Katz, and Ilyana Kuziemko. 2006. *The Homecoming of American College Women: The Reversal of the College Gender Gap*. Working Paper 12139. National Bureau of Economic Research. www.nber.org/papers/w12139.

Hancock, Ange-Marie. 2007. "When Multiplication Doesn't Equal Quick Addition: Examining Intersectionality as a Research Paradigm." *Perspectives on Politics* 5 (1): 63–79.

Hardy-Fanta, Carol. 1993. *Latina Politics, Latino Politics: Gender, Culture, and Political Participation in Boston*. Philadelphia, PA: Temple University Press.

Harris, Fredrick C. 1994. "Something Within: Religion as a Mobilizer of African-American Political Activism." *The Journal of Politics* 56 (1): 42–68.

Harris, Fredrick C., Valeria Sinclair-Chapman, and Brian D. McKenzie. 2005. "Macro-dynamics of Black Political Participation in the Post-Civil Rights Era." *The Journal of Politics* 67 (4): 1143–63.

Harris-Lacewell, Melissa Victoria. 2004. *Barbershops, Bibles, and BET: Everyday Talk and Black Political Thought*. Princeton, NJ: Princeton University Press.

Hemck, Rebekah, and Susan Welch. 1992. "The Impact of At-Large Elections on the Representation of Black and White Women." *National Political Science Review* 3: 62–77.

High-Pippert, Angela, and John Comer. 1998. "Female Empowerment." *Women & Politics* 19 (4): 53–66.

Hooghe, Marc, and Dietlind Stolle. 2004. "Good Girls Go to the Polling Booth, Bad Boys Go Everywhere: Gender Differences in Anticipated Political Participation among American Fourteen-Year-Olds." *Women & Politics* 26 (3–4): 1–23.

"How Does Race Affect the Gender Wage Gap?" 2014. *AAUW: Empowering Women Since 1881.* www.aauw.org/2014/04/03/race-and-the-gender-wage-gap/.

Junn, Jane. 1997. "Assimilating or Coloring Participation? Gender, Race and Democratic Political Participation." In *Women Transforming Politics: An Alternative Reader*, edited by Cathy Cohen, Kathleen Jones and Joan Tronto, 387–97. New York: New York University Press.

Junn, Jane, and Nadia E. Brown. 2008. "What Revolution? Incorporating Intersectionality in Women and Politics." In *Political Women and American Democracy*, edited by Christina Wolbrecht, Karen Beckwith, and Lisa Baldez. Cambridge: Cambridge University Press.

Leighley, Jan E., and Jonathan Nagler. 2013. *Who Votes Now?: Demographics, Issues, Inequality, and Turnout in the United States*. Princeton, NJ: Princeton University Press.

Leighley, Jan E., and Arnold Vedlitz. 1999. "Race, Ethnicity, and Political Participation: Competing Models and Contrasting Explanations." *The Journal of Politics* 61 (4): 1092–1114.

Luscombe, Belinda. 2014. "Workplace Salaries: At Last, Women on Top." *Time*. Accessed September 12. http://content.time.com/time/business/article/0,8599,2015274,00.html.

Marschall, Melissa. 2001. "Does the Shoe Fit? Testing Models of Participation for African-American and Latino Involvement in Local Politics." *Urban Affairs Review* 37 (2): 227–48.

Marschall, Melissa J., and Dietlind Stolle. 2004. "Race and the City: Neighborhood Context and the Development of Generalized Trust." *Political Behavior* 26 (2): 125–53.

Mattingly, Marybeth J., and Suzanne M. Blanchi. 2003. "Gender Differences in the Quantity and Quality of Free Time: The US Experience." *Social Forces* 81 (3): 999–1030.

McCall, Leslie. 2005. "The Complexity of Intersectionality." *Signs* 30 (3): 1771–1800.

McClerking, Harwood K., and Eric L. McDaniel. 2005. "Belonging and Doing: Political Churches and Black Political Participation." *Political Psychology* 26 (5): 721–34.

Merolla, Jennifer L., Abbylin H. Sellers, and Derek J. Fowler. 2013. "Descriptive Representation, Political Efficacy, and African Americans in the 2008 Presidential Election." *Political Psychology* 34 (6): 863–75.

Miller, Arthur H., Patricia Gurin, Gerald Gurin, and Oksana Malachuk. 1981. "Group Consciousness and Political Participation." *American Journal of Political Science* 25 (3): 494–511.

Mohamed, Heather Silber. 2015. "Americana or Latina? Gender and Identity Acquisition among Hispanics in the United States." *Politics, Groups, and Identities* 3 (1): 40–58.

Montoya, Lisa J., Carol Hardy-Fanta, and Sonia Garcia. 2000. "Latina Politics: Gender, Participation, and Leadership." *PS: Political Science & Politics* 33 (3): 555–62.

Morris, Aldon D. 1986. *Origins of the Civil Rights Movements*. New York: Simon and Schuster.

Putnam, Robert D. 1995. "Tuning In, Tuning Out: The Strange Disappearance of Social Capital in America." *PS: Political Science & Politics* 28 (4): 664–83.

Quintelier, E. M. Hooghe, and S. Marien. 2011. "The Effect of Compulsory Voting on Turnout Stratification Patterns: A Cross-National Analysis." *International Political Science Review* 32 (4): 396–416.

Robnett, Belinda, and James A. Bany. 2011. "Gender, Church Involvement, and African-American Political Participation." *Sociological Perspectives* 54 (4): 689–712.

Schlozman, Kay Lehman, Nancy Burns, and Sidney Verba. 1994. "Gender and the Pathways to Participation: The Role of Resources." *The Journal of Politics* 56 (4): 963–90.

Shingles, Richard D. 1981. "Black Consciousness and Political Participation: The Missing Link." *American Political Science Review* 75 (1): 76–91.

Simien, Evelyn M., and Rosalee A. Clawson. 2004. "The Intersection of Race and Gender: An Examination of Black Feminist Consciousness, Race Consciousness, and Policy Attitudes." *Social Science Quarterly (Blackwell Publishing Limited)* 85 (3): 793–810.

Stolle, D., M. Hooghe, and M. Micheletti. 2005. "Politics in the Supermarket: Political Consumerism as a Form of Political Participation." *International Political Science Review* 26 (3): 245–69.

Stout, Christopher, and Katherine Tate. 2013. "The 2008 Presidential Election, Political Efficacy, and Group Empowerment." *Politics, Groups, and Identities* 1 (2): 143–63.

Sweet-Cushman, Jennifer, Lisa Ficker, Mary Herring, Cathy Lysack, Mark Kruman, and Peter Lichtenberg. 2013. "Is Participation Decline Inevitable as Generations Age? Insights from African-American Elders." In *Generations: Rethinking Age and Citizenship*, edited by Richard Marback. Detroit, MI: Wayne State University Press.

Tate, Katherine. 1991. "Black Political Participation in the 1984 and 1988 Presidential Elections." *The American Political Science Review*, 1159–76.

Thomas, Melanee. 2012. "The Complexity Conundrum: Why Hasn't the Gender Gap in Subjective Political Competence Closed?" *Canadian Journal of Political Science* 45 (2): 337–58.

Valdez, Zulema. 2011. "Political Participation Among Latinos in the United States: The Effect of Group Identity and Consciousness." *Social Science Quarterly* 92 (2): 466–82.

Verba, Sidney, Nancy Burns, and Kay Lehman Schlozman. 1997. "Knowing and Caring about Politics: Gender and Political Engagement." *The Journal of Politics* 59 (4): 1051–72.

Waters, Mary C. 1994. "Ethnic and Racial Identities of Second-Generation Black Immigrants in New York City." *International Migration Review*, 795–820.

Wolfinger, Raymond, and Steven Rosenstone. 1980. *Who Votes?*. New Haven, CT: Yale University Press.

3

LINKED FATE AT THE INTERSECTION OF RACE, GENDER, AND ETHNICITY

K. Jurée Capers and Candis Watts Smith

The standard models of American political behavior and attitudes include predictive variables like socioeconomic status, age, gender, and political ideology. Scholars of Black politics note that it is imperative that we also include factors that measure racial identity, group consciousness, and linked fate in order to develop a fully specified model of Black political behavior and attitudes. While many groups, especially underrepresented minority groups, may develop a sense of group consciousness (Conover 1984; Gurin 1985; Gurin et al. 1980; Miller et al. 1981), African Americans'[1] sense of racial group consciousness stems from living in a racialized social system, or a society where they have been disadvantaged due to their racial group membership and identity while others, namely Whites, have been granted a plethora of advantages and benefits because of their race (Bonilla-Silva 1997; Dawson 1994; Gay and Tate 1998).

There are two important expectations that scholars of Black politics have noted over the years as they relate to racial group consciousness. The first is that we should expect Blacks in the United States to consider their racial group membership, identity, and status when making political decisions as long as these factors continue to constrain their life chances and opportunity structure (Dawson 1994). Second, scholars, like Arthur Miller, Patricia Gurin and their colleagues, expect group consciousness to be stable because group membership and identification are assumed to be stable, but they note that "a sense of group consciousness may also vary from individual to individual, over time, and across strata, depending on the existing social conditions" (Miller et al. 1981, 495).

These expectations are straightforward, but we must also be cognizant of complexity presented by the fact that people have multiple identities. An intersectional approach helps scholars to depict a more accurate portrait of the

ways in which various identities influence political attitudes and behaviors. As an analytical strategy,

> intersectionality is based on the idea that more than one category should be analyzed, that categories matter equally and that the relationship between categories is an open empirical question, that members within a category are diverse, that analysis of the individual or a set of individuals is integrated with institutional analysis, and that empirical and theoretical claims are both possible and necessary.
>
> (Dhamoon 2010, 231)

For example, scholars like Gay and Tate (1998) note that African American women are "doubly bound" and therefore equally and simultaneously consider their racial identity and gender identity when making political decisions: "race constructs the way Black women experience gender; gender constructs the way Black women experience race" (Mansbridge and Tate 1992, 488). Similarly, Wilcox (1990) points out that racial consciousness actually helps to foster a gender consciousness, and therefore the two are intrinsically bound together. However, other researchers have suggested that racial identity and group consciousness negate gender identity, and African American women's racial group consciousness serves a stronger role in political decision making and behavior than gender consciousness due to the more extreme and historically overt nature of the racial inequality and the shared economic and political fates men and women share within a racial or ethnic group (Gurin 1985; Mansbridge and Tate 1992). These explorations offer a first step in questioning the stability of the racial group consciousness paradigm in the face of other intersecting identities like gender.

The intersection of race and gender (as well as class) have tended to be the major focus of analyses of intersectionality, but other identities including ethnicity and immigration status are becoming increasingly important to simultaneously consider as the ethnic diversity of Blacks, in particular, grows over time (Dhamoon 2010; Wadsworth 2011). Black immigrants are transforming the demographic make-up of the Black population and the American population, and Black immigrant women are specifically contributing to this transformation. In 2013, women made up a larger portion of the foreign-born Black population (Anderson 2015). A growing number of African immigrants are women, and immigrants from the Caribbean are more likely to be women (McCabe 2011; Ruiz et al. 2015; Thomas 2012). African women make up 46.4 percent of the immigrants from Africa, and 55 percent of the immigrants from the Caribbean are Black women (McCabe 2011; Thomas 2012). The Census Bureau estimates that foreign-born Blacks will make up 16.5 percent of the U.S. Black population by 2060, suggesting that the number of Black immigrant women will also continue to grow (Anderson 2015; Brown 2015).

We are concerned with the extent to which racial group consciousness will continue to explain the political behavior and attitudes of Blacks in the United States in the face of increasing growth and diversity – or more specifically, in the face of an increasing diversity of Black experiences with racism, ethnocentrism, sexism, and oppression that targets those who fall into multiple low-strata groups. Here, we ask a series of questions whose answers will help us to gain a better understanding of the extent to which, and the circumstances under which, racial group consciousness will continue to affect and homogenize Black political attitudes and behaviors: Considering that "Black" is not only a racial category, but also a pan-ethnic group, do African Americans and Black immigrants have similar levels of group consciousness? Considering the fact that racialized experiences and immigration are often gendered, is there a gender gap in racial group consciousness? Will racial group consciousness influence Black immigrants' attitudes toward gender equality as we have seen it for African Americans?

Racial Group Consciousness

Racial group consciousness is "in-group identification *politicized* by a set of ideological beliefs about one's group's social standing, as well as the view that collective action is the best means by which the group can improve its status and realize its interests" (McClain et al. 2009, 476). While one's identity may influence one's political outlook, it is racial group consciousness that ultimately connects these two things together. There are several steps between being (involuntarily) ascribed a racial or ethnic identity and intentionally mobilizing that identity in politics. To begin, one must recognize a racial group membership, feel a psychological attachment to that group, perceive that one's group status is unfairly placed at the low end of the status hierarchy, and finally, believe that the group should work collectively to improve that status (Gurin et al. 1980). Group consciousness has been the linchpin in explaining, understanding and predicting Black political behavior and attitudes (Allen et al. 1989; Chong and Rogers 2005a; Dawson 1994; McClain et al. 2009). This politicized identity stems from Black Americans' historical and contemporary experiences within a racialized social system. Historically, Black Americans have been treated as group members rather than as individuals, and in turn, they consider the well-being of their group as a proxy for the well-being of the individual when making political decisions (Dawson 1994).

The political effects of group members having a sense of group consciousness are vast and consequential. Group consciousness "is a resource that generates political activity through an individual's attachment to a group" (Sanchez 2006, 436) and, it "potentially heightens awareness of interest in politics, bolsters group pride and political efficacy, alters interpretations of group problems, and promotes support for collective action" (Chong and Rogers 2005b, 350).

Research has provided a great deal of empirical support for these claims, especially as they relate to Blacks' political policy preferences. For example, we tend to see that Black Americans are more liberal than most other racial groups on issues like social welfare, the size and role of the federal government, and affirmative action. Group consciousness helps us to understand that since Blacks are concerned with improving the status of the group, they are more likely to prefer policies that are aimed to support this effort; Blacks have tended to "support an activist welfare state as a form of racial redress" (Tate 2010, 5).[2]

Additionally, there is a nascent literature devoted to exploring the effects of pan-ethnic diversity on racial group consciousness (Greer 2013; Nunnally 2010; Rogers 2004, 2006; Smith 2014). The knowledge produced by this small set of scholars will help us to develop more accurate predictions about what we should expect for Black politics as ethnic diversity increases due to the influx of Black immigrants from Africa, Latin America, and the Caribbean. To begin, this literature reveals [that] the factors that have influenced African Americans to develop a sense of racial group consciousness also plague Black immigrants. Black immigrants are just as, and in some cases more likely, to face discrimination in housing and job markets, wage disparities, and negative health outcomes due to their racial group membership (Crowder 1999; Denton and Massey 1989; Kim and White 2010; Read and Emerson 2005; Ryan et al. 2006).

But again, we must realize that simply because a person is ascribed an identity and treated similarly to other group members, it does not necessarily follow that they will develop a sense of group consciousness. Research has shown that while some Black immigrants, especially those who are first generation, may distance themselves from African Americans, they are still likely to develop a sense of racial group consciousness. For example, Rogers (2006) finds that a great many of his Afro-Caribbean respondents have a shared sense of racial identity with African Americans, but he also predicts that his respondents' identities may not be politically mobilized in the same way as African Americans'. Smith (2013, 2014) asserts levels of group consciousness vary across ethnic group and across generational status and finds that second generation Black immigrants have higher levels of racial group consciousness than African Americans, on average. What's more, Smith (2013, 2014) as well as Austin et al. (2012), who focus on people of African descent in Miami-Dade County, Florida, find that African Americans' sense of group consciousness influences a wide array of political behaviors (rally attendance, contacting representatives, signing petitions, voting, volunteering, meeting representatives) and attitudes (including ostensibly non-racialized policies like abortion), while Black immigrants' group consciousness tends to be constrained to influence only overtly racialized public policies and traditional political behaviors like voting and rally attendance. Overall, while racial discrimination may serve to invoke a sense of racial group consciousness among Blacks, in general, the influence of group consciousness may not have similar effects across ethnic groups. We add an

additional layer of nuance in this chapter, considering whether gender serves as a modality through which political attitudes and policy preferences are viewed.

Gender and Group Consciousness

While the aforementioned bodies of literature have helped to fill a void in our knowledge about the extent to which a concept that was developed with a specific group in mind may extend to those with a different (or new) relationship with America's racial hierarchy, much of the analyses use a single-axis approach in order to determine the role of group consciousness across ethnic groups, political behaviors, and policy preferences. That is to say, that while public policies, in particular, are likely to influence individuals differently because of an individual's race, ethnicity, immigration status, and/or gender, research does not always disaggregate groups to get a more precise understanding of the effects of important independent variables. Needless to say, the literature that examines the interlocking oppression that Black women face provides a model and a solid rationale as to why researchers must consider the variation in experiences within a group (Collins 1986, 1990). At the most basic level, intersectionality helps us to "understand the differences between and among groups" (Jordan-Zachery 2007, 256). Black feminist ideology takes us one step further in understanding what intersectionality is, asserting that "race, class, gender and sexuality are codependent variables that cannot readily be separated and ranked in scholarship, in political practice, or in lived experience" (Ransby 2000, 1218).

Scholarship shows that Black men and Black women experience the racial implications of (public) policies quite differently in the United States. For example, Black men are much more likely than most other demographic groups to have experiences with the criminal justice and mass incarceration systems (Alexander 2010). Black men's wages typically lag behind that of White men, while Black male unemployment is more than twice as high as their White counterparts (Bureau of Labor Statistics 2014). Meanwhile, Black women similarly lag behind White women in terms of wages and outpace them in terms of unemployment, but scholars have also noted the "feminization of poverty" (Reingold and Smith 2012). Beth Reingold and Adrienne Smith note that "the poverty rate for women and girls (14.4%) was approximately 2% higher than for men and boys (12%), which translates into almost 4.5 million more females living in poverty" (2012, 133). Additionally, Evelyn Simien asserts, "Black women are doubly disadvantaged in the social, political and economic structure of the United States. African American women continue to lag behind on practically every measure of well-being – income, employment, education and social class" (Simien 2005, 532).

These gendered policy differences have also led scholars to consider other within group differences based on the intersections of race and gender. For example, some scholars have expected gender to potentially mitigate the effects

of linked fate; Black men and women, they contend, may differ on the extent to which they have a sense of racial group consciousness as well as how racial group consciousness may or may not be related to gender identity. Claudine Gay and Katherine Tate found a close and positive relationship between gender identification and racial identification among Black women; their analysis also revealed that Black women's racial identity was more likely to influence their political attitudes than their gender except in cases where their racial interests and gender interests were in conflict (Gay and Tate 1998). Similarly, Wilcox found that Black women's racial and gender consciousness were positively correlated (Wilcox 1996).

After noting that the traditional linked fate question was inadequate to gauge gender variation among Blacks, Simien analyzed Black men's and women's responses to two questions: "Do you think what happens to [Black men, Black women] in this country will have something to do with your life?" and for those who affirm the first question, "Will it affect you a lot, some, or not very much?" (2005, 538). Here, she seeks to develop a better measure of Black feminist consciousness. She found that while Black men were more likely to report having a sense of linked fate with other Black men in comparison to Black women, Black men and women reported similar levels of linked fate with Black women; in all, she found that Black men seemed to have greater sense of group consciousness than Black women (Simien 2005). Also within this research agenda, Simien and Clawson found that while Black feminist consciousness is highly related to racial identity among Black women and Black men, "black feminist consciousness is part and parcel of race consciousness for black women," but "black feminism is not as fully integrated into black men's racial belief system" (2004, 803). Finally, they found that while Black feminist consciousness increased support for abortion for men and women, race identification dampened this support among Black women (Simien and Clawson 2004).

Overall, what this literature reveals is that we have to be aware of and account for "the simultaneous and interactive effects of race, gender, class, sexual orientation, and national origin as categories of difference" (Simien and Hancock 2011, 185). Black men and Black women experience race differently due to gender. Taking this one step further, we should also expect racialized and gendered experiences to also be influenced by ethnicity and immigration status. As pan-ethnic diversity grows among Blacks in the United States, we must also keep in mind that ethnic identities are also one of the important identities that people of African descent must contend with in their day-to-day lives and consider in their political decision-making processes.

An Intersectional Approach

We take the notion and approach of intersectionality seriously in this chapter in efforts to develop a more accurate depiction of the role that racial group

consciousness may play in the face of the increasing diversity among Blacks. Kimberlé Crenshaw addresses the quandary that we face in a great deal of scholarship on identity politics; she notes, "The problem with identity politics is not that it fails to transcend difference, as some critics charge, but rather the opposite – that it frequently conflates or ignores intragroup differences" (1991, 1242). In efforts to unpack intragroup differences that arise because of race, gender, class, immigration status, and the like, she outlines three forms of intersectionality: structural, political, and representational. We center the concepts of structural and political intersectionality here to inform our theoretical and empirical expectations about the role racial group consciousness plays across gender and ethnic lines among Black people in the United States.

Structural intersectionality refers to "the ways in which the locality of women of color at the intersection of race and gender make our actual [experiences] and remedial reform qualitatively different than that of white women" (Crenshaw 1991, 1245). Structural inequality illuminates the idea that when women of color experience domestic violence, for example, they may have additional burdens such as poverty, childcare responsibilities or a lack of job skills that will exacerbate an already difficult set of circumstances. We can also foresee how immigration status or cultural norms may similarly intensify racialized or gendered experiences for women of color in comparison to men or White women. For example, Crenshaw (1991) provides an illustration of how an immigrant woman who fears deportation may shy away from reporting abuse to the police.

Crenshaw's concept of political intersectionality helps us to realize how pan-ethnic, intragroup conflict might ensue. For the issue at hand, political intersectionality highlights the fact that immigrants of color are "situated in at least two subordinate groups that frequently pursue conflicting political agendas" (Crenshaw 1991, 1252). African Americans have historically been ambivalent about immigration and immigrants (Carter 2007; Diamond 1998; Smith 2014), and this ambivalence may be exacerbated when and if they consider the fact that an increasing number of immigrants are members of their racial group. Similarly, even though some "women's interests" (i.e., abortion, gender wage gap) have an acute effect on Black women, it is unclear whether Black men will feel compelled to support these issues. Finally, given that Black immigrants may have a very different perspective on the roles of race and racism in America, it is unclear whether they will also view those policy domains that are racialized and gendered in the same way that African American men and women often do.

Theoretical and Empirical Expectations

Despite the vast variations in experiences with race and racism in the United States, we expect to find that African American men and women, as well as Black immigrant men and women, have a fairly high sense of racial group

consciousness. However, when we examine differences across gender, the extant literature leads us to predict that Black immigrant women may have lower levels of group consciousness than their co-ethnic male counterparts or African Americans. Mary Waters (1999, 2001) shows that Afro-Caribbean women and girls are more likely to hold onto and make salient their ethnic identity rather than their racial identity in comparison to Black immigrant men. What's more, we might also consider the fact that Black immigrant males are more likely to experience negative interpersonal interactions with police and other figures of authority. Among the unarmed Black men who have been killed by police in the United States, a number of them are Black immigrants. Amadou Diallo and Osumane Zongo are two examples.[3] African American women, on the other hand, are more likely to be well aware and perhaps less (psychologically) insulated from the effects of racial discrimination (Smith 2014), and thus we may expect no gender difference in racial group consciousness among African Americans (but see Seaton et al. 2008).

> **H1:** *There will be a gender gap in group consciousness among Black immigrants, but this gap will not appear among African Americans.*

Second, considering the research that shows that Black women's racial identity and feminist consciousness are more tightly intertwined than Black men's, we expect that African American women's racial group consciousness will influence their attitudes towards gender equality. That is to say, we expect racial group consciousness to influence African American women's policy preferences on issues that encourage equality across gender while the same may not be the case for members of the other three groups in question.

> **H2:** *African American women's sense of racial group consciousness will influence their attitudes on policy domains that will especially affect them because of their gender, but we will not see the same effect for African American men or Black immigrant men or women.*

Methodological Approach, Data, and Measures

Research shows that negative, racialized experiences increase the chance that both Black Americans and Black immigrants will have a sense of racial group consciousness (Austin et al. 2012; Smith 2014), but extant research has generally taken a single-axis approach to discern the effects of group consciousness among members of this group. A single-axis approach simply controls for factors like

race, ethnicity, gender, and immigration status, ultimately implying that these identities are mutually exclusive (Reingold and Smith 2012). Another strategy within this approach is to interact gender and race to make conclusions about intersectional identities and experiences (Simien 2004).

Here, we employ a methodological approach that takes seriously the notion that race, gender, and ethnicity mutually reinforce each other to produce advantages for those who are in dominate groups while producing disadvantages for those who simultaneously fall into multiple subordinate groups. Rather than using dummy variables, which only tell us that groups have a different "starting point" (y-intersect), we adopt a method of *comparative relational analysis* (Masuoka and Junn 2013). This approach comports well with a theory of intersectionality because it requires us to examine each "multi-identified" group separately; in this case, we examine African American women, African American men, Afro-Caribbean women, and Afro-Caribbean men separately. A comparative relational analysis allows for the possibility that racial group consciousness will not only influence respondents across various groups differently, but also that racial group consciousness and any of the other independent and control variables may have a different effect entirely for each group (i.e., have a different slope).

We use the National Politics Study to test our hypotheses. The survey includes questions concerning participants' voting preferences, attitudes toward policies such as immigration and social issues, general government support, party affiliation and opinions, racial consciousness, and acculturation. Data for the survey were collected through telephone interviews from September 2004 to February 2005. There were a total of 3,339 respondents, which consisted of 919 non-Hispanic Whites, 756 African Americans, 757 Hispanics, 503 Asians, and 404 Caribbean Blacks. The inclusion of Afro-Caribbean respondents makes the NPS a valuable source for investigating the extent to which, and the circumstances under which, immigrant and native-born Blacks' behaviors will be driven by attachments to (un)shared identities. The gender diversity of the survey also makes it suitable for the current research. The survey includes 1,439 men and 1,900 women; African American and Afro-Caribbean women make up 25 and 14 percent of the sample, respectively, while African American men make up 20 percent of the sample and Afro-Caribbean men make up roughly 11 percent.

Independent Variables

We use two traditional measures of group consciousness, "linked fate" and "closeness", to assess variation in racial group consciousness between Black immigrant women and Black immigrant men and African American men and African American women. Respondents are asked to indicate the extent to which they agree that the happenings of others in their racial group in the U.S.

will have an effect on their individual lives. The measure is coded such that one (1) indicates a "yes" response and zero otherwise. The closeness measure "emphasize[s] the facet of black identity that most closely resembles classic definitions of group identity" (Harris 1995, 228). Respondents indicated the extent to which they feel close to various racial groups, including their own, in ideas, interests, and feelings, on a scale from (1) *not close at all* to (4) *very close*.

Dependent Variable

In order to assess the influence of group consciousness on policies concerning gender, respondents were asked,

> Recently there has been a lot of talk about women's rights. Some people feel that women should have an equal role with men in running business, industry, and government. Others feel that a woman's place is in the home. Which is closer to the way you feel: men and women should have equal roles, or a woman's place is in the home?

We coded the variable such that one (1) corresponds to those who were supportive of gender equality (men and women should have equal roles) or zero, otherwise.

Additionally, the research on political attitudes suggests a range of demographic and political factors that are likely to affect attitudes toward policies. Demographic factors such as education, age, sex, and income have been found to influence policy attitudes. As such, we have controlled for the following demographic factors: age, marital status, income, homeownership, and highest level of education. Marital status and homeownership are dichotomous variables coded one if the respondent is married or owns a home. We also control for generational status and citizenship using dichotomous variables, in which "1" indicates a respondent that is second generation (or beyond) or a U.S. citizen, respectively. Both variables have shown to be important factors in determining the policy attitudes of immigrant-replenished groups (Branton 2007). Logit models assess these variables' effect on attitudes toward gender equality.

Descriptive Results: Group Consciousness

Table 3.1 summarizes the average levels of group consciousness and racial identification, comparing Black respondents across gender and ethnic lines. The descriptive findings offer limited support for our expectations concerning levels of group consciousness across ethnicity and gender. Table 3.1 shows that in comparison to Black immigrants, African Americans, in general, feel closer to other Blacks. African American women have a higher sense of racial group closeness than Black immigrant women, and the same can be said for African

TABLE 3.1 Closeness and Linked Fate Across Ethnicity and Gender

	Closeness			Linked Fate		
	All	Women	Men	All	Women	Men
African Americans	3.40 (0.03)*	3.39 (0.03)*	3.42 (0.04)*	0.70 (0.02)*	0.66 (0.02)*	0.75 (0.03)**
Black Immigrants	3.16 (0.04)	3.19 (0.05)	3.10 (0.07)	0.56 (0.03)	0.59 (0.03)	0.52 (0.04)

Notes
 * Significantly different by ethnicity at $p < 0.01$.
 ** Significantly different by ethnicity and gender $p < 0.01$ (standard error).

American men in comparison to Afro-Caribbean men. We do not observe a gender gap in group consciousness among Black immigrants; instead, we find that Black immigrant men and women generally share similar levels of closeness to other Blacks.

Table 3.1 also shows that African Americans have a greater sense of linked fate in comparison to Black immigrants. However, the results reveal that the difference in linked fate across ethnic groups is largely driven by African American men, contrary to our expectation. The difference of means test reveals that African American men report feeling a greater sense of linked fate in comparison to the other three groups, including African American women. Black women do have a greater sense of group consciousness than Afro-Caribbean women. Finally, the results show that Black immigrant men and women are not significantly different from each other in their belief that their life chances are inexorably linked to other Blacks.

There is a gender gap in linked fate, but we actually see it occur among African Americans rather than Black immigrants. Extant literature suggests that Black immigrant men are more likely to have negative, interpersonal experiences due to racial discrimination, but we see that these experiences have not translated into a sense of group consciousness in the way that we have seen it for African American men.

Results: Policy Attitudes

The previous analysis shows that there are variations in racial group consciousness and identity across ethnic groups as well as within ethnic groups due to gender. Next, we discern the role that racial group consciousness has on policy attitudes, particularly as they concern gender equality. Table 3.2 includes tests on the effect of group consciousness on African American and Afro-Caribbean men and women's attitudes on gender equality. We include two models for Afro-Caribbean men and women; the first model is a "comparative model";

TABLE 3.2 Effect of Racial Identity on Gender Equality Attitudes by Gender

Variables	Black Immigrant Female	Black Immigrant Female	African American Female	Black Immigrant Male	Black Immigrant Male	African American Male
	Coefficient (Standard Error)	Coefficient (Standard Error)	Coefficient (Standard Error)	Coefficient (Standard Error)	Coefficient (Standard Error)	Coefficient (Standard Error)
	(1)	(2)	(3)	(4)	(5)	(6)
Racial Identity						
Linked Fate	−0.3272	−0.4933	−0.5813	0.6111	0.4790	1.8962**
	(0.679)	(0.702)	(0.591)	(0.720)	(0.778)	(0.762)
Closeness to Blacks	0.8835**	1.1472**	−0.2712	0.6012*	0.8626**	0.4147
	(0.391)	(0.446)	(0.337)	(0.332)	(0.370)	(0.415)
Controls						
Homeownership	0.5367	0.5658	0.1721	0.5499	1.0184	−0.2379
	(0.675)	(0.722)	(0.555)	(0.817)	(0.912)	(0.749)
Party Identification	−0.2692	−0.4016	−0.5417	0.2039	0.0735	−0.9071
	(0.469)	(0.495)	(0.415)	(0.572)	(0.604)	(0.577)
Ideology	−0.8826*	−0.7844	−0.1732	−0.0885	−0.0725	0.0449
	(0.476)	(0.482)	(0.294)	(0.360)	(0.393)	(0.429)
Income ($1,000s)	0.0250	0.0291	0.0059	0.0031	0.0006	0.0027
	(0.017)	(0.018)	(0.007)	(0.007)	(0.004)	(0.004)
Level of Education	−0.0993	−0.0836	0.1019	0.0112	−0.0428	0.2474
	(0.179)	(0.184)	(0.128)	(0.156)	(0.165)	(0.191)

	(1)	(2)	(3)	(4)	(5)	(6)
Marital Status	0.1038	-0.1360	-0.7647	-0.4577	-0.7998	0.1501
	(0.792)	(0.833)	(0.527)	(0.754)	(0.871)	(0.783)
Age	-0.0240	-0.0190	-0.0173	-0.0115	-0.0319	-0.0125
	(0.021)	(0.022)	(0.017)	(0.027)	(0.032)	(0.023)
Generational Status		-0.8175			-1.0711	
		(0.829)			(0.930)	
Citizenship		-0.8350			0.2777	
		(1.077)			(0.967)	
Constant	2.5108	2.3486	5.3746***	-0.4144	-0.1770	1.7619
	(2.583)	(2.604)	(2.074)	(2.364)	(2.677)	(2.657)
Observations	203	200	381	135	134	219
Log likelihood	-35.2572	-33.8658	-68.6191	-34.8250	-30.6478	-34.2435
DF	9.0000	11.0000	9.0000	9.0000	11.0000	9.0000
χ^2	20.6410	23.0553	7.7851	6.5906	9.8440	18.7569
R^2	0.2264	0.2539	0.0537	0.0864	0.1384	0.2150

Notes

Logit coefficients reported. Homeowner = 1, 2nd generation = 1, citizen = 1, married = 1.

* $p < 0.10$.

** $p < 0.05$.

*** $p < 0.01$.

this model exactly mirrors that of African Americans. The second model is a "full model," and it includes "generational status" (1 = second generation) and "citizenship" (1 = citizen). These two variables do not have any variation among African Americans, but they are likely to provide additional information for Black immigrants.

As mentioned, the literature suggests that Black men and women have a sense of Black feminist consciousness, and that Black women's racial and gender identities are more closely linked in comparison to men. Our data are limited because we do not have a specific measure of Black feminist consciousness, but we are able to determine whether racial group consciousness and identity influence attitudes about gender equality; additionally, we can get a sense of the differential effect that racial group identity has on Blacks across ethnic groups.

Similar to VanSickle-Ward and Pantoja (Chapter 6), we also find immigrant men and women to hold policy attitudes that differ from native-born men and women. This finding stands out in Table 3.2; racial identity has an effect on the way that respondents feel toward gender equality, but it is most pronounced among Black immigrants, men and women alike. What is interesting and counterintuitive is that closeness does not influence either African American women's or men's attitudes toward gender equality. This is especially fascinating because across all four groups, there is high support for women to have equal access to opportunities outside the home. There is not an issue of a ceiling effect, but rather, we see that racial identity and feminist attitudes are more closely linked for Black immigrants than African Americans.

The second point of interest in Table 3.2 is the result that suggests that having a sense of a linked fate to other Blacks increases the odds of African American men supporting gender equality, while it fails to have a significant effect on African American women's support of gender equality. African American men who report having a sense of group consciousness are seven times more likely to support gender equality when compared to those who do not. Racial group consciousness seems to prime African American men to be more considerate of issues that affect women.

Contrary to our expectation, various dimensions of group consciousness influence attitudes on gender equality for all groups except African American women. We find that African American women are actually the *only* group in which group consciousness does not influence policy attitudes. Perhaps racial group consciousness is not the best measure to understand the role of African American women's identities, particularly on gender issues, given the equal salience that African American women give to both their gender and racial identities.

Even when we look at the pseudo-R^2 (which we realize cannot be interpreted exactly like the R-squared of an OLS regression), we see that the variables do not explain African American women's attitudes as well as they do for Black immigrants or African American men. It becomes apparent that the measures we have available to us do not do the explanatory work for African

American women as they do for the three groups. Here, Evelyn Simien's research becomes helpful to explain what we see, or rather don't see, here; she suggests that we may gain more leverage on understanding African American women's attitudes by more carefully and accurately measuring and accounting for Black feminist consciousness in addition to a more general racial group consciousness when examining African American women's attitudes. Nonetheless, the results reveal, at the very least, that there is a different link between racial group consciousness, racial identity, and feminism for African American and Afro-Caribbean men and women.

Implications and Conclusions

Race, gender, and class have been the dominant tripartite in intersectionality research. Here, we seek to contribute to this literature by considering the notion that ethnicity may also be an important identity to consider given the increasing ethnic diversity that the Black population is undergoing due to the immigration of Black immigrants from Africa, Latin America, and the Caribbean. We explored whether there was a gender gap in group consciousness across Black ethnic groups, and then ascertained the link between racial group consciousness and attitudes concerning gender equality. The analysis employed a method of comparative relational analysis (Masuoka and Junn 2013). Like Sriram (Chapter 8), we find ethnicity to be an important contributor to immigrant-replenished groups' identities and political behavior.

While past research literature offers a relatively strong finding that racial discrimination often invokes a sense of racial group consciousness in politics and political decisions among Blacks, we find that the levels and influence of group consciousness differ substantially across gender and ethnic groups. African Americans had a stronger sense of racial group consciousness than Black immigrants, but the results also exposed a gender gap in African Americans' sense of linked fate, where men had a greater sense of linked fate than women.

The results also illustrated the fact that group consciousness does not influence African Americans' and Black immigrants' attitudes in the same manner. Interestingly, we find greater evidence of group consciousness, particularly "closeness to African Americans," to be a predictor of Black immigrants' attitudes on gender equality when compared to the findings for African Americans. Black immigrants who feel closer to other Blacks held positive attitudes on gender equality, but the same could not be said for African Americans. Instead, we found that only one dimension of group consciousness, linked fate, influenced African American men's attitudes on gender equality. Meanwhile, the results here suggest that racial group consciousness, as measured here, did not influence African American women in any way. We posit above that a better measure, such as Simien and Clawson's (2004) "black feminist consciousness," might better assess African American women's policy attitudes on gender issues.

At the most basic level, these results reveal that ethnicity is an important category to consider more carefully when we discuss Black political attitudes, racial identity, and racial group consciousness. Second, literature shows that racial group consciousness is influenced by experiences and perception of racial discrimination; here, we found that African American men had very high levels of racial group consciousness. While an intersectional approach helps us to highlight the ways in which those who are in multiple minority, subordinate, or oppressed groups are similar, it also helps us to see the differential effect that racism, in this case, has on African American men in comparison to African American women or Black immigrants. While Black women do face unique challenges, we also see that Black women are more likely to attend college than Black men and have higher employment rates; what's more, Christina Greer (2013) suggests that Black immigrants tend to have an "elevated minority status"; so even though Black immigrant males are racialized as Black, they still manage to distance themselves from African American men in a way that is optimal for their life chances.

The third and final point of interest that should be highlighted is the notion that African American women's racial and gender identity may be linked in a way that is substantially different from African American men or Black immigrant women. We were able to see a clear link between racial group consciousness, racial identity, and attitudes about gender equality for all of the other groups, but the models did not help us to understand African American women's attitudes about gender equality by any means. It becomes more obvious, here, that scholars need to incorporate measures that more accurately describe and measure Black feminist group consciousness.

Notes

1 In this chapter, we use "African American" to describe Black people whose ancestors have been in the United States for several generations. We use "Black immigrant" to describe those who are categorized as Black in the U.S. but are first, 1.5, or second generation immigrants to the U.S. Finally, we use "Black" to describe all people who are categorized as Black despite their ethnicity.

2 Nonetheless, there have been major critiques of this theory and concept. Some scholars have questioned the ability of group consciousness and linked fate measures to transcend class and gender differences. As Price (2009) notes, focusing on "a shared fate does not explain intragroup differences"; we know very little about *why* some Blacks behave "out of sync" with other Blacks (5, 7). Cohen and Dawson (1993) and Marble (2000) also suggest that the social isolation and economic distress in poor Black communities can widen class divisions, reduce feelings of racial group solidarity, and weaken confidence in group consciousness's effectiveness (but see Tate 1993). Similarly, Simpson (1998) contends that integration with the majority population and generational status may also influence one's sense of group identity and the potential of link fate's effects on political behavior.

3 Amadou Diallo was an unarmed, 22-year-old Guinean immigrant who was shot and killed by four plain-clothed New York City Department (NYPD) police officers in

February of 1999. In an effort to show his identification, the police believed his wallet was a gun and shot at him 41 times; Diallo was struck by 19 bullets. Similarly, Ousa-mane Zongo, an unarmed Burkinabé man, was shot in the back and killed by a NYPD officer dressed as a postal worker, in May of 2003. These two cases were prominent in the news media, as they sparked protests against police brutality; more recently, the #BlackLivesMatter movement was sparked by the deaths of several unarmed Black people, mostly men, who have been shot and killed by the police, but it should be duly noted that Black women have also been shot and killed by the police and are vulnerable to police brutality, as well.

References

Alexander, Michelle. 2010. *The New Jim Crow: Mass Incarceration in the Age of Color-blindness*. New York: The New Press.

Allen, Richard L., Michael C. Dawson, and Ronald E. Brown. 1989. "A Schema-Based Approach to Modeling an African-American Racial Belief System." *The American Political Science Review* 83 (2): 421–441.

Anderson, Monica. 2015. "A Rising Share of the U.S. Black Population is Foreign Born; 9 Percent Are Immigrants; and While Most Are from the Caribbean, Africans Drive Recent Growth." *Pew Research Center*. Washington, D.C. Retrieved on April 29, 2015. www.pewsocialtrends.org/files/2015/04/2015–04–09_black-immigrants_FINAL.pdf.

Austin, Sharon D. Wright, Richard T. Middleton, and Rachel Yon. 2012. "The Effect of Racial Group Consciousness on the Political Participation of African Americans and Black Ethnics in Miami-Dade County, Florida." *Political Research Quarterly* 65 (3): 629–641.

Bonilla-Silva, Eduardo. 1997. "Rethinking Racism: Toward a Structural Interpretation." *American Sociological Review* 62 (3): 465–480.

Branton, Regina. 2007. "Latino Attitudes Toward Various Areas of Public Policy: The Importance of Acculturation." *Political Research Quarterly* 60 (2): 293–303.

Brown, Anna. 2015. "U.S. Immigrant Population Projected to Rise, Even as Share Falls among Hispanics, Asians." *Pew Research Center*. Retrieved on April 29, 2015. www.pewresearch.org/fact-tank/2015/03/09/u-s-immigrant-population-projected-to-rise-even-as-share-falls-among-hispanics-asians/.

Bureau of Labor Statistics. 2014. Table E-16. Unemployment Rates by Age, Sex, Race, and Hispanic or Latino Ethnicity. In *Labor Force Statistics from the Current Population Survey*: United States Department of Labor.

Carter, Niambi M. 2007. *The Black/White Paradigm Revisited: African Americans, Immigration, Race, and Nation in Durham, North Carolina*. Durham, NC: Political Science, Duke University.

Chong, Dennis, and Reuel Rogers. 2005a. "Reviving Group Consciousness." In *The Politics of Democratic Inclusion*, edited by Christina Wolbrecht and Rodney E. Hero, 45–74. Philadelphia, PA: Temple University Press.

Chong, Dennis, and Reuel Rogers. 2005b. "Racial Solidarity and Political Participation." *Political Behavior* 27 (4): 347–374.

Cohen, Cathy J., and Michael C. Dawson. 1993. "Neighborhood Poverty and African American Politics." *American Political Science Review* 87 (2): 286–302.

Collins, Patricia Hill. 1986. "Learning from the Outsider Within: The Sociological Significance of Black Feminist Thought." *Social Problems* 33 (6): 14–32.

Collins, Patricia Hill. 1990. *Black Feminist Thought: Knowledge, Consciousness, and the Politics of Empowerment*. Boston, MA: Unwin Hyman.

Conover, Pamela Johnston. 1984. "The Influence of Group Identifications on Political Perception and Evaluation." *The Journal of Politics* 46 (3): 760–785.

Crenshaw, Kimberlé. 1991. "Mapping the Margins: Intersectionality, Identity Politics, and Violence Against Women of Color." *Stanford Law Review* 43 (6): 1241–1299.

Crowder, Kyle D. 1999. "Residential Segregation of West Indians in the New York/ New Jersey Metropolitan Area: The Roles of Race and Ethnicity." *International Migration Review* 33 (1): 79–113.

Dawson, Michael C. 1994. *Behind the Mule: Race and Class in African-American Press.* Princeton, NJ: Princeton University Press.

Denton, Nancy A., and Douglas S. Massey. 1989. "Racial Identity Among Caribbean Hispanics: The Effect of Double Minority Status on Residential Segregation." *American Sociological Review* 54 (5): 790–808.

Dhamoon, Rita Kaur. 2010. "Considerations on Mainstreaming Intersectionality." *Political Research Quarterly* 64 (1): 230–243.

Diamond, Jeff. 1998. "African-American Attitudes Towards United States Immigration Policy." *International Migration Review* 32 (2): 451–470.

Gay, Claudine, and Katherine Tate. 1998. "Doubly Bound: The Impact of Gender and Race on the Politics of Black Women." *Political Psychology* 19 (1): 169–184.

Greer, Christina. 2013. *Black Ethnics: Race, Immigration, and the Pursuit of the American Dream.* New York: Oxford University Press.

Gurin, Patricia. 1985. "Women's Gender Consciousness." *Public Opinion Quarterly* 49 (2): 143–163.

Gurin, Patricia, Arthur H. Miller, and Gerald Gurin. 1980. "Stratum Identification and Consciousness." *Social Psychology Quarterly* 43 (1): 30–47.

Harris, David. 1995. "Exploring the Determinants of Adult Black Identity: Context and Process." *Social Forces* 74 (1): 227–241.

Jordan-Zachery, Julia S. 2007. "Am I a Black Woman or a Woman Who Is Black? A Few Thoughts on the Meaning of Intersectionality." *Politics & Gender* 3 (2): 254–263.

Kim, Arthur H., and Michael J. White. 2010. "Pathethnicity, Ethnic Diversity, and Residential Segregation." *American Journal of Sociology* 115 (5): 1558–1596.

Mansbridge, Jane, and Katherine Tate. 1992. "Race Trumps Gender: The Thomas Nomination in the Black Community." *PS: Political Science and Politics* 25 (3): 488–492.

Marble, Manning. 2000. *How Capitalism Underdeveloped Black America: Problems in Race, Political Economy and Society.* London: Pluto Press.

Masuoka, Natalie, and Jane Junn. 2013. *The Politics of Belonging: Race, Public Opinion, and Immigration.* Chicago, IL: University of Chicago Press.

McCabe. K. 2011. "African Immigrants in the United States." *Migration Policy Institute.* Retrieved on March 26, 2015. www.migrationpolicy.org/article/african-immigrants-united-states.

McClain, Paula, Jessica D. Johnson Carew, Eugene Walton Jr., and Candis S. Watts. 2009. "Group Membership, Group Identity, and Group Consciousness: Measures of Racial Identity in American Politics?" *Annual Review of Political Science* 12: 471–484.

Miller, Arthur H., Patricia Gurin, Gerald Gurin, and Oksana Malanchuk. 1981. "Group Consciousness and Political Participation." *American Journal of Political Science* 25 (3): 494–511.

Nunnally, Shayla C. 2010. "Linking Blackness or Ethnic Othering? African Americans' Diasporic Linked Fate with West Indian and African Peoples in the United States." *Du Bois Review* 7 (2): 335–355.

Price, Melanye T. 2009. *Dreaming Blackness: Black Nationalism and African American Public Opinion*. New York: New York University Press.

Ransby, Barbara. 2000. "Black Feminism at Twenty-One: Reflections on the Evolution of a National Community." *Signs*: 1215–1221.

Read, Jen'nan Ghazai, and Michael O. Emerson. 2005. "Racial Context, Black Immigration and the U.S. Black/White Health Disparity." *Social Forces* 84 (1): 181–199.

Reingold, Beth, and Adrienne R. Smith. 2012. "Welfare Policymaking and Intersections of Race, Ethnicity, and Gender in U.S. State Legislatures." *American Journal of Political Science* 56 (1): 131–147.

Rogers, Reuel R. 2004. "Race-Based Coalitions Among Minority Groups: Afro-Caribbean Immigrants and African-Americans in New York City." *Urban Affairs Review* 39 (3): 283–317.

Rogers, Reuel R. 2006. *Afro-Caribbean Immigrants and the Politics of Incorporation: Ethnicity, Exception, or Exit*. New York: Cambridge University Press.

Ruiz, A.G., Jie Zong, and Jeanna Batalova. 2015. "Immigrant Women in the United States." *Migration Policy Institute*. Retrieved on March 26, 2015. www.migrationpolicy.org/article/immigrant-women-united-states.

Ryan, Andrew M., Gilbert C. Gee and David F. Laflamme. 2006. "The Association Between Self-reported Discrimination, Physical Health and Blood Pressure: Findings from African Americans, Black Immigrants, and Latino Immigrants in New Hampshire." *Journal of Health Care for the Poor and Underserved* 17: 116–132.

Sanchez, Gabriel R. 2006. "The Role of Group Consciousness in Latino Public Opinion." *Political Research Quarterly* 59 (3): 435–446.

Seaton, E.K., Cleopatra H. Caldwell, Robert M. Sellers, and James S. Jackson. 2008. "The Prevalence of Perceived Discrimination Among African American and Caribbean Black Youth." *Developmental Psychology* 44 (5): 1288–1297.

Simien, Evelyn M. 2004. "Black Feminist Theory: Charting a Course for Black Women's Studies in Political Science." *Women & Politics* 26 (2): 81–93.

Simien, Evelyn M. 2005. "Race, Gender, and Linked Fate." *Journal of Black Studies* 35 (5): 529–550.

Simien, Evelyn M., and Rosalee A Clawson. 2004. "The Intersection of Race and Gender: An Examination of Black Feminist Consciousness, Race Consciousness, and Policy Attitudes." *Social Science Quarterly* 85 (3): 793–810.

Simien, Evelyn M., and Ange-Marie Hancock. 2011. "Mini-Symposium: Intersectionality Research." *Political Research Quarterly* 64 (1): 185–186.

Simpson, Andrea Y. 1998. *The Tie That Binds: Identity and Political Attitudes in the Post-Civil Rights Generation*. New York: New York University Press.

Smith, Candis Watts. 2013. "Ethnicity and the Role of Group Consciousness: A Comparison Between African Americans and Black Immigrants." *Politics, Groups, and Identities* 1 (2): 199–220.

Smith, Candis Watts. 2014. *Black Mosaic: The Politics of Black Pan-Ethnicity*. New York: NYU Press.

Tate, Katherine. 1993. *From Protest to Politics: The New Black Voters in American Elections*. Cambridge, MA: Harvard University Press.

Tate, Katherine. 2010. *What's Going On? Political Incorporation and the Transformation of Black Public Opinion*. Washington, D.C.: Georgetown University Press.

Thomas, K.J.A. 2012. "A Demographic Profile of Black Caribbean Immigrants in the United States." *Center on Immigrant Integration Policy*. Washington, D.C.: Migration Policy Institute.

Wadsworth, Nancy D. 2011. "Intersectionality in California's Same-sex Marriage Battles: A Complex Proposition." *Political Research Quarterly* 64 (1): 200–216.

Waters, Mary C. 1999. *Black Identities: West Indian Immigrant Dreams and American Realities.* Cambridge, MA: Harvard University Press.

Waters, Mary C. 2001. "Growing Up West Indian and African American: Gender and Class Differences in the Second Generation." In *Islands in the City: West Indian Migration to New York*, edited by Nancy Foner. Berkeley, CA: University of California Press.

Wilcox, Clyde. 1990. "Black Women and Feminism." *Women and Politics* 10 (3): 65–84.

Wilcox, Clyde. 1996. "Racial and Gender Consciousness Among African-American Women: Sources and Consequences." *Women & Politics* 17 (1): 73–94.

4

AFRICAN AMERICAN WOMEN

Leading Ladies of Liberal Politics

Pearl K. Ford Dowe

Introduction

For most of my academic career my research interest primarily focused on African American political behavior. It was not until very recently I decided to shift my focus to African American women. Although my focus has been the overall group, I know the important role that Black women play in electoral politics as both voters and candidates. My decision to refocus my work came about during the lead up to the 2014 mid-term elections when I came across an article arguing White female candidates were the key to potential Democratic Party success in winning back Southern state legislatures and future congressional seats (Keith 2014). This article was synonymous with a trope often stated in media and in political strategies – ignore African American voters and politicians and engage only when absolutely necessary. Unfortunately that particular article was not singular in ignoring the political strength of Blacks and especially Black female candidates (Fineman 2014). These articles ignored the fact that while the election of women to state legislatures has declined overall, African American women have steadily increased their numbers in state legislatures (Sanbonmatsu 2006; Scola 2006; Smooth 2006).

Black female participation is also evident in the voting booth in 2008 when Black women had the highest voter turnout rate among all groups of eligible voters. Black women again exceeded expectations in 2012 as they led all other groups again in turnout (Taylor 2012). The unique level of consistent participation by African American women has been ignored and often not incorporated into the discussion of the gender gap in elections which has primarily focused on the behavior of White women (Carroll 1999; Simien 2006; Smooth 2006). Historically African American women have viewed political participation as a means to achieve full equality and improve the status of the group (Shingles

1981; Giddings 1985; Tate 1991; Collins 1998, 1999; Barker et al. 1999; Simien 2006). The far-reaching role of African American women as political partici- pants, laborers, and activists compels me to develop a greater understanding of these women during this critical economic and demographic shift in America. African American women are more likely to participate in the workforce and be the primary source of income for their households than women of other races (U.S. Department of Labor 2013). The contributions these women make and will continue to make to the workforce can't be understated as it is estim- ated that by 2043, the population will be comprised of only 50 percent of Whites. This pattern already evident in communities throughout the nation (U.S. Census 2013). A shift in population presents not only potential opportun- ities but a need for persons of color to have the ability to advance within the workplace, in particular Black women. In the post Great Recession climate, occupations with high growth and higher incomes such as those in computer and mathematical fields and positions of professional management, Black women are three times less likely to participate in (U.S. Department of Labor 2013). Effort or the lack thereof to develop policies and practices that address the challenges Black women face will have a long term implication on the success of the workforce to meet the nation's economic needs in the future.

African American women also play a compelling role in political socialization within their communities and contribute to their economic stability (Giddings 1985; King 1988; Gay 2001; Guerra 2013). Their perspective is relevant to the discussion of policy preferences, potential coalition development, political engagement, and the advancement of the liberal politics of African Americans.

In this chapter I will examine national survey data to explore the varied atti- tudes and behaviors of African American women. Given the general absence of accurate data on African American political behavior and trends, the research from this dataset is a source of accurate information about politics and policy, as well as the political and social attitudes of African American women. Analysis of the poll data will explore attitudes and opinions concerning public policy, eco- nomic outlook, social issues such as same sex marriage and attitudes towards group identity, and racial commonality. This is necessary to provide a broader sense of the complex nuances of Black female life, issues, and concerns in order to substantiate the potential needs these women may have of public policy, society, and potential allies. I will also explore any regional cleavages in the opinions of Black women when it comes to their racialized lived experiences within the South. As the South remains a critical region in national elections, it is important to explore regional aspects of attitudes Black women may hold.

The Political Black Woman

Black women are a significant proportion of the Black vote; their strength is often ignored by scholars, media, and politicians (Gay and Tate 1998; Stokes-Brown

and Dolan 2010). Typically women vote in higher numbers and in higher percentages than men. With the exception of Asian Americans this has been mostly true. Black men and women have exhibited the greatest gap in participation (Harris 2014; Holman 2016). Since 1998 Black women have registered and voted at higher rates than their male counterparts in every election. In 2012 for the first time African Americans as a racial/ethnic group surpassed White voters in turnout (U.S. Census 2013b). This is largely attributed to the increase of African American female voters who as a group voted at a higher rate than any other group across gender, race, and ethnicity.

The significance of Black women in the electorate has also transcended to their significant role in not only increasing descriptive representation of African Americans but also substantive representation. Once in office, Black women champion the interests of Blacks and underrepresented populations, supporting progressive agendas more so than their White female counterparts (Smooth 2006). With the passage of the Voting Rights Act of 1965 the number of African American elected officials quickly increased to 1,469 but only 160 were held by Black women. Black women would be critical to the growth of the overall number of African American elected officials. Since 1990 there has been a significant increase in the number of Black elected officials nationwide, this is largely due to Black women. During this same period Black women have exceeded the number of Black male elected officials (Hardy-Fanta et al. 2006; Orey et al., 2006; Smooth 2014). This form of participation has been sustained and is evident in the newly seated 114th Congress which seats 46 Blacks of which 20 are women. In this same Congress, there are two male African American Senators as well.

All women running for office face considerable obstacles, however it has been shown that Black women face considerably more due to the fact they are more likely to be discouraged to run and are less likely to be recruited (Carroll and Sanbonmatsu 2013). Carroll and Sanbonmatsu also argue that for these women candidate recruitment is more important for the potential run of a woman than a male candidate (Sanbonmatsu 2016). This hesitancy by party leadership reflects the limited idea of what type of candidate is electable. Limited recruitment impacts the ability of Black women to secure campaign resources necessary to establish a viable campaign early, especially resources outside of their districts (Sanbonmatsu 2006). Resources that can be provided via a party are critical for the success of Black female candidates. It has been shown that Black candidates are more likely to raise less money, rely heavily on small donations, and rely on donations outside of their districts (Theilmann and Wilhite 1989; Singh 1998). Party leaders' doubts about candidate electability are problematic for Black women seeking election in majority White districts. This hesitancy poses difficulty in launching a successful campaign due to challenges in securing resources to launch a campaign (Sanbonmatsu 2006).

As a result of the challenges faced by Black women, including their socio-economic status, we would predict low levels of participation. However, the level of participation by African American women transcends voting and includes a high level of political activism, organizing, and civic engagement that is also ignored in literature (Holman 2016). According to Smooth, the multiple roles Black women play as activists in the church and community and as laborers provide an avenue for their own political success (Darcy and Hadley 1988; Tate 2003; Kaba and Ward 2009; Frederick 2013). These factors that lend to political success locally and within state legislators have not formed a bridge to move up the political pipeline to national office (Gamble 2010).

Although Black women proportionately hold small numbers of seats particularly in the legislatures, these numbers of African American women elected to state legislatures has steadily increased while the number of White women elected to state legislatures has plateaued over the last ten years (Sanbonmatsu and Dolan 2009; Smooth 2009; Brown 2014). As of 2014, 241 African American women served in 40 state legislatures. The majority of these women are Democrats (236) while four are Republican and one serves in a non-partisan legislature. Sixty-seven serve as state senators and 174 serve in the lower chamber (Ditmar 2014). Black women are 3.3 percent of all state legislators and comprise 13.5 percent of all female state legislators. Black women have their strongest showing in the Southern states. Black women are more than half of all women legislators in Alabama, Georgia, Mississippi, and Louisiana (Ditmar 2014). In Georgia, Black women are 16.4 percent of the state's population; however, they hold 11.4 percent of state legislative seats. In Maryland, Black women are 16 percent of the population and 10.1 percent of state legislators.

African Americans have consistently supported the Democratic Party and a liberal policy agenda. The Democratic Party has long argued its strength with women which largely comes as a result of the staunch support of Black women along with Latinas (Scruggs-Leftwich 2000; Smooth 2006). The scholarly study of the gender gap often focuses on a gender-based difference which emphasizes the choices of White women; however, further analysis of the gender gap reveals that Black women are more supportive of the Democratic Party than their White counterparts as evidenced in the gravitation of White women to the Republican Party going back to 2004. Black women have also supported a progressive agenda. As elected officials, research has shown that African American women tend to focus on both women's and Black interests (Bratton et al. 2007), but are there cleavages within this group concerning policy preferences and social issues due to various levels of interests, successes, and income levels?

It is expected that the more middle class the group becomes, the more likely they are to develop more conservative attitudes towards public policy (Dawson 1995; Tate 2010). To advance the scholarship on Black women a broader perspective is needed. Scholars have argued that perceptions of common or linked

fate hinder the ability to develop political action that is inclusive of all voices within the group (Simpson 1998; Price 2009; Brown 2014). Brown posits that simply viewing Blacks through the lens of linked fate "fails to clarify the reasons for agreement and disagreement within the Black community and among African American women as a distinct race/gender group or its link to Black women's legislative behavior" (2014, 14–15). As a group Black women overall face significant adversity in major indicators that affect quality of life. To place in proper context how these women view the world in which they navigate it is imperative to not only see their racial identity but also their gendered existence.

Data

The public opinion data utilized comes from the 2012 Blair–Clinton School Poll (*BCCS Poll*). The 2012 poll is a nationally representative survey created by the Blair Center of Southern Politics and Society at the University of Arkansas and the Clinton School of Public Affairs. The 2012 Blair–Clinton School Poll was fielded in November 2012 and has a total sample of 3,606 individuals aged 18 years or older, including 1,110 Latino, 843 African American (441 women), and 1,653 non-Hispanic White respondents. This poll allows for the comparison of the southern region to the rest of the country. While many national surveys include only small samples from the South, the Blair Poll oversampled southerners of all races and weighted the data to reflect a true national portrait by race and region. Rather than assessing the region based on the opinions of relatively few southerners (white southerners specifically), the Blair–Rockefeller Poll provides an accurate snapshot in time of the South and the Non-South.

The *BCCS Poll* informs us that African Americans disparities persist in income and educational attainment for the group. Of the sample, African American women were the least employed with 18 percent stating they were temporarily laid off or looking for work while only 9 percent of Whites and 19 percent of Latinos reported the same. Those who were employed reported low levels of income, with 59 percent earning less than $35,000 in comparison to 29 percent of White women and 50 percent of Latinas. Only 18 percent earned a bachelor degree or higher in comparison to 33 percent of Whites and 12 percent of Latinos. African Americans were also the least likely to own a home. Black respondents indicated that 54 percent rent while 41 percent own, compared to 75 percent of Whites and 51 percent of Latinos reporting home ownership. The issue of access to quality healthcare and the persistence of health disparities continue to be problematic for the group, with 43 percent reporting that they have private health insurance while 14 percent identified Medicaid as their primary source of health insurance in comparison to 4.3 percent of Whites and 7.6 percent of Latinos (see Figure 4.1).

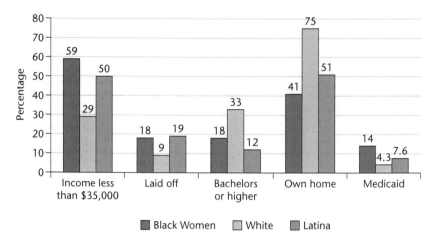

FIGURE 4.1 Quality of Life of African American Women (source: 2012 Blair–Clinton School Poll: Sample size, 441 African American women, 553 Latinas, and 853 White women)

Race and Policy Preferences

Policies designed to address societal racial inequality are among the most controversial in our contemporary political debates. Historically, African Americans have been progressive in leading the fight for racial, social, and economic justice. This is evident in the fact that as a group African Americans tend to support state action to redistribute wealth to bring about a more equal and just society than any other group of Americans. Scholars have explored the limited support among Whites for policies created to address racial equality while at the same time Whites profess general support for the principles of equality. To some scholars, the gap between ideology and policy among Whites often reveals thinly veiled forms of racism (Gilliam and Iyengar 2000; Sears and Henry 2003; Peffley and Hurwitz 2007). To others, the response is much more nuanced, suggesting that opposition to specific policies doesn't represent racial animosity, but rather opposition to government intrusion into private affairs (Abramowitz 1994; Gomez and Wilson 2006; Shafer and Johnston 2006).

Public policy implementation can influence how individuals understand their rights and responsibilities as members of a political community. They can redefine citizenship and expand how groups interpret the distribution of goods and services (Esping-Andersen 1990). For African American women public policy that directly impacts Black female life has often been shaped by stereotypes and developed with the purpose to control Black female fertility as well as justify the lower status in the labor market (Collins 1999; Gillespie 2016). Black women's understanding of these tropes and practices along with the legacy of fighting

injustices has led Black women to continue their legacy of advocacy for racial, social, and economic justice.

According to data from the 2012 *BCCS Poll*, African American women still express strong liberal opinions on political issues and increased liberal support for social issues. Of African Americans, 49 percent say abortion is a personal choice. In the case of gay marriage, 27 percent of African American women are in favor of gay marriage. This is a slight increase from the 23 percent of African American female respondents who were in support in the 2010 *Blair–Rockefeller Poll*. While 34 percent are in opposition, the group's opposition to gay marriage is slightly higher than White women (32 percent) and 31 percent of Latinas.

The issue of immigration is of national importance and has impacted African Americans (Harvie 2016). Latino immigrants are more likely to live in communities with or are in close proximity to African Americans. Only 31 percent of African American women favored stricter immigration laws similar to the one in Arizona. Interestingly, 44 percent stated they were neither opposed nor in favor of tougher immigration laws. Fortunately, the *Blair–Rockefeller Poll* asked respondents about the levels of discrimination various racial and ethnic groups experienced. Examination of this data reveals that race still significantly influences the day to day experiences of African American women across the country. However, the expected high level of reporting of similar experiences does not occur amongst Latinas. Eighty percent of African American women reported experiencing discrimination in their day to day life. Latino respondents reported less discrimination in their lives compared to African American women. Interestingly, a considerable number of White women expressed that they had experienced discrimination. However, in responses to more specific examples of racial discrimination these percentages decline (see Figure 4.2).

These data are significant for exploring the possibilities and limitations of coalition development with Latinas around the issues of discrimination. Scholars have long maintained that African American/Latino affinity is rooted in perceived discrimination and shared outsider status (Cain et al. 1991; Uhlaner 1991). It has long been understood that both groups experience severe social and economic discrimination and they often see their opportunities for upward mobility and political inclusion thwarted by a larger culture that discriminates against them. However, these data reveal that the perception of discrimination varies between the women in these groups therefore there possibly is a greater challenge to coalition development than earlier scholarship has perceived (Capers and Smith 2016).

The South: Home Again Home Again Jiggity Jig

Since 1970, more African Americans have migrated to the South than have left the region (Falk et al., 2004; Frey 2004). The movement reverses the Great Migration that began around World War I, when more than five million Blacks left the South to move to the North and West.

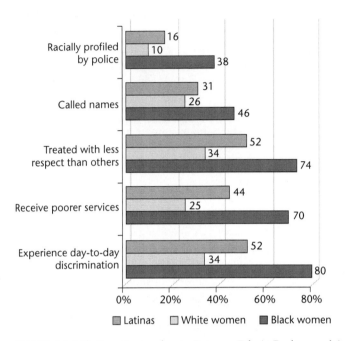

FIGURE 4.2 Life Experiences due to Race or Ethnic Background (source: 2012 Blair–Clinton School Poll: Sample size, 441 African American women, 553 Latinas, and 853 White women)

There are multiple factors that contribute to this migration back to the South. The outmigration of Blacks from the South slowed down as the result of the idea of the "New South" which emphasized Black economic mobility in cities such as Atlanta, Birmingham, and Charlotte. The job losses associated with deindustrialization in other regions along with high cost of living led people, particularly African Americans who often had familial ties to Southerners, to relocate to the region. This current migration is unique in that African Americans who are returning are distinctly different from their parents and who were apart from the Great Migration. Black Southerners who traveled north were often persons with limited education and an agricultural background; however, the returners are disproportionately well educated professionals. Also, the Great Migration was initially dominated by men with women and families traveling later to join their husbands and fathers. This new migration consists of a disproportionate number of Black females who are relocating to urban, suburban, and rural locations throughout the region (Fuguitt et al., 2001; Falk et al. 2004; Frey 2004).

The lives of Black Americans have been shaped by the legacy of slavery and Southern Jim Crow. The Southern racial divide is one in which Whites and Blacks developed two worlds that included separate schools, neighborhoods,

and places of worship as well as separate political development and cultures. Scholars of politics and the South have limited the study of the South and Southern Blacks by failing to acknowledge the differences in these cultures and, specifically, devaluing the unique factors that contributed to African American political culture and development (Dowe 2011). Black southern women, rich and poor, urban and rural, worked together to achieve the dual goals of racial and individual betterment. Intense periods of racial hostility led Black women to focus on group advancement. When efforts failed, they would advocate for their own rights and the rights of their men. This is evident in the efforts of the Black Women's Club Movement in the late nineteenth century and the Civil Rights Era (Giddings 1985; Barnett 1993; Simien 2006), Black women were forced into the labor market as a result of the impact of double discrimination. The gender dynamic of this double discrimination although subtle at times in comparison to racial discrimination was as powerful and immobilizing as racism. Pauli Murray referred to this dynamic as Jane Crow (Murray and Eastwood 1965). This dynamic contributed to Black women seeking higher education at rates higher than Black men, who had more work options (although considerably limited in comparison to White males), such as blue-collar work that often paid more than professional jobs. Black women became convinced that education was critical in addressing the plight of working women, including limited employment opportunities, inferior housing, and the inequality of Jim Crow in general.

The South's racial caste system powerfully shaped Blacks' experiences during the Great Migration (Wilkerson 2010; Pendergrass 2013); however, little is known about how Blacks perceive race and region as they return to the South. Approximately 57 percent of African Americans reside in the South; this is the highest percentage living in the region in half a century. How do the new old southerners that are Black and female perceive small differences across regions in levels of racial prejudice or do they perceive they are moving to a region with greater racial hostility?

Religion is often referenced as a distinctive trait of African American and Southern culture. The increasing influence of religious denominations to impact politics has led to a major focus on evangelical White Christians who develop a theology based on Biblical literalism. The role of religion and Biblical literalism is as significant in the Black community and is grounded in the social conservatism of the group. The largest group of women to believe in a literal interpretation of the Bible is Black women (56 percent) in comparison to 44 percent of Latinas and 27 percent of White women.

In light of the racialized experiences reported above, it is expected that there is a gap between ideology and policy preference among Whites in their support for specific policies designed to address racial issues. The majority of Black women express strong concern that race and racial issues remain to be resolved. When asked if they felt that too much, too little, or about the right amount

attention is being paid to race, 52.1 percent of Blacks and 34 percent Latinas felt that "too little attention" was being paid. In comparison, only 16 percent of Southern White women reported that "too little attention" was being paid to race. There is little variation in these percentages when we compare across regions. A majority of Southern White women (53 percent) felt too much attention was being paid to race. Only 18 percent of Southern Black women and 17 percent of non-Southern Black women agreed that too much attention was being paid to race. There is a similar pattern among Latinos as well with 24 percent of Latinas agreeing that too much attention is given to race and 23 percent of Southern Latinas agreeing that too much attention is given to race. The Blair Poll also asked a series of questions concerning the role of the federal government to ensure equality in various areas of life even if it were to mean a tax increase. Again, Southern Black women expressed a strong sense of liberalism about the role of government to address discrimination. Southern Black women's liberalism is consistent with the liberal attitudes of Black women throughout the nation.

Conclusion

African American women have advanced politically and socially. From 2000 to 2010 Black women have increased their share of advanced degrees earned by Black students, earning 71 percent of masters and 65 percent of doctoral degrees conferred by Black students (NCES 2012). Black female business ownership is the fastest segment of the women-owned business market, starting up at a rate six times higher than the national average (Guerra 2013). Despite gains, African American women professionals and managers still earn less than White men do and remain segregated in segments of the workforce with limited advancement opportunities and "glass ceilings" (U.S. Department of Labor, Federal Glass Ceiling Commission 1995; U.S. Department of Labor 2013).

This complex lived experience of Black women that consists of economic and educational advancements is still marred with day to day discrimination and limitations within the workplace. These experiences give Black women a complexity that informs their understanding of liberal politics and the need for political engagement whether as the voter or the candidate. The Blair Poll reveals this awareness of discrimination and support of liberal ideas may not always extend to what is perceived as a natural idea of a coalition partner with the Latino community (Harvie 2015; VanSickle-Ward and Pantoja 2016).

Understanding the ways African American women perceive inequality is important for the development of a common ground to forge collective action to redress inequities. Efforts to forge multiracial coalition among women have often failed when women of color have been expected to accept a political agenda that does not reflect their day to day realities (Giddings 1985; Zinn et al.

1986; Collins 1999). Thus understanding the nuances in the ways that Black women perceive and respond to racial inequality is critical to understanding the forging of multiracial coalitions and the development of policy positions for the group and the nation.

References

Abramowitz, Alan I. 1994. "Issue Evolution Reconsidered: Racial Attitudes and Partisanship in the American Electorate." *American Journal of Political Science* 38 (February): 1–24.

Barker, Lucius J., Mack Jones, and Katherine Tate. 1999. *African Americans and the American Political System.* Upper Saddle River, NJ: Prentice Hall.

Barnett, Bernice McNair. 1993. "Invisible Southern Black Women Leaders in the Civil Rights Movement: The Triple Constraints of Gender, Race, and Class." *Gender & Society* 7(2): 162–182.

Bratton, Kathleen A., Kerry L. Haynie, and Beth Reingold. 2007. "Agenda Setting and African American Women in State Legislatures." *Journal of Women, Politics & Policy* 28(3–4): 71–96.

Brown, Nadia. 2014. *Sisters in the Statehouse: Black Women and Legislative Decision-Making.* New York: Oxford University Press.

Cain, Bruce E., D. Roderick Kiewiet, and Carole J. Uhlaner. 1991. "The Acquisition of Partisanship by Latinos and Asian Americans." *Journal of Politics* 35(2): 390–422.

Capers, K. Jurée, and Candis Watts Smith. 2016. "Linked Fate at the Intersection of Race, Gender and Ethnicity" in *Distinct Identities*, eds. Nadia E. Brown and Sarah Allen Gershon. London: Routledge.

Carroll, Susan J. 1999. "The Disempowerment of the Gender Gap: Soccer Moms and the 1996 Elections." *PS: Political Science & Politics* 32(1): 7–12.

Carroll, Susan J., and Kira Sanbonmatsu. 2013. *More Women Can Run.* New York: Oxford University Press.

Ditmar, Kelly. 2014. "The Status of Black Women in American Politics." Center for American Women and Politics. www.higherheightsforamerica.org/reports.

Collins, Patricia Hill. 1998. *Fighting Words: Black Women and the Search for Justice.* Vol. 7. Minneapolis, MN: University of Minnesota Press.

Collins, Patricia Hill. 1999. *Black Feminist Thought: Knowledge, Consciousness, and the Politics of Empowerment.* New York; London: Routledge.

Darcy, Robert, and Charles D. Hadley. 1988. "Black Women in Politics: The Puzzle of Success." *Social Science Quarterly* 69: 629–645.

Darcy, R., Charles D. Hadley, and Jason F. Kirksey. 1997. "Election Systems and the Representation of Black Women in American State Legislatures" in *Women Transforming Politics: An Alternative Reader*, eds. Joan C. Tronto, Cathy Cohen, and Kathy Jones. New York: New York University Press, PGS.

Dawson, Michael C. 1995. *Behind the Mule: Race and Class in African-American Politics.* Princeton, NJ: Princeton University Press.

Dowe, Pearl K. Ford. 2011. "V.O. Key's Missing Link" in *Unlocking V.O. Key*, eds. Angie Maxwell and Todd Shields. Fayetteville, NC: University of Arkansas Press.

Esping-Andersen, Gøsta. 1990. *The Three Worlds of Welfare Capitalism.* Cambridge: Polity.

Falk, William W., Larry L. Hunt, and Matthew O. Hunt. 2004. "Return Migrations of African Americans to the South: Reclaiming a Land of Promise, Going Home, or Both?" *Rural Sociology* 69: 490–509.

Fineman, Howard. 2014. "It's all About Southern Women in the 2014 Elections." *Huffington Post*. July 7. www.huffingtonpost.com/2014/07/20/southern-women-elections_n_5601185.html.

Frederick, Angela. 2013. "Bringing Narrative In: Race-Gender Storytelling, Political Ambition, and Women's Paths to Public Office." *Journal of Women, Politics, and Policy* 34(2): 113–137.

Frey, William. 2004. *The New Great Migration: Black Americans Return to the South, 1965–2000*. Washington, D.C.: Brookings Institution, Living Cities Census Series.

Fuguitt, Glenn Victor, John A. Fulton, and Calvin Lunsford Beale. 2001. "The Shifting Patterns of Black Migration From and Into the Nonmetropolitan South, 1965–95." U.S. Department of Agriculture, Economic Research Service.

Gamble, Katrina. 2010. "'Young, Gifted, Black and Female': Why Aren't There More Yvette Clarkes in Congress" in *Whose Black Politics, Cases in Post-Racial Black Leadership*, ed. Andra Gillespie. New York: Routledge.

Gay, Claudine. 2001. "The Effect of Black Congressional Representation on Political Participation." *American Political Science Review* 95(3): 589–602.

Gay, Claudine, and Katherine Tate. 1998. "Doubly Bound: The Impact of Gender and Race on the Politics of Black Women." *Political Psychology* 19(1): 169–184.

Giddings, Paula. 1985. *When and Where I Enter*. Toronto; New York: Bantam Books.

Gillespie, Andra Race. 2016. "Race, Perceptions of Femininity and the Power of the First Lady: A Comparative Analysis" in *Distinct Identities*, eds. Nadia E. Brown and Sarah Allen Gershon. London: Routledge.

Gilliam, Frank D., Jr., and Shanto Iyengar. 2000. "Prime Suspects: The Influence of Local Television News on the Viewing Public." *American Journal of Political Science* 44 (July): 560–573.

Gomez, Brad T., and J. Matthew Wilson. 2006. "Rethinking Symbolic Racism: Evidence of Attribution Bias." *Journal of Politics* 68 (August): 611–625.

Guerra, Maria. 2013. "Fact Sheet: The State of African American Women in the United States." Center for American Progress. http://americanprogress.org/wp-content/uploads/2013/SOW-factsheet-AA.pdf.

Hardy-Fanta, Carol, Pei-te Lien, Dianne M. Pinderhughes, and Christine M. Sierra. 2006. "Gender, Race, and Descriptive Representation in the United States: Findings from the Gender and Multicultural Leadership Project." *Journal of Women Politics & Policy* 28(3–4): 7–41.

Harris, Maya. 2014. "Women of Color: A Growing Force in the American Electorate." Center for American Progress. www.americanprogress.org/issues/race/report/2014/10/30/99962/women-of-color/.

Harvie, Jeanette Yih. 2016. "In Considering the Political Behavior of Asian American Women" in *Distinct Identities*, eds. Nadia E. Brown and Sarah Allen Gershon. London: Routledge.

Holman, Mirya. 2016. "The Differential Effect of Resources on Political Participation Across Gender and Racial Groups" in *Distinct Identities*, eds. Nadia E. Brown and Sarah Allen Gershon. London: Routledge.

Kaba, Amadu Jacky, and Deborah E. Ward. 2009. "African Americans and U.S. Politics: The Gradual Progress of Black Women in Political Representation." *Review of Black Political Economy* 36: 29–50.

Keith, Jarod. 2014. "Can Moderate White Women Turn the South Blue?" *Deep South Daily*. March 31. www.deepsouthdaily.com/2014/03/can-moderate-White-women-turn-south-blue.html.

King, Deborah K. 1988. "Multiple Jeopardy, Multiple Consciousnesses: The Context of a Black Feminist Ideology." *Signs*: 42–72.

Murray, Pauli, and Mary O. Eastwood. 1965. "Jane Crow and the Law: Sex Discrimination and Title VII." *George Washington Law Rev*. 34: 232.

NCES (National Center for Education Statistics). 2012. "The Condition of Education 2012." http://nces.ed.gov/pubs2012/2012045.pdf.

Orey, Byron D., Wendy Smooth, Kimberly S. Adams, and Kisha Harris-Clark. 2006. "Race and Gender Matter: Refining Models of Legislative Policy Making In State Legislatures." *Journal of Women, Politics, & Policy* 28(3–4): 97–120.

Peffley, Mark, and Jon Hurwitz. 2007. "Persuasion and Resistance: Race and the Death Penalty in America." *American Journal of Political Science* 51 (October): 996–1012.

Pendergrass, Sabrina. 2013. "Perceptions of Race and Region in the Black Reverse Migration to the South." *Du Bois Review: Social Science Research on Race* 10(1): 155–178.

Price, Melanye T. 2009. *Dreaming Blackness: Black Nationalism and African American Public Opinion*. New York: New York University Press.

Sanbonmatsu, Kira. 2006. *Where Women Run: Gender and Party in the American States*. Ann Arbor, MI: University of Michigan Press.

Sanbonmatsu, Kira. 2016. "Officeholding in the Fifty States: The Pathways Women of Color Take to Statewide Elective Executive Office" in *Distinct Identities*, eds. Nadia E. Brown and Sarah Allen Gershon. London: Routledge.

Sanbonmatsu, Kira, and Kathleen Dolan. 2009. "Do Gender Stereotypes Transcend Party?" *Political Research Quarterly* 62(3): 485–494.

Scola, Becki. 2006. "Women of Color in State Legislatures: Gender, Race, Ethnicity and Legislative Office Holding." *Journal of Women Politics & Policy* 28(3/4): 43–70.

Scruggs-Leftwich, Yvonne. 2000. "Significance of Black Women's Vote Ignored." *Women's E-News*. November 15. www.womensenews.org/article. cfm/dyn/aid/341/context/archive.

Sears, David O., and P. J. Henry. 2003. "The Origins of Symbolic Racism." *Journal of Personality and Social Psychology* 85: 259–275.

Shafer, Byron, and Richard Johnston. 2006. *The End of Southern Exceptionalism: Class, Race and Partisan Change in the Postwar South*. Cambridge, MA: Harvard University Press.

Shingles, Richard D. 1981. "Black Consciousness and Political Participation: The Missing Link." *The American Political Science Review*: 76–91.

Simien, Evelyn M. 2006. *Black Feminist Voices in Politics*. Albany, NY: SUNY Press.

Simpson, Andrea, Y. 1998. *The Tie that Binds: Identity and Political Attitudes in the Post-Civil Rights Generation*. New York, NY: NYU Press.

Singh, Robert. 1998. *The Congressional Black Caucus*. Thousand Oaks, CA: Sage Publications.

Smooth, Wendy. 2006. "Intersectionality in Electoral Politics: A Mess Worth Making." *Politics & Gender* 2(3): 400–414.

Smooth, Wendy. 2014. "African American Women and Electoral Politics: Translating Voting Power into Officeholding" in *Gender and Elections: Shaping the Future of American Politics* (3rd edition), eds. Susan J. Carroll and Richard L. Fox. New York, NY: Cambridge University Press, 167–189.

Stokes-Brown, Atiya, and Kathleen Dolan. 2010. "Race, Gender, and Symbolic Representation: African American Female Candidates as Mobilizing Agents." *Journal of Elections, Public Opinion, and Parties* 20: 473–494.

Tate, Katherine. 1991. "Black Political Participation in the 1984 and 1988 Presidential Elections." *The American Political Science Review*: 1159–1176.

Tate, Katherine. 2003. *Black Faces in the Mirror: African Americans and Their Representatives in the U.S. Congress*. Princeton, NJ: Princeton University Press.

Tate, Katherine. 2010. *What's Going On?: Political Incorporation and the Transformation of Black Public Opinion*. Washington, D.C.: Georgetown University Press.

Taylor, Paul. 2012. "The Growing Electoral Clout of Blacks is Driven by Turnout, Not Demographics." Pew Research Center, Social & Demographic Trends (December).

Theilmann, John, and Al Wilhite. 1989. "The Determinants of Individuals' Campaign Contributions to Congressional Campaigns." *American Politics Quarterly* 17(3): 312–331.

Uhlaner, Carole J. 1991. "Perceived Discrimination and Prejudice and the Coalition Prospects of Blacks, Latinos, and Asian Americans" in *Racial and Ethnic Politics in California*, eds. Michael B. Preston, Bruce E. Cain, and Sandra Bass. Berkeley, CA: University of California, Institute of Governmental Studies Press, 339–371.

U.S. Census. 2013a. *The Diversifying Electorate, Voting Rates by Race and Hispanic Origin in 2012 (and Other Recent Elections)* (May).

U.S. Census. 2013b. *U.S. Census Bureau Projections Show a Slower Growing, Older, More Diverse Nation a Half Century from Now*.

U.S. Department of Labor. 2013. "Black Women in the Workforce." www.dol.gov/wb/factsheets/BlackWomenInTheWorkforce.pdf.

U.S. Department of Labor, Federal Glass Ceiling Commission. 1995. *Good for Business: Making Full Use of the Nation's Human Capital* (March).

VanSickel-Ward, Rachel, and Adrian D. Pantoja. 2016. "Hawks and Doves? An Analysis of Latina and Latino Attitudes Toward Military Intervention in Iraq" in *Distinct Identities*, eds. Nadia E. Brown and Sarah Allen Gershon. London: Routledge.

Wilkerson, Isabel. 2010. *The Warmth of Other Suns: The Epic Story of America's Great Migration*. New York, NY: Random House.

Zinn, Maxine Baca, Lynn Weber Cannon, Elizabeth Higginbotham, and Bonnie Thornton Dill. 1986. "The Costs of Exclusionary Practices in Women's Studies." *Signs*: 290–303.

5

IN CONSIDERING THE POLITICAL BEHAVIOR OF ASIAN AMERICAN WOMEN

Jeanette Yih Harvie

Introduction

Cognizant of the multi-racial and multi-ethnic realities in the United States, research in political science is also highlighting the political experiences of certain segments of the U.S. population, such as those of women of color.[1] The sociopolitical context, which fuels the formation of political opinions, behaviors, and treatment of women of color, is heavily mediated by the intersection of their race, ethnicity, and gender identities (Smooth 2006; Hancock 2007). It is with such contextual and scholarly considerations that I provide an empirical understanding of the political attitudes and behaviors of Asian American women as political participants in the United States.

Currently, there is limited research that focuses on the political experience of Asian American women (please see Filler and Lien, and Sriram, from this volume, on discussion of Asian American women as electoral candidates). This is an unfortunate oversight since Asian Americans, as a whole, are the fastest growing racial group in the United States. According to the 2010 U.S. Census Redistricting Data, Asian Americans experienced a 46 percent growth since 2000, which is more than any other ethno-racial group (U.S. Census Bureau 2010b). Also specific within the Asian American community, Asian American women are distinct in some of their demographic and political characteristics. First, census data show that women make up of over half of those who are 18 years or older in the Asian American community.[2] Second, the Current Population Survey (CPS) from November 2012 indicates that among all Asian American women, who are citizens, close to two-thirds are registered to vote (U.S. Census Bureau 2012). However, given the large number of noncitizens (new immigrants) who are women, only a little over 38 percent of the overall Asian

American women population are registered voters (U.S. Census Bureau 2012). These numbers are significant because there has long been talk of a potential Asian American "voting bloc" during presidential elections (Tam 1995). Therefore, the political behavior and preferences of Asian American women raise normative questions about the significance of their role as voters in American electoral politics. The study of Asian American women, consequently, adds both a theoretical and normative dimension to an overall understanding of the political behavior of ethno-racial minorities in the United States.

This chapter highlights the political attitudes and behaviors of Asian American women voters and provides preliminary empirical evidence towards understanding their electoral preferences. There are two ways to get a sense of where Asian American women stand in the overall political spectrum of American politics. First is to consider the possibility of a gender gap in the political attitudes and behaviors within the Asian American community. The second is to examine how they compare in their political preferences to other women of color (i.e., Latinos and Blacks). A baseline in the political behaviors and preferences of Asian American women can be established through these comparisons. In addition, I also assess how current scholarship has conceptualized the politics of Asian American women, including the socio-political dimensions that set Asian Americans apart from other women of color.

Deciphering the Demography and Politics of Asian American Women

Due to restrictive immigration policies, there has been a striking imbalance between the numbers of men versus women in the Asian American community for most of U.S. history.[3] Through the elimination of quota-based immigration in 1965, Asians were free to come to the United States through different means regardless of gender or country of origin. By the 1980s, the sex ratio within the Asian American community became balanced for the first time in U.S. history due to the influx of new Asian immigrants (Chow 1987). Today, there are approximately 14.7 million Asian Americans residing in the United States, and of which, over half are women (U.S. Census Bureau 2010a).[4]

In the context of Asian American political participation, some research has discussed whether there are gendered differences in the political behavior of individuals. Particularly in the work of Lien et al. (2004), they found that compared to other variables, "gender" is often *not* the strongest explaining factor for differences in individuals' political behavior within the Asian American community. Instead, scholars need to look toward "the impact of ethnic culture, citizenship status, education context, and social network" for convincing explanations to these differences (Lien et al. 2004, 206). This echoes a previous study also by Pei-te Lien (1998) where she concludes that while gender is a significant predictor of political behavior by itself, it becomes far less salient when

considered in conjunction with race. Nevertheless, there are still instances when gender does appear to be a significant factor in interpreting political behavior and attitudes. For example, while there is little difference between men and women in terms of partisanship, as seen in the 2008 National Asian American Survey (NAAS), researchers did find a gender gap among partisan "non-identifiers" (Wong et al. 2011, 139). Specifically, 39 percent of women versus 30 percent of men are considered partisan "non-identifiers." In this sense, more Asian American women seem to "reject the traditional tripartite partisan categorization" compared to men (Wong et al. 2011, 139). This result is significant because it implies that even more so than Asian American men, Asian American women do not think in traditional partisan terms that are familiar to most Americans.[5] Therefore, partisan identification, as a variable, should be reconsidered when used as a proxy for understanding the political behavior of Asian American women. More so than Asian American men, their lack of partisan affiliation may be a result of indifference rather than independence of the major ideologies and policies espoused by the Republican and Democratic Parties.

Another way that researchers have assessed the sociopolitical experiences of Asian American women is within the context of cross-racial political alliances. Loo and Ong (1982) highlight the failure of the second wave feminist movement to motivate working class women from San Francisco's Chinatown into social and political action. While there were many explanations, including those that are cultural and structural, as to why the movement failed, the authors ultimately determine that Chinatown women perceived themselves as having more in common with Chinatown men than White activists, making an overall coalition of women a challenge (Loo and Ong 1982; Chow 1987).

Ultimately, Asian American women did not play a prominent role during the second wave feminist movement in or out of their ethnic enclaves (Chow 1987, 1989). It was not surprising given that the sociopolitical concerns of Asian American women were arguably different from those of White women. These differences contributed to the lack of consciousness and political activism (Chow 1987, 293). Additionally, there was an absence of dialogue between Asian American women and activists in terms of grievances, needs, and goals (Chow 1987, 1989). Therefore, Asian American women and other women of color were not well represented in the feminist movement, which was led and focused on predominately White, middle-class issues (Yamada 1981; Loo and Ong 1982; Dill 1983; Chow 1987, 1989).

Given the lack of connection between women of color and White women, scholars point out that solidarity between women of color, instead, might be viable since this population shares "the triple oppression of race, class, and gender" (Lien 2001, 218).

Studies that assess the sociopolitical relationship between women of color have generated interesting and complex results. First, scholarship suggests that there are indeed applicable shared experiences between women of color, such as the

working conditions of the sweatshop industry, whose labor force is dominated by Latina and Asian American women (Kwong 1997; Silliman et al. 2004). These commonalities are potential seeds for cooperation. Second, research, however, also argues that Asian American women do not necessarily find solidarity with other women of color (or even White women). This is because, according to Lien (2001), "differences in education, income, socialization, acculturation, group consciousness, and identity, and other factors may also set apart their political choices from those other immigrant and U.S.-born women" (218–219). Other marked variances include that Asian American women are more likely to be foreign-born compared to women in other racial groups (Chow 1987; Lien 2001). Furthermore, recent studies commissioned by the American Association of University Women (AAUW) also show that Asian women, while still lacking income parity compared to White men and Asian American men, have out-earned Black women, Latinas, and even White women (Benson 2013). Third, those who have written on the topic of community organizing, especially from the perspective of a community activist, focus on the ability of the organizer to formulate an effective activist collaboration (Sen 1997). This type of perspective redirects the assessment of coalition formation among women of color from structural barriers (such as intrinsic difference in terms of socioeconomic status) to the talents and perception of community organizers.

A study by Nadia Brown (2014) examines assumptions in political science about individual resources and political activities to further illustrate the similarities and differences in political activism among women of color. For example, Brown finds that women with more education and income (Asian and White women) are actually more likely to engage in nontraditional forms of politics (e.g., sign a petition, march in a protest, participate in a boycott) compared to Black women or Latinas. This runs contrary to expectations given what scholars currently understand about the relationship between resources and different types of political participation.

Overall, there is limited research available on the political experiences of Asian American women; literature in this area also shows a complex and often contradictory picture of political activism. At this point, there is still a gap in our knowledge of the political behavior and attitudinal preferences of Asian American women. Literature has shown that their political activism (or the lack thereof) cannot be explained through a conventional understanding in political science. Furthermore, the possibility of political alliances among women of color seems mixed and largely unexamined for a variety of reasons discussed in this section. While the socioeconomic status (SES) of Asian American women today is vastly different from Asian immigrants who lived in the United States prior to 1965, they still share common sources of social and political oppression as other communities of women of color. In theory, the gendered aspect of their identity is what sets Asian American women apart from men in their ethno-racial community. However, the relatively high level of education and

the high number of foreign-borns among Asian American women are just a few of the many reasons they are distinct in their political preferences and behaviors compared to other communities of women of color.

Assessing Asian American Women's Political Behavior and Attitudes

I assess several aspects of political behavior and attitudes of Asian American women as compared to Asian American men and other women of color with the 2008 Collaborative Multi-racial Post-election Study (CMPS). This dataset is uniquely appropriate because it is a national telephone survey of registered voters that includes representative samples of African Americans, Asian Americans, Latinos, and Whites. The survey was conducted between November 9, 2008 and January 5, 2009, after the 2008 presidential elections. The sample was drawn from a list of registered voters in the 18 states where there are higher concentrations of non-White minorities. The survey had an overall return of 4,563 respondents and 2,713 are women. After breaking down by race and gender, there are 753 Latinas, 451 Asian American women, and 430 Black women. The results and findings here are mainly exploratory to help situate an understanding of Asian American women voters in the context of ethnic and gender politics.

I examine two broad categories of political outcomes for Asian Americans and among women of color. The first category of dependent variables is those associated with various political acts, such as party identification, turnout, vote choice in the 2008 presidential election, political volunteering, campaign donations, and participation in protest activities. The second category of dependent variables focuses on political attitudes of issues that may unite communities of women of color, such as citizenship for unauthorized aliens and in-state college tuition for DREAMers. The independent variables are gender and race.

Key Dependent Variables

Several political acts are chosen for discussion in this chapter and each are selected as points of research interests in the political experience of Asian American women. First, partisanship is tested and examined as prior studies by Wong et al. (2011) have raised the question of whether Asian American women are in fact more "non-partisan" than Asian American men. Acknowledging how partisanship influences (or does not influence) Asian Americans has theoretical and empirical implications. Furthermore, as competition in American politics continues and presidential candidates from both major parties find it necessary to "court" minority communities with favorable policies (McIlwain and Caliendo 2011; Brownstein 2013), an understanding of turnout (if Asian Americans go to the polls) and who they have supported in past presidential

elections are significant aspects in deciphering the potential "Asian American Voting Bloc." In addition, I also include three measures of political participation – volunteering, donations, and participation in protest – as these variables measure a variety of political behaviors. The first two are considered "traditional" forms of participation, and as such, they should be more easily attained by those who have higher socioeconomic status and more "resources" (Verba et al. 1995; Rosenstone and Hansen 2003). Past research and census data have shown Asian American women to be the most progressive earners and have the highest education level among women, on average. Compared to other women of color, they should also be the most engaged in these forms of political activities. Finally, one measure of "non-traditional" or "resource poor" political activity is included in the analysis as Nadia Brown's (2014) article finds that resource rich women (White and Asian American women) are more likely to participate in "resource poor" political activities, such as participating in a protest. Her finding challenges conventional understanding of the linkage between SES and participation in different kinds of political activities. This is a good opportunity to reexamine this contradiction between theory and data results.

The second broad category of dependent variables examines political attitudes of Asian Americans and women of color on various controversies and issues. Both measures are related to citizenship/immigration. An alliance between women (and women of color) is often understood in the context of social movements and social justice issues (Tronto et al. 1997; Silliman et al. 2004). Therefore, both variables were selected based on their potential to gauge individual opinion on these issues and provide a preliminary assessment of the possibility for political alliances.

Methods

A series of crosstabs were generated to examine the relationship between gender and different aspects of political behavior and attitudes. Race is controlled for and a chi-square test was used to determine the goodness of fit between dependent and independent variables. Also, for the purpose of my analysis, survey questions with answers that measure the strength of responses (e.g., strongly agree, somewhat agree) were collapsed into fewer categories that convey positive, neutral, or negative feelings.

Dynamics of Political Participation for Asian American Women

Partisanship

I first look at party identification across groups of women of color and that of within the Asian American community. As seen in Table 5.1, survey results from the 2008 CMPS show that there are proportionally more Democrats versus Republicans among women of color. Specifically, Black women overwhelmingly

TABLE 5.1 Partisanship Affiliation Based on Race/Gender (%)

	Latino Women (n = 753)	Asian Women (n = 451)	Black Women (n = 430)	Asian Men (n = 478)
Republican	14.7	20	2.6	24.3
Democrat	57.8	40.1	72.6	34.9
Independent	11.2	16.2	10.9	23.8
Others	0.4	0.7	0.7	0.4
Don't think in these terms	12.1	16.9	10.9	13

identify with the Democratic Party (72.6 percent) and over half of Latina respondents identify with the Democrats (57.8 percent). Asian American women are also mostly Democrats (40.1 percent) but close to 17 percent also said that they "don't think in these [partisan] terms." In this sense, Asian American women have the highest proportion of "non-partisans" of any of the groups that were compared. When looking at the gender differences that exist among all Asian Americans surveyed, there are proportionally more Asian American women who identify with the Democratic Party or as "non-partisans."

Turnout and Vote Choice

Respondents of the 2008 CMPS have a very high turnout rate during the 2008 November elections – over 90 percent of those surveyed said they had voted during the midterm/presidential elections. These numbers seem incredibly high but there are several possible explanations for that. First, the survey was sampled through a population of registered voters and during a presidential election year, which usually corresponds to higher turnout rates because of its high profile (Hill and Leighley 1999; The Center for Voting and Democracy 2014). Second, the 2008 presidential elections were historic due to the candidacy of Barack Obama, who became the first African American president of the United States. And third, the social desirability effect of voting generates inflation on self-reported turnout rates (Burden 2000; Holbrook and Krosnick 2009). In contrast, data published by the U.S. Census on the November 2012 elections (also a presidential election year) show a turnout of 48.5 percent for Asian American registered women voters (U.S. Census Bureau 2012).

During the 2008 presidential elections, two-thirds of women of color voted for Barack Obama. Black women, not surprisingly, were overwhelmingly supportive with close to 90 percent of those surveyed indicating that they voted for Obama. Of all three groups of women, Asian American women had the highest proportion of supporters for John McCain. And compared to Asian American women, Asian American men showed more support for McCain (31.9 percent). Even so, over half of Asian American male respondents said they voted for Barack Obama.

Political Volunteering and Donations

When considering the political participation of minorities, results from the 2008 CMPS show that most respondents have not volunteered at a political campaign. Among Black women, approximately 15 percent responded positively about volunteering, while Latinas, Asian American women, and Asian American men all had fewer than 10 percent of respondents who had volunteered.

As for donating money to a candidate or an electoral campaign, over 20 percent of both Black women and Asian American women respondents said that they have made donations. There were proportionally fewer Asian American men who have donated to campaigns compared to Asian American women. And Latinas had the least proportion of political donors with approximately 13 percent indicating that they made political contributions during the 2008 electoral season.

Protest Activities

Results from 2008 CMPS show no clear variance between participation in political protests in all groups. Overall, few respondents mentioned to have participated in protests in the 12 month period leading up to the time of the survey (late 2008, early 2009).

Attitude on Awarding Citizenship to Undocumented Immigrants

Next, I turn to political attitudes on controversial political topics in the United States. Looking at respondents' opinions on whether undocumented immigrants should qualify for U.S. citizenship under certain circumstances, Latina respondents stood out to be overwhelmingly supportive of this policy position at over 91 percent. This is consistent with research that shows that Latinos are often politically galvanized through immigration-related issues and supportive of "liberal" immigration policies (Suro 2005; Leal et al. 2008). Furthermore, while all women of color surveyed are generally supportive (over two-thirds), Black women are more supportive of citizenship for unauthorized immigrants compared to Asian women. Among Asian Americans, men are less supportive than women of citizenship for undocumented immigrants.

Attitude on In-State Tuition for DREAMers

Another controversial topic in the recent years concerns DREAMers – usually understood as undocumented immigrant youths who were brought to the United States as children. Many entered the United States before the age of 16, have continued residency, and have graduated from U.S. high schools (or earned a GED) (Immigration Policy Center 2012). Analysis based on the 2008 CMPS demonstrates

that much like the question about citizenship for undocumented immigrants, Latinas are overwhelmingly supportive with close to 85 percent of those surveyed agreeing that DREAMers who graduated from U.S. high schools should qualify for in-state college tuition. Black women are also fairly supportive, with over two-thirds agreeing with the questionnaire statement. The Asian American community, both men and women, is generally supportive of this policy position but only at around 55 percent or so. There does not appear to be a marked gender difference of this issue for Asian Americans.

Discussion

Preliminary results based on the 2008 CMPS offer several interesting perspectives on the political attitudes and behaviors of women of color and the possibility of gender-based differences within the Asian American community.

First, results on the partisanship of Asian American women are consistent with findings from previous studies. The high number of non-partisans among Asian American women further confirms the notion that Asian Americans cannot be motivated by political parties the same way as those who understand the political cues of parties as they are intended in the American context (Lien 2001; Lien et al. 2004; Wong et al. 2011). Additionally, based on statistical tests, observable differences between Asian American men and women on partisanship can be explained by their gender ($p = 0.05$).

Second, results from the 2008 voter turnout and vote choice in the presidential elections give reasons to consider the power of descriptive representation to motivate political participation for racial minorities (Mansbridge 1999). And while Table 5.2 shows Asian American women to be more supportive of Barack Obama over John McCain compared to Asian American men, the chi-squared probability is greater than 0.05, leading to the conclusion that there is no real gender difference in the 2008 presidential election vote choice within the community.

Third, results from three aspects of political participation outside of voting (volunteering, donating money, and protest/demonstration activities) are mixed and without a clear pattern. Proportionally, Black women are the only group to have high numbers of political volunteers. Given the historic significance of the

TABLE 5.2 2008 Presidential Vote Choice by Race and Gender (%)

	Latino Women (n = 753)	Asian Women (n = 451)	Black Women (n = 430)	Asian Men (n = 478)
McCain	20.7	26.4	3.4	31.9
Obama	67.9	62.3	89.8	54.2
Someone else	2.4	1.2	0.7	2.1

2008 presidential elections for the Black community, it could be argued that Blacks, in general, were more motivated to participate. This seems to be confirmed by looking at the proportion of Black men (17.8 percent) who said they had volunteered (in the same survey). Less than 10 percent of Asian women, like Latinas and Asian American men, had volunteered.

In terms of political donations, Asian American women and Black women had the highest proportion of donors. While donations, similar to volunteering, are considered "resource rich" political activities, Black women, who are usually lower in SES compared to Asian women, actually donated at a higher proportion than other groups of women. Black women's level of participation can likely be explained by the singularity of Obama's candidacy in 2008. And while Asian American women seemed to donate more than Asian American men in the 2008 election cycle, statistical tests have shown that gender is not a significant source of variance between men and women in the Asian American community.

As for participation in protests and demonstrations, results from the survey show a lack of involvement and very little difference among all groups compared. The lack of variance runs contrary to previous research about who participates in protests and why they do so (Brown 2014).

Fourth, results from political attitudes on citizenship and immigration controversies highlight the prominence of these issues for Latinas. While Asian American women generally take a more "liberal" position towards immigration and citizenship, they trail behind Black women in terms of support. However, compared to Asian American men, statistical tests confirm gender to be a significant explanation ($p < 0.05$) for differences on citizenship and immigration policy preferences within the Asian American community. Overall, women of color hold similar opinions on social justice related issues, especially those pertaining to immigration and citizenship. One possible explanation for common policy preferences may be traced to a mutual bond that many Latinas and Asian American women share as new immigrants and the histories of immigration in their ethnic communities. However, one can also argue that Black women and Latinas have a deeper connection due to struggles associated with low SES within their populations. I argue that these commonalities and differences among women of color need to be further unpacked to properly assess the possibilities of political coalition and alliances.

Conclusion

The results seen in the 2008 CMPS on various aspects of political participation and political attitudes are preliminary indicators of political differences and similarities among women of color and the Asian American community. I conclude that the politics of Asian American women are unique in the sense that they are a group of women whose preferences are simultaneously affected by their socioeconomic status, their gender, and for many, their distinctive shared

history as an immigrant community. As a result, some of their political behaviors can be explained by existing research (e.g., relationship between partisanship and gender), while others are unique because of their exclusive experience at the intersection of their various identities (e.g., their support for a liberal immigration and citizenship policy for undocumented aliens).

Based on the limited analysis on political attitudes and behaviors, I argue that Asian American women usually see eye to eye with women of color on a variety of political matters. They often share similar predisposition in terms of partisanship, favorability of candidates, as well as key social justice issues. The option for alliance and support is likely possible among these women. At the same time, Asian American women can often find resonance for their political position *within* their racial community. Aside from Asian American women, Asian American men had the largest proportion of "non-partisans" according to the 2008 CMPS, which is likely explained by the high number of new immigrants, in general, within the community. It is unclear whether their history of immigration, gender, race, or some combination of all these variables, will come to define the political preferences and behavior of Asian American women in the long term.

In suggestion of future direction for research, any study on Asian Americans cannot preclude the possibility that political behaviors and preferences are a result of one's *Asian-specific* ethnic identity. It is well understood in scholarship on Asian American politics that ethnicity is an important contributing factor to variances in political behavior (Lien 2001; Lien et al. 2004; Wong et al. 2011; Harvie and Lien 2016). Therefore, any future study on the political behavior and attitudes of Asian American women should take Asian ethnicities as a factor of analysis. Other contextual aspects for analysis include the process of political socialization in the receiving country (Jones-Correa 1998; Cho et al. 2006; Lien 2008) and the significance of homeland politics for immigrant individuals residing in the United States (Lien 2006).

Finally, it is also possible that survey data are ultimately limited in helping us understand *how* Asian American women form their political preferences. Other research methods, such as in-depth interviews or focus groups, may serve to gather findings in addition to what we already know about the political experiences of Asian American women.

Appendix available online at www.routledge.com/9781138958845.

Notes

1 An earlier version of this chapter was presented at the 2015 Annual Meeting of the Southern Political Science Association (New Orleans, LA). I thank Nadia Brown and Sarah Gershon for their insight and comments.
2 This is based on the 2013 American Community Survey (one-year estimates) published by the U.S. Census.

3 Even prior to the closing of Chinese immigration through the Chinese Exclusion Act of 1882, Chinese laborers already lived in what was characterized as a "bachelor society" due to the Page Law (meant to stem the tide of Chinese prostitutes). Particularly, U.S. governmental officials were prejudiced against Chinese female immigrants (Peffer 1999).
4 This number only includes those who identified as "Asian alone" in the U.S. Census.
5 In other words, the Democrat and Republican labels do not hold the same political implication for Asian Americans.

References

Benson, Katie. 2013 *What Does Race Have to Do with a Woman's Salary? A Lot.* AAU. Available from www.aauw.org/2013/04/26/race-and-a-womans-salary/.

Brown, Nadia E. 2014. "Political Participation of Women of Color: An Intersectional Analysis." *Journal of Women, Politics & Policy* 35 (4): 315–348.

Brownstein, Ronald. 2013. *Republicans Can't Win With White Voters Alone.* The Atlantic. Available from www.theatlantic.com/politics/archive/2013/09/republicans-cant-win-with-white-voters-alone/279436/.

Burden, Barry C. 2000. "Voter Turnout and the National Election Studies." *Political Analysis* 8 (4): 389–398.

Cho, Wendy K. Tam, James G. Gimpel, and Joshua J. Dyck. 2006. "Residential Concentration, Political Socialization, and Voter Turnout." *The Journal of Politics* 68 (1): 156–167.

Chow, Esther Ngan-Ling. 1987. "The Development of Feminist Consciousness among Asian American Women." *Gender and Society* 1 (3): 284–299.

Chow, Esther Ngan-Ling. 1989. "The Feminist Movement: Where Are All the Asian American Women?" In *Making Waves: An Anthology of Writings By and About Asian American Women*, edited by Asian Women United of California, 362–377. Boston: Beacon Press.

Dill, Bonnie Thornton. 1983. "Race, Class, and Gender: Prospects for an Inclusive Sisterhood." *Feminist Studies* 9: 131–150.

Jones-Correa, Michael A. 1998. "Different Paths: Gender, Immigration and Political Participation." *International Migration Review* 32 (2): 326–349.

Hancock, Ange-Marie. 2007. "When Multiplication Doesn't Equal Quick Addition: Examining Intersectionality as a Research Paradigm." *Perspectives on Politics* 5: 63–79.

Harvie, Jeanette Yih, and Pei-te Lien. 2016. "East Asian American Voters." In *Minority Voting in the United States*, edited by Kyle L. Kreider and Thomas J. Baldino. Westport, CT: Praeger.

Hill, Kim Quaile, and Jan E. Leighley. 1999. "Racial Diversity, Voter Turnout, and Mobilization Institutions in the United States." *American Politics Quarterly* 27 (3): 275–295.

Holbrook, Allyson L., and Jon A. Krosnick. 2009. "Social Desirability Bias in Voter Turnout Reports." *Public Opinion Quarterly* 74 (1): 37–67.

Immigration Policy Center. 2012. *Who and Where the DREAMers Are: A Demographic Profile of Immigrants Who Might Benefit from the Obama Administration's Deferred Action Initiative.* Immigration Policy Center. Available from www.immigrationpolicy.org/sites/default/files/docs/who_and_where_the_dreamers_are_0.pdf.

Kwong, Peter. 1997. "American Sweatshop 1980s Style: Chinese Women Garment Workers." In *Women Transforming Politics: An Alternative Reader*, edited by Kathy Jones, 84–93. New York: NYU Press.

Leal, David L., Stephen A. Nuno, Jongho Lee, and Rodolfo O. de la Garza. 2008. "Latinos, Immigration, and the 2006 Midterm Elections." *PS: Political Science and Politics* 41 (2): 309–317.

Lien, Pei-te. 1998. "Does the Gender Gap in Political Attitudes and Behavior Vary Across Racial Groups." *Political Research Quarterly* 51 (4).

Lien, Pei-te. 2001. *The Making of Asian Americans through Political Participation.* Philadelphia: Temple University Press.

Lien, Pei-te. 2006. "Transnational Homeland Concerns and Participation in US Politics: A Comparison Among Immigrants from China, Taiwan, and Hong Kong." *Journal of Chinese Overseas* 2 (1): 56–78.

Lien, Pei-te. 2008. "Places of Socialization and (Sub)Ethnic Identities Among Asian Immigrants in the US: Evidence from the 2007 Chinese American Homeland Politics Survey." *Asian Ethnicity* 9 (3): 151–170.

Lien, Pei-te, Margaret Conway, and Janelle Wong. 2004. *The Politics of Asian Americans.* New York: Routledge.

Loo, Chalsa M., and Paul Ong. 1982. "Slaying Demons With a Sewing Needle: Feminist Issues for Chinatown Women." *Berkeley Journal of Sociology* 27: 77–88.

Mansbridge, Jane J. 1999. "Should Blacks Represent Blacks and Women Represent Women? A Contingent 'Yes'." *The Journal of Politics* 61 (3): 628–657.

McIlwain, Charlton, and Stephen M. Caliendo. 2011. *Race Appeal: How Candidates Invoke Race in U.S. Political Campaigns.* Philadelphia: Temple University Press.

Peffer, George Anthony. 1999. *If They Don't Bring Their Women Here.* Urbana, IL: University of Illinois Press.

Rosenstone, Steven J., and John Mark Hansen. 2003. *Mobilization, Participation, and Democracy in America.* New York: Pearson Education, Inc.

Sen, Rinku. 1997. "Winning Action for Gender Equity: A Plan for Organizing Communities of Color." In *Women Transforming Politics: An Alternative Reader*, edited by Kathy Jones, 302–323. New York: NYU Press.

Silliman, Jael, Marlene Gerber Fried, Loretta Ross, and Elena Gutierrez. 2004. *Undivided Rights: Women of Color Organizing for Reproductive Justice.* New York: South End Press.

Smooth, Wendy. 2006. "Intersectionality in Electoral Politics: A Mess Worth Making." *Politics and Gender* 2: 400–414.

Suro, Roberto. 2005. *Attitudes Toward Immigrants and Immigration Policy: Surveys Among Latinos in the U.S. and in Mexico.* Pew Hispanic Center. Available from www.pewhispanic.org/files/reports/52.pdf.

Tam, Wendy. 1995. "Asians – A Monolithic Voting Bloc?" *Political Behavior* 17:223–249.

The Center for Voting and Democracy. 2014. *What Affects Voter Turnout Rates.* Fair Vote. Available from www.fairvote.org/research-and-analysis/voter-turnout/what-affects-voter-turnout-rates/.

Tronto, Joan, Cathy Cohen, and Kathy Jones. 1997. *Women Transforming Politics: An Alternative Reader.* New York: NYU Press.

U.S. Census Bureau. 2010a. *Asian Population in the United States.* Available from www.census.gov/content/dam/Census/newsroom/facts-for-features/2014/cb14-ff13_asian_graphic.pdf.

U.S. Census Bureau. 2010b. *2010 Census Redistricting Data Summary File.*

U.S. Census Bureau. 2012. *Reported Voting and Registration by Race, Hispanic Origin, Sex, and Age, for the United States: November 2012.*

Verba, Sidney, Kay Lehman Schlozman, and Henry E. Brady. 1995. *Voice and Equality: Civic Volunteerism in American Politics*. Cambridge, MA: Harvard University Press.

Wong, Janelle, S. Karthick Ramakrishnan, Taeku Lee, and Jane Junn. 2011. *Asian American Political Participation*. New York: Russell Sage Foundation.

Yamada, Mitsuye. 1981. "Asian Pacific American Women and Feminism." In *This Bridge Called My Back: Writings by Radical Women of Color*, edited by C. Moraga and G. Anzaldua, 71–75. Watertown, MA: Persephone.

6

HAWKS AND DOVES?

An Analysis of Latina and Latino Attitudes Toward Military Intervention in Iraq

Rachel VanSickle-Ward and Adrian D. Pantoja

Introduction

Since the U.S. invasion of Iraq in March 2003, the presence of our military footprint in the country remains a contentious and on-going issue in American politics. The resurgence of ISIS (Islamic State of Iraq and Syria) may make Iraq a defining issue in the 2016 Presidential Election. Events in Iraq have prompted pollsters to gauge public support for intervention abroad. Although public opinion research reveals that men tend to be more hawkish while women are more dovish on certain foreign policy issues (Conover and Sapiro 1993; Eichenberg 2003; Nincic and Nincic 2002; Shapiro and Mahajan 1986; Togeby 1994; Wilcox et al. 1993), much of our knowledge of the gender gap in foreign policy attitudes is based on data taken from non-Hispanic Whites. Given that Latinos have become a critical segment of the electorate, in this chapter we ask: Are Latinas more "dovish" and Latinos more "hawkish" in their foreign policy attitudes? The extent to which a gender gap in foreign affairs attitudes is present among Latinas and Latinos remains unexplored.

This chapter seeks to fill this gap by extending research on the foreign policy gender gap to Latinos, using data from the 2006 Latino National Survey. Specifically, we analyze Latino and Latina attitudes on a question asking whether the U.S. should keep military troops in Iraq as long as it takes to stabilize their government. Our analysis reveals a clear gender gap on this policy issue, with Latinos being more supportive of U.S. action in Iraq than Latinas. We further demonstrate that Latino and Latina foreign policy attitudes are influenced by many of the same factors with notable exceptions: for men, experience with military service is an important predictor of hawkish attitudes, and for women, marital status and their socioeconomic status

contribute to more dovish positions. Military service has been an important influence in the lives of Latino men (Barreto and Leal 2007; Garcia 2000; Oropeza 2005), and we find that it plays a critical role in shaping attitudes toward war. These results mirror those of Holsti (1999), which finds military service to correlate with conservative political values. Our discussion of the contours of these differences provides a richer understating of the ways in which gender and ethnicity shape attitudes towards foreign policy, and of the unique perspectives of Latinos and Latinas toward foreign policy.

While pundits and scholars examine Latinos' public policy preferences in order to determine how their participation in politics will affect policy outputs, much of that analysis is limited to domestic issues like education, crime, immigration, and the economy. Less attention has been devoted to analyzing the foreign policy preferences of Latinos. This may in part be driven by the assumption that Latinos are more concerned with domestic policy issues rather than foreign policy issues (Pantoja 2015). However, there is clear evidence that Latinos care about foreign affairs and that their voting preferences are shaped by foreign policy considerations (Pachon et al. 2000). We contend that the continued growth of the Latino electorate will not only have an effect on domestic policies, but also on the country's foreign policy.

Research on Latino electoral behavior has been able to demonstrate the applicability of standard behavior models to this population as well as augment popular understanding of political participation by considering the effects of previously overlooked determinants such as language use, nativity, generational status, and ethnic identity (Fraga et al. 2010). Other accounts emphasize the ways in which Latinos are unique in their policy preferences and pathways to elected office (Bejarano, Chapter 12). In a similar vein, we seek to expand and problematize standard explanations of public opinion toward war, by considering the intersection of gender- and ethnic-specific factors in structuring these attitudes. Our chapter outlines areas of overlap and difference between our findings and those explaining foreign policy attitudes among non-Hispanic Whites.

The Gender Gap in Foreign Policy

Studies examining mass attitudes on foreign affairs can be divided into two camps: those concerned with the political *consequences* of those attitudes and those concerned with their underlying *causes*. The former largely examines the degree to which foreign events and policies shape citizens' vote choice and/or presidential evaluations (Hurwitz and Peffley 1987a; Klinker 2006), while the latter looks to reasons why the public holds certain opinions on foreign affairs (Gartner and Segura 1998, 2000; Hurwitz and Peffley 1987b; Peffley et al. 1995). Because of our chapter's focus, our review is limited to research examining the determinants of foreign policy attitudes among the mass public.

Despite the diversity of international events and interactions, much of the public opinion research on foreign affairs centers on examining mass attitudes toward militarized disputes. No doubt, the salience of these events and their human, financial, and political costs explain the focus of the research. Although the research has stressed the primacy of events on the battlefield, e.g., casualties to explain support and/or opposition to conflict (Gartner and Segura 1998; Mueller 1973), recent studies have argued that elite cues play a more prominent role (Berinsky 2007). Other studies focus on the primacy of other predictors such as partisanship, the perceived costs and outcomes of the conflict, and the effects of certain sociodemographic characteristics. While the impact is more complex than on domestic policies, party has nonetheless proven an important predictor (Baum 2002, 2004; Berinsky 2007; Eichenberg et al. 2006; Gaines et al. 2007; Groeling and Baum 2008; Martini 2012).

Extensive scholarship has demonstrated that foreign policy attitudes are strongly shaped by gender. In other words, women tend to hold more dovish attitudes when it comes to the use of force abroad (Fite et al. 1990). This finding has spurred other studies focusing on the role of gender in shaping foreign policy opinions. Scholars have applied the question of women's attitudes toward war and foreign intervention to a wide range of years, regions, conflicts, and conditions. Wilcox et al. (1993) consider attitudes toward the U.S. intervention in the Gulf War in 1990. Nincic and Nincic (2002) investigate the role of race and gender in shaping opinion toward American intervention in Korea, Vietnam in 1966, Vietnam in 1972, Desert Shield, and Desert Storm. Eichenberg (2003) treats gendered opinion toward U.S. action in the Persian Gulf, Bosnia, North Korea, Haiti, Somalia, Rwanda, Sudan/ Afghanistan, and Serbia/Kosovo, and Conover and Sapiro (1993) examine three abstract foreign orientations: militarism, fear of war, and isolationism, as well as a range of views on the first gulf war. The general consensus is that women, relative to men, are more reluctant to support military force. Indeed, gendered differences are more pronounced in attitudes toward the appropriate use of government-sponsored violence than in any other policy arena (Huddy et al. 2008).

Why are women less supportive of military intervention than men? Prior literature suggests that the causal mechanisms at play are not simply structural or due to social location (gender serving as a proxy for partisan or socioeconomic differences). A variety of alternate explanations have been put forward. Some suggest a unique feminist consciousness or an "essentialist" or "mothering" explanation (Cook and Wilcox 1991; Fukuyama 1998; Goldstein 2001; Ruddick 1989). Others have posited self-interest, noting that, "although women are rarely participants in the decisions that lead to war, they are increasingly its major victims" (Nincic and Nincic 2002, 552; see also As 1982; Berkman 1990). A third explanation is political socialization (Conover and Sapiro 1993; Wilcox et al. 1993). Conover and Sapiro (1993) note that the fact

that gender difference persists in multivariate analyses suggests "a pervasive, gendered pattern of early learning of cognitive and especially affective orientations toward the use of violence" (1096).

Other studies indicate that gender differences are conditioned by the way in which a conflict is framed. More specifically, question wording and mention of loss of life matters, with women reacting more strongly to mentions of body-counts. They are less supportive than men of aggression abroad in general but especially when casualties are mentioned (Eichenberg 2003; Wilcox et al. 1993). Furthermore, gender differences are impacted by the principal policy objective of the intervention and the type of intervention. Specifically, women are more supportive than otherwise for humanitarian intervention, and thus the gender gap is reduced in these cases (Eichenberg 2003).

It also appears that women's and men's attitudes towards war and intervention are not just different but differently structured. Looking specifically at the first Gulf War, Conover and Sapiro (1993) investigate four categories of reactions that go beyond support and opposition: (1) attention to reporting of the war, (2) evaluations of the war, (3) approval of tactics, and (4) emotional response. While women did not differ significantly from men in levels of attention to the war, the gap did emerge in all other categories, and was most pronounced on questions designed to activate emotional reactions. More emotional reactions among women have also been found in response to terrorism and the more recent Gulf War, and have been linked to higher levels of anxiety (Huddy et al. 2008). Conover and Sapiro's findings (1993) suggest that, relative to women, men's attitudes are consistently more informed by partisanship. In contrast Allison (2011) finds partisanship to be significant for both men and women, and possibly stronger among women. Beyond partisanship, Conover and Sapiro conclude that women's negative attitudes are pronounced when they are confronted by concrete rather than abstract conflict.

Although limited, some work does consider both race and gender when looking at attitudes toward foreign intervention, but rarely are gender differences *within* racial groups the subject of extensive discussion, and Latinos are often left out of the discussion altogether. For example, research by Wilcox et al. (1993) note that African Americans and Latinos were less supportive than Whites of military action in the Gulf in 1990, and they note that a gender gap was found among Blacks and Whites; yet there is no mention of a gender gap among Latinos or whether they analyzed the Latino sample separately. Nincic and Nincic (2002) note that African Americans generally, and women specifically, are less supportive of military intervention abroad, and emphasize the role of political alienation in shaping their attitudes. When it comes to the most recent conflict in Iraq, Allison (2011) similarly finds a gender gap among African Americans. Only two works to date examine Latino and Latina foreign policy attitudes and these works find limited evidence of a gender gap

(Bedolla et al. 2007; Montoya 1996). The mixed findings on Latinos may be the result of the question used to capture foreign policy attitudes – military expenditures. Military expenditures are only one policy area and it remains to be seen whether a gap emerges on questions relating to *the actual* use of force abroad.

The limited scholarship on the attitudes of women of color generally, and Latinas specifically, gives us an incomplete picture of public opinion on foreign intervention. Theories of intersectionality are instructive here. The expectation that the gender gap found among non-Hispanic Whites will be simply and precisely mirrored by Latinos and Latinas fails to recognize real differences in lived experience, socialization, socioeconomic status, and cultural identity. As Kimberlé Crenshaw states in one of her foundational works on the subject, "women of color are differently situated in the economic, social, and political worlds" (Crenshaw 1991, 1250). Policies that do not address these interwoven marginalized identities thus often fail the women who may need them most (Crenshaw 1991). Scholars of intersectionality have investigated the ways in which gender and race are mutually constructed and simultaneously experienced, proposed ways to operationalize theories of intersectionality to promote empirical analysis, and examined consequences for policy attitudes (Collins 1998, 1999; Hancock 2007, 2011; Williams, Chapter 18).

Our analysis also brings theories of social connectedness to bear on Latina and Latino attitudes toward foreign policy. As articulated by Leighley and Vedlitz (1999; see also Putnam 1995, 2001; Teixeira 2011), social connectedness (sometimes called social capital or social incorporation) captures an "individual's relationship to the larger society" (Leighley and Vedlitz 1999, 1095). Commonly used indicators include home ownership and marital status – factors that theoretically enhance one's social network, status, and opportunities for civic and social engagement. Social connectedness has most commonly been used in explaining political participation, more specifically limited social capital has been linked to lower levels of participation. Few studies consider the particular impact of social connectedness on racial and ethnic minorities (Leighley and Vedlitz 1999; Rosenstone and Hansen 2002); fewer still consider the impact on structuring political attitudes on foreign policy. Our analysis illustrates that not only are these factors significant for structuring the attitudes of the Latino/a population in general, they have a differential impact based on gender.

Our chapter seeks to contribute to this dialogue through an analysis of the Latina/Latino gender gap, including identifying variations within the Latino community based on nation of ancestry. We illustrate the ways in which intersections between gender and ethnicity in foreign policy attitudes both reinforce and problematize traditional understanding of the gender gap. In so doing, we aim to provide a more finely grained account of the ways in which Latinos and Latinas view war.

Data, Methods, and Results

In order to investigate whether Latinas are more dovish relative to Latinos in their attitudes toward war, we rely on data from the 2006 Latino National Survey (ICPSR 20862). The 2006 survey has a sample of 8,634, with women making up slightly more than half of the respondents or 54.9 percent. The LNS is presently the largest survey on the Hispanic population in the United States. The sample was drawn from 15 states and the District of Columbia, covering 87.5 percent of the U.S. Hispanic population. Interviews were conducted by telephone in Spanish and English. Approximately 60 percent (5,180 respondents) of the sample completed the interview in Spanish, while 40 percent (3,454 respondents) completed the survey in English. Although our primary focus is on the Latino and Latina population, we occasionally draw comparisons between the LNS data and a PEW 2008 survey that asks a substantially comparable question of the general population. This allows us to note when the analysis of Latinos and Latinas differs from results drawn from predominantly White, non-Hispanic respondents.[1]

Operation Iraqi Freedom began on March 20, 2003 and the conflict quickly became controversial, as weapons of mass destruction and the rationale for going into war remained elusive. The rising insurgency and growing American casualties also led the U.S. public to quickly turn against the war. By early 2007, two-thirds (67 percent) of Americans said the war in Iraq was not going well (Pew Research Center, 2008 report). In the 2006 Latino National Survey, respondents were asked whether they supported or opposed the following statement: *Keep U.S. military troops in Iraq as long as it takes to stabilize their government.* The response options included *strongly support, support, opposed,* or *strongly opposed.* In the survey, only a quarter of Latinos (24.9 percent) supported (*support* and *strongly support*) the presence of U.S. troops in Iraq.

Comparing overall levels of support reveals a striking gender difference. There is a 13.3 point difference between men and women, with 32.3 percent of men supporting the presence of U.S. troops in Iraq, while only 19 percent of women are supportive of U.S. involvement. Research by Bedolla et al. (2007) and Montoya (1996) find that Latinas and Latinos have distinct views across a number of domestic policies issues. Our results thus far suggest that Latinos and Latinas have distinct foreign policy preferences. While Latinos were less supportive of the troop presence than the general population, the size of the gender gap is comparable (in the 2008 Pew poll 57.8 percent of men supported continued troop presence compared to 46.3 percent of women). How significant are these gender differences? Merely observing the presence or lack of a percentage difference cannot tell us if being female underlies these foreign policy attitudes. It may be that the differences are driven by certain sociodemographic characteristics and not gender. In order to assess the independent effects of gender vis-à-vis other factors, we now turn to a series of multivariate statistical analyses.

In this case logistic regression will be used since the dependent variable is coded dichotomously (1 support/strongly support and 0 oppose/strongly oppose). In addition to gender (*Women*), the independent variables include the following sociodemographic characteristics, *Age*, *Education*, *Renter* (a proxy for income), marital status (*Married*), and nativity (*Foreign Born*). Dummies are used to isolate the three largest ancestry groups, Mexican Americans, Puerto Ricans, and Cuban Americans. We include the variable *Born-again Christian*, which captures respondents' self-identity as born-again Christians. We hypothesize that this religious identity is positively associated with support for the presence of U.S. forces in Iraq. The variable *Military Service* identifies respondents who noted they have a family member in the armed forces. Given the connection between military service and conservatism (Holsti 1999), we also anticipate this variable will be positive. Finally, we include three measures of political beliefs and attitudes. The variable *Democrat* captures respondent's partisan identity. Since the intervention was initiated under a Republican administration, we anticipate that Democrats will be opposed to the intervention. The variable *Like Bush* is an evaluation of President Bush and is anticipated to be positively associated with a pro-interventionist position. Concerns over events in Iraq is captured by the variable *Worry Iraq* (see appendix for the coding of these variables). Increased concern over Iraq will be negatively related to the continuation of U.S. forces in Iraq.

Table 6.1 presents the results of three models. This first model includes gender as an independent variable with the controls discussed above to determine whether gender is a significant factor shaping Latino foreign policy attitudes. The other two models show separate logistic analysis for Latina women and Latino men to determine whether foreign policy attitudes are differentially structured among men and women. Looking at the results in Table 6.1, we can conclude that the influence of gender is striking. Women are less supportive of the presence of U.S. troops in Iraq *ceteris paribus*. Before discussing whether the foreign policy attitudes are differentially structured, we will discuss the significance of the additional variables.

It is worth noting that most of the control variables, while not our central theoretical focus, also had a significant impact on support for the presence of U.S. troops in Iraq. We find that support increases among older and more educated respondents, and decreases among renters and foreign-born respondents. A self-interest explanation could be at work here, because individuals who are older and have higher socioeconomic status are less likely to be eligible for military service. We will return to the impact of demographic and social status variables when we consider them in the specific context of gender.

Given the literature covered earlier on elite cues, event specific factors, and partisanship, the impact of religion, party, concerns about Iraq, and attitudes toward Bush are expected. Evangelical Christians played an important role in the election of George W. Bush because of their conservative orientations. The

TABLE 6.1 Determinants of Latino and Latina Attitudes Toward Iraq

	Latina/Latino Model	Latina Women	Latino Men
Women	−0.740*** (0.061)		
Age	0.010*** (0.002)	0.009** (0.003)	0.011*** (0.003)
Education	0.046* (0.019)	0.051* (0.029)	0.041 (0.026)
Renter	−0.216*** (0.067)	−0.384*** (0.098)	−0.070 (0.092)
Married	−0.001 (0.064)	−0.156* (0.092)	0.135 (0.091)
Foreign Born	−0.437*** (0.072)	−0.546*** (0.105)	−0.326*** (0.101)
Born-again Christian	0.236*** (0.061)	0.223* (0.089)	0.249** (0.086)
Military Service	0.289*** (0.073)	0.060 (0.105)	0.508*** (0.102)
Democrat	−0.627*** (0.065)	−0.506*** (0.097)	−0.738*** (0.088)
Like Bush	1.476*** (0.085)	1.487*** (0.121)	1.491*** (0.122)
Worry Iraq	−0.248*** (0.066)	−0.363*** (0.100)	−0.155** (0.090)
Mexican	0.049 (0.083)	−0.029 (0.123)	0.114 (0.113)
Puerto Rican	0.179 (0.116)	0.170 (0.165)	0.152 (0.165)
Cuban	0.543*** (0.141)	0.375* (0.204)	0.708*** (0.200)
Constant	−1.100*** (0.169)	−1.458*** (0.248)	−1.446*** (0.227)
LR χ^2	871.70	314.94	434.09
Significance	0.000	0.000	0.000
Sample Size	6,581	3,531	3,050

Notes
$p<0.10$*; $p<0.05$**; $p<0.001$***.

support for the war in Iraq is predictably strong among Latino evangelicals, as captured by the variable *Born-again Christian*. *Democrats* are less supportive of the war and therefore we anticipated the variable would be negatively related to the dependent variable. Positive evaluations of George W. Bush (*Like Bush*) positively structure support for having troops abroad. Concerns about the war (*Worry Iraq*) negatively structure support for the intervention. We also find that having served in the military or knowing someone who has served increases support for maintaining U.S. troops abroad. Finally, among the selected ancestry groups, Cuban Americans are most supportive of the intervention. The ideological orientations of this group and more hawkish foreign policy attitudes (Pachon et al. 2000) explain why this segment of the Latino population has a pro-interventionist position.

One of the primary focuses of our chapter is to consider whether gender differentially structures attitudes toward military interventions. Table 6.1 separates female and male respondents in an effort to show whether the factures underlying the dependent variable are differentially constituted for women and men. First, among the statistically significant variables, all have signs in the expected direction. Second, six variables have a similar impact across the two groups. In other words, for men and women, attitudes toward U.S. intervention in Iraq

are similarly structured by the variables, *Age, Foreign Born, Born-again Christian, Democrat, Like Bush,* and *Worry Iraq*. In addition, Cuban American women and men are more likely to support the presence of U.S. forces in Iraq among the different ancestry groups. Nonetheless, there are important differences worth examining in detail. For women, we find that having higher levels of education, lower incomes (specifically, being a renter), and being married have a significant effect on their foreign policy attitudes. These variables are not significant among the male respondents. Among men, serving in the military and/or knowing someone who serves (*Military Service*) has a positive effect on their attitudes toward intervention. This variable does not have an effect on women's attitudes. Thus there are four variables that have differing effects.

It is worth noting here that these differences do not entirely align with those found between men and women in the PEW survey of predominantly White non-Hispanic respondents. The renting versus homeownership variable did obtain in a parallel manner for the PEW respondents – making women but not men less likely to support continued troop presence. However, unlike the Latino/Latina model, level of education was a significant positive predictor for both men and women. Perhaps most striking, among the predominantly White non-Hispanic respondents, marital status affected men but not women, and in the opposite direction from Latinas. In other words, being married makes white men more likely to support the war, and Latinas less so.[2]

Discussion

Considered in concert with one another, these differences in attitudes point to the centrality of social connectedness and intersectionality. As we noted at the outset, home ownership and marital status are key indicators of social connectedness. While military service is less commonly used, one can easily see how it provides the same social network, status, and opportunities for civic and social engagement. The fact that these variables impact attitudes for Latinas and Latinos in distinct ways suggests that gender and ethnicity intersect to shape lived experience, and in turn, opinion on foreign intervention.

Why do education, income, marital status, and military service have distinct impacts across female and male respondents? Our income variable captures respondents who are renters, or have lower incomes. We hypothesize that this would have a negative effect among Latinos since this segment is most vulnerable to serving in the military either through volunteering or draft. For low-income groups, the military is one of the few avenues available for career and educational development (e.g., through the G.I. Bill). Moreover, when it comes to the draft, historically, low-income groups are disproportionately drafted into active service. Yet, low-income men are most susceptible to entering the military. The fact that low-income women and not low-income men are most opposed to U.S. military intervention suggests that self-interest (specifically, fear

of the draft) is an insufficient explanation. Rather, the intersection of gender and ethnicity and lack of social capital and economic security (as evidenced by not owning a home) leads Latinas to feel more negatively about foreign conflict. The impact of education illustrates a similar dynamic. For Latinas, educational attainment, and the attendant increase in status and opportunities, likely produces a less vulnerable outlook and thus a more hawkish stance.

Being married has a significant and negative effect for Latinas but not Latinos. There is scant literature on the impact of marital status on attitudes toward foreign policy, though some proffer that marital status increases conservative leanings overall, which is clearly not the case here (Weisberg 1987).[3] On first blush, the most straightforward explanation is self-interest. The risks of war and the possibility of a draft may make married women more concerned about the possibility of their husbands being called into active service. This is likely true, but if this were the sole or even primary explanation, we would also expect to see Latinas' attitudes significantly affected by whether they or a close family member were serving in the military. And we would expect to see a parallel difference among all women. We do not. Thus, here again self-interest is insufficient – married Latinas experience the general threat of war differently than their unmarried counterparts, and differently than married Latino counterparts. The puzzle remains: marriage is generally thought to increase social capital and connectedness (Rosenstone and Hansen 2002). Like home ownership or education, these factors ought to make women feel less vulnerable, not more so. The fact that this pattern appears to be unique to Latinas suggests the need for further investigation.

Finally, for men, serving in the military, or having a close family member who serves, has a positive effect in shaping their attitudes toward U.S. forces abroad. This is perhaps the clearest indictment of the pure self-interest explanation. Concerns over the safety of self or loved ones could understandably increase opposition toward the presence of troops in Iraq. But this variable has the opposite effect. The feelings of patriotism and the need to "support the troops abroad" instilled by exposure to military service lead Latinos (but not Latinas) to be supportive of President Bush's Iraqi policy. This comports with scholarship that military service generally leads to ideological conservatism in foreign affairs (Holsti 1999), but the gendered impact warrants further investigation.

The particular impact of military service on men could be linked to higher rates of participation in the armed services (Segal and Segal 2004). But it's worth reiterating that the military service question asks, "Have you *or any close member of your family* ever served in the U.S. military?" (emphasis added). The variable is dichotomous with 1 for respondents who answered yes and 0 for those who answered no. In the survey 32.7 percent of men answered yes and 30.4 percent of women answered yes (31.4 percent answered yes overall). So despite having comparable rates of exposure to military experience (directly or indirectly through family), the results clearly show that this variable positively structures

men's attitudes toward the war in Iraq while it has no effect on women. The differential impact of the variable is larger than we expected because of men's *direct* experience with the armed forces. This of course is an inference since we have no way of assessing the number of men who answered that question in terms of their own personal experience with the military. Regardless, it is clear from our analysis that Latino attitudes are informed by (either direct or indirect) association with the military in way that Latinas are not.

For Latino men, support for the military is longstanding, given that the armed forces were one of the only institutions that provided upward mobility (Barreto and Leal 2007). Being in the military not only afforded men social status in the barrio, but also provided them with tangible benefits through the G.I. Bill. Many of the first-generation Latino political leaders were able to attend college because of the G.I. Bill and their participation in World War II (Garcia 2000). Symbolically, for Latinos, military service was also considered as a catalyst for acceptance or, as Oropeza (2005) writes, "Serving in the U.S. military was traditionally not only an important marker of masculinity but also, through the long era of segregation, an important marker of whiteness" (7). By extension it makes sense that Latinos with a family connection to the military feel a sense of pride and militarism that Latinas, lacking this specific socialization, do not share. This finding is important and warrants greater investigation given that there is little systematic attention to the role of military service in shaping political values and behaviors, or as Barreto and Leal (2007) write, "If the question is how veterans of different races and ethnicities engage the political system, there is almost no evidence" (224). This lacuna is particularly notable given the diversity of the armed forces.

Conclusion

This study sought to examine the extent to which a gender gap exists among Latinos when it comes to the use of force in international politics. Using data from the 2006 Latino National Survey, and a question capturing support for military intervention in Iraq, we find that indeed Latinas are more dovish than Latinos. These differences persist even after controlling for a host of political, social, and demographic factors. In addition, we explored whether Latina and Latino attitudes were differentially structured by the selected predictors. For both Latino and Latinas we find that the variables, *Like Bush, Partisanship, Age, Education, Born-again Christian, Foreign Born,* are significant in the expected direction. But key differences exist as well. For men, having served in the military or having a relative in the military increased their support for having U.S. troops in Iraq. In the case of women, marriage, being a renter, and worry about Iraq decreased support.

Our findings both reinforce and challenge existing scholarship. Some previous research has indicated that men's views toward war are more determined by

partisanship, and that it is *women* who react more strongly to more tangible concerns (Conover and Sapiro 1993). In contrast, our analysis indicates that partisanship is a significant factor for both men and women (consistent with the analysis of African American women in Allison 2011). The findings on concrete versus abstract concerns are more complex. Both Latinos and Latinas are shaped by their specific concerns about the Iraq war, but Latina attitudes appear to be uniquely shaped by forces that make them feel less economically or socially secure. Serving in the military or having a family member is the military is clearly a concrete concern, and this variable is only significant for Latinos. Thus, while not an outright contradiction of earlier findings, our analysis suggests that the inclusion of Latinos and Latinas complicates that model.

To further understand these results, it is helpful to return to the proxy, essentialist, self-interest, and socialization theories articulated at the outset of the chapter. The inclusion of socioeconomic control variables helps us establish that gender differences are not merely a proxy for income or education – gender has its own, independent, and persistent effect. The essentialist and self-interest theories for gendered attitudes offer little traction here. The self-interest explanation would presumably predict that serving in the military or having family in the military would lead both genders to oppose military intervention, because it places an individual or his or her loved ones in harm's way. Yet this variable is only significant for men and in the opposite direction. Finally, the socialization hypothesis holds that attitudes are shaped by learned values and political orientations. While our data do not allow us to test some of the classic indicators of socialization that may differentially affect men and women (parental or peer modeling, peaceful versus violent models of play), we do see socializing effects through partisanship, education, and connections with religious and military institutions. More specifically, our results point to variables measuring social connectedness, the feelings of connection to one's community. The fact that gender not only persists controlling for these variables, but that the impact of these variables is different for Latinas than it is for Latinos, suggests that intersectionality is at play.

In addition to being interesting in its own right, these findings remind us that we are limited in our analysis of the impact of gender on attitudes when we assume male attitudes to be the norm and look for "difference" in women. In this case, one interesting "difference" is among men in terms of military service contributing to hawkish attitudes. This reinforces the points raised by Holman (Chapter 2) about rethinking the presumed default category of male. Overall, the persistence of the gender gap for Latinos does more than reinforce similar findings among non-Hispanic White men and women. It challenges us to develop a deeper understanding of why these gendered differences exist across ethnic and racial groups in the United States.

While there is great deal of discussion of the gender gap in policy attitudes, many of the differences turn out to be relatively small, and sometimes nonexistent, when other factors, namely party, are carefully controlled for. This is not

the case for foreign policy: Women and men have markedly different perspectives, and women are consistently more dovish then men on issues of violent foreign intervention. Our analysis of how this gap obtains for Latinos and Latinas demonstrates the power of bringing intersectionality to bear in discussion of foreign affairs, and the complex ways in which social connectedness shapes attitude formation.

Appendix available online at www.routledge.com/9781138958845.

Notes

1 From the methodological summary of the PEW survey: "The September Political/ Foreign Policy Survey, sponsored by the Pew Research Center for the People and the Press, obtained telephone interviews with a nationally representative sample of 2,982 adults living in the continental United States." The comparison question we analyzed asks: "Do you think the U.S. should keep military troops in Iraq until the situation has stabilized, or do you think the U.S. should bring its troops home as soon as possible?" Possible answers include "Keep troops in Iraq, Bring troops home, and Don't know?/ Refused (voluntary)." Hispanics constituted 13.4 percent of the sample; White/non-Hispanics constituted 69.3 percent. We employed similar controls, where available.
2 The positive impact of marital status on support for continued troops held for all men in the predominantly White non-Latino PEW survey, and for white men only.
3 Chapman (1985) finds divorced and separated respondents in Great Britain to be more in favor of *reducing* military expenditure relative to their married counterparts, but the difference between men and women is not significant. More recent scholarship on parenthood has found that, for women, having children contributes to positive feelings toward the military and support for military spending (Greenlee 2010), but not toward concern for war and support for intervention (Conover and Sapiro 1993).

References

Allison, Rachel. 2011. "Race, Gender, and Attitudes Toward War in Chicago: An Intersectional Analysis." *Sociological Forum* 26(3): 668–691.

As, Berit. 1982. "A Materialist View of Men's and Women's Attitudes Toward War." *Women's Studies International Forum* 1(3/4): 351–372.

Barreto, Matt A., and David L. Leal. 2007. "Latinos, Military Service, and Support for Bush and Kerry in 2004." *American Politics Research* 35: 224–251.

Baum, Matthew A. 2002. "The Constituent Foundations of the Rally-Round-the-Flag Phenomenon." *International Studies Quarterly* 46(2): 263–298.

Baum, Matthew A. 2004. "Circling the Wagons: Soft News and Isolationism in American Public Opinion." *International Studies Quarterly* 48(2): 313–338.

Bedolla, Lisa Garcia, Jessica Lavariega-Monforti, and Adrian Pantoja. 2007. "A Second Look: Is There a Latina/o Gender Gap?" *Journal of Women, Politics & Policy* 28(3/4): 147–171.

Berinsky, Adam J. 2007. "Assuming the Costs of War: Events, Elites, and American Public Support for Military Conflict." *The Journal of Politics* 69: 975–997.

Berkman, Joyce. 1990. "Feminism, War, and Peace Politics: The Case of World War I," in Jean Bethke Elshtain and Sheila Tobias, eds., *Women, Militarism, and War: Essays in History, Politics, and Social Theory.* Savage, MD: Rowman & Littlefield (141–160).

Chapman, Jenny. 1985. "Marital Status, Sex and the Formation of Political Attitudes in Adult Life." *Political Studies* 33(4): 592–609.

Collins, Patricia Hill. 1998. "It's All In the Family: Intersections of Gender, Race, and Nation." *Hypatia* 13(3): 62–82.

Collins, Patricia Hill. 1999. *Black Feminist Thought: Knowledge, Consciousness, and the Politics of Empowerment.* Revised, 10th Anniv., 2nd edition. New York: Routledge.

Conover, Pamela Johnston, and Virginia Sapiro. 1993. "Gender, Feminist Consciousness, and War." *American Journal of Political Science* 37: 1079–1099.

Cook, Elizabeth, and Clyde Wilcox. 1991. "Feminism and the Gender Gap: A Second Look." *The Journal of Politics* 53: 1111–1122.

Crenshaw, Kimberlé. 1991. "Mapping the Margins: Intersectionality, Identity Politics, and Violence against Women of Color." *Stanford Law Review* 43: 1241–1299.

Eichenberg, Richard C. 2003. "Gender Differences in Public Attitudes toward the Use of Force by the United States, 1990–2003." *International Security* 28(1): 110–141.

Eichenberg, Richard C., Richard J. Stoll, and Matthew Lebo. 2006. "War President: The Approval Ratings of George W. Bush." *Journal of Conflict Resolution* 50(6): 783–808.

Fite, David, Marc Genest, and Clyde Wilcox. 1990. "Gender Differences in Foreign Policy Attitudes." *American Politics Quarterly* 18: 492–513.

Fraga, Luis Ricardo, John A. Garcia, Rodney E. Hero, Michael Jones-Correa, Valerie Martinez-Ebers, and Gary Segura. 2010. *Latino Lives in America, Making it Home.* Philadelphia, PA: Temple University Press.

Fukuyama, Francis E. 1998. "Women and the Evolution of World Politics." *Foreign Affairs* 77(5): 24–40.

Gaines, Brian J., James H. Kuklinski, Paul J. Quirk, Buddy Peyton, and Jay Verkuilen. 2007. "Same Facts, Different Interpretations: Partisan Motivation and Opinion on Iraq." *Journal of Politics* 69(4): 957–974.

Garcia, Ignacio M. 2000. *Viva Kennedy, Mexican Americans in Search of Camelot.* College Station, TX: Texas A&M University Press.

Gartner, Scott Sigmund, and Gary M. Segura. 1998. "War, Casualties, and Public Opinion." *Journal of Conflict Resolution* 42: 278–300.

Gartner, Scott Sigmund, and Gary M. Segura. 2000. "Race, Casulaties and Opinion in the Vietnam War." *The Journal of Politics* 62: 115–146.

Goldstein, Joshua. 2001. *War and Gender: How Gender Shapes the War System and Vice Versa.* Cambridge: Cambridge University Press.

Greenlee, Jill. 2010. "Soccer Moms, Hockey Moms and the Question of 'Transformative' Motherhood." *Politics & Gender* 6(3): 405–431.

Groeling, Tim, and Matthew A. Baum. 2008. "Crossing the Water's Edge: Elite Rhetoric, Media Coverage, and the Rally-Round-the-Flag Phenomenon." *The Journal of Politics* 70 (4): 1065–1085.

Hancock, Ange-Marie. 2007. "When Multiplication Doesn't Equal Quick Addition: Examining Intersectionality as a Research Paradigm." *Perspectives on Politics* 5(1): 63–79.

Hancock, Ange-Marie. 2011. *Solidarity Politics for Millennials: A Guide to Ending the Oppression Olympics.* New York: Palgrave Macmillan.

Holsti, Ole R. 1999. "A Widening Gap between the U.S. Military and Civilian Society? Some Evidence, 1976–1996." *International Security* 23: 5–42.

Huddy, Leonie, Erin Cassese, and Mary-Kate Lizotte. 2008. "Gender, Public Opinion, and Political Reasoning," in Christina Wolbrecht, Karen Bexkwith, and Lisa Baldez, eds., *Political Women and American Democracy.* Cambridge: Cambridge University Press.

Hurwitz, Jon, and Mark Peffley. 1987a. "The Means and Ends of Foreign Policy as Determinants of Presidential Support." *American Journal of Political Science* 31: 236–258.

Hurwitz, Jon, and Mark Peffley. 1987b. "How Are Foreign Policy Attitudes Structured? A Hierarchical Model." *American Political Science Review* 81: 1099–1120.

Klinker, Philip A. 2006. "Mr. Bush's War: Foreign Policy in the 2004 Election." *Presidential Studies Quarterly* 36: 281–296.

Leighley, Jan E., and Arnold Vedlitz. 1999. "Race, Ethnicity, and Political Participation: Competing Models and Contrasting Explanations." *The Journal of Politics* 61(4): 1092.

Martini, Nicholas Fred. 2012. "The Role of Ideology in Foreign Policy Attitude Formation." Ph.D. thesis, University of Iowa.

Montoya, Lisa J. 1996. "Latino Gender Differences in Public Opinion: Results from the Latino National Political Survey." *Hispanic Journal of Behavioral Sciences* 18: 255–276.

Mueller, John E. 1973. *War, Presidents and Public Opinion.* New York: John Wiley.

Nincic, Miroslav, and Donna J. Nincic. 2002. "Race, Gender, and War." *Journal of Peace Research* 39: 547–568.

Oropeza, Lorena. 2005. *Raza Si. Guerra No. Chicano Protest and Patriotism During the Viet Nam War Era.* Los Angeles, CA: University of California Press.

Pachon, Harry, Rodolfo O. de la Garza, and Adrian Pantoja. 2000. "Latinos and Foreign Policymaking," in Rodolfo O. de la Garza and Harry P. Pachon, eds. *Latinos and U.S. Foreign Policy, Representing the Homeland?* New York: Rowman & Littlefield.

Pantoja, Adrian. 2015. "El despertar del gigante latino." *Foreign Affairs Latinoamerica* 15(2): 12–18.

Peffley, Mark, Ronald E. Langley, and Robert Giodel. 1995. "Public Responses to the Presidential Use of Military Force: A Panel Analysis." *Political Behavior* 17: 307–337.

Putnam, Robert D. 1995. "Tuning In, Tuning Out: The Strange Disappearance of Social Capital in America." *PS: Political Science and Politics* 28(4): 664–683.

Putnam, Robert D. 2001. *Bowling Alone: The Collapse and Revival of American Community.* New York: Simon and Schuster.

Rosenstone, Steven J., and John Mark Hansen. 2002. *Mobilization, Participation, and Democracy in America (Longman Classics Edition).* New York: Longman Publishing Group.

Ruddick, Sara. 1989. *Maternal Thinking: Toward a Politics of Peace.* Boston, MA: Beacon.

Segal, David R., and Mandy Wechsler Segal. 2004. "America's Military Population." *Population Reference Bureau* 59(4).

Shapiro, Robert Y., and Harpreet Mahajaan. 1986. "Gender Differences in Policy Preferences: A Summary of Trends from the 1960s to the 1980s." *Public Opinion Quarterly* 50: 42–61.

Teixeira, Ruy A. 2011. *The Disappearing American Voter.* Washington, D.C.: Brookings Institution Press.

Togeby, Lise. 1994. "The Gender Gap in Foreign Policy Attitudes." *Journal of Peace Research* 31: 375–392.

Weisberg, Herbert F. 1987. "The Demographics of a New Voting Gap: Marital Differences in American Voting." *Public Opinion Quarterly* 51: 335–343.

Wilcox, Clyde, Joseph Ferrara, and Dee Allsop. 1993. "Group Differences in Early Support for Military Action in the Gulf: The Effects of Gender, Generation, and Ethnicity." *American Politics Research* 21: 343–358.

PART II

Race, Gender, and Campaigning for Office

7

HOW DO YOU SEE ME?

Stereotyping of Black Women and How It Affects Them in an Electoral Context

Jessica D. Johnson Carew

Introduction

In spite of the fact that Black women increasingly have attained higher propor-
tions of descriptive representation – representation in terms of salient physical
and social characteristics – these proportions still do not mirror their percentage
of the population in the United States. In 2014, Black (non-Hispanic) women
made up 6.93 percent of the total U.S. population, but only 2.80 percent of the
U.S. Congress in that same year (CAWP 2014; U.S. Census Bureau 2014). A
record number of women are now holding voting positions in the 114th U.S.
Congress, including 20 in the U.S. Senate, though only one of these Senators is
a woman of color (CAWP 2015). There are 32 women of color serving as
Congresswomen in the U.S. House, 18 of whom are Black women (CAWP
2015). The fact that a total of only 34 Black women have *ever* served as voting
members of Congress helps to elucidate the concept that this group has tradi-
tionally been excluded from and/or encountered extreme barriers to entry into
this important institution of the American political system (CAWP 2015) (see
the chapters by Sanbonmatsu and Bejarano in this volume for detailed examina-
tions of various factors that contribute to the underrepresentation of women of
color in electoral politics at the state level). Nevertheless, Hardy et al. (2006)
find that the presence of women of color elected officials is a key element in the
improvements in descriptive representation for racial/ethnic minorities and
women over time. Given these data, it is necessary to determine the factors that
are contributing to both the aforementioned underrepresentation and the elect-
oral advantages/disadvantages women of color encounter as political candidates.
In order to attain an office in a legislature, candidates must first obtain the
support of a majority of the voters within the district or state they wish to

represent; however, this can be a daunting feat if a candidate belongs to a group that has been continuously disadvantaged by ubiquitous negative stereotypes and images. Consequently, this chapter examines the degree to which stereotypes are attributed to elite Black women, as well as the effects of trait and belief stereotypes on the electoral prospects for Black female candidates.

The aforementioned form of exclusion from positions of political representation has real and significant sociopolitical implications. Various sources of theoretical and empirical support have made it apparent that racial, ethnic, and gender descriptive representation are of particular importance to the attainment of substantive representation within the U.S. political system. While some have argued that descriptive representation leads to lower levels of substantive representation for Blacks (Swain 2006), most racial and ethnic politics scholars have found the opposite to be the case in a wide variety of ways (Canon 1999; Whitby 2000; Tate 2004). Of particular importance, descriptive representation can lead to greater attention to race-based and gender-based interests via agenda-setting, to greater symbolic and substantive outcomes, and to increased minority trust in government, political knowledge, and political efficacy (Bratton and Haynie 1999; Mansbridge 1999; Tate 2004; Bratton et al. 2006; Orey et al. 2006).

Unfortunately, much of the extant literature concerning representation of marginalized groups focuses on one source of marginalization at a time. While a one-dimensional approach to identity can be important for examining the ways in which and degrees to which descriptive representation is essential for groups based on salient political identities such as race, ethnicity, gender, class, sexuality, and so on, this approach can omit important factors and inadvertently hide central findings that are specific to subgroups. Focusing on only one source of identity at a time implicitly treats groups as monolithic, thus leading to the invisibility of entire segments of various populations, such as African Americans and women (King 1988; Crenshaw 1989, 1991; Giddings 1996; Collins 2000; hooks 2000; Cohen 2003; Hancock 2007; Junn and Brown 2008; Purdie-Vaughns and Eibach 2008). Consequently, it is imperative that scholars recognize the importance of taking an intersectional approach to the influence of identity (Gay and Tate 1998; Simien and Clawson 2004; Smooth 2006; Jordan-Zachery 2007; Philpot and Walton Jr. 2007; Simien 2007; Brown 2014b, 2014c). By employing an intersectional approach to the examination of how identity politics influences the U.S. political system, researchers can more appropriately investigate the effects of historical and current sociopolitical hierarchies of White superiority and paternalism on individuals with multiple subordinate identities.

In order to develop a clearer picture of how and why we continue to see a relative lack of descriptive representation for multiply marginalized groups, such as Black women, it is critical to understand how society perceives the individuals from these groups that are most likely to run for office – i.e., elites. Societal perceptions and stereotypes (e.g., bossy, incompetent, strong) can directly

diminish or bolster Black women's chances of being elected. Further, in that Black women are particularly susceptible to the negative influences of colorism in both economic and sociopolitical matters (Herring et al. 2004; Russell-Cole et al. 2013; Norwood 2014), negative perceptions that are tied to darker complexions and which lead to damaging outcomes are likely to bleed over into the ways in which Black women are perceived and evaluated in an electoral context. Given the unique and under-examined influence of colorism on Black women in politics, it is essential to begin to determine whether and the degrees to which variations in the complexion of Black women running for office can influence electoral evaluations and outcomes. As such, there are several questions this chapter will address: How are *elite* Black women perceived in terms of the traits they hold? More specifically, how are Black female *political candidates* perceived regarding the aforementioned trait stereotypes, as well as their ideologies and electability? Are Black female political candidates perceived differently based on variations in their skin tone?

Perceptions, Ideals, and Reality

Gender- and Race-Based Stereotyping

The largest and most significant factor that helps to explain the underrepresentation of Black women in political office is the legacy of the systems of oppression in the United States that are based on race and gender. Throughout the vast majority of the history of the nation, Blacks and women have been considered inferior to White males in practically all realms (Smedley 2001). These narratives of inferiority provided the necessary justification for legal, social, economic, and political discrimination and exclusion of these groups. Although the United States finished dismantling the main *legal* barriers to sociopolitical and economic inclusion for these groups in the mid-twentieth century, changes such as these do not immediately lead to an alteration in societal views concerning groups that have long been deemed inferior. Further, as is the case with Blacks in particular, even once legal barriers to inclusion are broken down, society works to build new ones that help to recreate and perpetuate old narratives of inferiority and justifications for exclusion (as is seen with the progression from slavery to Jim Crow to the system of mass incarceration) (Alexander 2012). Although we do not continue to encounter directly the same degrees of "old-fashioned" racism and sexism concerning biological inferiority of Blacks and women that we have witnessed in previous decades, these old narratives largely have been replaced by new ones that justify negative views and treatment of these groups (Swim et al. 1995; Sears et al. 1997). These new narratives are often tied to American values of egalitarianism and individualism, which can be conceptualized and measured by way of traits such as "hardworking" and "trustworthy." In turn, these narratives lead society to attribute to these groups

stereotypes that suggest they violate core values by way of seeking undeserved preferential treatment (Swim and Cohen 1997; Schuman et al. 1998; Kinder and Mendelberg 2000; Sniderman et al. 2000).

In spite of the fact that old-fashioned sexism and belief in the biological inferiority of women has sharply declined over the past several decades, various stereotypes continue to persist within, and even to be perpetuated by, society. Some of these include the ideas that, particularly as compared to men, women both are and/or should be nurturing, compassionate, passive, warm, dependable, and trustworthy (Huddy and Terkildsen 1993a; Swim et al. 1995; Swim and Cohen 1997). Although the lack of these traits has fewer negative societal consequences for women *now* as compared to previous decades, women who do not express these traits outwardly are considered not to be feminine. Further, modern forms of sexism reflect the idea that gender discrimination no longer exists, which leads to feelings of antagonism toward women that seek more equitable gender standards within society (Swim et al. 1995).

With regard to African Americans, we see a similar progression of the breakdown of old-fashioned racism and the building up of its modern equivalents, in terms of modern racism and racial resentment (Sears et al. 2000). While Blacks are less likely to be viewed overtly as *biologically* inferior to Whites, many of the same stereotypes attributed to this group still remain. These include the idea that Blacks are irresponsible, violent, lazy, unintelligent, and dishonest (Kinder and Sears 1981; Devine and Elliot 1995; Nunnally 2009). As referenced above, these stereotypes persist and are perpetuated by the creation of new systems of oppression that are supported by society, and these stereotypes provide justifications for the new systems. One major difference between gendered and racialized stereotypes is that individuals perceived to not hold these racialized traits are not penalized in the same way women are. On the whole, African Americans that are viewed as "less Black" because they do not clearly reflect the aforementioned traits are perceived more positively than women who are not "feminine." For example, a Black man who is viewed as intelligent and hardworking may be perceived positively and called "a credit to his race" because he does not match the negative societal "Black male" prototype (Schneider 2005); however, the White woman who is neither outwardly nurturing nor passively deferential to her male counterparts does not match society's positive, though limiting, "White female" prototype, and she is likely to suffer for this. Further complicating these issues relating to identity recognition and stereotype ascription is the fact that people from oppressed groups often work to negotiate, compromise, and perform their identities in order to avoid the negative consequences associated with identity group membership (Carbado and Gulati 2000: 1267). This is accomplished by way of counteraction against negative and discriminatory perceptions. Given these opposing directional effects concerning racialized and gendered stereotyping, the ways in which Black women are perceived and affected in the context of social views concerning race and gender is a particularly murky subject.

Toward Examining Perceptions of Black Women

One of the major reasons this is such a "messy" issue, as referred to by Wendy Smooth (2006), is that Black women are viewed not only as Black and not only as women, but also as a separate entity that is specific to the intersection of these two identities, which is multiplicative in nature (Crenshaw 1989; Collins 2000; Hancock 2007; Simien 2007). The practice of viewing and evaluating people based on only one salient dimension of their identity is an insufficient custom, in that it overlooks important complexities of how society perceives people. Instead, it is essential to take an intersectional approach (i.e., examining how multiple axes of subordination interact to influence individuals and groups in society) to understanding identity politics, given that groups at each point of an intersection of salient identities are viewed in specific, differing manners (Gay and Tate 1998; Crenshaw 1989, 1991; Collins 2000; Jordan-Zachery 2007; Simien 2007; Goff et al. 2008; Carew 2012; Brown 2014a). Unfortunately, examinations of stereotyping that are both intersectional and empirical are few and far between (for exceptions, see Gordon and Miller 2005; Carew 2012; Ghavami and Peplau 2013; Gillespie, this volume). Patricia Hill Collins' path breaking research on Black women, first published in 1990, drew on literature regarding controlling images of Black women in order to clearly demonstrate how and for what purposes societal perceptions of this group were constructed, thus leading to her important framework for the current body and direction of Black feminist thought (2000). More recently, Harris-Perry (2013) extended this work to provide an examination of the ways in which the three main traditional Black female controlling stereotype images (Mammy, Jezebel, and Sapphire) continue to be perpetuated in U.S. society presently. Various other studies include empirical examinations of how stereotypes and traits are attributed to Black women at different socioeconomic and political levels in society (Gordon and Miller 2005; Carew 2012; Ghavami and Peplau 2013). Of particular importance, each of these studies demonstrates that women of color are not solely perceived in terms of racial/ethnic stereotypes and gendered stereotypes, but rather, they are perceived as separate groups with unique attributes.

Further complicating the matter of race, gender, and intersectional identity is the issue of colorism – discrimination based on skin tone and physical features as they vary within and among racial groups (Hunter 2007; Weaver 2012). Given the social construction of race in the United States on the basis of the "one-drop rule" – under which varying levels of discernible Black ancestry make an individual Black – African Americans have many different skin complexions (Davis 1991). Rather than differences in skin tone becoming an innocuous feature of racial identity, over time they became the basis for hierarchy in the case of Blackness. Given the connection to Whiteness, more positive meanings became attached to lighter skin tones, while darker skin tones and phenotypic features were attached to more negative attributes and beliefs (Hill 2002; Hunter 2002). This higher valuation of light complexion does not indicate an outright

positive perception of Blacks with this skin tone. Rather, colorism "can operate independently from racism; two people in the same racial group can experience different treatment by complexion while both being subject to discrimination by race" (Weaver 2012: 5). In essence, racism and colorism exist simultaneously. Women are particularly susceptible to the negative effects of differentiation by skin tone, by way of what Hill (2002) refers to as "gendered colorism." Though its effects have diminished slightly over time, skin tone for women of color continues to operate as a form of social capital that can directly influence socio-economic and marital prospects and outcomes (Hill 2002; Hunter 2002; Herring et al. 2004; Russell-Cole et al. 2013). Research that begins to focus on gendered colorism in politics is still in its nascent stages (Hochschild and Weaver 2007; Carew 2012; Brown 2014a).

In spite of the fact that some argue that colorism against African Americans is largely instigated and perpetuated by Blacks themselves (Gullickson 2005), there is reason to believe that Whites recognize significant and subtle complexion differences and ascribe meaning to these differences. The results of a study commissioned by CNN and developed by child psychologist Margaret Beale Spencer demonstrate that while Black children do show a bias in favor of lighter skin tones, White children show an even stronger bias in favor of lighter complexions (Billante and Hadad 2010).[1] This finding is significant in that it demonstrates that from a very early age, Whites recognize subtle differences in skin tone and begin to ascribe meaning to them. In turn, this has sociopolitical ramifications in many areas, such as hiring practices, criminal punishment disparities, and even political outcomes (Wade et al. 2004; Gyimah-Brempong and Price 2006; Weaver 2012).

While there is little known about how variations of the skin tone of African-American political actors influences perceptions of these individuals, Brown (2014a) finds that the complexion of Black female state legislators can be a source of contention and difficulty in the context of the perceptions of other Black female legislators in particular. Terkildsen (1993) and Weaver (2012) find that colorism affects how Whites perceive and react to fictitious Black political candidates. White respondents evaluated candidates with a darker complexion more harshly than they did candidates with lighter complexions, and they favored the latter in terms of electoral choice (Terkildsen 1993; Carew 2012; Weaver 2012). Given the presence of gendered colorism, it is essential to continue examining the electoral effects of discrimination based on complexion in the context of Black female candidates and political actors.

Attribution of Traits and Belief/Ideology Stereotypes to Political Candidates

There are various similarities and differences regarding how women and Blacks are viewed broadly in society and how they are viewed when they are candidates for political office. While voters are increasingly likely to believe that women ought

to be political representatives, they are also likely to perceive women running for office in terms of traits that are not viewed favorably in politics, such as the stereotypes of "passive" and "indecisive" (Leeper 1991; Huddy and Terkildsen 1993b; Carroll 1994; Seltzer et al. 1997; McDermott 1998; Dolan 2005). While female candidates are also viewed in terms of ideal candidate traits such as "honest," "compassionate," and "trustworthy" (Huddy and Terkildsen 1993b; McDermott 1998; Dolan 2005; Schneider and Bos 2014), this is not necessarily enough of a mitigating factor to counteract the non-ideal, anti-leadership, "feminine" traits that voters attribute to female candidates.

Much of the literature concerning Black political candidates assumes that racialized stereotypes are applied to them, but does not carefully walk through the degree to which stereotypes are attributed to this group in conjunction with voter evaluations of the candidates (for exceptions, see Sigelman et al. 1995; McDermott 1998). Given the concept that Black female political actors are a subtype of the larger racial group, it is imperative to determine the degree to which society holds a different set of stereotypes for this group (Schneider and Bos 2011, 2014). Schneider and Bos' (2011) research suggests that Black politicians are viewed as ambitious, charismatic, passionate, empathic, and only concerned about their group's interests. They are also viewed as compassionate toward the poor, though less competent on other issues as compared to other candidates seeking office (Sigelman et al. 1995; McDermott 1998). Additionally, both female and Black political candidates are stereotyped as ideologically liberal in a way that enhances the perception of moderation among conservative candidates and liberal extremism in the midst of a candidate's moderate liberalism (McDermott 1998).

Perceptions Concerning Elite Black Women and Black Female Political Candidates

The field of study concerning women of color as political candidates and officeholders is burgeoning, but it is still in its nascent stages. As referenced above, scholars are increasingly recognizing the importance of employing intersectional frameworks to better understand the influence of salient identities in all areas of political study. Bedolla et al. (2005) provide a focused historical examination of the similarities and differences among women of color in the U.S. Congress over time. Various studies examine voter support for and voter evaluation of women of color at both the candidate and officeholders levels (Philpot and Walton 2007; Gershon 2013). While Black women are the group most likely to support Black female candidates, followed by Black men, White voters are also willing to support Black female candidates that have significant political experience (Philpot and Walton 2007). Gershon (2013) finds that the content, tenor, and frequency of media attention concerning female racial and ethnic minority political candidates can influence voter evaluations.

The concept of divergent stereotype attribution (Schneider and Bos 2011) to various subtypes of a larger group is at the heart of this project, in that Black women are perceived as separate from White women and Black men. This concept also extends into the realm of politics, where it can be presumed that Black female office-seekers are viewed as separate from Black male and White female office-seekers, in spite of their shared racial and gender identities. Unfortunately, just as there is a relative lack of data available on general perceptions regarding Black women, there is also little available on how Black female candidates are perceived and evaluated by voters and the degree to which stereotypes are attached to this group (for exceptions see Gordon and Miller 2005; Carew 2012). Gordon and Miller (2005) find that Black female candidates are viewed as being more competent and knowledgeable about civil rights issues than other candidates, and that they are seen as particularly sophisticated. Carew (2012) finds that elite Black women are subject to racialized and gendered stereotypes, though these stereotypes are applied uniquely to Black women as compared to Black men and White women. Further, Black female political candidates are evaluated more harshly, as well as in a stereotypical manner, in terms of perceptions of their issue competencies, with several variations based on skin color (Carew 2012). For example, a Black female candidate with a darker complexion was only seen as more competent than her opponent in terms of welfare and less competent on ethics, while a Black female candidate with a lighter skin tone was viewed as more competent than her opponent in terms of welfare, civil rights, and ethics. Respondents perceived both of these candidates as less competent regarding the economy, immigration, jobs, and security/military when compared to their opponents (Carew 2012) (see the chapter by Cargile in this volume for an examination of how Latina political candidates are stereotyped in terms of their issue competencies). More work must be conducted in these areas to develop a clearer picture of who the Black female candidate is in the mind of the voter.

The following data and analysis provides an examination of precisely how Black women are perceived, both in general and in terms of their presence and effects in politics. Given the relative dearth of literature and data concerning how voters perceive and apply stereotypes to Black female political candidates, and how/whether this varies with differences in their skin tones, I do not posit any hypotheses for this examination. Rather, this chapter presents empirical data and analysis regarding perceptions of this group. In order to better understand the significance of these data, I test for statistical significance with regard to differences in attitudes and perceptions on a variety of measures specific to the evaluation of elite Black women both in general and as political candidates.

Data

For this project, I utilize data from two separate sources. The first is the 2011 Social Cognition and Evaluation Survey, which allows for the examination of

attitudes regarding elites and "average" groups at the intersection of race and gender.[2] There are very few data available that examine how society applies stereotypes to people at the intersection of multiple salient identities, such as race and gender, and much of the literature concerning the application of stereotypes to political actors implicitly assumes that the stereotypes regarding the general population are the same that are ascribed to elite populations (i.e., those that are most likely to run for office). This dataset allows for the examination of how society views those Black women that are likely to seek political office, while simultaneously allowing for a comparison with other elite groups at the intersection of race and gender. The survey asks respondents to rate both the "average" individual and the "elite" from each of the four aforementioned groups on nine character traits, or stereotypes, that are recognized broadly in the extant literature as applying to at least one of the groups. A 10-point scale (ranging from 1 = "Not at all" to 10 = "Extremely") was used to record respondent ratings, though respondents were able to use a sliding scale that would allow them to place their ratings up to the first decimal point. While the survey provided the opportunity in separate sections for respondents to differentiate their personal views from how they think society perceives these groups, I am only using the "social views" data for this project, as to better avoid social desirability issues.

The second source of data evaluated herein is the 2012 Political Candidate Evaluations and Social Beliefs Survey, which includes mock election data relating to Black female political candidates, differentiated by skin tone.[3] These data allow for a direct, in-depth examination of Black women in an electoral context by way of showing how they are evaluated in comparison to other groups. Within the survey, respondents report their personal political policy area preferences, as well as their ideal political candidate trait preferences. They are then randomly assigned one (1) of three (3) candidate pairings in each of two (2) sets of candidate evaluation/mock primary elections for a U.S. House of Representatives seat. As a result, in both Set 1 and Set 2, subjects are randomly assigned into one of the following election-scenarios: 1) Black female vs. White male, 2) Black female vs. White female, and 3) Black female vs. Black male. The Black female candidate in Set 1 has a light complexion while the Black female in Set 2 has a dark complexion (the order in which respondents encounter these sets is randomized). As such, each respondent engages in two separate mock-elections: one with a dark-skinned Black female candidate and one with a light-skinned Black female candidate. Within each mock election, respondents view photographs and biographies of the two fictitious candidates, whose education, occupation, and political experience levels are roughly equal. By holding constant the attributes of the opponents, I am able to extract the intersectional influence of an opponent's race and gender. Issue positions of the candidates are not provided so as not to directly influence ratings concerning candidates' issue competencies.

Respondents' evaluations allow for an examination of the degree to which stereotypical beliefs regarding candidates' traits, issue competencies, and ideologies/beliefs influence their likelihood of being elected, in the context of their position at the intersection of race and gender. At the end of the survey, respondents provide information regarding their personal political engagement, demographics, and political beliefs. In order to rate both candidate and respondent ideology, subjects placed each candidate on 7-point scales for social and economic issues, with "1" being "liberal" and "7" being "conservative." Examples of social issues provided included abortion, capital punishment, gay marriage, while examples provided for economic issues included tax policy and government spending.

In order to examine whether the attribution of particular characteristics to Black women is unique to this group or is conducted evenly across groups at the intersection of race and gender, I examine the mean scores of respondents' ratings concerning the aforementioned trait stereotypes – e.g., "trustworthy" and "emotional" – as well as belief stereotypes – i.e., social and economic ideologies. In these examinations, I employ difference of means tests (t-tests) to determine whether there is statistically significant variation in the ratings for elite Black women (2011 data) and Black female candidates (2012 data) as compared to White women, Black men, and White men.

Findings and Discussion

Perceptions of Traits of Elite Black Women

Traditional stereotypes concerning Blacks – such as lazy, violent, unintelligent, dishonest, and irresponsible – do not easily fit into societal views regarding either elite Black men or Black women (Schneider and Bos 2011), largely due to the fact that "elite" identity carries with it assumptions and stereotypes that are often positive, such as sociopolitical and economic success by way of hard work and intelligence. Though it may seem that society does not make a huge distinction between and among various elites, these relatively small differences can constitute significant and distinct viewpoints. To facilitate a better understanding of the ways in which elite Black women are viewed as distinct by society, it is necessary to examine how they are perceived as compared to others at the Black/White, female/male identity intersection. In order to examine whether and how stereotypes are applied differentially at the intersection of race and gender, I employ difference of means testing for the stereotype and social/economic ideology ratings of elite Black women as compared to the other three elite groups. If the difference of means for a trait or ideology – such as "compassionate" or "economically liberal" – is statistically significant, then elite Black women are perceived by society as distinct from the comparison group in the context of that trait.

The results of this testing demonstrate that there are many points at which there is a statistically significant difference between elite Black women and other groups when it comes to specific stereotype traits. For example, elite Black women are considered to be more compassionate than all other groups. They are viewed as more bossy and emotional than elite males, thus suggesting an increased application of gendered stereotyping in the context of these traits. Elite Black women are viewed as more hardworking than elite White females, and not significantly less hardworking than elite men. Interestingly, elite Black women are viewed as more trustworthy than elite Whites, with no significant difference as compared to elite Black men. This may suggest that, should African Americans choose to enter politics, they could have an advantage in a political climate where trustworthiness is of the utmost importance to a constituency. Additionally, while Black men are seen as less unethical than Black women, Black women are seen as less unethical than White men. This suggests that elite status for Blacks may actually work to their advantage in terms of issues of ethics and trust. This is a finding that is in direct contrast to traditional racial stereotypes and therefore should be further examined in research concerning the influence of stereotypes on political candidates.

These data paint a relatively rosy picture for the electoral prospects of the subset of Black women that are most likely to make it to the primary election phase for the U.S. House of Representatives, given the perception that this group holds many of the traits of an ideal political candidate. Nevertheless, when it comes to stereotypes regarding the social and economic ideologies of Black women, the data suggest that support for Black women could be quite contingent upon *voter ideology*. The results from the social and economic ideology difference of means tests show that elite Black women are viewed as more liberal than the other three elite groups, though Black men are still rated relatively close to Black women. In this way, it appears that racialized and gendered conceptions of both social and economic ideology are working intersectionally to produce the beliefs that elite Black women are particularly liberal in both areas. These perceptions of elite Black women as more liberal than other groups at the intersection of race and gender can lead to misconceptions regarding any given individual elite Black woman's ideological opinions and policy stances.

Of particular interest is that Black women's social and economic ideological viewpoints are considered to be most different from those held by White men. This suggests that respondents believe that these two groups are particularly far removed from one another when it comes to how they believe sociopolitical and economic matters should be addressed and handled. These assumptions may work in Black women's favor when it comes to liberal voters; however, these women may find less support and more barriers when it comes to conservative voters, even if these candidates, in actuality, are highly conservative. In order to better understand the degree to which these perceptions of potential Black female candidates play out in electoral politics, it is necessary to engage mock election and candidate evaluation data.

Perceptions of Issue Positions and Electability of Black Female Candidates

While it is essential to examine data concerning the stereotyping of elites at the intersection of race and gender, the following mock election and candidate evaluation data will allow for an examination of how intersectional identity influences perceptions when there is an opponent as a point of comparison. These data allow for the determination of the ways in which race, gender, and skin color influence how voters perceive political candidates. Based on difference of means testing of data from the 2012 Political Candidate Evaluation and Social Beliefs Survey, it is apparent that the Black female candidate with a light complexion generally was not rated as distinct from her opponents in terms of the degree to which she holds various positive traits. This result is in line with the concept that Black women with a lighter skin tone are viewed in a more positive vein than those with darker complexions, in that the former on the whole are *not* being rated negatively in the context of candidate evaluations connected to opponents that are not Black women. Nevertheless, while respondents perceived elite Black females as more trustworthy than elite White females in the social cognition study, subjects rated the light-skinned Black female candidate as less trustworthy than her White female opponent in the candidate evaluations. The difference of means between the lighter Black female and the White male, as well as the lighter Black female and the Black male, were not statistically significant. Additionally, respondents rated the lighter Black female candidate as less assertive than the Black male candidate. On the whole, these results demonstrate that voters do not apply trait stereotypes to Black female candidates in ways that are particularly different from how they are applied to others at the intersection of race and gender. At the same time, when considered in the context of the data regarding Black female elites, it appears likely that skin color plays a role in altering how people view Black women, particularly when they are being compared to other individuals running for political office.

A comparison of these results with those pertaining to the Black female candidate with a darker complexion reveals that skin color has a pronounced effect on how Black female political candidates are evaluated as compared to opponents at other points of the intersection of race and gender. The Black female with a darker complexion was rated as more compassionate, cooperative, ethical, and trustworthy than the White male candidate. She was also viewed as more compassionate than the White female candidate and the Black male candidate, and less assertive than the latter. In all, these evaluations place the dark-skinned Black female much closer to the standards for an ideal political candidate (Matland and King 2002; Banducci et al. 2008; Adams et al. 2011). Subjects did not engage in this sort of differentiation in the case of the light-skinned Black woman. It is possible that these results would suggest that people

more generally have high positive opinions of Black female political candidates with darker complexions. Nonetheless, this interpretation appears rather unlikely in the face of the literature demonstrating the negative opinions and socioeconomic outcomes of Blacks with dark skin (Hill 2002; Hunter 2002, 2007; Herring et al. 2004; Russell-Cole et al. 2013). The more appropriate interpretation of these data is that respondents receive a stronger racial cue upon seeing a darker racial hue, and they go out of their way to differentiate their ratings of the darker Black female candidate in a positive direction, especially as compared to the White male candidate. This finding supports similar results in Weaver (2012), in which respondents evaluated the candidate with the darker complexion more positively on certain measures in an election with another Black candidate, all in the context of greater awareness of the issue of race in the study and the subsequent likely interest in providing socially desirable responses.

With regard to belief stereotypes concerning the light-skinned Black female candidate, she is viewed as more liberal than the White male and the Black male on both social and economic issues, while this is only the case in terms of economic ideology when she is running against the White female candidate (Table 7.1). These findings point to the idea that Black women running against men are far more likely to be viewed as liberal on a variety of issues, while there may be more nuanced variation concerning Black female ideological leanings when they compete against White female political candidates. In this way, we can see a more detailed picture of how perceptions regarding Black women running for office form in the context of the subtler racial cue of a light complexion. On the other hand, as Table 7.1 shows, respondents do not suggest that there is a perceived difference between the dark-skinned Black female candidate and the White candidates in terms of either social or economic ideology, though she is

TABLE 7.1 Difference of Means Tests (t-test) of Ideology Compared to Black Female Candidate with Dark and Light Complexions

	White Male	White Female	Black Male
Black Female Candidate with Dark Complexion			
Social	−0.01	−0.30	−0.38**
Economic	0.10	−0.09	−0.25*
Black Female Candidate with Light Complexion			
Social	−0.65***	−0.26	−0.52***
Economic	−0.60***	−0.29*	−0.34**

Source: 2012 Political Candidate Evaluations and Social Beliefs Survey.

Notes
(two-tailed) * $p < 0.10$; ** $p < 0.05$; *** $p < 0.01$.

rated as more liberal than the Black male on both categories. Once again, it appears as though the darker complexion of the Black female candidate brings forward the issue of race in a way such that respondents may be reticent to highlight anything that may appear to be stereotypical in nature.

Given the seemingly more favorable and less extremely ideological ratings of the Black female with the darker complexion, it would appear that she would be favored in terms of her electoral prospects. Nevertheless, precisely the opposite result occurs. Table 7.2 reports the percentages of respondents stating they believed the Black female to be the candidate most electable and likely to win the primary election. The data show that the Black female with the lighter complexion was favored over her opponent, regardless of the race and gender of the other candidate. Conversely, respondents viewed the Black female with the darker complexion as the least electable and likely to win in each iteration of the mock election. These results are in line with Terkildsen's (1993) findings that candidates with darker complexions are electorally disadvantaged. It also mirrors and may help to explain the historical reality of African-American political actors and skin tone. Hochschild and Weaver (2007) observe that light-skinned Blacks traditionally have been overrepresented among African-American elected officials, though this phenomenon has shifted toward increased political success for those with darker complexions over time. Philpot and Walton Jr. (2007) find that Black female political candidates can attract both White and Black voters of all genders, and the results from the current study support their finding in the case of the light-skinned woman. Interestingly, the percentages by which the light Black female was favored in the three elections are relatively equal, with the highest support coming in her contest against the Black male candidate.[4] In contrast, while the darker Black female was viewed as unelectable in all of her elections, she was seen as particularly unlikely to win in contests against White candidates. This further supports the idea that a candidate's darker skin tone can act as a racial cue that leads to more positive, socially acceptable evaluations, but negative, racially based electoral outcomes. Taken all together, these results suggest that voters want to indicate they do not view the Black female with a darker complexion negatively, but they believe society would do so by way of denying electoral support.

TABLE 7.2 Percentage of Respondents Stating Black Female Candidate is More Electable or Likely to Win than Her Opponent, Differentiated by Skin Tone

Black Female (BF)	White Male	White Female	Black Male
Light Complexion	57% (BF win: +14% pts)	56% (BF win: +12% pts)	59% (BF win: +18% pts)
Dark Complexion	30% (BF loss: −40% pts)	25% (BF loss: −50% pts)	41% (BF loss: −18% pts)

Source: 2012 Political Candidate Evaluations and Social Beliefs Survey.

Conclusion

The data in this chapter demonstrate that an intersectional approach to the evaluation of stereotyping reveals significant differences in how various groups, notably, elite Black women, are viewed by the public. These women are viewed as unique in certain circumstances, such as their ability to show compassion, while at other points they are more likely to be viewed in terms of their gender (e.g., emotional state) or race (e.g., trustworthiness). These differences in the application of stereotypes to elites support previous research on stereotypes (Sigelman et al. 1995; McDermott 1998; Schneider and Bos 2011, 2014), and demonstrate the importance of examining political candidate evaluation and electoral prospects in an intersectional light.

This study also demonstrates that the intersectional identity of a Black female candidate's *opponent* can influence how she is perceived. In other words, the degree to which a Black woman is viewed as holding a trait relative to her opponent is contingent upon the race and gender of that opponent. On the whole, voters view Black women as closer to the traits held by ideal political candidates in some contexts – such as being hardworking, trustworthy, and ethical (Matland and King 2002; Banducci et al. 2008; Adams et al. 2011) – and farther away in others – such as being emotional. These differences in both positive and negative political perceptions may help to explain why women of color are driving increasing descriptive representation, all while racial/ethnic minorities and women continue to be descriptively underrepresented (Hardy et al. 2006; CAWP 2015). There is a significant and decided perception that Black women are the most liberal of their counterparts residing at the Black/White, Female/Male identity intersection, which can give them an advantage in the context of Democratic voters, and conversely, a disadvantage in the context of Republican voters. This perception of liberal views of Black women in or seeking political office (and the subsequent expectation of relative advantage in being connected to the Democratic Party, as compared to the Republican Party) is supported in reality, in that Black women holding office are most likely to be affiliated with the Democratic Party (Orey et al. 2006; Brown 2014b). Regardless of any perceptions or realities concerning these candidates, Black women seeking office must work hard to present messages that counter any views that are detrimental to their electoral success in order to overcome stereotypes concerning traits and beliefs. Where they find positive perceptions, they can emphasize these traits to bolster electoral support, and where they find negative perceptions, they can work to demonstrate how those perceptions are not applicable.

Finally, this chapter further validates that colorism exists with electoral politics. Black women with a darker skin tone may have more difficulty in getting elected in a majority-White district as compared to Black women with a lighter skin tone, as demonstrated above whereby the former is *rated* relatively

positively when evaluated, but is highly disadvantaged when it comes to vote choice. The stronger racial cues that are perceived when people see darker complexions appear to activate socially desirable answers to specific questions relating to the *evaluation* of candidates; however, at the point of *choosing* a candidate, the ability to point to other reasons for supporting an opponent removes the need to pointedly demonstrate that one is not making a decision or judgment based on negative race- and gender-based attitudes. It is necessary to examine further other factors, such as perceptions of issue competencies, in order to better understand the differences in electability based on variations in opponent race and gender. The measure used herein – perception of electability and likelihood to win – is important in that it taps into respondents' understandings of how others near them are likely to perceive and lend their support to candidates with specific visible characteristics. Additionally, in the vein of much of the literature concerning the efforts, experiences, realities of, and barriers faced by Black female state legislators (Bratton et al. 2006; Orey et al. 2006; Brown 2014b; Brown and Banks 2014), more empirical and qualitative research should be conducted to determine their experiences with skin tone and whether/how they believe it has influenced their elections and legislative work. Much more research must be conducted in order to fully map the ways in which individuals with multiple subordinate identities are perceived by society, and consequently, how those individuals are then affected by those perceptions in terms of their likelihood of success in seeking political office.

Notes

1 This study was an updated version of the Kenneth and Mamie Clark "Doll Studies" of the 1930s and 1940s, which demonstrated that White and Black children alike almost always selected a White doll to play with, and ascribed positive characteristics to this doll and negative ones to the Black doll (Russell-Cole et al. 2013).
2 This online survey was conducted in August 2011, and it measures the degree to which people attribute various stereotypical traits to four groups at the intersection of race and gender: White females, Black females, White males, and Black males. In order to avoid inadvertently measuring any priming effects from the treatments found within the survey, I only use data from the control group for this project ($n = 101$). Respondents evaluated each group on a panel of nine traits, which consisted of various stereotypes identified in the extant literature as pertaining to women, Blacks, Black women, and ideal political candidates: aggressive, bossy, compassionate, emotional, hardworking, intelligent, irresponsible, trustworthy, and unethical.
3 This online survey experiment was conducted in February 2012 and was designed to investigate the ways in which Black female political candidates are evaluated when directly compared with a political opponent. The 339 respondents constituted a relatively representative United States sample with regard to race, gender, education, income, and geography.
4 One factor that may have contributed to the lighter Black female candidate winning all of her races while the darker Black female lost all of hers and was viewed as unelectable is that the former was a lawyer and the latter was a doctor. While there are many individuals from both fields that enter politics, it is possible that these differences

in occupation directly influenced views of electability. Nevertheless, the fact that there is a great deal of differentiation that occurs solely based on changes in the race and gender of the opponents of the darker Black female demonstrates that the factors need to be examined to a much greater degree than they have been at present.

References

Adams, James, Samuel III Merrill, Elizabeth N. Simas, and Walter J. Stone. 2011. "When Candidates Value Good Character: A Spatial Model with Applications to Congressional Elections." *The Journal of Politics* 73 (1): 17–30.

Alexander, Michelle. 2012. *The New Jim Crow: Mass Incarceration in the Age of Colorblindness*. New York: The New Press.

Banducci, Susan A., Jeffrey A. Karp, Michael Thrasher, and Colin Rallings. 2008. "Ballot Photographs as Cues in Low-Information Elections." *Political Psychology* 29 (6): 903–17.

Bedolla, Lisa Garcia, Katherine Tate, and Janelle Wong. 2005. "Indelible Effects: The Impact of Women of Color in the U.S. Congress." In *Women and Elective Office: Past, Present, and Future*, edited by Clyde Wilcox and Sue Thomas. New York: Oxford University Press.

Billante, Jill, and Chuck Hadad. 2010. "Study: White and Black Children Biased Toward Lighter Skin." *CNN [online]*. May 14, 2010; www.cnn.com/2010/US/05/13/doll.study.

Bratton, Kathleen A., and Kerry L. Haynie. 1999. "Agenda Setting and Legislative Success in State Legislatures: The Effects of Gender and Race." *The Journal of Politics* 61 (3): 658–79.

Bratton, Kathleen A., Kerry L. Haynie, and Beth Reingold. 2006. "Agenda Setting and African American Women in State Legislatures." *Journal of Women, Politics & Policy* 28 (3–4): 71–96.

Brown, Nadia. 2014a. "'It's More than Hair … That's Why You Should Care': The Politics of Appearance for Black Women State Legislators." *Politics, Groups, and Identities* 2 (3): 295–312.

Brown, Nadia. 2014b. *Sisters in the Statehouse: Black Women and Legislative Decision Making*. Oxford; New York: Oxford University Press.

Brown, Nadia. 2014c. "Political Participation of Women of Color: An Intersectional Analysis." *Journal of Women, Politics & Policy* 35 (4): 315–48.

Brown, Nadia, and Kira Hudson Banks. 2014. "Black Women's Agenda Setting in the Maryland State Legislature." *Journal of African American Studies* 18 (2): 164–80.

Canon, David T. 1999. *Race, Redistricting, and Representation: The Unintended Consequences of Black Majority Districts*. Chicago: University of Chicago Press.

Carbado, Devon, and Mitu Gulati. 2000. "Working Identity." *Cornell Law Review* 85 (5): 1259–308.

Carew, Jessica Denyse Johnson. 2012. "'Lifting as We Climb?': The Role of Stereotypes in the Evaluation of Political Candidates at the Intersection of Race and Gender." http://dukespace.lib.duke.edu/dspace/handle/10161/5527.

Carroll, Susan J. 1994. *Women as Candidates in American Politics*. Second Edition. Bloomington: Indiana University Press.

CAWP. 2014. "Fact Sheet: Women of Color in Elective Office: Congress, Statewide, State Legislature." Center for American Women and Politics, Eagleton Institute of Politics, Rutgers University.

CAWP. 2015. "Fact Sheet: Women of Color in Elective Office: Congress, Statewide, State Legislature." Center for American Women and Politics, Eagleton Institute of Politics, Rutgers University.

Cohen, Cathy. 2003. "A Portrait of Continuing Marginality: The Study of Women of Color in American Politics." In *Women and American Politics: New Questions, New Directions*, edited by Susan Carroll. Oxford: Oxford University Press.

Collins, Patricia Hill. 2000. *Black Feminist Thought: Knowledge, Consciousness, and the Politics of Empowerment*. Second Edition. New York: Routledge.

Crenshaw, Kimberle. 1989. "Demarginalizing the Intersection of Race and Sex: A Black Feminist Critique of Antidiscrimination Doctrine, Feminist Theory and Antiracist Politics." *University of Chicago Legal Forum* 1989: 139.

Crenshaw, Kimberle. 1991. "Mapping the Margins: Intersectionality, Identity Politics, and Violence against Women of Color." *Stanford Law Review* 43 (6): 1241–99.

Davis, F. James. 1991. *Who is Black? One Nation's Definition*. University Park: Pennsylvania State University Press.

Devine, Patricia G., and Andrew J. Elliot. 1995. "Are Racial Stereotypes Really Fading? The Princeton Trilogy Revisited." *Personality and Social Psychology Bulletin* 21 (11): 1139–50.

Dolan, Kathleen. 2005. "How the Public Views Women Candidates." In *Women and Elective Office: Past, Present, and Future*, edited by Sue Thomas and Clyde Wilcox. Oxford: Oxford University Press.

Gay, Claudine, and Katherine Tate. 1998. "Doubly Bound: The Impact of Gender and Race on the Politics of Black Women." *Political Psychology* 19 (1): 169–84.

Gershon, Sarah Allen. 2013. "Media Coverage of Minority Congresswomen and Voter Evaluations: Evidence from an Online Experimental Study." *Political Research Quarterly* 66 (3): 702–14.

Ghavami, Negin, and Letitia Anne Peplau. 2013. "An Intersectional Analysis of Gender and Ethnic Stereotypes." *Psychology of Women Quarterly* 37 (1): 113–27.

Giddings, Paula. 1996. *When and Where I Enter: The Impact of Black Women on Race and Sex in America*. New York: W. Morrow.

Goff, Phillip Atiba, Margaret A. Thomas, and Matthew Christian Jackson. 2008. "'Ain't I a Woman?': Towards an Intersectional Approach to Person Perception and Group-Based Harms." *Sex Roles* 59 (5–6): 392–403.

Gordon, Ann, and Jerry L. Miller. 2005. *When Stereotypes Collide: Race/Ethnicity, Gender, and Videostyle in Congressional Campaigns*. New York: Peter Lang International Academic Publishers.

Gullickson, Aaron. 2005. "The Significance of Color Declines: A Re-Analysis of Skin Tone Differentials in Post-Civil Rights America." *Social Forces* 84 (1): 157–80.

Gyimah-Brempong, Kwabena, and Gregory N. Price. 2006. "Crime and Punishment: And Skin Hue Too?" *The American Economic Review* 96 (2): 246–50.

Hancock, Ange-Marie. 2007. "When Multiplication Doesn't Equal Quick Addition: Examining Intersectionality as a Research Paradigm." *Perspectives on Politics* 5 (1): 63–79.

Hardy-Fanta, Carol, Pei-te Lien, Dianne M. Pinderhughes, and Christine Marie Sierra. 2006. "Gender, Race, and Descriptive Representation in the United States: Findings from the Gender and Multicultural Leadership Project." *Journal of Women, Politics & Policy* 28 (3–4): 7–41.

Harris-Perry, Melissa V. 2013. *Sister Citizen: Shame, Stereotypes, and Black Women in America*. Reprint edition. New Haven, CT: Yale University Press.

Herring, Cedric, Hayward Derrick Horton, and Verna Keith. 2004. *Skin Deep: How Race and Complexion Matter in the "Color-Blind" Era.* Urbana: University of Illinois Press: Institute for Research on Race and Public Policy, University of Illinois at Chicago.

Hill, Mark E. 2002. "Skin Color and the Perception of Attractiveness among African Americans: Does Gender Make a Difference?" *Social Psychology Quarterly* 65 (1): 77–91.

Hochschild, Jennifer L., and Vesla Weaver. 2007. "The Skin Color Paradox and the American Racial Order." *Social Forces* 86 (2): 643–70.

hooks, bell. 2000. *Feminist Theory: From Margin to Center.* Second edition. United Kingdom: Pluto Press.

Huddy, Leonie, and Nayda Terkildsen. 1993a. "Gender Stereotypes and the Perception of Male and Female Candidates." *American Journal of Political Science* 37 (1): 119–47.

Huddy, Leonie, and Nayda Terkildsen. 1993b. "The Consequences of Gender Stereotypes for Women Candidates at Different Levels and Types of Office." *Political Research Quarterly* 46 (3): 503–25.

Hunter, Margaret. 2007. "The Persistent Problem of Colorism: Skin Tone, Status, and Inequality." *Sociology Compass* 1 (1): 237–54.

Hunter, Margaret L. 2002. " 'If You're Light You're Alright': Light Skin Color as Social Capital for Women of Color." *Gender & Society* 16 (2): 175–93.

Jordan-Zachery, Julia S. 2007. "Am I a Black Woman or a Woman Who Is Black? A Few Thoughts on the Meaning of Intersectionality." *Politics & Gender* 3 (2): 254–63.

Junn, Jane, and Nadia Brown. 2008. "What Revolution? Incorporating Intersectionality in Women and Politics." In *Political Women and American Democracy*, edited by Christina Wolbrecht, Karen Beckwith, Lisa Baldez. New York: Cambridge University Press.

Kinder, Donald, and Tali Mendelberg. 2000. "Individualism Reconsidered: Principles and Prejudice in Contemporary American Opinion." In *Racialized Politics: The Debate About Racism in America*, edited by David O. Sears, Jim Sidanius, and Lawrence Bobo. Chicago: University of Chicago Press.

Kinder, Donald R., and David O. Sears. 1981. "Prejudice and Politics: Symbolic Racism versus Racial Threats to the Good Life." *Journal of Personality and Social Psychology* 40 (3): 414–31.

King, Deborah. 1988. "Multiple Jeopardy, Multiple Consciousness: The Context of a Black Feminist Ideology." *Signs* 14 (1): 42–72.

Leeper, Mark Stephen. 1991. "The Impact of Prejudice on Female Candidates: An Experimental Look at Voter Inference." *American Politics Research* 19 (2): 248–61.

Mansbridge, Jane. 1999. "Should Blacks Represent Blacks and Women Represent Women? A Contingent 'Yes.' " *The Journal of Politics* 61 (3): 628–57.

Matland, R., and D. King. 2002. "Women as Candidates in Congressional Elections." In *Women Transforming Congress*, edited by C. Rosenthal. Norman: University of Oklahoma Press.

McDermott, Monika L. 1998. "Race and Gender Cues in Low-Information Elections." *Political Research Quarterly* 51 (4): 895–918.

Norwood, Kimberly (ed.). 2014. *Color Matters: Skin Tone Bias and the Myth of a Post-Racial America.* New York: Routledge.

Nunnally, Shayla C. 2009. "Racial Homogenization and Stereotypes Black American College Students' Stereotypes About Racial Groups." *Journal of Black Studies* 40 (2): 252–65.

Orey, Byron D'Andrá, Wendy Smooth, Kimberly S. Adams, and Kisha Harris-Clark. 2006. "Race and Gender Matter: Refining Models of Legislative Policy Making in State Legislatures." *Journal of Women, Politics & Policy* 28 (3–4): 97–119.

Philpot, Tasha S., and Hanes Walton Jr. 2007. "One of Our Own: Black Female Candidates and the Voters Who Support Them." *American Journal of Political Science* 51 (1): 49–62.

Purdie-Vaughns, Valerie, and Richard P. Eibach. 2008. "Intersectional Invisibility: The Distinctive Advantages and Disadvantages of Multiple Subordinate-Group Identities." *Sex Roles* 59 (5–6): 377–91.

Russell-Cole, Kathy, Ronald E. Hall, and Midge Wilson. 2013. *The Color Complex: The Politics of Skin Color in a New Millennium.* Rev. ed. New York: Anchor Books.

Schneider, David J. 2005. *The Psychology of Stereotyping.* New York: The Guilford Press.

Schneider, Monica C., and Angela L. Bos. 2011. "An Exploration of the Content of Stereotypes of Black Politicians." *Political Psychology* 32 (2): 205–33.

Schneider, Monica C., and Angela L. Bos. 2014. "Measuring Stereotypes of Female Politicians." *Political Psychology* 35 (2): 245–66.

Schuman, Howard, Charlotte Steeh, Lawrence D. Bobo, and Maria Krysan. 1998. *Racial Attitudes in America: Trends and Interpretations.* Revised edition. Cambridge, MA: Harvard University Press.

Sears, David O., Colette Van Laar, Mary Carrillo, and Rick Kosterman. 1997. "Is It Really Racism?: The Origins of White Americans' Opposition to Race-Targeted Policies." *The Public Opinion Quarterly* 61 (1): 16–53.

Sears, David O., James Sidanius, and Lawrence Bobo (eds.). 2000. *Racialized Politics: The Debate about Racism in America.* Chicago: University of Chicago Press.

Seltzer, Richard, Melissa Voorhees Leighton, and Jody Newman. 1997. *Sex as a Political Variable: Women as Candidates and Voters in U.S. Elections.* Boulder, CO: Lynne Rienner Publishers.

Sigelman, Carol K., Lee Sigelman, Barbara Walkosz, and Michael Nitz. 1995. "Black Candidates, White Voters: Understanding Racial Bias in Political Perceptions." *American Journal of Political Science* 39 (1): 243–65.

Simien, Evelyn M. 2007. "Doing Intersectionality Research: From Conceptual Issues to Practical Examples." *Politics & Gender* 3 (2): 264–71.

Simien, Evelyn M., and Rosalee A. Clawson. 2004. "The Intersection of Race and Gender: An Examination of Black Feminist Consciousness, Race Consciousness, and Policy Attitudes." *Social Science Quarterly* 85 (3): 793–810.

Smedley, Audrey. 2001. "Social Origins of the Idea of Race." In *Race in 21st Century America*, edited by C. Stokes, T. Melendez, and G. Rhodes-Reed. East Lansing: Michigan States University Press.

Smooth, Wendy. 2006. "Intersectionality in Electoral Politics: A Mess Worth Making." *Politics & Gender* 2 (3): 400–14.

Sniderman, Paul, G. Crosby, and W. Howell. 2000. "The Politics of Race." In *Racialized Politics: The Debate about Racism in America*, edited by David O. Sears, James Sidanius, and Lawrence Bobo. Chicago: University of Chicago Press.

Swain, Carol M. 2006. *Black Faces, Black Interests: The Representation of African Americans in Congress.* Enlarged edition. Lanham, MD: University Press of America.

Swim, Janet K., and Laurie L. Cohen. 1997. "Overt, Covert, and Subtle Sexism." *Psychology of Women Quarterly* 21 (1): 103–18.

Swim, Janet K., Kathryn J. Aikin, Wayne S. Hall, and Barbara A. Hunter. 1995. "Sexism and Racism: Old-Fashioned and Modern Prejudices." *Journal of Personality and Social Psychology* 68 (2): 199–214.

Tate, Katherine. 2004. *Black Faces in the Mirror: African Americans and Their Representatives in the U.S. Congress.* Princeton, NJ; Chichester: Princeton University Press.

Terkildsen, Nayda. 1993. "When White Voters Evaluate Black Candidates: The Processing Implications of Candidate Skin Color, Prejudice, and Self-Monitoring." *American Journal of Political Science* 37 (4): 1032–53.

U.S. Census Bureau, Population Division. 2014. "Annual Estimates of the Resident Population by Sex, Single Year of Age, Race Alone or in Combination, and Hispanic Origin for the United States: April 1, 2010 to July 1, 2014." Release date: June 2015.

Wade, T. Joel, Melanie Judkins Romano, and Leslie Blue. 2004. "The Effect of African American Skin Color on Hiring Preferences." *Journal of Applied Social Psychology* 34 (12): 2550–58.

Weaver, Vesla. 2012. "The Electoral Consequences of Skin Color: The 'Hidden' Side of Race in Politics." *Political Behavior* 34 (1): 159–92.

Whitby, Kenny. 2000. *The Color of Representation: Congressional Behavior and Black Interests.* Michigan: University of Michigan Press.

8

A TULSI BY ANY OTHER NAME

An Analysis of South Asian American Support for a Hindu Congressional Candidate

Shyam K. Sriram

The Case of Tulsi Gabbard[1]

1989 is almost unanimously considered the year that the concept of intersectionality – imagined as a Womanist hometruth as early as the nineteenth century (Rycenga 2005) – came to its *prominence* in a legal studies article by Kimberlé Crenshaw. Her work on black feminist and critical race theories have set the stage for much of the intersectional analysis in political science, including this edited volume. However, Crenshaw (1989) was not the only scholar at the time calling for a focus on viewing the concurrent effects of race and gender, particularly for women of color; the very same year included the publication of *Making Waves*, an early anthology on the experiences of Asian Pacific American women. One particular piece that stands out from that volume is Esther Chow's essay, "The Feminist Movement: Where Are All the Asian American Women?" Chow (1989) called for a re-imagining of feminist discourse to "address the interconnectedness of sex, gender, race, class, and culture," which would, in turn, provide a foundation for Asian American women (373). While she did not explicitly use the term "intersectionality," her reasoning supported the concept: "Asian American women derive their identification and self-esteem from both ethnicity and gender" (Chow 1989, 367).

In the 25-plus years since Crenshaw (1989) and Chow (1989) both spoke of the need for a revolution in how to understand and appreciate the multi-layered and vibrant attitudes and beliefs of women of color, intersectionality and the use of intersectional analysis have both become focal points of discussion and critique under the aegis of political science. According to Shukla (1997), this new evolution of "the political space that embraces gender, sexuality, and transnationality ... can legitimately be called a 'new ethnic politics'" (271). And yet,

while Race and Ethnic Politics (REP) continues to grow as a new subfield of focus in our discipline, Asian American women continue to remain a "a marginalized population within a historically marginalized minority community" (Lien 2001, 198) and a group that is trapped in the "false divisions" of "the black/white paradigms of both feminist and civil rights struggle" (Shah 1997, 545).

In particular, I am fascinated by a unique community *within* a community, the South Asian American diaspora or what Shankar (1998) termed "a part, yet apart" (x). By South Asian Americans, I am referring to immigrants and native-born Americans from the Indian Sub-Continent (India, Pakistan, Sri Lanka, Bangladesh, Nepal, Afghanistan, etc.). Based on the 2010 Census, there are approximately 3.4 million Americans of South Asian descent in the United States with 80 percent of immigrants coming from India, followed by Pakistan, Bangladesh, Nepal, and other countries (SAALT 2012). According to Shankar (1998), "South Asian migration to America has had a different sense of pathos or urgency or conflict associated with it – not brought as laborers, put in camps, not affected by male-only policies" (xii). He continues by saying that "under the *genus* Asian American we may have the *species* of East/Southeast Asian American and South Asian American" (xiii).

While Khagram et al. (2001, 279) surmised over a decade ago that "Asian Indian Americans have not been able to make significant inroads into positions of political authority similar to those made by other Asian American groups," recent elections and scholarship suggest otherwise (Cho and Lad 2004; Sriram et al. 2015). According to the South Asian American Political Activity Database (SAAPAD), 193 men and women of South Asian descent have run for local, state, and federal political office in the United States between 1956 and 2014 (Sriram and grindlife 2014). In that time, the community has elected four members to the U.S. House of Representatives (Dalip Singh Saund – California, 1956; Bobby Jindal – Louisiana, 2004; Hansen Clarke – Michigan, 2010; and Ami Bera – California, 2012) and two governors, Nikki Haley (South Carolina, 2010) and Bobby Jindal (Louisiana, 2008).

What is extraordinary, however, is that *none* of these politicians were Hindu. Recent estimates indicate that there are almost 1.8 million Hindus in the United States, and that 51 percent of Indian-Americans are Hindu (Pew Research Forum 2012; Desilver 2014). While some were born Hindu like Jindal and Bera, who converted to Roman Catholicism and Unitarian Universalism, respectively, one was Sikh (Saund), another a Sikh convert to Methodism (Haley), and one, Clarke, was born in a Christian and Muslim household, but considers himself a practicing Christian (Sriram and grindlife 2014). This all changed in 2012 with the election of Tulsi Gabbard[2] to the U.S. Congress from Hawaii's second congressional district. Gabbard, a captain in the Hawaii National Guard[3], became the first American Samoan elected to Congress, as well as the second female combat veteran after Tammy Duckworth of Illinois.

Gabbard is also Hindu and took her Oath of Office in front of Speaker John Boehner with her left hand resting on a copy of the Bhagavad Gita, the Hindu holy book (Mayani 2014).

Gabbard's election produced an interesting electoral puzzle: How will traditional South Asian American voters respond to a political candidate who is Hindu, but not South Asian? While the research on Asian Pacific Americans is slim, Asian Pacific Americans are more likely than other minorities to support co-ethnics and even cross district, state and party lines to support co-ethnics in an election (Cho 2001, 2002; Sriram et al. 2015). But would Asian Pacific Americans, specifically those of South Asian descent, cross the line, and support a candidate of shared faith, but not of shared ethnicity?

And what of South Asian American women? Will they, as representatives of a diverse set of ethnicities, nationalities, and faiths, support a Hindu candidate who is not from their community of origin? This is a vital question because there is so little we know of the political attitudes of South Asian American women. Outside of broader, group-level examinations of voting, participation, incorporation, and mobilization among Asian Americans as a whole, and Asian American women more specifically, there has been little work on the political attitudes of South Asian American women; to my knowledge, this is the *first* project to contribute to this area. According to Shah (1997, 541), South Asian feminist heritage "consisted of feisty immigrant mothers, ball-breaking grandmothers, Kali worship ... social activist aunts, freedom-fighting/Gandhian great-aunts." What is the South Asian American feminist response to Tulsi Gabbard? Does she speak for South Asian women? Can she speak for Hindu women?

In order to partly examine this question and make an initial attempt at understanding the voting behavior of South Asian American women, I created a survey of political attitudes and beliefs to examine how South Asian American voters, and specifically women, would respond to three, fictional, female candidates for Congress – one Indian-American and Hindu; one Indian-American and Muslim; and one White[4] and Hindu. Using Facebook and email, the survey was sent out using a network sampling technique and collected 104 respondents including 45 women and 59 men. Using simple descriptive statistics and cross tabs, my initial findings suggest in a low-information election that South Asian American voters, particularly Indian-Americans, are far more likely to vote for an Indian-American candidate, regardless of religion, than a White candidate who is Hindu. I found a similar pattern when looking just at female voters.

An Overview of South Asian American Feminism

The South Asian American feminist movement partly owes its origins to the women's movements of the Indian subcontinent, but also due to the common experiences of South Asian immigrant women to the United States. While

women's rights have been a staple of mass protest and mobilization in India even before independence in 1947 (Chaudhuri 1993), two particular events – the 1985 Shah Bano judgment from the Supreme Court of India, and the 1987 Deorala sati case – are considered to be the more recent catalysts for a renewal of feminist inquiry in India in particular. According to Chaudhuri (1993, ix), "Both events brought to the fore the complexity involved in a post-colonial society's travails in modernization and affirmation of its traditional past. India's multi-religious, multi-linguistic, caste, and tribe-based society compounded matters." Feminists have also created a rich, scholarly body of theory in other South Asian nations including Pakistan (Gardezi 1990; Jamal 2005), Bangladesh (Hashmi 2000; Chowdhury 2010), Nepal (Enslin 1990), Sri Lanka (Hyndman and De Alwis 2003, 2004), and Afghanistan (Hirschkind and Mahmood 2002; Choudhury 2007).

The struggles of South Asian immigrant women, particularly around the horrors of domestic abuse and intimate partner violence, provided the impetus for a groundswell of support and the unification of women of different backgrounds in the United States (Vaid 1989; Purvi Shah 1997; Sonia Shah 1997; Shukla 1997, 2003; Bhattacharjee 2012). According to Sonia Shah, South Asian American feminists drew from White feminism and Black feminism, but "neither included our South Asian American agendas – battery of immigrant women, the ghettoization of the Indian community, cultural discrimination, and bicultural history and identity" (1997, 541). Building upon this thought, Purkayastha et al. (1997) believe that the ideologies of South Asian women are not so much contradictory to Western liberal beliefs about women, as they are complementary – they empower because of their difference. Vaid (1989) suggests that South Asian women share problems with South Asian men, women in general, and all Asian immigrant women, but also have unique issues that don't affect everyone else. Shukla (1997) has argued that the South Asian American women's movement has succeeded by "giving life to a feminism that is diasporic, with an international set of reference points, and yet highly localized with respect to actual communities" (269). According to Khandelwal (2003), "South Asian American women's leadership may be distinguished by their efforts to look for new paradigms for defining 'community' and its agenda" (351).

Pakistani, Bangladeshi, Indian, Nepali, and other immigrant women have also created a unique identity by adopting the ethnic identifier "South Asian" and using it to break nationalist, imperialist, and capitalist tendencies to forge a new face for women whose origins were the former British colonies (Shukla 1997, 2003). For Mohanty (1997, 120), "regional differences among those from different South Asian countries are often less relevant than the commonality based on our histories of immigration and our experiences in the U.S." Purvi Shah (1997) has suggested that the moniker "South Asian" works because it "allows progressive workers for social change to bypass national allegiances and claim belonging elsewhere" (53).

Political Candidates and Vote Choice

As the previous section detailed, South Asian American women experience life, political and otherwise, through the crosscutting cleavages of ethnicity, religion, cultural norms, immigration status, and other areas. But, how does this relate to candidates and vote choice? The field of heuristics and cues, particularly in low-information elections, can provide us with an initial template to understand how South Asian American women might evaluate certain candidates. While the literature on Asian American politics is small, it is also rich with scholarship and findings on questions such as how members of this community vote (Cho 1999; Leighley and Vedlitz 1999; Lien et al. 2001; Ramakrishnan 2005; Wong et al. 2011) as well as identification (Lien et al. 2004; Junn and Masuoka 2008). There is also considerable recent work on how, and under what conditions, Asian American voters support co-ethnic candidates (Espiritu 1993; Cho 2001; Lai et al. 2001; Lai and Geron 2006; Collet 2008). More specifically, the concentrated scholarship of Cho (2001) and Cho and Lad (2004) provides the greatest incentive of support in the belief that co-ethnics, through the vehicle of fundraising and campaign contributions, strongly support the candidacies of their own community members. However, in order to understand how South Asian Americans might vote, we can examine the research in a number of other facets related to voters and candidates.

We know from the literature that voters are more likely to support and vote for candidates who are like themselves (Sigelman and Sigelman 1982) and that gender (McDermott 1997) and race (Sigelman et al. 1995; McDermott 1998) all have an effect on voter evaluation of candidates. While there is a substantial literature on low-information cues and voting behavior in the United States, what is less studied is how cues affect voter perceptions of minority candidates, and in particular, female candidates of color. This matters; for example, scholarship indicates that while Blacks and women continue to remain underrepresented in political institutions, the circumstances are one and the same. According to Darcy et al. (1997), "The problem of black underrepresentation cannot ignore the underrepresentation of black women" (449). Further, there are two assumptions that need to be made. The first is that race and sexuality, particularly for women of color, have been linked together for almost two centuries (Mendelberg 2001). Second, knowledge of a candidate's sex is important in an election. According to Dolan (2005), "Implicit in any study of voting for women candidates is the idea that their sex matters, that voters are choosing a *woman* candidate, as opposed to choosing a candidate without any consideration of his or her sex" (53).The inherent problem is a theoretical one: American political parties and institutions still operate from the privileged perspective of White masculinity, while "nonwhite women experience 'gender, class, and racial statuses concurrently'" (Zavella 1988, 202). This means that women of color experience political institutions that are "raced" *and* "gendered," while White women do not (Hawkesworth 2003).

Winter (2008) has also pointed out that while gender and race may be fictional constructions, they are "real psychologically and socially" as "children are socialized very early to recognize and understand the importance of sex and race differences and to act accordingly" (3).

Unfortunately, little work has been accomplished in political science on intersectionality or the ways in which these cues work with and against each other as a sort of multivariate equation.

This vacuum in the literature is of particular concern to communities of color who grapple with political goals, resources, and institutions from multiple perspectives and not just one issue. I take umbrage, for example, with McDermott (1997) who suggests that "candidate gender, unlike other demographic cues, can usually be determined by the candidate's first name" (271). Looking at gender as a "dead giveaway" is an aspect of White privilege; outside of American and European names, distinguishing men's and women's names from each other may prove to be much more difficult. With regards to minority American candidates, race and ethnicity may be much better cues.

Since Lippmann's landmark work (1922), political scientists have focused more and more on the notion of low-information elections and how voters continue to struggle with choosing candidates and depend more and more on "pictures in their heads" as well as "cues" including race, ethnicity, gender, religion, etc. McDermott (2005) has termed these "voter heuristics." One of the first major studies to examine the intersection of race and gender on voter behavior was the work of Philpot and Walton (2007) on Black female candidates. They argued that neither race nor gender could be examined individually in this situation because each affected the other. According to the authors, "gender and race interact to create a separate consciousness whereby race trumps gender but the intersection of the two trumps both" (2007, 49). They also suggest that

> It is important to note that when it comes to examining the electoral prospects of Black female candidates, it is difficult to disentangle the effects of race and gender. For Black women, race and gender do not operate separately from one another.
>
> (2007, 58)

Another recent work looking at the intersection of race and gender on voting behavior was by Matson and Fine (2006). The authors looked at political races for community advising and zoning boards in a Florida county that had little to no media coverage, in an attempt to examine how voters responded in the absence of almost no information about the candidates. Matson and Fine (2006) concluded that voters used gender and names as cues to determine the sex and ethnicity (Hispanic or not) of candidates; as a consequence, "female, non-Hispanic, and high campaign-spending candidates received more votes than did males, Hispanics,

and low campaign-spending candidates, all else being equal" (2006, 50). Further, they determined that negative stereotypes about Hispanics and/or women also hurt some candidates, as voters went with their preconceived notions about the political acumen of those perceived as being Hispanic vs. non-Hispanic, and male versus female.

There is a rich literature on the effects of race and ethnicity[5] on voting behavior and public opinion. Under the aegis of African-American politics alone, scholars have examined everything from Tom Bradley's unsuccessful 1982 bid to become the first Black Governor of California (Citrin et al. 1990) to the perceptions of Black legislators in North Carolina by lobbyists, journalists, and other legislators (Haynie 2002) to effect of skin color and African phenotypes on White voters (Terkildsen 1993; Stokes-Brown 2004; Weaver 2012). Matson and Fine (2006) also argued that ethnicity, in particular Hispanic ethnicity, provided a formidable cue for voters in the Florida elections they studied. The Hispanic or Latino community provides an ideal image to model Asian American voting behavior on because of a wide range of ethnicities represented by the monikers "Latino" and "Asian." According to Manzano and Sanchez (2010, 569), "Latino ethnic attachments are complicated by the group's heterogeneity or nationality, citizenship, language, number of ethnic friends, etc." For Barreto (2012, 25), racial and ethnic identities "provide a psychological foundation for group identification and are central to an intimate sense of peoplehood." The question of Latino identity formation is at the heart of the recent volume by Stokes-Brown (2012) who suggests that a multitude of intersecting factors affect the creation of Latino identity and these individual characteristics cannot be separated. Since each group "has a unique historical and contemporary experience in the U.S.," this is "likely to influence the construction of one's racial identity" (2012, 31).

Although focused on sub-national politics in Africa, Conroy-Krutz's (2013) work deals with the issue of co-ethnicity, which is analogous to ethnic issues in the United States. According to the author, there are multiple explanations for ethnic voting. It could range from social identity theory or "the psychological benefits the individual gains from membership in a particular identity group" to more rationalist beliefs and the "tangible gains" and "collective action" derived from supporting one's own ethnic group (346). According to Conroy-Krutz (2013), the added value of ethnicity in elections is its "potential as a cheap source of political information … at least part of the utility of ethnicity lies in its function as a facilitator of political communication and learning" (346). As such, ethnicity "acts as an informational shortcut, or heuristic, as it provides important cues about competitors' potential preferences and characteristics, at a low cost to the voter" (346).

While infinitesimal compared to the extant studies on race and ethnic identity as cues, the current scholarship on voter perceptions of religion and religiosity provide a partial answer, and template, to my research question. For example, in

their oft-cited work on trait versus belief stereotypes, Huddy and Terkildsen (1993) suggest that religion matters a great deal, especially in low-information elections. According to them, "voters do not need constant exposure to or detailed knowledge of candidate religious identifications to react to them when making their candidate judgments – they just need to have come across the information elsewhere" (1993, 342). While partisanship and party identification have consistently been valued as the most important predictors of voting behavior since Campbell et al. (1960), we also know that citizens' images of parties takes place through the public's view of candidates' social characteristics (Kalkan et al. 2008; Campbell et al. 2009). In a more recent study, Campbell et al. (2011) examined partisan images, candidate religion, and party identification. They determined that religion can condition partisan voting. By manipulating the candidate's religion in an experimental design, the authors found that evangelical candidates received more support from Republicans and less from Democrats, and that identifying as a Catholic had no bearing on voter support. Other work on religious cues has specifically examined voter perceptions of Christian candidates (Wilcox and Jelen 1990; Kellstedt and Green 1993; McDermott 2009), Jewish leaders (Berinsky and Mendelberg 2005), and Muslim politicians (Kalkan et al. 2008; Braman and Sinno 2009). Braman and Sinno's (2009) recent experimental design on voter evaluations of Muslim candidates is among the few studies of non-Christian candidates. The authors examined voter support for a fictional Muslim and a fictional Christian candidate for state attorney general, and U.S. Senator. They determined that individual voter sophistication is correlated to perceptions of Muslims in public office, and that voters have different perceptions of Christian and Muslim candidates, most intriguingly when the potential Muslim attorney general would be prosecuting terrorism cases.

Survey Methodology (see Appendix at www.routledge.com/9781138958845).

The focus of this part of the project was to test how South Asian Americans would evaluate three female candidates for office, in a *female-only* primary race or general election – what Atkeson (2003) called an "intragender contest." The only aspects of the candidates that are being changed in this experiment are their race, ethnicity, and/or religion. A few recent studies have followed this format including experiments on voter evaluations of Black, White, and Latina/o candidates (Gershon and Montforti 2015), and of contests involving *only* female candidates (Morehouse Mendez and Herrick 2011), as well as media coverage of Black women's campaigns for the House of Representatives (Orlanda Ward, this volume), and media coverage and voter evaluation of congresswomen of color (Gershon 2012).

Inspired by other race, ethnicity, and gender surveys (McDermott 1998; Lien et al. 2004), I created a unique, survey-based test to examine how South Asian American voters would evaluate a Hindu candidate for office who was *not* of

South Asian descent. The survey consisted of 13 questions covering demographic information (gender, year of birth, citizenship status); identity (ethnic heritage, religion, and ethnic classification); political knowledge; and, finally, three questions connected to the controlled experiment on voter choice. This resulted in ten explanatory variables and three dependent variables (from the controlled experiment).

This project also focused on gaining the attitudes and behaviors of a wide range of Americans of South Asian descent. Respondents were asked to identify their ethnic heritage and choose from 13 possibilities. The same strategy was also applied to the question on religious affiliation to capture as many of the respondents' religious beliefs as possible. While most South Asian American immigrants are Hindu, Muslim, or Sikh, there are also sizable populations of other faiths in the United States. The question on ethnic classification was of particular interest in order to replicate the results of a similar question from the Pilot National Asian American Political Survey (PNAAPS). In the original survey, respondents were asked to identify as American, Asian American, Asian, ethnic American (e.g., as a Chinese American), or just be ethnic origin (e.g., Chinese).[6]

I created fictional biographies for three congressional candidates. All the candidates – Candidate A, B, and C – were women, and of the same age, marital status, education, and occupation, as well as political experience. Partisanship was never mentioned. The only information that was manipulated in each biographical statement was the race/ethnicity or religion. While this design is unique, its use of fictional candidates in a fictional congressional race does raise questions of external validity, even though this has been the dominant method in the discipline, to date, to examine voter perceptions of candidates. The recent work by Dolan and Lynch (2014) is the best representative of a newer approach to examining this topic. The authors used a two-wave panel survey with respondents in 29 states; the first wave contained questions on gender stereotypes, while the second wave asked respondents questions about their vote choice in *actual* House races in their states.

The literature on Asian American representation and voting allows us to build two hypotheses; namely that respondents are more likely to support co-ethnic candidates, regardless of religion, rather than a candidate from another race or ethnicity. Further, voters are more likely to believe that a South Asian American candidate is not only a better political representative, but also provides a better symbolic representation for the South Asian American community as a whole. As such,

H1: Respondents are more likely to say they will vote for either the Muslim or Hindu Indian-American female candidates than the White, Hindu, female candidate.

H2: Respondents are more likely to believe that the Hindu or Muslim Indian-American female candidates are better representatives of the South Asian American community than the White, Hindu, female candidate.

Survey Delivery

Data were collected relying on an Internet-based survey. Since the target population was small, and this study was unfunded, I borrowed a methodology common in public health known as "network sampling" to reach what scholars have termed "hidden populations" (Spreen and Zwaagstra 1994; Semaan et al. 2002). Through networks of friends via email and Facebook, the survey reached South Asian Americans across the United States and ultimately 107 respondents completed the survey. After three respondents were dropped from the survey due to their data not being recorded, I was left with 104 respondents (45 women and 59 men) ranging in age from 18 to 81. The summary statistics indicate that the average survey respondent was a 44.2-year-old Hindu male of Indian descent who identified as an Indian-American; was registered to vote; was a naturalized citizen of the United States; self-admitted a political knowledge level of 6 on a scale of 0–10; affiliated himself with the Democratic Party; and had lived in the U.S. over 25 years.

Summary of Findings

The results[7] provide evidence that my first hypothesis was supported. Most of the respondents said they would vote for Candidate A, the Hindu Indian-American candidate (58.7 percent) followed by Candidate C, the Muslim Indian-American candidate (26 percent), and lastly Candidate B, the Hindu White candidate (15.4 percent). Taken together, 74 percent of all respondents said they would vote for an Indian-American female candidate, regardless of religion, over the White female candidate. When I looked just at South Asian American women, the findings were somewhat similar. Table 8.1 displays the results: over 90 percent of Hindu female respondents said they would vote for an Indian-American Hindu female candidate; 100 percent of Muslim female respondents pledged their vote to the Indian-American Muslim candidate; and the White Hindu candidate received the least amount of potential vote support across the board (around 8 percent).

The second hypothesis was also supported over which candidate best represents the South Asian community. The results[8] indicate an overall feeling of support for the Hindu Indian-American candidate, who was considered the most representative (69.2 percent), followed by the Muslim Indian-American candidate (22.1 percent), and lastly the Hindu White candidate (8.7 percent). Taken together, an even greater number of respondents believe that the

TABLE 8.1 Candidate Vote Choice (Female Respondents)

Respondent's Religious Affiliation	Candidate A (Hindu/Indian)	Candidate B (Muslim/Indian)	Candidate C (Hindu/White)	Totals
Atheism	0	0	0	0
Buddhism	0	0	1	1
Catholicism	2	0	0	2
Hinduism	20	1	2	23
Hinduism + Other	4	3	1	8
Islam	0	0	9	9
Not Religious	0	0	1	1
Protestantism	1	0	0	1
Sikhism	0	0	0	0
Column Totals	26	4	14	44

Indian-American candidates were more representative of the South Asian community as whole than the White candidate (91.3 percent). The results are similar when we just look at female respondents in the survey (Table 8.2). A little over 90 percent of the Hindu female respondents and 80 percent of the Hindu/mixed respondents believed that the Indian-American Hindu candidate (A) was more representative of the South Asian American community, while 80 percent of the Muslim female respondents expressed support for the Indian-American Muslim candidate (C). A mere 4 percent of all women in the sample believed that the White Hindu candidate could adequately represent the South Asian American community. More broadly, these findings provide substantial support for the argument that Tulsi Gabbard, while highly qualified and a self-identified Hindu, is not viewed as an ideal candidate and representative for South Asian American voters, particularly women.

TABLE 8.2 South Asian Representative (Female Respondents)

Respondent's Religious Affiliation	Candidate A (Hindu/Indian)	Candidate B (Hindu/White)	Candidate C (Muslim/Indian)	Totals
Atheism	0	0	0	0
Buddhism	0	0	1	1
Catholicism	2	0	0	2
Hinduism	20	0	2	22
Hinduism + Other	6	1	1	8
Islam	1	1	8	10
Not Religious	0	0	1	1
Protestantism	1	0	0	1
Sikhism	0	0	0	0
Column Totals	30	2	13	45

Conclusion

In her work on South Asian feminisms, Chandra Mohanty (1997) has remarked that being asked "Where is home?" brings with it a contentious internal struggle for South Asian American women because it begs a simple response to a complex question. According to Mohanty, "Since settled notions of territory, community, geography, and history don't work for us, what does it really mean to be South Asian in the U.S.A.?" (1997, 120). While some work has been accomplished on that front in sociology, history, and literature, political scientists have yet to catch up, and give South Asian American women the respect and attention they deserve.

While the sample size limits the inferences that can be drawn, this study offers a unique look at South Asian American political attitudes, and especially, those of South Asian American women. I believe that this original and exploratory dataset does answer the theoretical questions posed at the beginning of this project – will South Asian American voters support a White woman candidate who is Hindu, and do South Asian American women believe that a woman of similar religious background, but a dissimilar ethnicity, can represent their beliefs? The data suggest not for both questions and the inference I can make is that ethnicity, particularly as a shared solidarity, trumps religion. This is a major finding, particularly in light of historic tensions between Hindus and Muslims in India (Varshney 2003), and in the South Asian diaspora (Kurien 2004). And what of the role of gender? While this chapter provides an overview of South Asian American feminism and some initial quantitative findings on how South Asian American women might respond to a fictional female candidate, there is still so much to be done to understand the role of gender in the political attitude formation of women in this community.

The goals of this project were two-fold – make an argument for the importance of intersectionality and the need for much more scholarship at the nexus of race, ethnicity, religion, and gender in American politics; and frame an original research question regarding voter behavior for a small, but surging political ethnicity in the United States. Can research examine not just how voters perceive female candidates whose race or ethnicity may be different from what is "expected" in current political discourse, but female candidates whose identity as women also intersects with their ethnic and racial identities as Muslims, Hindus, Christians, Jews, Buddhists, Sikhs, and any other faith? Taken another way, how do we, as scholars, perceive women of faith *and* color *in* political science? This question yields an enormous amount of intellectual inquiry because it addresses a vast and gaping hole in political science. According to Lien (2001, 198), "A study of Asian Americans and political participation cannot be complete without addressing the role of women as well as the issue of gender and its intersectionality with race, class, ethnicity, and class." How do information cues work in the context of intersectionality when taken simultaneously? And how should voters perceive candidates of color whose religious preferences

must also be understood as part of their candidacies? This project provides the first step in a continuing and current research agenda to focus on how the South Asian American community responds to female candidates from within and outside of the immigrant community.

Appendix available online at www.routledge.com/9781138958845.

Notes

1 Earlier versions of this chapter were presented at the 2015 Annual Meeting of the Southern Political Science Association, New Orleans, LA and the 2014 Annual Meeting of the Midwest Political Science Association in Chicago, IL. I would like to dedicate this chapter to my mother, Dr. Usha Sriram, and to both my grandmothers, Vasantha Jayaraman and Janaki Krishnan.
2 "Tulsi" is a flowering plant with special significance in Hinduism (Sacirbey 2012).
3 She was promoted to major in October 2015.
4 Rep. Gabbard is biracial (of White and Samoan heritage), but for the purposes of this chapter, the stand-in fictional candidate to mimic voter perceptions of her is a White candidate.
5 Like Conroy-Krutz (2013), I used the definition of ethnicity espoused by Chandra (2006, 398), i.e., "eligibility for membership is determined by attributes associated with, or believed to be associated with, descent."
6 According to Lien et al. (2004, 40), among all the respondents, the most (34 percent) "chose to identify as ethnic American and 30 percent by ethnic identity alone." A similar question was asked by Huang (2009, 15) in an experimental design involving a fictional city council race with Asian American candidates. Fifty-three percent of respondents identified as "Asian-American"; 16 percent as "Ethnic American"; 15 percent by "Ethnic Term Only"; 9 percent as "Asian"; and 7 percent as "American."
7 See Table 8.3 in the appendix.
8 See Table 8.4 in the appendix.

References

Atkeson, Lonna Rae. 2003. "Not All Cues Are Created Equal: The Conditional Impact of Female Candidates on Political Engagement." *Journal of Politics*, 65 (4): 1040–1061.
Barreto, Matt A. 2012. *Ethnic Cues: The Role of Shared Ethnicity in Latino Political Participation*. Ann Arbor, MI: The University of Michigan Press.
Berinsky, Adam J. 1999. "The Two Faces of Public Opinion." *American Journal of Political Science*, 43 (4): 1209–1230.
Berinksy, Adam J. and Tali Mendelberg. 2005. "The Indirect Effects of Discredited Stereotypes in Judgments of Jewish Leaders." *American Journal of Political Science*, 49 (4): 845–864.
Bhattacharjee, Anannya. 2012. "Feminism, Migration, and Labor: Movement Building in a Globalized World." In *South Asian Feminisms*, eds. Ania Loomba and Ritty A. Lukose. Durham, NC: Duke University Press, 117–138.
Braman, Eileen and Abdulkader H. Sinno. 2009. "An Experimental Investigation of Causal Attributions for the Political Behavior of Muslim Candidates: Can a Muslim Represent You?" *Politics and Religion*, 2 (2): 247–276.
Calfano, Brian Robert and Paul A. Djupe. 2009. "God Talk: Religious Cues and Electoral Support." *Political Research Quarterly*, 62 (2): 329–339.

Campbell, Angus, Philip E. Converse, Warren E. Miller, and E. Donald. 1960. *The American Voter*. New York: John Wiley and Sons.

Campbell, David, John C. Green, and Quin Monson. 2009. "Framing Faith: How Voters Respond to Candidates' Religions in the 2008 Presidential Campaign." Presented at the *Annual Meeting of the American Political Science Association*, Toronto, Ontario.

Campbell, David E., John C. Green, and Geoffrey C. Layman. 2011. "The Party Faithful: Partisan Images, Candidate Religion, and the Electoral Impact of Party Identification." *American Journal of Political Science*, 55 (1): 42–58.

Chandra, Kanchan. 2006. "What is Ethnic Identity and Does it Matter?" *Annual Review of Political Science*, 9: 397–424.

Chaudhuri, Maitrayee. 1993. *Indian Women's Movement: Reform and Revival*. New Delhi: Radiant Publishers.

Cho, Wendy K. Tam. 1999. "Naturalization, Socialization, Participation: Immigrants and (Non-) Voting." *Journal of Politics*, 61 (4): 1140–1155.

Cho, Wendy K. Tam. 2001. "Foreshadowing Strategic Pan-Ethnic Politics: Asian American Campaign Finance Activity in Varying Multicultural Contexts." *State Politics & Policy Quarterly*, 1 (3): 273–294.

Cho, Wendy K. Tam. 2002. "Tapping Motives and Dynamics Behind Campaign Contributions: Insights from the Asian American Case." *American Politics Research*, 30 (4): 347–383.

Cho, Wendy K. Tam and Suneet Lad. 2004. "Subcontinental Divide: Asian Indians and Asian American Politics." *American Politics Research*, 32 (3): 239–263.

Chow, Esther Ngan-Ling. 1989. "The Feminist Movement: Where Are All the Asian American Women?" In *Making Waves: An Anthology of Writings By and About Asian American Women*, eds. Asian Women United of California. Boston, MA: Beacon Press.

Chowdhury, Elora Halim. 2010. "Feminism and its 'Other': Representing the 'New Woman' of Bangladesh." *Gender, Place and Culture*, 17 (3): 301–318.

Choudhury, Nusrat. 2007. "Constrained Spaces for Islamic Feminism: Women's Rights and the 2004 Constitution of Afghanistan." *Yale Journal of Law and Feminism*, 19 (1): 155–199.

Citrin, Jack, Donald Phillip Green, and David O. Sears. 1990. "White Reactions to Black Candidates: When Does Race Matter?" *The Public Opinion Quarterly*, 54 (1): 74–96.

Cohen, Cathy J. 2003. "A Portrait of Continuing Marginality: The Study of Women of Color in American Politics." In *Women and American Politics: New Questions, New Directions*, ed. Sue Carroll. New York: Oxford University Press, 190–214.

Collet, Christian. 2008. "Minority Candidates, Alternative Media, and Multiethnic America: Deracialization or Toggling?" *Perspectives on Politics*, 6 (4): 707–728.

Conroy-Krutz, Jeffrey. 2013. "Information and Ethnic Politics in Africa." *British Journal of Political Science*, 43 (2): 345–373.

Crenshaw, Kimberlé. 1989. "Demarginalizing the Intersection of Race and Sex: A Black Feminist Critique of Antidiscrimination Doctrine, Feminist Theory and Antiracist Politics." *The University of Chicago Legal Forum*, 139–168.

Darcy, R., Charles D. Hadley, and Jason F. Kirksey. 1997. "Election Systems and the Representation of Black Women in American State Legislatures." In *Women Transforming Politics: An Alternative Reader*, eds. Cathy J. Cohen, Kathleen B. Jones, and Joan C. Tronto. New York: New York University Press, 447–455.

Desilver, Drew. 2014. "5 Facts About Indian Americans." *Pew Research Center*, September 30. Retrieved May 1, 2015: www.pewresearch.org/fact-tank/2014/09/30/5-facts-about-indian-americans/.

Dolan, Kathleen. 2005. "How the Public Views Women Candidates." In *Women and Elective Office: Past, Present, and Future*, eds. Sue Thomas and Clyde Wilcox. New York: Oxford University Press, 41–59.

Dolan, Kathleen and Timothy Lynch. 2014. "It Takes a Survey: Understanding Gender Stereotypes, Abstract Attitudes, and Voting for Women Candidates." *American Political Research*, 42 (4): 656–676.

Enslin, Elizabeth Mary Winona. 1990. *The Dynamics of Gender, Class and Caste in a Women's Movement in Rural Nepal*. Stanford, CA: Stanford University.

Espiritu, Yen Le. 1993. *Asian American Panethnicity*. Philadelphia: Temple University Press.

Espiritu, Yen Le. 1997. "Race, Class, and Gender in Asian America." In *South Asian Feminisms*, eds. Ania Loomba and Ritty A. Lukose. Durham, NC: Duke University Press, 135–141.

Gardezi, Fauzia. 1990. "Islam, Feminism, and the Women's Movement in Pakistan: 1981–1991." *Comparative Studies of South Asia, Africa and the Middle East*, 10 (2): 18–24.

Gershon, Sarah Allen. 2012. "Media Coverage of Minority Congresswomen and Voter Evaluations: Evidence from an Online Experimental Study." *Political Research Quarterly*, 66 (3): 702–714.

Gershon, Sarah Allen and Jessica Lavariega Montforti. 2015. "The Impact of Race, Gender, and Ethnicity of Candidates on Congressional Elections" (Working paper).

Hashmi, Taj I. 2000. *Women and Islam in Bangladesh: Beyond Subjection and Tyranny*. London: Macmillan.

Hawkesworth, Mary. 2003. "Congressional Enactments of Race-Gender: Toward a Theory of Raced-Gendered Institutions." *American Political Science Review*, 97 (4): 529–550.

Haynie, Kerry L. 2002. "The Color of Their Skin or the Content of Their Behavior? Race and Perceptions of African-American Legislators." *Legislative Studies Quarterly*, 27 (2): 295–314.

Hirschkind, Charles and Saba Mahmood. 2002. "Feminism, the Taliban, and Politics of Counter-Insurgency." *Anthropological Quarterly*, 75 (2): 339–354.

Huang, Taofang. 2009. "Descriptive Representation of Asian Americans: Electing One of Our Own." Presented at the *Annual Meeting of the Midwest Political Science Association*, Chicago.

Huddy, Leonie and Nayda Terkildsen. 1993. "The Consequences of Gender Stereotypes for Women Candidates at Different Levels and Types of Office." *Political Research Quarterly*, 46 (3): 503–525.

Hyndman, Jennifer and Malathi De Alwis. 2003. "Beyond Gender: Towards a Feminist Analysis of Humanitarianism and Development in Sri Lanka." *Women's Studies Quarterly*, 31 (3/4): 212–226.

Hyndman, Jennifer and Malathi De Alwis. 2004. "Bodies, Shrines, and Roads: Violence, (Im)mobility and Displacement in Sri Lanka." *Gender, Place & Culture*, 11 (4): 535–557.

Jamal, Amina. 2005. "Transnational Feminism as Critical Practice: A Reading of Feminist Discourses in Pakistan." *Meridians: Feminism, Race, Transnationalism*, 5 (2): 57–82.

Junn, Jane and Nadia Brown. 2008. "What Revolution? Incorporating Intersectionality in Women and Politics." In *Political Women and American Democracy*, eds. Christina Wolbrecht, Karen Beckwith, and Lisa Baldez. Cambridge, MA: Cambridge University Press, 64–78.

Junn, Jane and Natalia Masuoka. 2008. "Asian American Identity: Shared Racial Status and Political Context." *Perspectives on Politics*, 6 (4): 729–740.

Kalkan, Kerem Ozan, Geoffrey C. Layman, and John C. Green. 2008. "Will Americans Vote for Muslims? The Impact of Religious and Ethnic Identifiers on Candidate Support." Presented at the *Annual Meeting of the American Political Science Association*, Boston.

Kellstedt, Lyman A. and John C. Green. 1993. "Knowing God's Many People: Denominational Preference and Political Behavior." In *Rediscovering the Religious Factor in American Politics*, eds. David C. Leege and Lyman A. Kellstedt. Armonk, NY: M. E. Sharpe, 53–71.

Khagram, Sanjeev, Manish Desai, and Jason Varughese. 2001. "Seen, Rich, but Unheard: The Politics of Asian Indians in the United States." In *Asian Americans and Politics: Perspectives, Experiences, Prospects*, ed. Gordon H. Chang. Washington, D.C.: Woodrow Wilson Center Press, 258–284.

Khandelwal, Madhulika S. 2003. "Opening Spaces: South Asian American Women Leaders in the Late Twentieth Century." In *Asian/Pacific Islander American Women: A Historical Anthology*, eds. Shirley Hune and Gail M. Nomura. New York: New York University Press, 350–364.

Kurien, Prema. 2004. "Multiculturalism, Immigrant Religion, and Diasporic Nationalism: The Development of an American Hinduism." *Social Problems*, 51 (3): 362–385.

Lai, James S. and Kim Geron. 2006. "When Asian Americans Run: The Suburban and Urban Dimensions of Asian American Candidates in California Local Politics." *California Politics and Policy*, 10 (1): 62–88.

Lai, James S., Wendy K. Tam Cho, Thomas P. Kim, and Okiyoshi Takeda. 2001. "Asian Pacific-American Campaigns, Elections, and Elected Officials." *PS: Political Science and Politics*, 34 (3): 611–617.

Leighley, Jan E. and Arnold Vedlitz. 1999. "Race, Ethnicity, and Political Participation: Competing Models and Contrasting Explanations." *Journal of Politics*, 61 (4): 1092–1114.

Lippmann, Walter. 1922. *Public Opinion*. New York: Macmillan.

Lien, Pei-te 2001. *The Making of Asian America Through Political Participation*. Philadelphia, PA: Temple University Press.

Lien, Pei-te, Christian Collet, Janelle Wong, and S. Karthick Ramakrishnan. 2001. "Asian Pacific-American Public Opinion and Political Participation." *PS: Political Science and Politics*, 34 (3): 625–630.

Lien, Pei-te, M. Margaret Conway, and Janelle Wong. 2004. *The Politics of Asian Americans: Diversity and Community*. Routledge: New York.

Manzano, Sylvia and Gabriel R. Sanchez. 2010. "Take One for the Team? Limits of Shared Ethnicity and Candidate Preferences." *Political Research Quarterly*, 63 (3): 560–580.

Matson, Marsha and Terri Susan Fine. 2006. "Gender, Ethnicity and Ballot Information: Ballot Cues in Low-Information Elections." *State Politics & Policy Quarterly*, 6 (1): 49–72.

Mayani, Viren. 2014. "Raising Hindu Pride in America." *Khabar Magazine*, January, 66–74.

McDermott, Monika L. 1997. "Voting Cues in Low-Information Elections: Candidate Gender as a Social Information Variable in Contemporary United States Elections." *American Journal of Political Science*, 41 (1): 270–283.

McDermott, Monika L. 1998. "Race and Gender Cues in Low-Information Elections." *Political Research Quarterly*, 51: 895–918.

McDermott, Monika L. 2005. "Candidate Occupations and Voter Information Shortcuts." *Journal of Politics*, 67 (1): 201–219.

McDermott, Monika L. 2009. "Religious Stereotyping and Voter Support for Evangelical Candidates." *Political Research Quarterly*, 62 (2): 340–354.

Mendelberg, Tali. 2001. *The Race Card: Campaign Strategy, Implicit Messages, and the Norm of Equality*. Princeton, NJ: Princeton University Press.

Mohanty, Chandra Talpade. 1997. "Defining Genealogies: Feminist Reflections on Being South Asian in North America." In *Making More Waves: New Writing by Asian American Women*, eds. Asian Women United of California. Boston, MA: Beacon Press, 119–127.

Morehouse Mendez, Jeanette and Rebecca Herrick. 2011. "Not the Other But the Only: Women Running Against Women." Presented at the *Annual Meeting of the American Political Science Association*, Seattle, WA.

Pew Research Forum. 2012. "The Global Religious Landscape: A Report on the Size and Distribution of the World's Major Religious Groups as of 2010." *The Pew Forum on Religion & Public Life*. Retrieved May 1, 2015: www.pewforum.org/files/2014/01/global-religion-full.pdf.

Philpot, Tasha S. and Hanes Walton, Jr. 2007. "One of Our Own: Black Female Candidates and the Voters Who Support Them." *American Journal of Political Science*, 51 (1): 49–62.

Purkayastha, Bandana, Shyamala Raman, and Kshiteeja Bhide. 1997. "Empowering Women: SNEHA's Multifaceted Activism." In *Dragon Ladies: Asian American Feminists Breathe Fire*, ed. Sonia Shah. Boston, MA: South End Press, 100–107.

Ramakrishnan, S. Karthick. 2005. *Democracy in Immigrant America: Changing Demographics and Political Participation*. Stanford, CA: Stanford University Press.

Rycenga, Jennifer. 2005. "A Greater Awakening: Women's Intellect as a Factor in Early Abolitionist Movements, 1824–1834." *Journal of Feminist Studies in Religion*, 21 (2): 31–59.

SAALT. 2012. "A Demographic Snapshot of South Asians in the United States: July 2012 Update." Retrieved April 30, 2015: http://saalt.org/wp-content/uploads/2012/09/Demographic-Snapshot-Asian-American-Foundation-2012.pdf.

Sacirbey, Omar. 2012. "Tulsi Gabbard, Hawaii Democrat, Poised to be Elected First Hindu in Congress." *The Huffington Post*, November 2. Retrieved March 29, 2014: www.huffingtonpost.com/2012/11/02/tulsi-gabbard-hawaii-democrat-hindu-in-congress_n_2062358.html.

Sanbonmatsu, Kira, 2002. "Gender Stereotypes and Vote Choice." *American Journal of Political Science*, 46 (1): 20–34.

Semaan, Salaam, Jennifer Lauby, and Jon Liebman. 2002. "Street and Network Sampling in Evaluation Studies of HIV Risk-Reduction Interventions." *AIDS Reviews*, 4 (4): 213–223.

Shah, Purvi. 1997. "Redefining the Home: How Community Elites Silence Feminist Activism." In *Dragon Ladies: Asian American Feminists Breathe Fire*, ed. Sonia Shah. Boston, MA: South End Press, 46–56.

Shah, Sonia. 1997. "Presenting the Blue Goddess: Toward a National Pan-Asian Feminist Agenda." In *Women Transforming Politics: An Alternative Reader*, eds. Cathy J. Cohen, Kathleen B. Jones, and Joan C. Tronto. New York: New York Press, 541–548.

Shankar, Rajiv. 1998. "Foreword: South Asian Identity in Asian America." In *A Part, Yet Apart: South Asians in Asian America*, eds. Lavina Dhingra Shankar and Rajini Srikanth. Philadelphia, PA: Temple University Press, ix–xv.

Shukla, Sandhya. 1997. "Feminisms of the Diaspora Both Local and Global." In *Women Transforming Politics: An Alternative Reader*, eds. Cathy J. Cohen, Kathleen B. Jones, and Joan C. Tronto. New York: New York Press, 269–283.

Shukla, Sandhya. 2003. *India Abroad: Diasporic Cultures of Postwar America and England*. Princeton, NJ: Princeton University Press.

Sigelman, Carol K., Lee Sigelman, Barbara J. Walkosz, and Michael Nitz. 1995. "Black Candidates, White Voters: Understanding Racial Bias in Political Perceptions." *American Journal of Political Science*, 39: 243–265.

Sigelman, Lee and Carol K. Sigelman. 1982. "Sexism, Racism and Ageism in Voting Behavior: An Experimental Analysis." *Social Psychology Quarterly*, 45: 263–269.

Spreen, Marinus and Ronald Zwaagstra. 1994. "Personal Network Sampling, Outdegree Analysis and Multilevel Analysis: Introducing the Network Concept in Studies of Hidden Populations." *International Sociology*, 9 (4): 475–491.

Sriram, Shyam and stonegarden grindlife. 2014. "The Choices They Make: Ethnicity, Nicknames and the Representation Tactics of South Asian American Candidates for Office" (Working paper).

Sriram, Shyam K., stonegarden grindlife, and James Lai. 2015. "Honda and Khanna Go to White Castle: An Analysis of Campaign Contributions and Media Framing in a California Congressional Race" (Working paper).

Stokes-Brown, Atiya Kai. 2004. "Candidate Race, White Crossover Voting, and Issue Strategy in State Legislative Elections." Presented at the *Annual Meeting of the Southern Political Science Association*, New Orleans.

Stokes-Brown, Atiya Kai. 2012. *The Politics of Race in Latino Communities: Walking the Color Line*. New York: Routledge.

Terkildsen, Nadia. 1993. "When White Voters Evaluate Black Candidates: The Processing Implications of Candidate Skin Color, Prejudice and Self-Monitoring." *American Journal of Political Science*, 37 (4): 1032–1053.

Vaid, Jyotsna. 1989. "Seeking a Voice: South Asian Women's Groups in North America." In *Making Waves: An Anthology of Writings By and About Asian American Women*, eds. Asian Women United of California. Boston, MA: Beacon Press.

Varshney, Ashutosh. 2003. *Ethnic Conflict and Civic Life: Hindus and Muslims in India*. New Haven, CT: Yale University Press.

Wald, Kenneth D. and Allison Calhoun-Brown. 2014. *Religion and Politics in the United States*. Lanham, MD: Rowman & Littlefield.

Weaver, Vesla M. 2012. "The Electoral Consequences of Skin Color: The 'Hidden' Side of Race in Politics." *Political Behavior*, 34 (1): 159–192.

Wilcox, Clyde and Ted Jelen. 1990. "Evangelicals and Political Tolerance." *American Politics Research*, 18 (1): 25–46.

Winter, Nicholas. 2008. *Dangerous Frames: How Ideas About Race and Gender Shape Public Opinion*. Chicago, IL: University of Chicago Press.

Wong, Janelle, S. Karthick Ramakrishnan, Taeku Lee, and Jane Junn. 2011. *Asian American Political Participation: Emerging Constituents and Their Political Identities*. New York: Russell Sage Foundation.

Zavella, Patricia. 1988. "The Politics of Race and Gender: Organizing Cannery Workers in Northern California." In *Women and the Politics of Empowerment*, eds. Ann Boakman and Sandra Morgen. Philadelphia, PA: Temple University Press, 202–224.

9

LATINA ISSUES

An Analysis of the Policy Issue Competencies of Latina Candidates

Ivy A. M. Cargile

Introduction

The 2014-midterm elections had interesting results for Latinos. Not only did Latinos increase their number of elected officials to a little over 6000 across the U.S., but we also saw them elected to states, such as Alaska, where Latinos have not previously held elected office (NALEO, 2014). Yet, the overall numbers of Latino elected officials (particularly Latinas) still remain low. On the whole, Latinos make up 3 percent of national and statewide offices but Latinas only make up 1.7 percent of nationally elected leaders and 1.3 percent of state level officials (NALEO, 2014; Latinas Represent, 2015). In order to achieve a more representative government, it is necessary to understand how to increase the number of Latina elected officials. Particularly, it is key to be aware of how voters perceive Latinas as political candidates in regards to the stereotypes they attach to them. The goal of this chapter is to gain a clearer understanding of which policy issues Latina candidates are stereotyped as competent in handling.

Existing literature indicates that as a result of trait-based stereotypes that are attributed to female and male candidates there are also policy issues that each is perceived as competent in handling (Lawless, 2004; Meeks, 2012). For example, female candidates are perceived as competent in handling issues of health care and assisting the poor while males are seen as better able to handle issues such as tax policy and the military (Huddy and Terkildsen, 1993b; Lawless, 2004; Banwart, 2010). What this body of research seems to be missing is how the gender and race/ethnicity of a candidate intersect and influence attributions of the candidate's issue competencies. A survey of the literature indicates that much of the current scholarship that addresses gender

and issue stereotypes tends to analyze the White female candidate (Huddy and Terkildsen, 1993a; Matson and Fine, 2006; Fowler and Lawless, 2009; Banwart, 2010; Hogan, 2010; Burns et al., 2013).

Through the use of data from an on-line survey experiment, I explore how a Latina candidate is stereotyped on several policy issues. Respondents were randomly assigned to one of five candidate types and asked a battery of questions on different issue competencies. The hypothetical candidates consisted of racial or ethnic (white or Latino) and biological sex (male or female) combinations. Therefore, respondents were asked to evaluate one of five candidate types: a male candidate, a White candidate, a female candidate, a Latino candidate, or a Latina candidate. The ability to make comparisons across these different hypothetical candidates will provide insight into how Latinas running for office may be stereotyped. I will be able to address questions regarding how a Latina candidate will be stereotyped on feminine policy issues, masculine policy issues, and minority policy issues such as racial discrimination and immigration. Lastly, I will also be able to analyze if there is a difference in candidate stereotyping based on the respondent's race/ethnicity (Latino/not Latino).[1]

Female Candidate Stereotyping

In elections, gender continues to be a voting cue for many voters (Popkin, 1991; McDermott, 1998; Matson and Fine, 2006). It is found that a candidate's gender, including sex-linked roles, influences the types of character traits and belief-based traits that voters stereotype a candidate as possessing. This in turn affects the kinds of policy issues that a candidate is considered competent in handling (Huddy and Terkildsen, 1993a; Sanbonmatsu, 2002; Gordon et al., 2003; King and Matland, 2003; Kenski and Falk, 2004; Hogan, 2010; Hayes, 2011; Meeks, 2012; Schneider, 2014). For example, because women are perceived as the warmer sex and are mothers, female candidates are said to be competent on issues of education. Since men are perceived to be the assertive sex and are often the heads of house, they are therefore seen as competent on the issue of national defense. This relationship, between gender stereotyping and issue competencies, is important since for many voters, a male candidate continues to be the baseline preference, in particular for higher-level political offices (Sanbonmatsu, 2002).

We can trace the origin of perceived issue competencies to the use of trait-based stereotypes, which occur when voters make assumptions about a candidate based on their gender-linked personality traits. In addition to stereotypes based on traits, voters also employ belief-based stereotyping, which emphasizes the differing political outlooks of male and female candidates (Huddy and Terkildsen, 1993a). Moreover, there is a perception of female candidates as empathetic, thus more ideologically liberal (McDermott, 1998; Fridkin et al., 2009; Hayes, 2011; Schneider and Bos, 2013). Males are stereotyped as tough,

leading voters to believe that male candidates are more conservative (Winter, 2010; Hayes, 2011). What is left out of current research is the influence of a female candidate's race/ethnicity.

Stereotyping African American and Latino Candidates

Turning our attention to race/ethnicity-based scholarship, only a few scholars have analyzed the influence of race and ethnicity on candidate stereotyping. Sigelman et al. (1995) have found that both African American and Latino candidates are perceived as more compassionate relative to the White candidate (Sigelman et al., 1995). Unfortunately, this study does not ask about policy issues or disaggregate by gender. However, McDermott (1998) has found that African American candidates were thought to be more capable of handling poverty as well as minority issues. Perhaps, voters are stereotyping African American candidates based on what they think the candidate or members from the candidate's community have experienced. Unfortunately, McDermott's study only analyzes stereotypes regarding African American candidates but not Latinos, and she does not disaggregate by gender. Therefore, we are not clear about the influence that the intersection of gender and race or ethnicity may have on these kinds of issues.

While research has not necessarily analyzed the role of stereotypes regarding Latino/a candidates, some have looked at the experience of these candidates, particularly Latinas. For instance, Matson and Fine (2006) found that Latino candidates were advantaged in the majority-minority areas. When they disaggregated by gender to see if Latina and Latino candidates were advantaged similarly, they found that the Latina was the candidate with the smallest vote share, indicating the least amount of support (Matson and Fine, 2006). Likewise, in a study on media framing of African American, Latina, and White congresswomen, Gershon (2012) found that Latinas receive the least amount of media coverage and when they do receive coverage, it is highly connected to immigration. This, in turn, results in lower voter support for the Latina congresswoman (Gershon, 2012). These findings point to the Latina not being a strong candidate, which is in juxtaposition to other scholars who have found these candidates to be advantaged due to their ability to secure support from a wider array of voters, as well as running in electorally favorable areas (Bejarano, 2013, and see her chapter in this volume). Furthermore, it is not clear why the Latina candidate is not always advantaged. This is the gap this chapter seeks to fill.

Influence of Latino Respondents

As we consider how gender stereotyping and issue competencies function for Latina candidates, bearing in mind who is evaluating them also matters. It has been previously established that Latinas are quite successful in majority-minority

districts or in electoral areas that have a substantial percentage of Latinos (Barreto et al., 2004; Fraga et al., 2006; Casellas, 2011; Bejarano, 2013 and see her chapter in this volume). This could lead one to assume that amongst a group of respondents who identify as Latino, they might stereotype her in a more positive and favorable manner that will not hurt her candidacy when compared to respondents who are non-Latinos. As Schneider (2014) posits, when the level of office and the perceptions of the candidate align in the mind of the voter, stereotyping can have favorable outcomes.

Furthermore, I explore how issue competencies function for a Latina candidate. Bejarano (2013) finds Latina candidates do have electoral advantages but we do not know if these advantages come as a result of candidate evaluations. I argue that stereotypes about a Latina candidate and the policy issues she is perceived as competent in will be influenced by the intersection of gender and the ethnicity that she represents.

Expectations about Latina Candidates

Due to her gender and ethnicity, my first hypothesis is that a Latina candidate will be doubly advantaged. Since the Latina candidate is female, voters will be more likely to attribute feminine policy issues to her as they might do to any other female candidate (Larson, 2001; Banwart, 2010; Meeks, 2012). I posit that the Latina candidate will also benefit from her ethnicity. Sigelman et al. (1995) found that a hypothetical Latino candidate is stereotyped as compassionate, which is a feminine trait. Considering that trait-based stereotypes lead to issue competency stereotypes I expect that both Latino and Latina candidates will be perceived as competent on feminine issues. A Latina candidate will be doubly advantaged because she represents the intersection of gender and ethnicity resulting in her being perceived as more competent on feminine issues. Therefore, I hypothesize the following:

> **H1:** *The Latina candidate will benefit from the intersection of gender and ethnicity and therefore will be stereotyped more positively on feminine policy issues relative to a male, white, female, or Latino candidate.*

Regarding masculine policy issues, this is an area where female candidates tend to be assessed negatively (Huddy and Terkildsen, 1993a; Lawless, 2004). Policy issues such as tax policy, or terrorism, are those which voters continuously say male candidates are better able to handle, especially in a post 9/11 society (Lawless, 2004; Dolan, 2009; Brooks, 2013). Male candidates are not only seen as better able to deal with masculine issues, but scholars have found that men are preferred when it comes to these issues (Sanbonmatsu, 2002; Banwart, 2010). Therefore, I expect

that a Latina candidate will be disadvantaged because of her gender when evaluated on masculine issues. As previously noted, Latinos are perceived as more compassionate but we do not know if these findings hold if Latino candidates are disaggregated by gender (Sigelman et al., 1995). If they do this can cause the Latina candidate to be perceived as weak on masculine issues. In other words, when thinking about masculine policy issues, a Latina candidate may not be advantaged because she has two characteristics, gender and ethnicity, working against her. Consequently, I posit the following hypothesis:

> **H2:** *Latina candidates will be assessed more negatively in relation to masculine policy issues than are male, white, female, or Latino candidates.*

If McDermott (1998) found that African American candidates are perceived as competent on poverty and minority issues it is possible that immigration and racial discrimination may function similarly for Latina candidates. Particularly, because both of these are issues the Latino community continues to face. For instance, the issue of immigration, which is constantly in the news, continues to rank as one of the top five political issues for Latinos (Lopez and Gonzalez-Barrera, 2013). Consequently, because of continued negative rhetoric over immigration as well as harsh anti-immigration legislation, the Pew Research Hispanic Trends Project (Lopez et al., 2010) finds that six in ten Latinos think discrimination remains a major problem for their community.

A recent poll suggests that one in three non-Latino Americans thinks that more than half of Latinos in the U.S. are undocumented; further suggesting that this is an issue a Latina candidate will have to address (Barreto et al., 2012). Immigration is a policy issue that remains highly linked to the Latino community resulting in a necessity to understand how a Latina candidate is stereotyped on this policy. In regards to racial discrimination, as noted above for 61 percent of Latinos, this issue continues to be a problem that afflicts the community (Lopez et al., 2010). It is an issue that Latinos experience in different parts of their lives such as employment, education, and even in the area of housing (Pager and Shepard, 2008). Since the issue of racial discrimination persists for Latinos, it is necessary to know if a Latina candidate is perceived as competent in its handling.

Regarding immigration and racial discrimination, I posit that the Latina candidate will also be advantaged by her gender. Both of these issues are of the types that require lawmakers to be empathetic and compassionate. These are traits usually associated with female candidates (Alexander and Andersen, 1993; McDermott, 1997; Larson, 2001). Moreover, a Latina candidate is advantaged because of her gender and ethnicity as they relate to these issues. So, regarding minority issues I argue the following:

H3: *Latina candidates are going to be more competent in handling minority rights issues than are male, white, female, or Latino candidates.*

Lastly, I argue that who is evaluating the Latina candidate matters in terms of whether the gender stereotyping of issue competencies will be positive and favorable or negative. Gender is a characteristic that cuts across all racial and ethnic groups, but opinions regarding women's involvement in domains that have been primarily male oriented, such as politics, are not always clear. It is possible that non-Latinos and members of the Latino community have different perspectives regarding their presence in politics. If this is the case, then any kind of evaluation that they engage in regarding a Latina candidate will be influenced. For those from the Latino community, it may be that those who have experienced discrimination may be more sensitive to stereotypes because of a shared sense of unequal treatment (Masuoka, 2006). Therefore, it is possible that members from the Latino community have a sense of pan-ethnicity that could result in supportive stereotyping of a Latina candidate. In other words, because members of the Latino community share a history of discrimination and unequal treatment, they may be more inclined to support a fellow co-ethnic. Accordingly, Latinos may be less likely to apply negative stereotypes and instead perceive Latina candidates in a more positive manner. As a result my last hypothesis states the following:

H4: *Latino respondents will be more likely to assess a Latina candidate positively on all policy issues when compared to non-Latino respondents.*

Data and Methods

To test my hypotheses, an on-line experimental survey was conducted during the summer of 2012 using the internet-based research firm YouGov. YouGov provided a nationally representative sample, as well as an oversample of Latinos. It is important to note that the sample of Latinos used in this analysis consists of those who are predominantly English speaking. As of the time that this survey was conducted, YouGov did not have a sample of Latinos who are primarily Spanish speakers. While there is a value in including the opinions of those whose primary language is Spanish, existing surveys that have been partially conducted in Spanish, such as the Latino National Survey, do not have questions that address evaluations of Latinas as political candidates.

To refresh, each participant was randomly assigned to evaluate one of five candidates: a male candidate, a White candidate, a female, a Latino, or a Latina

candidate. The benefit of using this approach where respondents are randomly assigned to one of five conditions is the ability to compare between the Latina candidate and the other four candidate types. After answering some basic demographic questions, respondents were introduced to the candidate type they would be evaluating. Respondents saw which of the five candidates they were randomly assigned in the first question in the sequence battery of policy issue questions they were asked. To be clear, the only information participants received regarding the candidate they would be evaluating is the candidate's gender and race/ethnicity. The reason for only providing respondents with a candidate's gender and race/ethnicity is because I wanted to establish a baseline regarding how a Latina candidate is perceived. Previous scholarship finds that male candidates continue to be the standard choice for voters (Sanbonmatsu, 2002). Consequently, it is not yet clear in the established research how voters stereotype a Latina candidate. Thus, the methodological design I employ here will offer insight into perceptions voters hold of Latina candidates and then allow me to compare these with perceptions of other candidate types. Overall, the goal is to gain some idea of how a Latina candidate may perform against different types of candidates during an election.

Respondents were asked about the following feminine issues: education, assisting the poor, reproductive health, and health care. They were also asked about masculine issues: economy, foreign affairs, crime and public safety, and national security. Lastly, they were also asked about minority issues such as immigration and racial discrimination. Below is the actual question participants received.

> We would now like you to evaluate this candidate along the dimension of policy issues. What is your best guess about a (Insert Randomized Candidate: Male, Female, Latino, White, or Latina) candidate's competence in handling the following issues?

Some of the treatments do not have a race/ethnicity or gender assignation because I wanted to be able to compare responses about a Latina candidate against baselines established in previous research (e.g., Alexander and Andersen, 1993; Huddy and Terkildsen, 1993a; Sanbonmatsu, 2002; Fox and Oxley, 2003; Dolan, 2009; Banwart, 2010).

Of the 1300 respondents, 52 percent are female and 48 percent are male. This is similar to the national breakdown as reported by the U.S. Census (Humes et al., 2011). With respect to race and ethnicity, 61 percent identify as white, 24 percent as Latino, 9.5 percent as African American, and 5.5 percent identify as another undisclosed race/ethnicity. These percentages are not exactly representative of the national population because of the intentional over-sample of Latinos. The average age of participants is 47 years old. Regarding party identification, 46 percent of respondents identify as Democrat, 37 percent

identify as Republican, and 15 percent identify as Independent. Ideologically, the average participant describes herself as a moderate conservative. Lastly, the average participant indicated that they earn between $40,000 and $60,000 a year, which is similar to the national population who reports an average income of $51,000 (DeNavas-Walt et al., 2013). Turning to the respondent distribution across each candidate type, it is as follows: *white candidate* (*n* = 257), *male candidate* (*n* = 270), *female candidate* (*n* = 269), *Latino candidate* (*n* = 260), and *Latina candidate* (*n* = 244).

Results

In the following sections, I discuss my measures and findings. As is appropriate for an experimental design, I conducted difference in means tests in order to see if there are any significant differences in stereotyping of Latina candidates relative to other candidates. I am also able to examine if stereotypes differ between Latino respondents and non-Latino respondents. I consider a stereotype to be present if there is a significant p-value for the stated mean for any given policy issue across experimental conditions. The objective is to assess what significant differences exist between the mean responses for the Latina candidate, on any given issue, versus another candidate type such as the male or the White candidate. In order to establish significance *t*-tests were conducted. This is consistent with how previous studies analyze gender and racial/ethnic stereotypes (Huddy and Terkildsen, 1993a; Sigelman et al., 1995; McDermott, 1998; Banwart, 2010).

The policy issues respondents were asked about for this chapter are those which reflect previous questions in studies of gender stereotyping (Huddy and Terkildsen, 1993a; Herrnson et al., 2003; Lawless, 2004; Meeks, 2012; Dolan, 2013). Specifically, respondents were asked to evaluate the candidate that they were randomly assigned on feminine, masculine, and minority policy issues. Respondents were asked to evaluate the level of competency that they attributed to the candidate from a scale of 1 to 6 where 1 = very incompetent; 2 = incompetent; 3 = somewhat incompetent; 4 = somewhat competent; 5 = competent; 6 = very competent.

Feminine Issues

First, I will review the difference of means results for the feminine policy issues. In Table 9.1, I present the mean values for the difference of means tests for the feminine policy issues.[2] Again, my expectation regarding feminine policy issues is that the Latina candidate is going to be doubly advantaged by her gender and ethnicity. I also expect that on feminine issues Latino respondents will stereotype the Latina candidate more positively.

If we turn to Table 9.1 we can see the mean responses for each candidate by both Latino and non-Latino respondent. Turning to responses by non-Latino

respondents, the results indicate that the Latina candidate is rated significantly higher than the male candidate on all four issues (education, assisting the poor, reproductive health, and health care) (Huddy and Terkildsen, 1993a; Sanbonmatsu, 2002; Dolan, 2009). This is in line with my expectations that due to her gender the Latina candidate would be perceived as better able to handle these issues as opposed to the male candidate. Regarding the White candidate, it is only on the issue of assisting the poor that the Latina candidate is stereotyped as significantly higher. For the remaining three issues, there is no significant difference between the two candidates.

Looking at the mean difference between the Latina, female, and Latino candidates the results are mixed. Table 9.1 demonstrates that non-Latinos perceive a significant difference between the female and Latina candidate. Specifically, they stereotype the female candidate as significantly more competent than the Latina on all four feminine issues. We can see that the biggest difference is regarding the issue of education. The female candidate is also stereotyped as significantly more competent than the White and Latino candidates on all issues. These findings confirm previous results demonstrating the female candidate as the most competent on feminine issues (Alexander and Andersen, 1993; Kahn, 1996; Sanbonmatsu, 2002; Dolan, 2009). Turning to the comparison between the Latino and Latina candidates, non-Latinos stereotype both as similarly competent on all feminine issues. There is no significant difference between the Latino candidate relative to the Latina candidate.

For the sample of Latino respondents, I expect they will stereotype the Latina candidate more favorably when compared with non-Latinos. Starting with the comparison between the Latina candidate and the male candidate, Table 9.1 indicates that the Latina candidate is rated higher on all of the feminine issues. However, the differences are only significant for two issues, those of assisting the poor and reproductive health. Thus, indicating that for the rest of the issues Latinos do not sense a difference between the two candidates. When compared to the White candidate, Latino respondents perceive the Latina candidate as significantly more competent on all issues. The data indicate that Latino respondents are slightly different than non-Latinos in that the former perceive the Latina candidate as significantly more competent on feminine issues when she is compared to the male and White candidates.

Regarding the female and Latino candidates, we can see that the results differ between Latino and non-Latino respondents. Latino respondents do not necessarily stereotype the female candidate as the most competent on feminine issues. Table 9.1 indicates that there is a difference between the Latina and female candidate on the issue of health care and the difference is significant. Looking over the remainder of the issues, we can see that Latino respondents stereotype both the female and Latina candidates similarly since there are no significant differences. Similarly to the non-Latino respondent sample, Latinos do not see any significant differences between the Latino and Latina candidates on these issues.

TABLE 9.1 Mean Values for Feminine Issues Across Conditions by Latino and Non-Latino Respondents

	Latina Candidate (Latino)	Latina Candidate (Non-Latino)	Latino Candidate (Latino)	Latino Candidate (Non-Latino)	Female Candidate (Latino)	Female Candidate (Non-Latino)	Male Candidate (Latino)	Male Candidate (Non-Latino)	White Candidate (Latino)	White Candidate (Non-Latino)
Education	4.324 (0.201)	3.874 (0.106)	4.497 (0.169)	4.052 (0.092)	4.523 (0.220)	4.623 (0.086)	3.936 (0.208)	3.657 (0.097)	3.800 (0.224)	3.962 (0.110)
Assisting the Poor	4.536 (0.263)	4.243 (0.106)	4.370 (0.257)	4.281 (0.096)	4.450 (0.217)	4.502 (0.087)	3.402 (0.235)	3.225 (0.107)	3.387 (0.199)	3.461 (0.117)
Reproductive Health	4.090 (0.256)	3.791 (0.114)	4.241 (0.247)	3.867 (0.098)	4.488 (0.239)	4.475 (0.100)	3.546 (0.235)	3.053 (0.108)	3.440 (0.229)	3.630 (0.111)
Health Care	4.034 (0.226)	3.776 (0.112)	4.593 (0.224)	3.942 (0.096)	3.738 (0.244)	4.322 (0.101)	3.827 (0.045)	3.095 (0.107)	3.577 (0.204)	3.653 (0.117)
Racial Discrim.	4.556 (0.233)	4.121 (0.112)	4.523 (0.239)	4.187 (0.108)	4.297 (0.215)	4.383 (0.090)	3.568 (0.223)	3.531 (0.103)	3.357 (0.205)	3.682 (0.110)
Immigration	4.362 (0.276)	3.756 (0.126)	4.474 (0.260)	3.966 (0.114)	4.261 (0.231)	4.061 (0.098)	3.500 (0.246)	3.234 (0.106)	3.467 (0.220)	3.570 (0.116)

Based on these results my first and last hypotheses can be partially accepted. I posit that I would find that the Latina candidate would be doubly advantaged on feminine issues due to her gender and ethnicity. I also expected that Latino respondents would stereotype the Latina candidate more favorably. These expectations hold true for the sample of Latino respondents, when we compare how the Latina candidate is stereotyped relative to the male and White candidates. For non-Latino respondents, they only stereotype the Latina candidate as more competent relative to the male candidate. Both groups of respondents do not see any significant differences between Latina and Latino candidates in competence, contrary to my expectations.

Masculine Issues

Turning to masculine issues, I posited that the Latina candidate is not going to be advantaged by her gender or ethnicity. A review of Table 9.2 in fact confirms that non-Latinos do not stereotype her as the most competent on any of the masculine issues. First, if we look at how she compares with the male candidate we see interesting results. According to existing research the male candidate should be stereotyped the most competent on masculine issues but results here show otherwise (Alexander and Andersen, 1993; Sanbonmatsu, 2002; Lawless, 2004; Dolan, 2005; Meeks, 2012). On three (economy, foreign affairs, and crime and public safety) of the four issues non-Latinos do not see a significant difference between the male and Latina candidate. It is only regarding the issue of national security that non-Latino respondents perceive the male candidate as significantly more competent than the Latina candidate. Turning to the comparison with the White candidate, non-Latinos perceive the Latina candidate as less competent on two of the four issues. It appears that the White candidate is perceived as significantly more competent on the economy and national security but is viewed as no different to the Latina on the issues of foreign affairs and crime and public safety.

If we turn to the comparison between the Latina candidate versus the female and Latino candidates, results demonstrate that non-Latino respondents do not stereotype the Latina candidate favorably. On all four masculine issues the female candidate is perceived as significantly more competent than the Latina. Particularly, on the issue of the economy there is a large difference between the two candidates. Interestingly, the female candidate is perceived as more competent on all four issues relative to the male, white, and Latino candidates. This is somewhat surprising since the female candidate should be perceived as weaker especially when compared to the male candidate (Huddy and Terkildsen, 1993a; Alexander and Anderson, 1993; McDermott, 1997; Dolan, 2009). Turning to the comparison between the Latino and Latina candidates, non-Latinos stereotype the Latino candidate as significantly better on all four masculine issues with the biggest difference being the issue of the economy (Table 9.2). Overall, the

TABLE 9.2 Mean Values of Masculine Issues Across Conditions by Latino and Non-Latino Respondents

	Latina Candidate (Latino)	Latina Candidate (Non-Latino)	Latino Candidate (Latino)	Latino Candidate (Non-Latino)	Female Candidate (Latino)	Female Candidate (Non-Latino)	Male Candidate (Latino)	Male Candidate (Non-Latino)	White Candidate (Latino)	White Candidate (Non-Latino)
Economy	4.099 (0.207)	3.557 (0.108)	4.206 (0.218)	3.822 (0.097)	4.275 (0.227)	4.283 (0.090)	3.788 (0.241)	3.387 (0.102)	3.686 (0.203)	3.905 (0.113)
Foreign Affairs	3.391 (0.234)	3.715 (0.103)	3.510 (0.165)	3.944 (0.089)	4.122 (0.212)	4.176 (0.090)	3.742 (0.184)	3.777 (0.093)	4.143 (0.255)	3.921 (0.109)
Crime & Public Safety	4.161 (0.192)	3.758 (0.105)	4.573 (0.202)	3.986 (0.098)	4.218 (0.202)	4.223 (0.093)	3.940 (0.194)	3.555 (0.096)	3.720 (0.226)	3.874 (0.107)
National Security	3.754 (0.201)	3.560 (0.109)	4.143 (0.241)	3.821 (0.093)	4.013 (0.212)	4.182 (0.092)	4.000 (0.204)	3.941 (0.097)	4.069 (0.240)	4.077 (0.111)

assessment of the sample of non-Latino respondents is in line with my expectation that the Latina candidate would be seen as the weakest on masculine issues.

In slight contrast, Latino respondents appear to stereotype the Latina candidate in a somewhat more favorable manner. This is a result of co-ethnics not perceiving many significant differences between her and the other candidates. In particular, if we turn to the male and female candidates Latino respondents do not perceive any significant differences between these two candidate types and the Latina candidate. On all four issues there is no significant difference when the Latina candidate is compared to the female or male candidate. When compared to the White candidate results are mixed. On the issue of foreign affairs the White candidate is stereotyped as significantly more competent than the Latina while for the issue of crime and public safety the Latina candidate is rated significantly higher. When comparing the Latino and Latina candidates on three of the four issues there is no significant difference. However, regarding the issue of crime and public safety Latino respondents stereotype the Latino candidate as significantly more competent than his female counterpart.

Overall, the results indicate that support for my second and fourth hypotheses is found. The non-Latino sample does not perceive the Latina candidate as more competent than any of the other candidates. However, Latino respondents do perceive her as competent but only on one issue, that of crime and public safety. Furthermore, it is evident that non-Latino respondents hold an unfavorable assessment of the Latina candidate regarding masculine issues. Latinos respondents, for the most part, view her similarly competent to the rest of the candidates on a majority of the issues; thus indicating a less negative assessment. While the Latina candidate is seen as the weakest on this set of issues, Latino respondents rate her higher than do non-Latinos.

Minority Issues

Lastly, respondents were asked to evaluate their candidate on two issues that the Latino community tends to be associated with: racial discrimination and immigration. My expectation is that the Latina candidate will be advantaged by her gender and ethnicity, thus will be stereotyped the most competent in handling these issues. Starting with non-Latino respondents, Table 9.1 demonstrates higher mean values for the Latina candidate, which are also significant, meaning that the Latina candidate is stereotyped as better able to handle these issues relative to the male candidate. Relative to the White candidate the Latina candidate is perceived as significantly better on the issue of racial discrimination but there is no significant difference between the two on the issue of immigration. Interestingly, non-Latino respondents consider the female candidate significantly more competent on the issues of racial discrimination and immigration relative to the Latina candidate. When comparing the Latino to the Latina candidate she is perceived similarly on racial discrimination, since the difference is not

significant, but he is perceived as better able to handle immigration. Overall, the Latina candidate does better relative to the male candidate on both issues but only on racial discrimination when compared to the White candidate.

Table 9.1 demonstrates that Latino respondents have a better assessment of the Latina candidate. The Latina candidate is perceived as better able to handle both issues in comparison to the male and White candidates. Regarding the female and Latino candidates, the Latina candidate is only stereotyped as significantly better than the female on the issue of racial discrimination. There is no significant difference on this issue when compared to the Latino candidate. In regards to the issue of immigration the Latina candidate is seen similarly to both the female and the Latino candidate. Furthermore, while she is not stereotyped as more competent on these issues relative to all four candidates, Latino respondents do have a better assessment of her than non-Latinos. Consequently, I can partially accept my third hypothesis since the Latina candidate is perceived as better able to handle these issues than the male candidate by both groups of respondents.

Conclusion

The goal of this chapter was to explore how gender stereotyping on issue competencies function for a Latina candidate when evaluated by different groups of respondents. In this case, I looked at the evaluations by a sample of non-Latino and Latino respondents. While it is found that Latina candidates can be electorally advantaged, it is possible that these electoral benefits may stem from familiarity with Latinas in leadership positions as is common in states such as California and Texas (Fraga et al., 2006; Bejarano, in this volume; Ramírez and Burlingame, in this volume). It appears that Latina candidates may run into issues when evaluated by non-Latino voters who are not always supportive of her.

This lack of support could be attributed to a lack of exposure to Latinas as political candidates. As previously noted, the percentage of Latinas in office, at all levels, is quite low. This analysis may shed light on the fact that voters, in particular non-Latinos, are not familiar with Latinas as political candidates. So, thinking about them in relation to policy issues is unusual. The low numbers of Latinas in office could also assist in explaining why even among Latino respondents, the Latina candidate did not do as well as expected. While it is true that Latinas tend to run more often in majority-minority areas, the fact that the number of candidates is low can be having an overall negative effect, even among Latino voters (Barreto et al., 2004; Fraga et al., 2006; Casellas, 2011). Perhaps the Latina candidate might have benefited from the inclusion of Spanish speaking Latinos in the overall sample of respondents. It has been found that Latinos who are Spanish dominant have a strong sense of ethnic identity in comparison to English dominant Latinos (Barreto and Pedraza, 2008). It is possible that this stronger sense of identity could have resulted in the Latina candidate being perceived as more competent on more policy issues relative to the female candidate. However, with a clearer understanding of

how Latinas can succeed when running for office we may begin to see a change in the results found in this analysis in regards to non-Latino and Latino voters.

As has been found in other research, it could be that part of what is hurting the Latina candidate in this analysis is that she is still a considerably novel candidate. Consequently, in low information environments people may fall back on negative stereotypes that they are getting from the media (Kahn, 1996). Moreover, these assessments may be exacerbated in an unfavorable way in instances where there is no personal familiarity with Latinos. However, as more Latinas seek political office, it is likely that these weak assessments will diminish.

Appendix tables available online at www.routledge.com/9781138958845.

Note

1 When text states Latino the reference being made is regarding the community at-large, i.e. both male and female Latinos. When the tex reads Latino candidate the reference being made is to the Latino male candidate.
2 For more information regarding the p-values for the treatments please refer to the appendix.

References

Alexander, Deborah and Kristi Andersen. 1993. "Gender as a Factor in the Attribution of Leadership Traits." *Political Research Quarterly*. 46: 527–545.

Banwart, Mary Christine. 2010. "Gender and Candidate Communication: Effects of Stereotypes in the 2008 Election." *American Behavioral Scientist*. 54(3): 265–283.

Barreto, Matt A. and Francisco I. Pedraza. 2008. "The Renewal and Persistence of Group Identification in American Politics." *Electoral Studies*. 28(4): 595–605.

Barreto, Matt A., Gary M. Segura, and Nathan D. Woods. 2004. "The Mobilizing Effect of Majority-Minority Districts on Latino Turnout." *The American Political Science Review*. 98(1): 65–75.

Barreto, Matt A., Sylvia Manzano, and Gary Segura. 2012. *The Impact of Media Stereotypes on Opinions and Attitudes Towards Latinos*. Latino Decisions. www.latinodecisions.com/blog/wp-content/uploads/2012/09/RevisedNHMC.Aug2012.pdf, accessed 03/01/2014.

Bejarano, Christina E. 2013. *The Latina Advantage: Gender, Race and Political Success*. Austin: University of Texas Press.

Brooks, Deborah. 2013. *He Runs, She Runs: Why Gender Stereotypes Do Not Harm Women Candidates*. Princeton, NJ: Princeton University Press.

Burns, Sarah, Lindsay Eberhardt, and Jennifer L. Merolla. 2013. "What is the Difference Between a Hockey Mom and a Pit Bull? Presentations of Palin and Gender Stereotypes in the 2008 Presidential Election." *Political Research Quarterly*. 66(3): 687–701.

Casellas, Jason. 2011. "Latinas in Legislatures: The Conditions and Strategies of Political Incorporation." *Aztlan*. 36(1): 171–190.

DeNavas-Walt, Carmen, Bernadette D. Proctor, and Jessica C. Smith. 2013. "Income, Poverty, and Health Insurance Coverage in the United States: 2012." *United States Census Bureau*. Washington D.C.

Dolan, Kathleen. 2005. "Do Women Candidates Play to Gender Stereotypes? Do Men Candidates Play to Women? Candidate Sex and Issue Priorities on Campaign Websites." *Political Research Quarterly*. 58(1): 31–44.

Dolan, Kathleen. 2009. "The Impact of Gender Stereotyped Evaluations on Support for Women Candidates." *Political Behavior*. 32(1): 69–88.

Dolan, Kathleen. 2013. "Gender Stereotypes, Candidate Evaluations, and Voting for Women Candidates: What Really Matters?" *Political Research Quarterly*. 67(1): 96–107.

Fowler, Linda L. and Jennifer Lawless. 2009. "Looking for Sex in all the Wrong Places: Press Coverage and the Electoral Fortunes of Gubernatorial Candidates." *Perspectives on Politics*. 7(3): 519–536.

Fox, Richard L. and Zoe M. Oxley. 2003. "Gender Stereotyping in State Executive Elections: Candidate Selection and Success." *Journal of Politics*. 65(3): 833–850.

Fraga, Luis Ricardo, Linda Lopez, Valerie Martinez-Ebers, and Ricardo Ramírez. 2006. "Gender and Ethnicity: Patterns of Electoral Success and Legislative Advocacy Among Latina and Latino State Officials in Four States." *Journal of Women. Politics, & Policy*. 28(3–4): 131–145.

Fridkin, Kim L., Patrick J. Kenney, and Gina Serignese Woodall. 2009. "Bad for Men, Better for Women: The Impact of Stereotypes during Negative Campaigns." *Political Behavior*. 31(1): 53–77.

Gershon, Sarah Allen. 2012. "Media Coverage of Minority Congresswomen and Voter Evaluations: Evidence from an Online Experimental Survey." *Political Research Quarterly*. 66(3): 702–714.

Gordon, Amy, David M. Shafie and Ann N. Crigler. 2003. "Is Negative Advertising Effective for Female Candidates: An Experiment in Voters' Uses of Gender Stereotypes." *Press/Politics*. 8(3): 35–53.

Hayes, Danny. 2011. "When Gender and Party Collide: Stereotyping in Candidate Trait Attribution." *Politics & Gender*. 7(2): 133–165.

Herrnson, Paul S., J. Celeste Lay, and Atiya Kai Stokes. 2003. "Women Running 'as Women': Candidate Gender, Campaign Issues, and Voter-Targeting Strategies." *Journal of Politics*. 65(1): 244–255.

Hogan, Robert E. 2010. "Candidate Gender and Voter Support in State Legislative Elections." *Journal of Women, Politics & Policy*. 31(1): 44–66.

Huddy, Leonie and Nayda Terkildsen. 1993a. "Gender Stereotypes and the Perception of Male and Female Candidates." *American Journal of Political Science*. 37(1): 119–147.

Huddy, Leonie and Nayda Terkildsen. 1993b. "The Consequences of Gender Stereotypes for Women Candidates at Different Levels and Types of Office." *Political Research Quarterly*. 46(3): 503–525.

Humes, Karen R., Nicholas A. Jones, and Roberto A. Ramírez. 2011. "Overview of Race and Hispanic Origin: 2010." *2010 U.S. Census Brief*. Washington, D.C.

Jones, Philips Edward. 2013. "Revisiting Stereotypes of Non-White Politicians' Ideological and Partisan Orientations." *American Politics Research*. 42(2): 283–310.

Kahn, Kim. 1996. *The Political Consequences of Being a Woman: How Stereotypes Influence the Conduct and Consequences of Political Campaigns*. New York: Columbia University Press.

Kenski, Kate and Erika Falk. 2004. "Of What is that Glass Ceiling Made?" *Women & Politics*. 26(2): 57–80.

King, David C. and Richard E. Matland. 2003. "Sex and the Grand Old Party: An Experimental Investigation of the Effect of Candidate Sex on Support for a Republican Candidate." *American Politics Research*. 31(6): 595–612.

Larson, Stephanie Grecco. 2001. "'Running as Women'"?: A Comparison of Female and Male Pennsylvania Assembly Candidates." *Women & Politics*. 22(2): 107–124.

Latinas Represent. 2015. *2015 Latinas Represent Research Booklet*. http://latinasrepresent. org/wp/wp-content/uploads/2015/01/LR-Booklet.pdf, accessed 04/23/2015.

Lawless, Jennifer. 2004. "Women, War, and Winning Elections: Gender Stereotyping in the Post-September 11th Era." *Political Research Quarterly*. 57(3): 479–490.

Lopez, Mark Hugo and Ana Gonzalez-Barrera. 2013. "Latinos' Views of Illegal Immigration's Impact on their Community Improve." *Pew Research Hispanic Trends Project*. Washington D.C.

Lopez, Mark Hugo, Rich Morin, and Paul Taylor. 2010. "Illegal Immigration Backlash Worries, Divides Latinos." *Pew Research Hispanic Trends Project*. Washington D.C.

Masuoka, Natalie. 2006. "Together They Become One: Examining the Predictors of Panethnic Group Consciousness Among Asian Americans and Latinos." *Social Science Quarterly*. 87(1): 993–1011.

Matson, Marsha and Terri Susan Fine. 2006. "Gender, Ethnicity, and Ballot Information: Ballot Cues in Low-Information Elections." *State Politics & Policy Quarterly*. 6(1): 49–72.

McDermott, Monika L. 1997. "Voting Cues in Low-Information Elections: Candidate Gender as a Social Information Variable in Contemporary United State Elections." *American Journal of Political Science*. 41(1): 270–283.

McDermott, Monika L. 1998. "Race and Gender Cues in Low-Information Elections." *Political Research Quarterly*. 51: 895–918.

Meeks, Lindsey. 2012. "Is She 'Man Enough'? Women Candidates, Executive Political Offices, and News Coverage." *Journal of Communication*. 62: 175–193.

NALEO (National Association of Latino Elected Officials). 2014. "2014 At-A-Glance National Directory of Latino Elected Officials." www.naleo.org/at_a_glance, accessed 04/23/2015.

Pager, Devah and Hans Sheperd. 2008. "The Sociology of Discrimination: Racial Discrimination in Employment, Housing, Credit and Consumer Markets." *Annual Review of Sociology*. 34: 181–209.

Popkin, Samuel L. 1991. *The Reasoning Voter: Communication and Persuasion in Presidential Campaigns*. Chicago, IL: University of Chicago Press.

Sanbonmatsu, Kira. 2002. "Gender Stereotypes and Vote Choice." *American Journal of Political Science*. 46(1): 20–34.

Schneider, Monica C. 2014. "The Effects of Gender-Bending on Candidate Evaluations." *Journal of Women, Politics & Policy*. 35(1): 55–77.

Schneider, Monica C. and Angela L. Bos. 2013. "Measuring Stereotypes of Female Politicians." *Political Psychology*. 35(2): 245–266.

Sigelman, Carol K., Lee Sigelman, Barbara J. Walkosz, and Michael Nitz. 1995. "Black Candidates, White Voters: Understanding Racial Bias in Political Perceptions." *American Journal of Political Science*. 39(1): 243–265.

Winter, Nicholas. 2010. "Masculine Republicans and Feminine Democrats: Gender and Americans' Explicit and Implicit Images of the Political Parties." *Political Behavior*. 32(4): 587–618.

PART III

Race, Gender, and Office Holding

10

MEDIA FRAMING OF BLACK WOMEN'S CAMPAIGNS FOR THE U.S. HOUSE OF REPRESENTATIVES

Orlanda Ward

Introduction

At the U.S. 2012 general election, six minority women were newly elected to the House of Representatives. Among the most prominent were Tulsi Gabbard (D-HI 2nd District) who became the "first Hindu American," and Mia Love (R-UT 4th District), the "first viable Black female Republican." Thus, in addition to rising numbers of minority women elected to the House, ethnic and religious diversity among minority female candidates is also on the rise, and competitive candidacies are no longer fielded solely by the Democratic Party. Indeed, parties increasingly appear to view racial and gender diversity among candidates as an electoral advantage, as was demonstrated by Love's invitation to address the 2012 Republican National Convention. Questions of how voters respond to this increased diversity are explored by Shyam Sriram in Chapter 8.

While it has long been demonstrated that women and minorities receive unfavorable campaign coverage in relation to their White male counterparts, little attention has been paid to the intersectional effects of these aspects of identity on coverage of political campaigns by minority women. Nearly all previous scholarship has treated race and gender as mutually exclusive categories. Thus coverage specific to minority women in politics remains almost entirely unexplored. Notable exceptions include Chapter 15 in this volume, in which Andra Gillespie discusses the framing of Michelle Obama as First Lady.

This exploratory analysis employs an open-ended, qualitative content analysis on local and national newspaper coverage of 16 Black women running for the U.S. House of Representatives in 2012. Three broad questions are considered:

- In what ways are Black female candidates' race and gender represented in newspaper coverage of electoral campaigns?

- Do media frames link race and gender to candidates' campaigns, character, or viability?
- Do representations of Black female political candidates correspond with stereotypes of Black women in general?

Single-axis studies of framing of predominantly White women and minority men have identified various "racial" and "gendered" frames (for respective reviews, see Caliendo and McIlwain, 2006; Murray, 2010: 50–52). This analysis considers the way in which racial and gendered references create specific intersectional frames applied to Black women running for office. Such frames simultaneously highlight both female and minority status, and have not previously been addressed in scholarship focusing solely on race or gender. Mia Love's candidacy is used as an illustrative case study, while more general framing of the cohort of viable Black women running for the House in 2012 is also analyzed.

The analysis indicates that Black women are subject to framing which posits them as substantive representatives of Black constituencies, but not of women in general. Additionally, textual links between intersectional identity and viability suggest Black women are framed as having advantages due to their race and gender, but at the same time failing to win over White voters, despite evidence to the contrary (Philpot and Walton, 2007). Furthermore, latent frames of Black women's character appear to correspond with generalized stereotypes and negative imaging of the "angry Black woman" and the "strong Black woman" as identified by Hill Collins (1990) and others. This topic is also addressed by Gillespie in Chapter 15.

Finally, the anomaly of a Black female Republican led to a variety of first frames portraying Mia Love as motivated by her race and gender and co-opted by her party, as well as skeptical responses towards her attempts to employ counter-frames, which reduced the saliency of her race and gender. The exceptionalism of Love's candidacy goes beyond her framing as a Black female Republican first. In 2012, Love eventually secured 47 percent of the vote against a White male six-term incumbent, Jim Matheson. She achieved this in an almost entirely White district and went on to win the race in 2014. Love is also a Mormon. Her campaign called this racial, partisan, and religious identity "the trifecta." Additional aspects of Love's biography, which differentiate her from many other Black female candidates, include her Haitian heritage (and therefore exemption from experience as a descendent of U.S. slavery) and status as the wife of a White man, both of which add additional layers to the complex images which emerge in coverage of her campaign. Because of the many aspects of Love's candidacy that challenged expectations, she garnered exceptional press attention and was subject to several clear frames not applied to other Black women running for the House of Representatives in 2012.

Intersectionality and Campaign Coverage

This study employs a theoretical framework underpinned by the concept of intersectionality, as developed by Crenshaw (1989, 1991, 2011), Hill Collins (1990) and King (1988), among others.[1] In the context of this analysis, the media frames previously identified in coverage of (White) female candidates and minority (male) candidates are neither expected to apply fully to Black women, nor are effects simply expected to be the sum of both. Instead, previously identified gendered frames are regarded as implicitly racializing (often through the absence of reference to the race of White candidates), and racial frames applied to minority male candidates are regarded as implicitly gendered. Therefore, the frames applied to Black female candidates are instead expected to reflect their intersectional identities.

The exception to single-axis studies of race or gender in this context is recent work by Gershon (2012). Gershon shows that when an intersectional approach is employed – by comparing patterns of coverage of minority women, minority men, White women, and White men – minority women received *less frequent and less positive coverage than all other groups*. Therefore, Gershon demonstrates that in terms of frequency and tone, findings for White women and minority men do not apply to minority women. Building on Gershon's quantitative evidence of disadvantages for minority women of various ethnicities, this study narrows the focus to Black female representatives to provide a detailed qualitative examination of the content of frames present in coverage of their campaigns.

Foregrounding Race and Gender

Election-time news coverage has been shown to emphasize minority candidates' and representatives' ethnicity while ignoring the race or ethnicity of Whites (Clay, 1992; Niven and Zilber, 1996; Reeves, 1997; Larson, 2006; McIlwain and Caliendo, 2009: 11). In addition to highlighting minorities' race, minority candidates' deployment of racial messages is suppressed and instead replaced with the media's own racial emphases, both regarding candidates themselves, and their electoral base (Terkildsen and Damore, 1999). Similarly the tendency to foreground the gender of female candidates and representatives is well documented (Sreberny-Mohammadi and Ross, 1996; Heldman et al., 2005; Falk, 2012; Ross et al., 2013). Racial and gendered emphases may take many forms, either via explicit "first" frames, descriptions of supporters, the framing of candidates as substantive representatives of specific constituencies, or more latent references to appearance or family life.

For example, the foregrounding of gender is often manifested in references to female candidates' personal lives, creating a double bind in which they must be seen to display the qualities of a wife and mother, at the same time as conforming to contradictory leadership norms (Sreberny-Mohammadi and Ross,

1996; Ward, 2000; Sones et al., 2005; Stevens, 2007). However, for Black women, references to spouses and families may also serve to confirm or contradict negative intersectional stereotypes regarding families and motherhood.[2]

Similarly, frames of "racial authenticity" are constructed by coverage which highlights candidates' correspondence with physical, partisan, issue-based or historical expectations based on their racial identity. While Black voters express higher levels of satisfaction when descriptively represented in Washington (Tate, 2001), in non-majority-minority districts, minority candidates need to balance the need to appear racially authentic to minority voters while also appealing to Whites (see Tate, 1994: 174). Therefore, as Caliendo and McIlwain (2004) argue, frames of racial authenticity may position minority candidates in a troubling double bind. For example, the 2008 presidential election saw intense debate regarding whether Barack Obama was either "too Black" or "not Black enough" (Augoustinos and De Garis, 2012).

Thus there are parallels in the way in which racial and gendered stereotypes question the possibility of substantive representation by female and minority candidates who challenge norms by attempting to win elected office, leading to implied or explicit questions regarding whether they are "real" women or minorities. For Black women, these effects may be compounded by intersectional frames, which highlight both racial and gendered otherness.

Firsts

Throughout her first run in 2012 and successful campaign in 2014, media outlets focused on one aspect of Mia Love's candidacy above every other: the possibility of her becoming the first Black Republican woman elected to Congress. This is not unusual. Studies of news coverage of political campaigns show that women are consistently singled out as "firsts" or "novelty" candidates (Sreberny-Mohammadi and Ross, 1996; Heldman et al., 2005; Falk, 2012; Ross et al., 2013). Additionally, Caliendo and McIlwain (2004) note that the media's placement of race as a central issue of U.S. campaigns occurs particularly in majority White districts, such as Love's. While the ubiquity of the first frame is clear, debate remains regarding its effects on representations of women and minorities who run for public office. Sreberny-Mohammadi and Ross (1996) note that first frames are associated with increased frequency of coverage. This was certainly the case for Love, who rose to both national and international prominence following her speech to the Republican National Convention in 2012, and widespread interest in her candidacy continued in 2014. However Falk (2008: 37) has suggested that, despite the name recognition that may be gained from a first frame, emphasis on the "notion of women as out of place and unnatural in the political sphere may be longer lasting and have important political consequences." Ross et al. (2013: 7) argue that the frame ensures that "the role of politician continues to be codified as male, with women politicians

as 'other'." For minority women, otherness is likely to be heightened by the foregrounding of not one but two subordinated axes of identity. This may also have negative effects when women and minorities in elite politics are conceptualized as "space invaders" and as a result are subject to "super surveillance" in their roles, "thus their every gesture, movement and utterance is observed" (Puwar, 2004: 73).

Viability

Given the largely symbolic nature of some early campaigns by female and minority candidates, and associated lack of resources and infrastructure, it is unsurprising that media frames have previously raised questions concerning such candidates' chances of electoral success. This is important because voters' evaluations of candidates are influenced by assessments of viability (Abramowitz, 1989; Abramson et al., 1992). Such references include "any consideration of a candidate's strength or chances of success: strength of campaign organization, poll results, debate performance, and overall likelihood of winning" (Jalalzai, 2006, building on Kahn, 1994). This analysis considers how references to minority women's intersectional identity are linked with viability frames: whether race and/or gender are represented as irrelevant or relevant, an advantage or disadvantage, and whether possible advantages or disadvantages are portrayed as the responsibility of the candidate or the voting public.

Character and Stereotypes

Recent work by Schneider and Bos (2014) contends that a specific stereotypical category exists for female politicians, distinct from "women" or "politicians" in general. The effect is that female politicians are disadvantaged by perceptions that they lack masculine qualities associated with leadership, and at the same time are additionally perceived as lacking positive qualities usually associated with women, such as warmth or empathy. How then, does this play out for Black women who are subject to frames which highlight both race and gender? Are stereotypes of minority women in general applied to minority women politicians? If so, how do minority women negotiate this symbolic landscape while attempting to generate broad voter appeal on the campaign trail?

Jamieson (1995) identifies a "woman/brain" double bind in which women's emotions are deemed to hinder their intellectual and therefore leadership abilities, and Falk (2008) notes that female presidential candidates are described with different emotions to men: women are "sad" whereas men are "angry." However, this is in contrast to the ubiquitous controlling image of the "angry Black woman" (Hill Collins, 1990). While "feminine" traits often function as double binds for White female candidates, the "unfeminine" elements of persistent slavery era mythology may result in different or additional effects for Black women seeking

public office. This analysis explores the extent and ways in which specific intersectional frames represent Black female politicians' character, and how such frames correspond with existing stereotypes of Black women in general.

Such stereotypes are multifarious, overlapping, and non-static. Jordan-Zachery (2009: 46) provides a useful typology of six key images of black womanhood: the Mammy and the Jezebel, appearing during the slavery era, the Matriarch and Sapphire which gained prominence in the 1950s and 1960s, and the Welfare Queen and Urban Black Mother which were popularized in the 1980s and 1990s. Furthermore, Wallace (1990: 107) shows the way in which, "[f]rom the intricate web of mythology which surrounds the black woman, a fundamental image emerges. It is of a woman of inordinate strength." The fundamental image of the Strong Black Woman is illustrated by the personal reflections of Joan Morgan (2000: 87):

> by the sole virtues of my race and gender I was supposed to be the consummate professional, handle any life crisis, be the dependable rock for every soul who needed me, and, yes, the classic – require less from my lovers than they did from me.

Harris-Perry (2011) articulates the way in which stereotypes of Black women function in contrast with one another and new iterations are spawned from long lived characterizations. For example, the promiscuous Jezebel is contrasted with the asexual Mammy and the Welfare Queen is born of the promiscuous Jezebel:

> Although historical myths are seldom imported wholesale into the contemporary era, they are meaningfully connected to twenty-first-century portrayals of Black women in public discourse. African American women who exercise their citizenship must also try to manage the negative expectations born of this powerful mythology.
>
> (Harris-Perry, 2011: 45)

Additionally, Collins (2004: 147) argues that the media has generated "images of Black women that help justify and shape the new racism of color blind America." Political candidates are a specific group of Black women. Therefore intersectional frames incorporated in campaign coverage are expected to reflect elements of existing stereotypes rather than "importing them wholesale," as well as possibly generating new iterations which apply specifically to Black female politicians.

Data and Methods

Using data from the Federal Election Commission, the Center for American Women and Politics, and the National Journal, 16 Black women were identified as viable candidates for the U.S. House of Representatives at the 2012 election.

Only those who secured at least 40 percent of the vote were included in the sample, as viable candidates were expected to receive relatively substantial media coverage, and should be less likely to be framed as "symbolic." Of these 16 women, 15 ran as Democrats and Love ran as a Republican. Two thirds were incumbents, and all but two races were classified as "solid" Republican or Democrat (uncompetitive) by Cook's Political Report eight weeks prior to Election Day. Only Love and Val Demings (D-FL 10th District) ran in competitive races.

The national newspaper sample included all three nationally distributed U.S. newspapers: *USA Today*, the *Wall Street Journal*, and the *New York Times*, as well as the *Washington Post*, noted for its focus on national politics. Local U.S. newspaper circulation figures are not published by congressional district. Therefore the strategy developed by Lawless and Hayes (2014) was employed in order to identify the highest circulating newspaper published within each candidate's district. Circulation figures and place of publication were downloaded from the Alliance for Audited Media, and congressional district maps from www.govtrack.us. Where no local newspaper was published within a candidate's district, the highest circulating newspaper published in an adjacent district was used.

The timeline for the sample of coverage is eight weeks prior to the general election on November 6, 2012, and the week following the election. Articles were downloaded from Nexis, Newsbank, or Access World News where possible, and directly from newspaper website archives in a small number of cases. For each candidate, the search term "first name" AND "last name" was used within the date range, generating samples of 42 national newspaper articles, and 157 local newspaper articles. These include news reports, op-ed columns, and letters to the editor. In order to provide a more complete analysis of the intersectional "first Black woman frame" that was applied almost exclusively to Mia Love; the sample was then extended to cover the period between Love's primary nomination on April 21, 2012 and the week of her speech to the Republican National Convention on August 28th that year, as well as responses to her win at the 2014 general election.

Qualitative content analysis was used to analyze the texts. One advantage of this method of text analysis is its suitability for large N data. While qualitative work in this area has tended to focus on case studies of individuals such as Condoleezza Rice or Michelle Obama (Alexander-Floyd, 2008; Meyers, 2013), I instead analyze coverage of a cohort of candidates in order to also identify frames which apply to Black women in politics collectively. Both latent and manifest coding was employed to capture both overt references to candidates' racial and gendered identity as well as more subtle code-words, phrases, and images. For example, references to appearance or emotion, which often correspond with intersectional stereotypes. The coding process was open and quasi-inductive, beginning with general categories corresponding to aspects of coverage such as focus on candidate identity, the "horserace" or substantive policy, before identifying specific racial and gendered frames relating to these categories.

Entman (1993) defines media frames as the selection of aspects of perceived reality in order to make them more salient. Candidates' race and/or gender may be made salient by the presence of frames which include key-words or stereotypical images which thematically reinforce the relevance of their identity, and link it to other aspects of their candidacy. Building on the work of Meyers (2013: 57), these frames were considered in the context of broader stereotypes and representations of Black women.

Findings: Who Got Coverage and Why?

Before considering the content of this coverage, it is important to note which women are most prominent within it. Levels of exposure vary hugely from 44 articles and 229 name mentions for Mia Love (almost a quarter of all coverage in the sample) to none at all for Yvette Clarke (D-NY 9th District). Additionally, while some candidates gain high levels of local exposure, they are largely absent from the national stage, and vice versa. Only Love gained substantial coverage in both spheres, resulting from a combination of her framing as an intersectional and partisan "first," and the competitiveness of her race. Like Love, Val Demings also ran in an unusually competitive race and was therefore featured often in her local newspaper, but appeared only occasionally in the national press. An ethics investigation into Maxine Waters (D-CA 43rd District) and voting rights debates featuring Sheila Jackson Lee (D-TX 18th District) and Corrine Brown (D-FL 5th District) were all covered with relative frequency by national papers. Gloria Bromell Tinubu (D-SC 7th District) was not deemed newsworthy by the national media, but received the most frequent coverage from her local publication due to its comparatively small circulation size. Therefore, just as there is substantial variation among the candidates within the sample, there are also a myriad of candidate, campaign, and news agenda factors which result in the prominence of some individuals and silence around others. Just as there is increasingly no "typical" Black female candidate, there is little consistency in the quantity or quality of coverage they receive. The analysis did reveal, however, a number of specific intersectional frames and counter-frames applied to such candidates when particular conditions arise. Several such frames are outlined below, before a more in depth discussion of the exceptional coverage of Love's candidacy.

Explicit Foregrounding: "Black" or "Black Woman," but not just "Woman"

Explicit foregrounding of candidates' race or gender, for example referring to their status as a "first," to the race or gender or their supporters, or grouping them together with other female or minority political actors was relatively rare in both national and local reporting. While more frequent in national papers, the vast majority of references comprised the "first Black woman" frame applied specifically

to Love, and in conjunction with her Republican partisanship and Mormon religious identity. In coverage of other Black women, coverage most often highlighted one axis of identity without mentioning the other. In both national and local papers, articles referring to Black women's race were twice as frequent as those referring to gender. These occur in a broad variety of contexts. For example, in coverage of voting rights debates Sheila Jackson Lee is described as "a Democrat who is Black," arguably positing her race as incidental, while at the same time foregrounding it. Other women are more distinctly racialized in ways that represent their race as their primary identity. Barbara Lee (D-CA 13th District) is grouped with "other members of the Congressional Black Caucus" and Maxine Waters is aligned with other "Black politicians" who have "held their fire" regarding criticizing Obama, purportedly on grounds of racial solidarity. Perhaps more concerning, Waters' position as "a senior member of the Congressional Black Caucus" is occasionally foregrounded in the context of a long running ethics investigation, which eventually cleared the congresswoman of wrongdoing.

In contrast, coverage almost never highlights the gender of Black women without referring to their racial identity. It appears that Black women's identity as "Black" or "Black women" is made salient, but very rarely their identity as "just" women. Black women are framed as the symbolic and substantive representatives of Black constituents: for example, Marcia Fudge is dubbed a future "national spokeswoman for Black America" and is covered attending "a forum on breast cancer issues among Black women." However, Black women were not framed as the substantive representatives of "women" in general. This raises the question of whether such a frame is reserved only for White women.[3]

More dominant than the framing of candidates as substantive representatives of particular constituencies, or even substantive policy coverage of any kind, was discussion of electoral viability. Even in a sample of candidates where 14 of 16 were in "solid" districts (i.e., uncompetitive), over half of the articles in the sample featured the horserace. In this context, Black women's race was again made salient while their gender garnered less attention. In majority minority districts, minority voters are unsurprisingly described as an advantage: "Black voters comprise about 50 percent of the electorate, an edge for Brown, who is Black, over Kolb, who is white." Likewise, the coverage of campaign contributions of organizations such as the Ohio Legislative Black Caucus or Houston chapter of the NAACP is another straightforward way in which Blackness is explicitly linked with viability. However, while minority voters are described as an advantage to Black women seeking office, in majority, White districts the question posed is whether the candidate can win over White voters – not whether White voters are a hindrance. For example, "Democrats question whether Tinubu, an African-American woman, can win enough crossover votes to carry the politically moderate district," and later in the same article: "She turned out more than a minority vote. ... I am encouraged ... she can attract some middle-of-the-road and independent voters in the general election." Thus, in the case of Gloria Bromell Tinubu, her identity as

a Black woman is both explicitly foregrounded, and implicitly posited as at odds with a "politically moderate district" and "middle of the road" voters.

Overall, however, apart from the "first" frame applied to Love, explicit frames foregrounding Black women's racial, gendered identity were unusual. When they do arise, Black women are represented as substantive representatives of Black communities but not women. Campaign disadvantage and disadvantage associated with their identity is foregrounded, but the burden is on the Black female representative to win over White voters if there is a disadvantage. The frame includes no explicit onus on White voters to support such candidates.

Latent Foregrounding: Character

During the 2012 election, several African American female candidates seem to have been subject to framing that includes many of the tropes of the stereotype of the "angry Black woman," in particular, the "emasculating anger" identified by Harris-Perry as a key feature of contemporary myths about Black women informed by long lived stereotypes. The frame includes adjectives such as "outspoken" to describe Corrine Brown or speech verbs such as "screaming" in coverage of Gwen Moore (D-WI 4th District), as well as more substantial negative characterizations. In the case of Donna Edwards (D-MD 4th District), the frame was clearly linked with her status as other. While one *Washington Post* article cited Edwards framing herself as "straightforward," it also described her as taking an "aggressive stand," stating that she "did not hold back." The author interprets this as the behavior of an individual "accustomed to being on the outside looking in," and voice was given to criticism that Edwards is "not in touch" and "has alienated many colleagues and should do more to repair relationships." Similarly, criticisms of Gloria Bromell Tinubu's campaign by her local newspaper were highly personalized. An endorsement of her opponent argued that her "façade" was "stripped away" and instead the "true personality" that was alleged to have emerged in the context of a "stressful election season" was "not pretty." Behavior viewed as "belligerent" by the publication outweighed the benefits of her "economist background" and the editors elected instead to support a competitor they believed to possess a "calmer temperament" and "willingness to compromise." Thus an acrimonious contest between two candidates was represented as the "real" nature of a woman who apparently lacked rationality despite her expertise. Anger and rationality were also posited as opposites in other contexts. For example, the Reverend Al Sharpton was cited praising Marcia Fudge (D-OH 11th District), stating:

> She's a fighter, but she's also rational.... Sometimes you get people that are so fiery, they are not strategic. She has the passion and the fire in the belly, but she has the maturity in her mind to get things done.

Interestingly, the statement suggests that the "fighter" element of her public persona is apparently in need of qualification, despite her role. Furthermore,

visible anger is deemed not righteous, but a red flag of immaturity. It is worth noting also that these criticisms and characterizations are not confined to the sometimes more extreme sentiments expressed in Letters to the Editor, but regularly appear in news copy and editorial, as with the examples here. Thus they are firmly present within mainstream media platforms rather than relegated to the fringes.

Character references were by no means universally negative. However, explicitly positive representations also show substantial correspondence with the counter-frame of the "Strong Black woman." Candidates are praised for "tenacity," described as "capable and energetic," and cited representing themselves as "a hard-charger" or "secure enough in who I am and what I stand for." Harris-Perry (2011: 185) points out the ways in which this characterization can be a double-edged sword:

> What begins as empowering self-definition can quickly become a prison.... To protect against always being seen as inferior, they declare themselves uniquely capable, but this strength is a shield full of holes; it sets up new possibilities for being misrecognised.

The frame is defined as much by what is excluded as what is included. Even positive framing of Black women's character very rarely references any kind of straightforward likeability. Instead, strength is consistently made salient, while other positive traits stereotypically associated with women, such as warmth, compassion, or principle (Huddy and Terkildsen, 1993) are conspicuously absent.

"First Black Republican Woman"

The explicit foregrounding of Love's race and gender, and framing of her candidacy as extraordinary most often comprises ostensibly positive references to her position as a likely "historic first." These stem from the mouths of news reporters, columnists, political actors, academics, and other commentators. Not all such references are unequivocally affirmative, though. During the 2012 Republican primary, Utah Attorney General Mark Shurtleff labeled Love a "novelty" and was widely reported doing so. Similarly, University of Iowa political science professor Tim Hagle was quoted by local media attributing her success within the GOP to her status as "an attractive and articulate Black woman." Shortly afterwards, the *Deseret Morning News* published a letter to the editor, asking if it was only Love's identity that attracted interest, "rather than what she really has to say." Beyond these explicit examples of the intersectional first frame which dominates Love's coverage, there are also a wide variety of more latent versions. For example, political commentators were cited describing Love as "innovative" and "exciting." Similarly, reports quoted former Republican Matheson-challenger, John Swallow, characterizing her as "fresh." The

Washington Post commented, "there is little about Mia Love that doesn't stand out," asking, "How does a woman born in Brooklyn and reared in Connecticut end up in Utah?" Finally, *The Deseret Morning News* claimed Love and Matheson's backgrounds to be "so disparate they might as well come from different solar systems."

First as Motive

While otherness and difference are clearly a defining feature of representations of Love, the salience of her intersectional identity is enforced by several sometimes contradictory manifestations of the traditional "first" frame. News reports often present the possibility of becoming a historic first as Love's *primary* goal. Comments and headlines describing her "hope," "effort," "bid," or "challenge" to "become the first Black Republican woman in Congress" implied that Love's racial and gendered identity was the motive for her congressional race. Furthermore, this implication arguably aligned her with historical symbolic candidates who did not share Love's strong viability. This characterization is in striking contrast with much of Love's messaging regarding her motivation. Furthermore, there are also notable differences in the deployment of the frame by the candidate and her own party.

Token or Substantive Representative (of the Republican Party)

Explicitly positive messages around Love's identity from the Republican Party and its sympathizers are distinguished by the infrequency of references to other, more traditional leadership attributes: "Who better than Love, a Black Republican Mormon woman, to push the reset button on all of those preconceptions about Mormons and Republicans?" "John McCain said Thursday that he believes Mia Love can be an effective member of Congress, despite polarization in Washington, because of her profile and prominence in political circles." "The Republican Party has tried to highlight its diversity, giving prime speaking slots to Latinos and Blacks who have emphasized their party's economic appeal to all Americans." When Love's other leadership qualities are mentioned, they are often in the context of reference to what she can achieve for the Republican Party as a Black woman: "Besides being the first Black GOP woman in Congress, McCain said he liked Love's personal story of being raised by Haitian immigrants and that 'she's incredibly articulate for the conservative values and principles we believe in.'" This view is bolstered by Republican commentators who openly refer to the benefits of having a Black woman onside: "Mia has a great opportunity to extend the message of liberty and economic freedom in ways that a lot of us can't, and we're excited about that." *Ebony* magazine went as far as calling Love "the great Black G.O.P. hope," a moniker which was again picked up by the national press.

Co-opted

Perhaps most obviously negatively, the frame was used to suggest that the candidate had been co-opted by the party, implying a disturbing lack of agency. Love was frequently framed by her rival as a pawn of the Republican Party. It is explicitly suggested that she has been "co-opted" by the party, and that her success within it is a result of being a Black woman. This frame appears both in reported comments by Matheson's team, as well as in news copy: Utah Democratic Party Chairman Jim Dukakis is cited saying, "She's made a deal with the devil.... They bought her..." and, "She's been co-opted by all the lobbyists and members of Congress and we have to wonder if she's going to speak with an independent voice."

Similarly, Love's support by the national Republican Party is rationalized with reference to her race and gender: "Her campaign will receive tremendous support from many right-wing and Republican PACs interested in the realistic possibility of the first African-American Republican female in Congress"; "Love, who is Mormon, also could go a long way toward helping presidential candidate Mitt Romney, putting a fresh face on his church and his party as both try to appeal to an increasingly diverse nation." While these comments are ostensibly encouraging, they are also highly reductive and imply that the candidate is something of a puppet for the party: "She's good on television and makes for a good story on race and gender – two issues that have bedevilled the GOP."

Love on Being a "First"

Meanwhile, in the initial stages of the campaign, Love appeared reluctant to explicitly foreground her intersectional identity. For example, she was not cited describing herself as a representative of Black or female voters, or commenting on the possibility of being the first Black Republican woman in Congress. Instead, she was frequently quoted referring indirectly to the racial and gendered differences between herself and Matheson: "He's never been up against a candidate like me,... How is he going to be able to define me?" Similarly, she hinted at differences between herself and members of her own party without explicitly employing the frame: "I'm a new generation of Republican, grounded in conservative principles by demonstrating the diversity and tolerance of my party."

Instances of rhetoric from Love which actively challenged the media's first frame were relatively unusual, but were occasionally pointed. In one interview she stated "The only history I'm interested in making is getting our country on track." Overall, Love's apparent decision to only partially embrace the first frame was met with a dose of skepticism: "If elected, Ms. Love, 36, would be the first Black female Republican to serve in the House, *a fact that she studiously plays down* [emphasis added]" but "is impossible to ignore." Implied is the suggestion that it would be inconceivable to define the candidacy in another way without this intersectional first being an elephant in the room. This is problematic for candidates

for whom other frames may be more advantageous. In addition to "playing down" her intersectional identity, Love also appears to have challenged some of the racial othering she was subject to by playing up racial and gendered stereotypes around motherhood. There are similarities between this and the self presentation of Michelle Obama as First Lady as, "a woman to whom other married women can relate" (Meyers, 2013: 72). Khal (2009: 318) argues that Obama presents her family and her status as examples of racial progress. Love appears to do the same. However, even the tactic of foregrounding gendered stereotypes was met with skepticism by the press: "Ms. Love likes to say, during nearly every campaign stop or speech, that she is 'first and foremost a wife and mother.'" Furthermore, the image of Love's interracial family and her role as the mother of a White man's children has the potential to catalyze the additional slavery-era stereotype of the Mammy. There was, however, surprisingly little discussion or comment about Love's domestic life during her campaign, despite her own frequent use of the "wife and mother" frame.

Once elected, Love did enthusiastically acknowledge her position as a first: "Many of the naysayers out there said that Utah would never elect a Black, Republican, LDS woman to Congress. Not only did we do it, we were the first to do it." Yet she also continued to defend her right not to do so when she chose. In response, several media commentators began to overtly vent frustration at her refusal to conform to their framing of her candidacy and instead define it as she saw fit. After Love argued, "I wasn't elected because of the color of my skin. I wasn't elected because of my gender. I was elected because of the solutions I put on the table," she was addressed directly by several commentators and aggressively reprimanded for challenging the reporters' eagerness to frame her candidacy in these terms. It is somewhat ironic that Love was on the one hand framed as co-opted by the Republican Party for being a Black, female member, but on the other was directly challenged when she attempted to define herself in terms other than as an intersectional first.

Conclusion

In many ways, this snapshot raises more questions than it provides answers. A huge body of scholarship on political campaigns by minority women remains to be undertaken. There is much work to be done in further understanding the framing of campaigns by candidates, parties, reporters, and other commentators, as well as disparities between minority women's self presentation and representations made by others. Just as there are differences between White and minority women's experiences on the campaign trail, framing of minority women is likely to vary substantially by ethnicity. Likewise, how do other axes of identity, such as class, intersect with racial, gendered, and other media frames? The exceptionalism of a candidacy such as Love's also raises questions surrounding the generalizability of frames applied to particular individuals. Under what

circumstances can a minority woman be a political actor without her intersectional identity being the most salient aspect of her public profile? Finally, how does the framing of minority women affect voter evaluations of candidates, and what self presentation strategies can minority women seeking elective office employ in order to build on recent wins and gain future electoral successes?

A number of double binds have previously been identified as applying to (predominantly White) female leaders. From this exploratory analysis I would tentatively posit a number of intersectional binds which may apply specifically to Black women in the political sphere. In terms of viability, they are seen as advantaged by Black or female voters, but as failing to win over (rather than disadvantaged by) White or male voters. Their character is often described in terms of irrational anger or, perhaps more positively, strength, but not in terms of positive stereotypically "feminine" qualities. For those whose additional attributes, such as partisanship, renew the novelty of their race and gender, they may gain visibility due to their multiple novelties, but several varieties of the associated first frame imply tokenism, and a lack of agency or authenticity.

More positively, the relative scarcity of explicit foregrounding of race and gender for all but a few candidates suggests some progress may have been made. An optimistic explanation might point to gradually increasing racial diversity and gender balance among those seeking and gaining office, leading to the normalization of "non-traditional" candidates and decreased likelihood of their being framed as "symbolic." We might also hope that cultural changes mean that in mainstream media, explicit racial and gendered critique is increasingly unaccepted. However, a more critical interpretation could raise two further points. First, while the most *explicit* racism and/or sexism is, broadly speaking, no longer tolerated, negative or ambivalent sentiments towards Black women and other groups may find more subtle avenues for expression. There is some evidence for this embodied by the intersectional viability and character frames discussed above. Second, even in a sample of candidates where 14 of 16 were in "solid" districts (i.e., uncompetitive) over half of the coverage of these races featured the horserace. Much of the reporting is highly formulaic. In this context, detailed discussion of candidates' attributes and positions is relatively unusual.

The continued presence of stereotypical depictions of Black women in the political sphere is of pressing concern for several reasons. In her work on the effects of intersectional stereotypes on policy making, Jordan-Zachery (2009: 9) argues that

> [s]ymbols and myths serve a political purpose because they create a sense of reality by providing an index that is used to judge or define a group's societal worth – that is, their ability to contribute and participate in societal institutions.

Just as policy informed by such images "makes inferences available about causes and motivations for the group's behaviours" (Jordan-Zachery, 2009: 150), so

too do media frames of Black women running for public office. From the examples discussed in this chapter, this is exactly the case when the tone of Gloria Bromell Tinubu's campaign is ascribed to her character, or Mia Love's motivation is read contrary to her own statements. Furthermore, when the conditions arise to revive intersectional first frames, they become by far the most dominant frame for a candidate. This means that for trailblazing Black women who reach new heights of political office, frames are likely to revert to explicit othering. The centrality of race and gender in mediations of Love's recent campaigns is reminiscent of the treatment of former United States Secretary of State (2005–2009) and fellow Black female Republican, Condoleezza Rice. During her term, Rice has been "alternatively constructed as a representation of Black female hypersexuality and cultural and political disorder, in ways that affirm essentialist views of Black women" (Alexander-Floyd, 2008: 430). While this study contributes an exploratory qualitative analysis of the mediation of campaigns by Black women, it is clear that in this area much work remains to be done.

Notes

1 For a review, see Lykke (2011).
2 For example, see: www.clutchmagonline.com/2012/09/a-Black-mom-in-chief-is-revolutionary-what-white-feminist-get-wrong-about-michelle-obama/.
3 This positioning of Black women as perpetual outsiders in contrast to White women as representatives of "all women" is of course mirrored in many other contexts, not least successive feminist movements. As hooks (1981, 1984) and many others have noted, (White) feminism has regularly failed to mobilize around universal womanhood.

References

Abramowitz, A. I. (1989). Viability, Electability, and Candidate Choice in a Presidential Primary Election: A Test of Competing Models. *The Journal of Politics*, 51(4), 977–992.

Abramson, P. R., Aldrich, J. H., Paolino, P., and Rohde, D. W. (1992). "Sophisticated" Voting in the 1988 Presidential Primaries. *The American Political Science Review*, 86(1), 55–69.

Alexander-Floyd, N. (2008). Framing Condi(licious): Condoleezza Rice and the Storyline of "Closeness" in U.S. National Community Formation. *Politics & Gender*, 4(3), 427–449.

Augoustinos, M., and De Garis, S. (2012). "Too Black or Not Black Enough": Social Identity Complexity in the Political Rhetoric of Barack Obama. *European Journal of Social Psychology*, 42(5), 564–577.

Caliendo, S. M., and McIlwain, C. (2004). *Frames of Authenticity: News Coverage of Black Candidates and Their Campaigns*. Paper presented at the 62nd annual national conference of the Midwest Political Science Association, Palmer House Hilton, Chicago, Illinois, April 15–18. www.raceproject.org/pdfs/McIlwain_Caliendo2004.pdf.

Caliendo, S. M., and McIlwain, C. D. (2006). Minority Candidates, Media Framing, and Racial Cues in the 2004 Election. *The Harvard International Journal of Press/Politics*, 11(4), 45–69.

Clay, W. L. (1992). *Just Permanent Interests: Black Americans in Congress, 1870–1991*. New York, NY: Amistad Press: Distributed by Penguin USA.

Collins, P. H. (2004). *Black Sexual Politics: African Americans, Gender, and the New Racism.* New York, NY: Routledge.

Crenshaw, K. (1989). Demarginalizing the Intersection of Race and Sex: A Black Feminist Critique of Antidiscrimination Doctrine, Feminist Theory and Antiracist Politics. *U. Chi. Legal F.,* 139.

Crenshaw, K. (1991). Mapping the Margins: Intersectionality, Identity Politics, and Violence Against Women of Color. *Stanford Law Review,* 1241–1299.

Crenshaw, K. W. (2011). Demarginalising the Intersection of Race and Sex: A Black Feminist Critique of Anti-discrimination Doctrine, Feminist Theory, and Anti-racist Politics. In H. Lutz, M. T. H. Vivar, and L. Supick (Eds.), *Framing Intersectionality, Debates on Multi-Faceted Concept in Gender Studies* (pp. 25–42). Surrey: Ashgate.

Entman, R. M. (1993). Framing: Toward Clarification of a Fractured Paradigm. *Journal of Communication,* 43(4), 51–58.

Falk, E. (2008). *Women for President: Media Bias in Eight Campaigns.* Chicago, IL: University of Chicago.

Falk, E. (2012). Clinton and the Playing-the-Gender-Card Metaphor in Campaign News. *Feminist Media Studies,* 1–16.

Gershon, S. A. (2012). Media Coverage of Minority Congresswomen and Voter Evaluations: Evidence from an Online Experimental Survey. *Political Research Quarterly,* 66(3), 702–714.

Harris-Perry, M. (2011). *Sister Citizen.* New Haven, CT: Yale University Press.

Heldman, C., Carroll, S. J., and Olson, S. (2005). "She Brought Only a Skirt": Print Media Coverage of Elizabeth Dole's Bid for the Republican Presidential Nomination. *Political Communication,* 22(3), 315–335.

Hill Collins, P. (1990). Black Feminist Thought Knowledge, Consciousness, and the Politics of Empowerment, from http://public.eblib.com/EBLPublic/PublicView. do?ptiID=178421.

hooks, b. (1981). *Ain't I a Woman: Black Women and Feminism.* Boston, MA: South End Press.

hooks, b. (1984). *Feminist Theory from Margin to Center.* Boston, MA: South End Press.

Huddy, L., and Terkildsen, N. (1993). Gender Stereotypes and the Perception of Male and Female Candidates. *American Journal of Political Science,* 37(1), 119–147.

Jalalzai, F. (2006). Women Candidates and the Media: 1992–2000 Elections. *Politics & Policy,* 34(3), 606–633.

Jamieson, K. H. (1995). *Beyond the Double Bind: Women and Leadership.* New York, NY: Oxford University Press.

Jordan-Zachery, J. S. (2009). *Black Women, Cultural Images and Social Policy.* New York, NY: Routledge.

Kahn, K. F. (1994). The Distorted Mirror: Press Coverage of Women Candidates for Statewide Office. *The Journal of Politics,* 56(1), 154–173.

Kahl, M. L. (2009). First Lady Michelle Obama: Advocate for Strong Families. *Communication and Critical/Cultural Studies,* 6(3), 316–320.

King, D. K. (1988). Multiple Jeopardy, Multiple Consciousness: The Context of a Black Feminist Ideology. *Signs,* 14(1), 42–72.

Larson, S. G. (2006). *Media & Minorities: The Politics of Race in News and Entertainment.* Lanham, MD: Rowman & Littlefield.

Lawless, J. L., and Hayes, D. (2014). *How Uncompetitive Elections and Media Consolidation Impoverish the News and Diminish Democracy.* Paper presented at the Midwest Political Science Association, Chicago, Illinois.

Lykke, N. (2011). Intersectional Analysis: Black Box or Useful Critical Feminist Thinking Technology. In H. Lutz, M. T. H. Vivar, and L. Supick (Eds.), *Framing Intersectionality, Debates on Multi-Faceted Concept in Gender Studies* (pp. 207–220). Surrey: Ashgate.

McIlwain, C. D., and Caliendo, S. M. (2009). Black Messages, White Messages: The Differential Use of Racial Appeals by Black and White Candidates. *Journal of Black Studies*, 39(5), 732–743.

Meyers, M. (2013). *African American Women in the News: Gender, Race, and Class in Journalism*. New York, NY: Routledge.

Morgan, J. (2000). *When Chickenheads Come Home to Roost: A Hip-hop Feminist Breaks it Down*. New York, NY: Simon and Schuster.

Murray, R. (2010). Introduction: Gender Stereotypes and Media Coverage of Women Candidates. In R. Murray (Ed.), *Cracking the Highest Glass Ceiling: A Global Comparison of Women's Campaigns for Executive Office*. Santa Barbara, CA; Denver, CO; Oxford: Praeger.

Niven, D., and Zilber, J. (1996). *Media Treatment of Minorities in Congress: Coverage and Its Effects*. Paper presented at the annual meeting of the Southern Political Science Association, Atlanta, Georgia.

Philpot, T. S., and Walton, H., Jr. (2007). One of Our Own: Black Female Candidates and the Voters Who Support Them. *American Journal of Political Science*, 51(1), 49–62.

Puwar, N. (2004). *Space Invaders: Race, Gender and Bodies Out of Place*. Oxford: Berg Publishers.

Reeves, K. (1997). *Voting Hopes or Fears?: White Voters, Black Candidates & Racial Politics in America*. New York, NY: Oxford University Press.

Ross, K., Evans, E., Harrison, L., Shears, M., and Wadia, K. (2013). The Gender of News and News of Gender: A Study of Sex, Politics, and Press Coverage of the 2010 British General Election. *The International Journal of Press/Politics*, 18(1), 3–20.

Schneider, M. C., and Bos, A. L. (2014). Measuring Stereotypes of Female Politicians. *Political Psychology*, 35(2), 245–266.

Sones, B., Moran, M., and Lovenduski, J. (2005). *Women in Parliament: The New Suffragettes*. London: Politico's.

Sreberny-Mohammadi, A., and Ross, K. (1996). Women MPs and the Media: Representing the Body Politic. *Parliamentary Affairs*, 49(1), 103–115.

Stevens, A. (2007). *Women, Power and Politics*. Basingstoke [England]; New York: Palgrave Macmillan.

Tate, K. (1994). *From Protest to Politics: The New Black Voters in American Elections*. Cambridge, MA: Harvard University Press.

Tate, K. (2001). The Political Representation of Blacks in Congress: Does Race Matter? *Legislative Studies Quarterly*, 623–638.

Terkildsen, N., and Damore, D. F. (1999). The Dynamics of Racialized Media Coverage in Congressional Elections. *The Journal of Politics*, 61(3), 680–699.

Wallace, M. (1990). *Black Macho and the Myth of the Superwoman* (Vol. 26). London: Verso.

Ward, L. (2000). Learning from the "Babe" Experience: How the Finest Hour Became a Fiasco. In A. Coote (Ed.), *New Gender Agenda*. London: IPPR.

11

OFFICEHOLDING IN THE 50 STATES

The Pathways Women of Color Take to Statewide Elective Executive Office

Kira Sanbonmatsu

Women of color continue to make strides with respect to electoral politics.[1] We live in an era of historic highs for women of color including the largest number to ever serve in Congress (CAWP 2014a). State legislative statistics also reveal significant gains with rates of growth surpassing the progress of men of color in some cases (Fraga et al. 2006/2007; Smooth 2010). But one area where the situation is much less clear is statewide executive positions such as governor, secretary of state, and attorney general. These positions are powerful in their own right and are also credentials for congressional officeholding.

That women of color hold any statewide executive positions might seem surprising; after all, only two women of color have ever served in the statewide office of U.S. Senator. The challenges facing underrepresented populations, in terms of both race and gender, in securing statewide office are many (Sonenshein 1990; Tate 1997; Oxley and Fox 2004; Frederick and Jeffries 2009; Windett 2011; Johnson et al. 2012). Yet, women of color have indeed reached statewide executive office and more have been running for these offices than in the past (Sanbonmatsu 2015).

Because women of color are too often located at the intersection of multiple axes of disadvantage – at the intersection of gender, race, and class inequalities – it might seem premature or unrealistic to inquire about minority women's ability to reach statewide elective executive office. For Latinas and Asian American women disproportionately, there are also the issues of language and immigration. I would argue, however, that we need to ask these questions in order to understand the challenges that confront women of color in seeking such positions. As scholarship about minority women's distinctive policy impact continues to expand, it is clear that the dearth of women of color in office weakens American democracy. Though underrepresented, a sufficient number of minority women

have reached statewide executive office to make possible an initial analysis. At least one woman of color has held statewide elective executive office in a total of 17 states.

My purpose in this chapter is to investigate the pathways that women of color have taken to statewide elective executive office. As I discuss below, the traditional scholarly focus on either race alone or gender alone has often obscured the situation of women of color. Yet, previous scholarship has shown that minority women's access to office and pathways into office often differ from their male and White female counterparts (Prestage 1977; Carroll and Strimling 1983). I use this chapter to showcase the gains of women of color, identify patterns in their pathways to office, and explore the barriers that remain. Doing so can help practitioners who seek to advance the status of women of color in electoral politics.

I use the term "women of color" to refer to women other than non-Hispanic White women. I use women of color interchangeably with "minority women." No term is ideal. For this study, grouping minority women together is necessary in order to yield a sufficient number of cases for analysis. However, I also discuss differences by race.

Women of Color and Elective Officeholding

A growing body of theoretical and empirical work argues, persuasively, that attention to the intersection of race and gender is necessary in order to understand the experiences of women of color (Crenshaw 1989; Hill Collins 2000; Cohen 2003; Hawkesworth 2003; Junn and Brown 2008; Lien et al. 2008; Scola 2014). Scholarship focused on either gender or race alone risks treating the experiences of non-Hispanic White women or men of color as the norm, making women of color invisible (see chapter by Holman, this volume). Struggles to remedy race- and gender-based inequality can often leave behind or isolate minority women, who have much at stake in both feminist and antiracist struggles (hooks 1984; King 1988; Giddings 1996; Roth 2004; Beltran 2010). Defining the interests of women or racial minorities as groups without attention to internal diversity can result in further marginalization (Cohen 1999).

Experiences shaped by race, gender, and their intersection make for distinctive approaches to policymaking (Garcia Bedolla et al. 2014). New issues, agendas, and networks accompany minority women's lawmaking (Barrett 2001; Smooth 2001; Bratton et al. 2006; Fraga et al. 2008; Reingold and Smith 2012; Brown 2014d). Within legislative institutions, however, race and gender shape legislative life including norms, relationships, and legislators' access to influence (Hawkesworth 2003; Puwar 2004; Smooth 2008).

Much has changed for minority women with respect to electoral politics (Philpot and Walton 2007; Gamble 2010; Smooth 2010; Bejarano 2013; Dittmar

2014b). The civil rights movement, passage and implementation of the Voting Rights Act, and the women's movement helped to fuel the increase in minority women's officeholding (Williams 2001; Fraga et al. 2006/2007; Lien et al. 2008; Smooth 2010). By some metrics, growth in officeholding by women of color surpasses that of men of color; and women of color are better represented among people of color compared with White women among White legislators (Hardy-Fanta et al. 2006).

A "puzzle of participation," in which minority women's participation often exceeds expectations, is further proof that studies unique to women of color are needed (Brown 2014c; Smooth 2014). Unique stereotypes characterize the situation of minority women (Hill Collins 2000; McClain et al. 2005; McConnaughy and White 2011; Harris-Perry 2011; Ghavami and Peplau 2013). On the campaign trail, minority women face hurdles that can only be understood with reference to intersectionality (Brown 2014a, 2014b). And the strategies that minority women employ to present themselves and communicate with voters are distinct as well (Gershon 2008).

Pathways to Statewide Elective Executive Office

Across the 50 states there are over 300 statewide elective executive offices. While the governor is the most powerful and most studied office, the other offices are significant in their own right; they can also be credentials for bids for other offices including the office of governor and congressional office (Beyle 2011). Increasingly, these offices are attracting greater national interest as the two parties battle over the conduct of elections, including the adoption of voter identification laws; state politics have also arguably risen in importance as gridlock persists in national politics.

Data from the Center for American Women and Politics (CAWP) indicate that the presence of women of color as candidates and officeholders is on the rise. Today about 3.5 percent of all statewide officeholders are women of color (CAWP 2014b).[2]

Table 11.1 presents a table of the women of color who have held statewide elective executive office historically, organized by state.[3] Minority women have held a range of offices and hail from both major parties. Several features of the states in which women have served as statewide officials stand out. In particular, this table makes plain the exceptional status of New Mexico: women of color – all of whom have been Latinas – have been holding statewide office there since the early twentieth century. Meanwhile, in the other states there are never more than two cases of a woman of color holding statewide office. And, given that 17 states are represented in the table, the vast majority of the country is missing. By definition, most of the women listed in this table were "firsts" for their state because they were the very first minority woman to serve in a statewide elective executive office.

TABLE 11.1 Women of Color Statewide Elective Executive Officeholders: Previous Experience or Occupation

State	Name	Background	Dates	Party	Race/Ethnicity	Office
AZ	Sandra Kennedy	state legislator	2009–2012	D	Black	Corporation Commissioner
CA	March Fong Eu	state legislator	1975–1993	D	Asian American	Secretary of State
CA	Kamala Harris	district attorney	2011–	D	Multiracial	Attorney General
CO	Vikki Buckley	state employee	1995–1999	R	Black	Secretary of State
CT	Denise Nappier	city treasurer	1999–	D	Black	Treasurer
DE	Velda Jones Potter	Business	2009–2011	D	Black	Treasurer
FL	Jennifer Carroll	state legislator; Navy veteran	2011–2013	R	Black	Lt. Governor
HI	Mazie Hirono	state legislator	1995–2003	D	Asian American	Lt. Governor
HI	Jean Sadako King	state legislator	1979–1982	D	Asian American	Lt. Governor
IL	Evelyn Sanguinetti	city council	2015–	R	Latina	Lt. Governor
IN	Pamela Carter	deputy chief of staff	1993–1999	D	Black	Attorney General
IN	Karen Freeman-Wilson	city court judge; deputy prosecutor	2000–2001	D	Black	Attorney General
MT	Denise Juneau	education official	2009–	D	Native American	Supt. Public Instruction
NM	Dianna Duran	state legislator	2011–2015	R	Latina	Secretary of State
NM	Mary Herrera	county clerk	2007–2011	D	Latina	Secretary of State
NM	Patricia Madrid	district court judge	1999–2007	D	Latina	Attorney General

	Name	Prior office	Years	Party	Race/Ethnicity	Office
NM	Susana Martinez	county district attorney	2011–	R	Latina	Governor
NM	Clara Padilla Jones	county clerk	1983–1986	D	Latina	Secretary of State
NM	Rebecca Vigil-Giron	state government	1987–1990; 1999–2007	D	Latina	Secretary of State
NV	Catherine Cortez Masto	asst. county manager; federal criminal prosecutor	2007–2015	D	Latina	Attorney General
NV	Cheryl Lau	deputy attorney general	1991–1995	R	Asian American	Secretary of State
OH	Jennette Bradley	city council	2003–2005	R	Black	Lt. Governor
OH	Jennette Bradley	city council	2005–2007	R	Black	Treasurer
OR	Susan Castillo	state legislator	2003–2012	NP	Latina	Supt. Public Instruction
RI	Nellie Gorbea	deputy Secretary of State	2015–	D	Latina	Secretary of State
SC	Nikki Haley	state legislator	2011–	R	Asian American	Governor
WI	Velvalea "Vel" Phillips	city council; judge	1979–1983	D	Black	Secretary of State

Sources: CAWP; state websites; biographies; news stories; and other sources.

Notes

This table does not include early twentieth century cases (New Mexico Secretaries of State). Officials who served in an acting capacity are excluded. NP is nonpartisan.

New Mexico, as well as California and Hawaii, are somewhat obvious locations for minority women's success given that they lead the country in having racially diverse populations. State racial diversity predicts the greater likelihood of minority women's statewide officeholding, although there are many examples of states with sizable minority populations that have yet to see a woman of color in statewide office, as well as states lacking sizable minority populations that have experienced a "first" nonetheless (Sanbonmatsu 2013). Thus a state's diversity is predictive but neither a necessary nor sufficient condition (see chapter by Ramírez and Burlingame, this volume).

If one looks at the states where women of color have achieved statewide office unexpectedly, Florida, Ohio, and South Carolina stand out.[4] In the wake of Governor Mark Sanford's extramarital affair in 2010, Nikki Haley won a three-way primary and runoff to become the first woman and first person of color to serve as governor of South Carolina. I discuss Florida and Ohio below. All three of these cases involve Republican women.

The much stronger Democratic than Republican party loyalties of women and minorities, including women of color, are well-established (Tate 1994; Carroll 2014). For this reason, it is somewhat surprising that there are nine cases of statewide minority officeholding by Republican women compared with 17 for Democratic women. Indeed, the first women of color to achieve the office of governor in the United States were both Republicans: Haley in South Carolina and Susana Martinez in New Mexico. While the Republican party has become dominant in winning state executive elections in recent cycles, the vast share of women of color candidates who seek these offices are Democrats. Between 2000 and 2012, nearly 80 percent of women of color candidates were Democrats and only about 20 percent were Republicans (Sanbonmatsu 2015). The historic underrepresentation of women of color among Democratic state officials is striking.

Although I have largely treated women of color as a group, it is important to consider differences among women by race (Lien et al. 2008). That Black women are not better represented within the cases in this table is somewhat surprising given that Black women lead other women of color in state legislative and congressional representation (CAWP 2014b). Of course, it is true that all women of color are underrepresented. For example, only one Native American woman has ever held statewide office. And only four women of Asian descent have held statewide office in the continental United States. Thus, the success of Latinas in New Mexico stands out once again and in sharp relief to the situation of other groups of women.

The minority women in Table 11.1 exhibit as a group significant prior experience, which is not surprising in light of the visibility and competitiveness of these state offices. All but one woman had experience in local elective office, state legislative office, or local or state government. State legislative service, which characterizes eight minority women's backgrounds, was the single most common prior elective office experience.

That minority women can take a variety of pathways to statewide executive office is encouraging. Because minority women who have worked in local or state government have reached state office, elective officeholding is not a prerequisite. Thus, while it is common for scholars to predict officeholding for higher offices based on women's officeholding at lower levels, government service can lead directly to state officeholding.

Selection Method

A central question in understanding pathways to office is the method of selection. Past studies of women of color candidates typically focus on legislative contests and majority-minority districts. With state offices, the method of selection may differ across states. The electorate is usually different as well: in almost all states, winning state office means winning the support of a majority-White electorate. Perhaps as a result, minority women are worse represented in statewide than state legislative or congressional office (CAWP 2014b).

Table 11.2 revisits the cases from Table 11.1, although here I have organized the cases by race/ethnicity and added the selection method. I treat the New Mexico cases separately given the long history that Latinas have had in securing office in the state and the overrepresentation of New Mexico among the cases. I also exclude nonpartisan cases.

This examination of race and selection method reveals a potentially troubling pattern: that few Black women have reached statewide executive office through election on their own terms outside of states with party conventions. Black women achieved positions in Colorado, Connecticut, and Indiana by winning the nomination at a party convention. In two of three cases (Connecticut and Indiana), racial minorities do not comprise a large proportion of the state population. Meanwhile, in two other cases (in Delaware and Indiana, both involving Democratic women), Black women achieved office via appointment to fill a vacancy rather than by election.

Two cases in Table 11.2 involved a White male Republican gubernatorial candidate selecting a Black woman as his running mate. In Florida, candidate Rick Scott selected Jennifer Carroll to be his running mate in 2010; Carroll is a veteran and was the first Black female state legislator from the Republican party. Scott and Carroll narrowly won the election, making Carroll the first Black candidate to win election to statewide office and the first woman to be elected to the office of lieutenant governor. In the other case, Ohio Governor Bob Taft selected an African American city councilwoman, Jennette Bradley, as his running mate for his reelection bid in 2002. This selection occurred after the Democratic candidate Tim Hagan selected Charleta Tavares – who was also an African American city councilwoman – to be his running mate. In that case, the Republican ticket easily won the race.[5] Bradley became the first woman of color to hold statewide office in Ohio. While Taft subsequently appointed

TABLE 11.2 Women of Color Statewide Elective Executive Officeholders: Method of Selection

State	Name	Office	Selection	Dates	Party
Black women					
AZ	Sandra Kennedy	Corporation Commissioner	open seat	2009–2012	D
CA	Kamala Harris	Attorney General	open seat	2011–	D
CO	Vikki Buckley	Secretary of State	open seat; won party nominating convention	1995–1999	R
CT	Denise Nappier	Treasurer	challenger; won party nominating convention	1999–	D
DE	Velda Jones Potter	Treasurer	appointed	2009–2011	D
FL	Jennifer Carroll	Lt. Governor	selected as running mate	2011–2013	R
IN	Pamela Carter	Attorney General	open seat; won party nominating convention	1993–1999	D
IN	Karen Freeman–Wilson	Attorney General	appointed	2000–2001	D
OH	Jennette Bradley	Lt. Governor	selected as running mate	2003–2005	R
OH	Jennette Bradley	Treasurer	appointed	2005–2007	R
Asian women					
CA	March Fong Eu	Secretary of State	open seat	1975–1993	D
CA	Kamala Harris	Attorney General	open seat	2011–	D
HI	Mazie Hirono	Lt. Governor	open seat	1995–2003	D
HI	Jean Sadako King	Lt. Governor	open seat	1979–1982	D
NV	Cheryl Lau	Secretary of State	open seat	1991–1995	R
SC	Nikki Haley	Governor	open seat	2011–	R

Latina women (outside NM)

NV	Catherine Cortez Masto	Attorney General	open seat	2007–2015	D
IL	Evelyn Sanguinetti	Lt. Governor	selected as running mate	2015–	R
RI	Nellie Gorbea	Secretary of State	open seat	2015–	D

Native American women

MT	Denise Juneau	Supt. Public Instruction	open seat	2009–	D

Latina women (NM only)*

NM	Dianna Duran	Secretary of State	challenger	2011–2015	R
NM	Mary Herrera	Secretary of State	open seat	2007–2011	D
NM	Patricia Madrid	Attorney General	open seat	1999–2007	D
NM	Susana Martinez	Governor	open seat	2011–	R
NM	Clara Padilla Jones	Secretary of State	open seat	1983–1986	D
NM	Rebecca Vigil-Giron	Secretary of State	open seat	1987–1990; 1999–2007	D

Sources: CAWP; state websites; biographies; news stories; and other sources.

Notes

This table does not include early twentieth century cases (New Mexico secretaries of state). Officials who served in an acting capacity are excluded. This table only includes partisan offices. One officeholder, Kamala Harris, appears twice in this table because she is multiracial.

*NM combines the use of a party convention and primary election.

Bradley to another state position – Treasurer – she was not able to win the Republican party's nomination when her term expired. Karen Freeman-Wilson, a Democrat who was selected as Attorney General of Indiana to fill a vacancy, was also unable to win election subsequently, though her defeat came at the general election stage.

Thus a higher proportion of cases among Black women compared with other groups of minority women entailed reaching office via appointment to fill a vacancy, party endorsement through a statewide nominating convention, or selection as a running mate.

There is only one case among the remaining race/ethnic groups of women of color in which a woman reached office after being selected as a gubernatorial running mate. This occurred in 2014 when Evelyn Sanguinetti was selected to run with the Republican male nominee, Bruce Rauner, in Illinois.

Discussion

It is difficult to generalize across a relatively small number of cases. Nevertheless, this analysis of pathways reveals several important features of how women of color have reached statewide elective executive office to date.

First, there are differences among women of color by race. Black women, though they have typically been better represented in elective office compared with Asian and Latina women, seem to face unique challenges. Their underrepresentation in state office stands out because they have historically been the largest group of minority women.

Second, though minority women are disproportionately likely to identify as Democrats, many firsts have come for minority women as Republicans. The dominance of the Republican party in recent cycles may be a partial explanation. However, it is worth noting that half of the minority women who have held office as Republicans did so through appointment or selection to be the lieutenant governor candidate.

The successes of Republican women of color raise questions about why minority women have not fared better within the Democratic party. No woman of color has been elected governor on the Democratic side, and only in Hawaii have Democratic women of color served as lieutenant governor. Party differences also suggest the need to study voter reaction to Republican women of color candidates.

Third, if we set aside New Mexico and Hawaii, it is very unusual for Asian and Latina women to reach statewide executive office; and as mentioned previously, only one Native American woman has ever served. Governors of both parties have refrained from selecting women from these backgrounds to fill vacancies to statewide positions. Governors have, in three cases, appointed Black women to fill vacancies, though in none of these cases did the woman subsequently secure a full term.

A disproportionate percentage of Black women have reached office by means other than winning a statewide primary on their own terms (i.e., they have served as running mates, won the nomination at a party convention, or been appointed). These are somewhat atypical routes to office. Appointments to fill vacancies are unpredictable and do not seem to yield a subsequent term. Being the running mate is a pathway to a statewide position, but the office of lieutenant governor is not usually a particularly strong office.

The state convention relationship is interesting from the perspective of political party scholarship, although states using such nominating conventions are in the minority. Statewide nominating conventions appear to be a mixed blessing for women candidates of color. On one hand, conventions could provide an opportunity for party activists to rely on stereotypes as they assess potential candidates (Bos 2011). Party leaders can be expected to be more influential in nominating conventions than in a primary contest; and those leaders are likely to be skeptical about the statewide viability of women of color candidates (Sonenshein 1990; Niven 1998; Sanbonmatsu 2006; but see Oxley and Fox 2004). On the other hand, competing within the party ranks at a convention may be less expensive than running in a statewide primary. This aspect of conventions may aid women of color who as a group tend to be disadvantaged with respect to resources (Caul and Tate 2002; Johnson et al. 2012). This may help explain the few cases of success for Black women. Jewell (1984) finds that statewide nominating conventions provide the party with an opportunity to create a balanced slate. And while Jewell discussed balancing by ethnicity or region of a state, one can imagine the appeal of using the convention setting to try to balance on the dimensions of race and gender.

More research is needed on the candidacies of women of color for statewide office and the electoral conditions under which women of color can win the party nomination for a winnable race; the dearth of success stories seems to indicate a lack of informal or formal support for women of color prior to the primary contest (Sanbonmatsu 2015). One factor that likely shapes the dearth of candidates concerns campaign finance. Women of color lack the resources of other candidates and face fundraising hurdles for a statewide bid (Johnson et al. 2012; She Should Run 2012; Carroll and Sanbonmatsu 2013; Dittmar 2014a). The cost of running for office varies across states and statewide offices, making some offices more accessible than others. But the challenges of financing statewide campaigns for women of color, who are less likely to represent resourced constituents and groups and less likely to have personal means compared with non-Hispanic Whites, may make the prospect of a statewide campaign more daunting.

Thus, based on this initial analysis of pathways, the barriers that remain for women of color appear to be many. Once the state of New Mexico and selection method are taken into account, minority women seem to be even worse represented in statewide elective executive positions than it first appeared.

Conclusion

Recent years have seen record numbers of women of color seeking and holding statewide elective executive office. While many of these historic highs also capture the experience of women in statewide executive office, the persistence of minority women's underrepresentation in these offices is troubling. Women of color are taking a variety of pathways to these offices. But one state – the state of New Mexico – is home to the lion's share of cases. Future studies should focus on the challenges facing women in the remaining 49 states of the union. That non-Hispanic White women appear to have much greater access to statewide executive office than women of color means that minority women's situation seems to be hampering growth for women overall.

While past research has not considered the situation of women of color in achieving statewide executive office, such research is imperative in order to identify strategies for enhancing women's representation in these important offices. The small number of executive positions compared with legislative positions suggests a different type of strategy with respect to future growth.

The recruitment and support of minority women in racially diverse blue states, where the pool of minority women is larger and the electorate most conducive to nontraditional candidates, is one strategy. Another strategy, although perhaps not ideal, is to position women of color for running mate opportunities and appointments in all states.

Given the rise of the Republican party across states and its dominance of statewide positions, more Republican women of color may very well reach statewide office in the future. The small pool of minority women who identify as Republican should not be perceived to be a deterrent given that even one woman of color can represent a significant gain among the small number of statewide positions in a given state.

Women of color are heterogeneous and differ from one another in many respects. But they share the common situation of being underrepresented as statewide elective executives. As more women of color seek and hold these offices, other political actors – such as the media, voters, parties, interest groups, and donors – will become more accustomed to their presence.

Notes

1 I thank Gilda Morales at the Center for American Women and Politics for assistance and Nadia Brown and Sarah Gershon for their comments.
2 Between 1900 and 1999, non-Hispanic White women achieved at least one statewide elective executive office in 48 of 50 states; men of color 23 states (Martin 2001; Sanbonmatsu 2015); in only one case did a minority woman achieve a statewide office prior to a non-Hispanic White woman. Five of 15 cases of firsts for women of color were also firsts for people of color (Sanbonmatsu 2015).
3 I exclude statewide offices that are elected by district.
4 These cases were outliers in a multivariate analysis of party nominees (Sanbonmatsu 2013).

5 The first African American statewide officeholder in Ohio, Kenneth Blackwell, was appointed treasurer by Republican Governor George V. Voinovich in 1993, apparently after Jennette Bradley declined the appointment. Tavares had previously sought and lost a statewide bid. Democratic gubernatorial candidates (both Anglo men) had run with African American male running mates in 1994 and 1998, though the tickets were unsuccessful in both cases.

References

Barrett, E. J. (2001). Black Women in State Legislatures: The Relationship of Race and Gender to the Legislative Experience. In S. J. Carroll (Ed.), *The Impact of Women in Public Office* (pp. 185–204). Bloomington, IN: Indiana University Press.

Bejarano, C. (2013). *The Latina Advantage: Gender, Race, and Political Success.* Austin, TX: University of Texas Press.

Beltran, C. (2010). *The Trouble with Unity: Latino Politics and the Creation of Identity.* Oxford: Oxford University Press.

Beyle, T. (2011). Gubernatorial Elections, Campaign Costs and Powers. In *Book of the States 2011.* Lexington, KY: Council of State Governments.

Bos, A. (2011). Out of Control: Delegates' Information Sources and Perceptions of Female Candidates. *Political Communication,* 28 (1), 87–109.

Bratton, K. A., Haynie, K. L., and Reingold, B. (2006). Agenda Setting and African American Women in State Legislatures. *Journal of Women Politics & Policy,* 28 (3–4), 71–96.

Brown, N. (2014a). Black Women's Pathways to the Statehouse: The Impact of Race/Gender Identities. *National Political Science Review,* 16, 172–205.

Brown, N. (2014b). "It's More Than Hair … That's Why You Should Care": The Politics of Appearance for Black Women State Legislators. *Politics, Groups, & Identities,* 2 (3): 295–312.

Brown, N. (2014c). Political Participation of Women of Color: An Intersectional Analysis. *Journal of Women Politics & Policy,* 35 (4), 315–348.

Brown, N. (2014d). *Sisters in the Statehouse: Black Women and Legislative Decision Making.* New York, NY: Oxford University Press.

Carroll, S. J. (2014). Voting Choices: How and Why the Gender Gap Matters. In S. J. Carroll and R. L. Fox (Eds.), *Gender and Elections: Shaping the Future of American Politics, Third Edition* (pp. 119–145). New York, NY: Cambridge University Press.

Carroll, S. J. and Sanbonmatsu, K. (2013). *More Women Can Run: Gender and Pathways to the State Legislatures.* New York, NY: Oxford University Press.

Carroll, S. J. and Strimling, W. S. (1983). *Women's Routes to Elective Office: A Comparison with Men's.* New Brunswick, NJ: Center for the American Woman and Politics.

Caul, M. and Tate, K. (2002). Thinner Ranks: Women as Candidates and California's Blanket Primary. In B. E. Cain and E. R. Gerber (Eds.), *Voting at the Political Fault Line: California's Experiment with the Blanket Primary* (pp. 234–247). Berkeley, CA: University of California Press.

Center for American Women and Politics (CAWP). (2014a). 2014: Not a Landmark Year for Women and Politics, Despite Some Notable Firsts. Press Release. November 5. New Brunswick, NJ, Center for American Women and Politics (CAWP), Eagleton Institute of Politics, Rutgers University.

Center for American Women and Politics (CAWP). (2014b). Women of Color in Elective Office 2014. New Brunswick, NJ, Center for American Women and Politics

(CAWP), National Information Bank on Women in Public Office, Eagleton Institute of Politics, Rutgers University.

Cohen, C. (2003). A Portrait of Continuing Marginality: The Study of Women of Color in American Politics. In S. J. Carroll (Ed.), *Women and American Politics: New Questions, New Directions*. Oxford, UK: Oxford University Press.

Cohen, C. J. (1999). *The Boundaries of Blackness: AIDS and the Breakdown of Black Politics.* Chicago, IL: University of Chicago Press.

Crenshaw, K. (1989). Demarginalizing the Intersection of Race and Sex: A Black Feminist Critique of Antidiscrimination Doctrine, Feminist Theory and Antiracist Politics. *University of Chicago Legal Forum*, 129, 139–167.

Dittmar, K. (2014a). *Money in Politics with a Gendered Lens.* Joint Report by the Center for American Women and Politics and the National Council for Research on Women.

Dittmar, K. (2014b). *The Status of Black Women in American Politics.* A Report by the Center for American Women and Politics for Higher Heights.

Fraga, L. R., Lopez, L., Martinez-Ebers, V., and Ramírez, R. (2006/2007). Gender and Ethnicity: Patterns of Electoral Success and Legislative Advocacy among Latina and Latino State Officials in Four States. *Journal of Women Politics & Policy*, 28 (3–4), 121–145.

Fraga, L. R., Lopez, L., Martinez-Ebers, V., and Ramírez, R. (2008). Representing Gender and Ethnicity: Strategic Intersectionality. In B. Reingold (Ed.), *Legislative Women: Getting Elected, Getting Ahead* (pp. 157–174). Boulder, CO: Lynne Rienner.

Frederick, K. A. and Jeffries, J. L. (2009). A Study in African American Candidates for High-Profile Statewide Office. *Journal of Black Studies*, 39 (5), 689–718.

Gamble, K. (2010). Young, Gifted, Black, and Female: Why Aren't There More Yvette Clarkes in Congress? In A. Gillespie (Ed.), *Whose Black Politics? Cases in Post-Racial Black Leadership* (pp. 293–308). New York, NY: Routledge.

Garcia Bedolla, L., Tate, K., and Wong, J. (2014). Indelible Effects: The Impact of Women of Color in the U.S. Congress. In S. Thomas and C. Wilcox (Eds.), *Women and Elective Office: Past, Present, and Future*, Third Edition (pp. 235–252). New York, NY: Oxford University Press.

Gershon, S. A. (2008). Communicating Female and Minority Interests Online: A Study of Website Issue Discussion among Female, Latino and African American Members of Congress. *International Journal of Press/Politics*, 13 (2), 120–140.

Ghavami, N. and Peplau, L. A. (2013). An Intersectional Analysis of Gender and Ethnic Stereotypes: Testing Three Hypotheses. *Psychology of Women Quarterly*, 37 (1), 113–127.

Giddings, P. (1996). *When and Where I Enter: The Impact of Black Women on Race and Sex in America.* New York, NY: W. Morrow.

Hardy-Fanta, C., Lien, P., Pinderhughes, D. M., and Sierra, C. M. (2006). Gender, Race, and Descriptive Representation in the United States: Findings from the Gender and Multicultural Leadership Project. *Journal of Women Politics & Policy*, 28 (3–4), 7–41.

Harris-Perry, M. V. (2011). *Sister Citizen: Shame, Stereotypes, and Black Women in America.* New Haven, CT: Yale University Press.

Hawkesworth, M. (2003). Congressional Enactments of Race–Gender: Toward a Theory of Raced–Gendered Institutions. *American Political Science Review*, 97 (4), 529–550.

Hill Collins, P. (2000). *Black Feminist Thought: Knowledge, Consciousness, and the Politics of Empowerment* (Rev. 10th anniversary ed.). New York, NY: Routledge.

hooks, bell. 1984. *Feminist Theory from Margin to Center.* Boston, MA: South End Press.

Jewell, M. E. (1984). *Parties and Primaries: Nominating State Governors.* New York, NY: Praeger.

Johnson, G., Oppenheimer, B. I., and Selin, J. L. (2012). The House as a Stepping Stone to the Senate: Why Do So Few African American House Members Run? *American Journal of Political Science*, 56 (2), 387–399.

Junn, J. and Brown, N. (2008). What Revolution? Incorporating Intersectionality in Women and Politics. In C. Wolbrecht, K. Beckwith, and L. Baldez (Eds.), *Political Women and American Democracy* (pp. 64–78). New York, NY: Cambridge University Press.

King, D. K. (1988). Multiple Jeopardy, Multiple Consciousness: The Context of a Black Feminist Ideology. *Signs*, 14 (1), 42–72.

Lien, P., Hardy-Fanta, C., Pinderhughes, D. M., and Sierra, C. M. (2008). Expanding Categorization at the Intersection of Race and Gender: "Women of Color" as a Political Category for African American, Latina, Asian American, and American Indian Women. Paper presented at the Annual Meeting of the American Political Science Association, Boston, MA.

Martin, M. (2001). *The Almanac of Women and Minorities in American Politics, 2002.* Boulder, CO: Westview Press.

McClain, P. D., Carter, N. M., and Brady, M. C. (2005). Gender and Black Presidential Politics: From Chisholm to Moseley Braun. *Women and Politics*, 27 (1–2), 51–68.

McConnaughy, C. and White, I. (2011). Racial Politics Complicated: The Work of Gendered Race Cues in American Politics. Paper presented at the New Research on Gender in Political Psychology Conference, New Brunswick, NJ.

Niven, D. (1998). *The Missing Majority: The Recruitment of Women as State Legislative Candidates.* Westport, CT: Praeger.

Oxley, Z. M. and Fox, R. L. (2004). Women in Executive Office: Variation across American States. *Political Research Quarterly*, 57 (1), 113–120.

Philpot, T. S. and Walton, H. (2007). One of Our Own: Black Female Candidates and the Voters who Support Them. *American Journal of Political Science*, 51 (1), 49–62.

Prestage, J. L. (1977). Black Women State Legislators: A Profile. In M. Githens and J. L. Prestage (Eds.), *A Portrait of Marginality: The Political Behavior of the American Woman* (pp. 401–418). New York, NY: McKay.

Puwar, N. (2004). *Space Invaders: Race, Gender and Bodies Out of Place.* Oxford: Berg Publishers.

Reingold, B. and Smith, A. R. (2012). Welfare Policymaking and Intersections of Race, Ethnicity, and Gender in U.S. State Legislatures. *American Journal of Political Science*, 56 (1), 131–147.

Roth, B. (2004). *Separate Roads to Feminism: Black, Chicana, and White Feminist Movements in America's Second Wave.* Cambridge, UK: Cambridge University Press.

Sanbonmatsu, K. (2006). *Where Women Run: Gender and Party in the American States.* Ann Arbor, MI: University of Michigan Press.

Sanbonmatsu, K. (2013). The Candidacies of U.S. Women of Color for Statewide Executive Office. Paper presented at the Annual Meetings of the American Political Science Association, Chicago, IL.

Sanbonmatsu, K. (2015). Why Not a Woman of Color? The Candidacies of U.S. Women of Color for Statewide Executive Office. In D. King (Ed.), *Oxford Handbooks Online.* New York, NY: Oxford University Press [DOI: 10.1093/oxfordhb/9780199935307.013.43].

Scola, B. (2014). *Gender, Race, and Office Holding in the United States: Representation at the Intersections.* New York, NY: Routledge.

She Should Run (2012). *Vote with Your Purse: Lesson Learned: Women, Money, and Politics in the 2010 Election Cycle.* Washington, D.C.: WCF Foundation.

Smooth, W. (2001). *African American Women State Legislators: The Impact of Gender and Race on Legislative Influence.* University of Maryland, College Park. Ph.D. Dissertation.

Smooth, W. (2008). Gender, Race, and the Exercise of Power and Influence. In B. Reingold (Ed.), *Legislative Women: Getting Elected, Getting Ahead* (pp. 175–296). Boulder, CO: Lynne Rienner.

Smooth, W. (2010). African American Women and Electoral Politics: A Challenge to the Post-Race Rhetoric of the Obama Moment. In S. J. Carroll and R. L. Fox (Eds.), *Gender and Elections: Shaping the Future of American Politics* (pp. 165–186). New York, NY: Cambridge University Press.

Smooth, W. (2014). African-American Women and Electoral Politics: Translating Voting Power into Officeholding. In S. J. Carroll and R. L. Fox (Eds.), *Gender and Elections: Shaping the Future of American Politics* (pp. 167–189). New York, NY: Cambridge University Press.

Sonenshein, R. J. (1990). Can Black Candidates Win Statewide Elections? *Political Science Quarterly*, 105 (2), 219–241.

Tate, K. (1994). *From Protest to Politics: The New Black Voters in American Elections* (enl. ed.). New York, NY: Russell Sage Foundation.

Tate, K. (1997). African American Female Senatorial Candidates: Twin Assets of Double Liabilities? In H. Walton, Jr. (Ed.), *African American Power and Politics*. New York, NY: Columbia University Press.

Williams, L. F. (2001). The Civil Rights-Black Power Legacy: Black Women Elected Officials at the Local, State, and National Levels. In B. Collier-Thomas and V. P. Franklin (Eds.), *Sisters in the Struggle: African American Women in the Civil Rights-Black Power Movement* (pp. 306–331). New York, NY: New York University Press.

Windett, J. H. (2011). State Effects and the Emergence and Success of Female Gubernatorial Candidates. *State Politics and Policy Quarterly*, 11 (4), 460–482.

12

NEW EXPECTATIONS FOR LATINA STATE LEGISLATIVE REPRESENTATION

Christina E. Bejarano

There is increasing diversity in the make-up of our country and with our elected representatives, which is clearly highlighted in this volume. However, women and racial/ethnic minorities are still underrepresented in elected office, compared to their population numbers. As we strive for a more democratic government, we will need to elect many more diverse political representatives. The presence of more diverse officeholders will have multiple effects on the political environment, including differences in political leadership style and changes to government policy.

Researchers are challenged to provide explanations and assumptions for where we can find diverse political representatives. In particular, there are a variety of state-level political factors that are expected to influence the number of women and racial/ethnic minorities in state legislative office. However, this previous work usually does not focus on the political experiences of Latinas across the states. This chapter tackles a new set of questions to evaluate the state-level factors that can influence Latina political office-holding across the country. Where can we expect to find Latina state legislators? Do our standard expectations for women, minorities, and racial/ethnic minority women help explain where we find Latinas at state legislative office? If not, where shall we look to find Latina legislative representation?

To tackle the questions in this chapter, I first provide a review of the literature on the state-level political factors and the political representation of diverse groups. Next, I evaluate how Latinas experience the state-level political factors compared to their other female and Latino male counterparts. The analysis utilizes state-level characteristics to look for explanations of Latina state legislative representation in 2014. Overall, I find that Latina state legislative representation does not fit neatly with the traditional research models used to explain state variation for women, minority women, or Latino political representation.

State Variation and Women

There is a wide variation of female political descriptive representation in the U.S. state legislatures. Ramírez and Burlingame (Chapter 13) also highlight this variation of female and Latino representation in state legislative and local elected office. There are more women serving in state legislatures in the Northeast and West regions of the country and fewer women in the South. Scholars studying both variations across countries and across U.S. states commonly focus on three main groups of explanatory factors including structural, institutional, and cultural. Researchers (e.g., Arceneaux, 2001; Hogan, 2001; Norrander and Wilcox, 1998; Sanbonmatsu, 2002) have been able to successfully predict "the likelihood that women will hold state legislative office using various state-level and district measures, including voter demographics" (Sanbonmatsu, 2006a: 445).

Previous studies have pointed to a set of state-level institutional factors that contribute to more females in state legislatures, including states that have high turnover rates (Norrander and Wilcox, 1998), part-time and less professional legislatures (Hill, 1981; Nechemias, 1985; Rule, 1981; Squire, 1992), and multi-member districts (Arceneaux, 2001; Darcy et al., 1994, 1997; Hogan, 2001; Matland and Brown, 1992; Rule and Zimmerman, 1992; Welch and Studlar, 1990). High turnover rates, in particular, can create more open seat possibilities for women candidates, where women will not need to face a tough incumbent with a wealth of political advantages. This electoral opportunity is especially imperative since women are less likely than men to be incumbents (Sanbonmatsu, 2006a). There is still debate over the influence of term limits, which can arguably also provide a positive electoral situation for both females and minorities by opening up more critical open seat opportunities (Hodson et al., 1995; Jacobs, 1991; Thompson and Moncrief, 1993). However, researchers have not found strong support for the positive benefits of term limits for minority groups. Caress et al. examined election outcomes in four states and found that "the increase in minority membership of a legislative body is far more the result of a minority group's voting strength than the product of term limits" (2003: 194).

Cultural factors, including the characteristics of the state culture, can also either support or hinder women's active role in politics. For instance, Norris and Inglehart found "egalitarian attitudes toward women leaders are strongly related to the proportion of women elected to the lower houses of national parliaments" (2001: 134). The cultural factors that positively influence women's state legislative presence are less traditional gender role attitudes, a moralistic political culture, liberal political ideologies, and those with higher percentages of well-educated or urbanized electorates (Hill, 1981; Nechemias, 1987; Norrander and Wilcox, 2005; Rule, 1994). In terms of political culture, "moralistic" refers to one of Daniel Elazar's three classifications of how states govern and demonstrates states with political positions leaning more towards "achieving community minded purposes" (Mead 2004: 274).

There are also structural characteristics of a state that can significantly increase women's descriptive representation in politics, including large numbers of women in the workforce (Matland, 1998: Moore and Shackman, 1996; Paxton and Kunovich, 2003; Rule, 1981, 1987) and more women in professional occupations (Kenworthy and Malami, 1999; Norrander and Wilcox, 2005). In addition, there are six structural factors that can influence the pool of women candidates including availability of campaign money, time to devote to politics, "civic skills and community participation, education, work, and economic power" (Paxton and Hughes, 2007: 122).

State Variation and Minority Women

Researchers have also examined the state variation in racial/ethnic minority legislative representation. Racial/ethnic minorities benefit from single-member districts at the state and federal level (Grofman et al., 1992; Rule, 1994). The common assumption is that racial/ethnic minorities will also be successful in majority-minority districts (that include a majority of minority populations), which were created after the Voting Rights Act.

Research examining Black women's political chances for winning statewide elective offices (Darcy and Hadley 1988; Tate 1997), has found they are advantaged by their higher rates of running for office compared to White women, availability of more voter support, the potential to mobilize all women voters across racial barriers, new opportunities provided by the Voting Rights Act, and new majority-minority districts (García Bedolla et al., 2005: 167). Minority women can benefit from the creation of majority-minority districts, which make available more open seat opportunities (Smooth, 2006; Tate, 2003). However, as Sanbonmatsu's chapter reminds us, minority women are still drastically underrepresented in elective office, especially at the statewide elective executive posts. In particular, few women of color have reached statewide executive office through an election, which can highlight their obstacles attaining statewide electoral support and political party support (Prestage, 1977; Sanbonmatsu, 2006b).

Beyond the examinations of Black women or minority women in general, other researchers have also examined the political situation for Latina political candidates (Bejarano, 2013; Fraga et al., 2006; García, 2001; García et al., 2008; García Bedolla et al., 2005; Hardy-Fanta, 1993). Latinas can share some of the same political experiences as Black women. For example, Latina candidates can experience diminished disadvantages posed by their increased educational levels and increased political and community experience (Bejarano, 2013).

A few scholars (Barrett, 1995; Darcy and Hadley, 1988; Moncrief et al., 1991; Scola, 2006) have also examined how the standard set of state-level factors can influence the number of racial/ethnic minority women elected to state legislatures. Scola tested the predictive capacity of state-level variables that have commonly been used to explain percentages of female representation and

expanded the analysis to assess political representation of women of color (2006). She argues that the traditional state-level variables that influence White female political representation do not work equally well to explain political representation of women of color.

Scola found "women of color office holders are more likely to be present in Southern and Western legislatures, and White women office holders are located in Eastern and Midwestern States" (2006: 46). White women legislators tend to come from states with higher proportions of the electorate holding liberal ideologies and states classified as having Moralistic political cultures. While, "women of color are more likely to be present in states with higher per capita income and single member districts" (63).

Scola also notes that in states with a small proportion of minority legislators there are more women of color holding these seats, while the states with a larger percentage of minorities in the total legislature include fewer women of color (64). This research, however, does not parse out the influence of particular state-level factors for various groups of racial/ethnic minority women. We are left with the finding that minority women, as a group, do not conform to the same set of traditional predictions of how state-level variables explain White women's state legislative representation levels.

State Variation and Latinos

In terms of Latinos, Casellas found Latino legislative candidates "benefit from higher percentages of Latino citizens in the state, states that are more liberal, and the presence of citizen legislatures" (2010: 139). Contrary to expectations, Casellas also finds that Latino legislators benefit more from having more White constituents than Black constituents, so that there is evidence that "Latino legislators generally represent either majority-Latino districts or districts with White and Latino majorities" (140). As a consequence of these state factors, Latino candidates are provided the most political advantages in "Florida, New Mexico, and California, whereas the least conducive are the U.S. House and New York" (2010).

State Variation: Theory and Analysis

There are a variety of state-level political factors that are expected to influence the number of women and racial/ethnic minorities in state legislative office. However, this previous research either focuses on White women, an aggregate look at racial/ethnic minorities, or an aggregate look at racial/ethnic minority women. There are few previous studies that examine the distinct political experiences of Latinas across states.

This analysis evaluates how Latinas experience the state-level political factors compared to their other female and Latino male counterparts. The hypotheses

state that Latina legislators are expected to gain greater political representation in states (H1) with less professionalized legislatures, (H2) single-member districts, (H3) without term limits, (H4) with a liberal political ideology, and (H5) with higher percentage of Latino population.

State-Level Factors

This analysis utilizes state-level characteristics that are compiled in an original dataset for all 50 states. I include information on the 2014 legislative representation of all women (CAWP, 2014a), all racial/ethnic minority women (CAWP, 2014b), and all Latinos (NALEO, 2014). In 2014, there were 1,792 women state legislators or 24.3 percent of the total 7,383 legislators. There were also 377 minority women state legislators or 21 percent of the total women legislators. For Latinos, there was a total of 294 Latino state legislators, which included 97 Latina and 294 Latino male legislators.

To assess the influence of the type of state legislature itself: I include measures of legislative professionalization (Squire, 2007), legislative term limits (NCSL, 2009), the size of the legislature (number of seats) (NCSL, 2011), the use of multi-member districts (Kurtz, 2011), and the Democratic Party's control of the legislature in 2014 (NCSL, 2014). To assess the influence of the state: I include measures of region, state political culture (Mead, 2004), state political ideology (Medoff, 1997), state education level (U.S. Census Bureau, 2010), and the state per capita income (U.S. Census Bureau, 2010). I also include some specific measures of state diversity: the percentage of racial/ethnic group populations in the state (U.S. Census Bureau, 2012), the percentage of businesses in the state owned by women or Hispanic/Latinos (U.S. Census Bureau, 2010), as well as the measure for state distinction of ratifying the Equal Rights Amendment (Alice Paul Institute) or falling under protection of the Voting Rights Act (Leadership Conference on Civil/Human Rights).

Presence of Latino State Legislators

In this volume, Ramírez and Burlingame provide a look at women and Latino political representation in state legislative and local office from 1996 to 2011. They trace the rapid growth of Latinos in political office, which is most evident in a few specific states. In 2014, New Mexico had the highest number of Latino state legislators with 49; followed by Texas with 41, California with 27, and New York with 21. Six other states (Florida, Arizona, Illinois, Connecticut, Colorado, and New Jersey) include at least 10–18 Latinos in their state legislature.

A more thorough breakdown of Latino legislators includes a look at Latino males and females separately. In 2014, Latinas held a total of 97 seats in 26 state legislatures. The highest numbers of Latina legislators are located in New Mexico with 14, Texas with 11, and then Arizona and New Jersey with seven.

In comparison, Latino males held a total of 294 seats in 31 state legislatures. The highest numbers of Latino male legislators are located in New Mexico with 35, Texas with 30, and then California with 21. Overall, Latinas have fewer legislative seats than Latino males in the 37 states.

New Mexico and Texas are consistently among the top three in Latino legislative presence for both Latinas and Latino males. There is more variety in the states that are ranked in the remaining top ten slots for Latina and Latino male legislative representation. For Latinas, their top ten include New Jersey, Nevada, and Indiana. Meanwhile, the Latino male top ten includes Kansas.

The gender breakdown for the Latino legislative delegations for the top states, found in Figure 12.1, highlights this presence of Latina legislators across the states. Latinas represent a greater share of their Latino delegation in Nevada with 57.1 percent, and New Jersey with 70 percent. This is surprising given that women usually do not make up a majority of their state's legislative delegation. In fact, Colorado included the highest percentage of women legislators overall in 2014 with 41 percent women.

Latinas also represent high percentages of their Latino delegation in Arizona (38.9%), Massachusetts (40%), Colorado (41.7%), and Illinois (42.9%). Latinas comprise a smaller proportion of their group's legislative delegation in New Mexico (28.6%), Texas (26.8%), New York (23.8%), Connecticut (23.1%), California (22.2%), and Florida (16.7%). In addition, Latino males had no legislative seats in six states with Latina political presence. In other words, Latinas made up 100 percent of their Latino state delegation in Indiana, Louisiana, Maine, Minnesota, Tennessee, and Wisconsin. Meanwhile, Latinas had no legislative seats in 11 states with Latino male political presence (DE, GA, MI, MO,

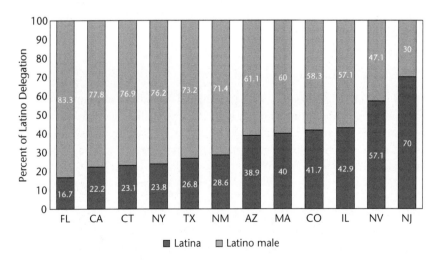

FIGURE 12.1 2014 Latino State Legislative Delegations, by Gender

NC, OH, OK, PA, VA, VT, WY). This shows we cannot expect to find Latinas and Latino males in all the same states.

We need to look more closely at the state-level factors that are related to Latino legislative representation for males and females. A quick look at the state-level factors provide few patterns that can help explain this state variation. The cultural factors that are present include a variety of state political cultures, where the majority appears to be individualistic culture in the northeast, Midwest, and western states. Latinas are also well-represented in the other Western and Southern states, which have both traditionalistic and moralistic political cultures. A majority of the states had Democratic controlled legislatures in 2014, which is one measure of liberal political ideology.

The institutional state factors show Latina legislators are located in states with both single-member and multi-member districts, however the majority of Latinas are located in the states with single-member districts. Latina legislators are also located in states that have term limits in place for their legislative membership including Arizona, California, Colorado, Florida, and Nevada. In addition, Latina legislators are found in states with both a high percentage of Latino population, New Mexico has 46.3 percent, as well as states with a much lower percentage of Latinos such as Indiana's 6 percent. In terms of state opportunities for diverse candidates, the top states for Latina legislators include those that have ratified the Equal Rights Amendment (ERA) and are protected by the Voting Rights Act (VRA).

It is also important to examine the gender dynamic among the Latino legislative district make-up. It is important to point out that research usually expects Latino state legislatures to represent majority-Latino or majority-minority districts (Casellas, 2010; Grofman et al., 1992; Rule, 1994). However, I find Latina legislators are just as likely as Latino male legislators to represent districts with less than 50 percent Latino populations (minority-Latino district). In terms of state house districts, there are more Latinas than Latino males representing minority-Latino districts in Connecticut (3), Indiana (3), New Mexico (7), New Jersey (4), New Hampshire (2), Nevada (2), and Utah (2). There is an even amount of Latino (male/female) state legislators that represent minority-Latino districts in California, Colorado, New York, Washington, Oregon, and Texas. For state senate districts, there are more Latinas than Latino males that represent minority-Latino districts in Minnesota (2), New Jersey (2), Massachusetts (1), and Utah (1). This finding highlights the ability of Latinas to attract more diverse voter coalitions in non-traditional states, which will be even more politically important as "the availability of majority minority districts continues to decline" (Smooth, 2006: 411).

Expectations for Presence of Women and Latino Legislators

Next, I move to a multivariate analysis, in Table 12.1, to examine the influence of the state-level factors on legislative representation of women and Latinos across all 50 states. The first three models test the standard explanatory models

TABLE 12.1 State Variation of Legislative Representation for Women and Latinos

	Total Women State Legislators (%)	Total Minority Women State Legislators (%)	Total Latino State Legislators (%)	Total Latina State Legislators (%)
Legislature:				
Professionalization	**−26.29**** (12.38)	−6.29 (5.95)	0.661 (6.54)	−2.08 (2.86)
Term Limits	3.85 (2.59)	−1.08 (1.24)	**−3.04**** (1.42)	**−1.27**** (0.609)
Multi-Member districts	**6.30**** (2.97)	1.46 (1.43)	**−5.34***** (1.58)	**−1.18*** (0.683)
Total # of Legislators	**0.303***** (0.023)	**0.032***** (0.011)	**0.031**** (0.012)	0.007 (0.005)
2014 Democratic Party Control	3.24 (3.47)	−1.90 (1.67)	**3.26*** (1.79)	**1.46*** (0.810)
State Characteristics:				
Southern Region	−5.11 (3.74)	−2.61 (1.80)	−1.64 (2.09)	−1.39 (0.894)
Western Region	4.26 (3.86)	−0.293 (1.85)	−2.14 (2.09)	−0.721 (0.914)
Moralistic culture	2.12 (3.44)	−2.30 (1.65)	0.622 (1.83)	0.102 (0.791)
Political Ideology (Liberal)	0.057 (0.088)	−0.021 (0.042)	−0.061 (0.047)	−0.018 (0.020)
State % BA degree	**1.14**** (0.539)	**0.499*** (0.259)	−0.098 (0.288)	−0.043 (0.124)
State Per Capita Income	−0.0001 (0.001)	**−0.001*** (0.0003)	0.00008 (0.0003)	0.00001 (0.0001)
ERA State	−0.310 (3.30)	1.67 (1.59)	**5.18***** (1.79)	1.08 (0.766)
VRA State	**−8.06**** (3.38)	**−2.86*** (1.63)	−1.59 (1.79)	−0.609 (0.778)
2010 % Black Population	0.114 (0.234)	**0.453***** (0.113)	0.131 (0.119)	0.069 (0.054)
2010 % Latino Population	**0.305*** (0.176)	**0.277***** (0.085)	**0.392*** (0.198)	**0.170*** (0.085)
2010 % Asian Population	0.153 (0.251)	**0.488***** (0.121)	0.033 (0.134)	0.024 (0.058)
2010 % Native American Population	0.147 (0.462)	**0.493***** (0.222)	**1.15***** (0.246)	**0.345***** (0.106)
2010 % Women Owned Firms	0.084 (0.822)	**0.839**** (0.395)	—	−0.080 (0.190)
2010 % Hispanic Owned Firms	—	—	**0.902***** (0.305)	0.147 (0.132)
Constant	−40.64* (21.34)	−23.63** (10.25)	−5.89 (6.00)	0.356 (5.03)
Adjusted R^2	0.8790	0.7209	0.8561	0.6947
N (states)	50	50	50	50

Notes

Significance:

 * $p <= 0.1$.

 ** $p <= 0.05$.

*** $p <= 0.01$.

Table entries are unstandardized regression coefficients; standard error appears in parentheses.

used to explain women's, minority women's, and Latino legislative representation. I add the fourth additional model to test the hypothesized expectations for Latina legislative representation. The four separate models provide a comparison across race/ethnicity and gender for the explanatory factors that can contribute to state legislative representation. The dependent variables include the total number of state legislators in 2014 for all women, all racial/ethnic minority women, all Latinos, and Latinas in particular. The models are estimated using ordinary least squares regression, with unstandardized regression coefficients and standard errors included in the table.

The first model tests the standard models used to explain women's representation in state legislatures. The findings support the previously mentioned literature in gender and politics. The results demonstrate that there are more female legislators in states that have less professionalized legislatures, multi-member districts, and legislatures with more seats. In addition, there are more female legislators in states that include a higher percentage of Bachelors (BA) degree holders, are not protected by the Voting Rights Act, and include a higher percentage of the Latino population.

The second model tests the standard expectations for racial/ethnic minority women state legislators. The findings do not generally support the previously mentioned literature on minority women in politics. In particular Scola's work (2006) argued that there is more representation for women of color in the states that are outside the South, have single-member districts, and have a higher state per capita income. In contrast, some of the findings are similar to women in general, since there are more minority women legislators in states with more total legislative seats, with a higher percentage of BA degree holders, states that are not protected by the Voting Rights Act, and include a higher percentage of Latino population. Compared with women, there are also more minority women legislators in states with a higher per capita income, a higher percentage of women-owned businesses, and higher percentage of all minority populations.

The third model tests the previous expectations for Latino (male/female) state legislative representation. The findings support the previously mentioned literature on Latino legislators (Casellas 2010). Latino's political presence is increased in the state legislatures that do not include term limits or multi-member districts, include more total seats, and are controlled by the Democratic Party. In terms of the state characteristics, there are more Latino legislators in states that previously ratified the Equal Rights Amendment, include a larger Latino and Native American population, and include more Hispanic-owned businesses. The state-specific factors point to increased diversity in the population, which can provide Latinos with more political support.

In terms of Latinas in particular, the fourth model test, there are more Latina legislators in the state legislatures with no term limits, single-member districts, and those that fall under Democratic Party control. In addition, there are more Latina legislators in states that include a larger Latino and American Indian

population. The findings almost mirror the results for Latinos; however Latina legislative representation does not seem to hinge on the number of legislative seats, the state ratification of the Equal Rights Amendment, or the number of Hispanic-owned businesses. In addition, the strength of the relationship for Latina legislators is smaller for the influence of multi-member districts, which can highlight the draw of women to multi-member districts.

Discussion

Overall, the results point to a different set of expectations regarding where to find Latina state legislators. This analysis of Latina legislative representation does not support the earlier Scola (2006) finding for minority women. Latina legislative representation also does not follow the previous gender research, where some of the state-level factors (legislative professionalization, state percentage of BA degree holders, and states that are protected by the Voting Rights Act) that explain female representation are not evident in the specific Latina case. This demonstrates a unique situation for the Latina state legislators, since they do not fit all the traditional models used to explain state variation for women, minority women, or Latino representation. Instead, Latinas are more likely to follow some of the explanations for overall Latino state legislative representation, which include the higher likelihood of finding them in single-member districts, with no term limits, a state liberal political ideology, and in areas of higher percentages of the Latino population.

It is important to note that Latina state legislators are also finding success attaining office in many non-traditional states across the country. We usually expect to find Latino state legislators in states that include a large Latino population; however this is increasingly not always true. Instead, we see Latinas attaining state legislative office in the South and Midwest, where the Latino population is growing. In fact, we find Latinas (and no Latino males) in Indiana, Louisiana, Maine, Minnesota, Tennessee, and Wisconsin (the small Latino population in these states range from 4.2 to 9.6 percent). In addition, Latina and Latino male legislators are able to break through and win office in districts that include a minority-Latino population. There are more Latinas than Latino males representing minority-Latino state house districts in Connecticut (3), Indiana (3), New Mexico (7), New Jersey (4), New Hampshire (2), Nevada (2), and Utah (2). This demonstrates that Latinas are able to attract the required voter support from areas that are not majority-Latino.

Moreover, Latinas are representing a large share of their Latino delegations in several states. Latinas make up 70 percent of the Latino delegation in New Jersey and 57.1 percent in Nevada. This is contrary to our expectations, since women do not make up more than 41 percent of a state's legislature. Future research can examine the growing influence of Latina descriptive representation on both voter behavior and substantive representation (or the policy impact).

All of the results highlight the unexpected explanations for Latina state legislative representation. Other researchers in this volume demonstrate that Latina officeholders face a different set of electoral conditions (Ramírez and Burlingame, Chapter 13) and different pathways to political office (Sanbonmatsu, Chapter 11). In addition, Cargile's chapter also reminds us that minority women can face a different set of campaign obstacles, due to their more novel candidacies that result in less knowledge of their strengths and the voter's reliance on possible negative stereotypes. Overall, much more research is needed to fully appreciate and understand the political factors that are impacting Latina success in political office. Researchers are challenged to engage in more analysis to adequately catch up to the increasing strides of minority women attaining electoral office.

References

Alice Paul Institute. "Thirty-Five States Have Ratified the Equal Rights Amendment." www.equalrightsamendment.org/ratified.htm (retrieved August 2011).

Arceneaux, Kevin. 2001. "The 'Gender Gap' in State Legislative Representation: New Data to Tackle an Old Question." *Political Research Quarterly* 54: 143–160.

Barrett, Edith J. 1995. "The Policy Priorities of African American Women in State Legislatures." *Legislative Studies Quarterly* 20: 223–247.

Bejarano, Christina. 2013. *The Latina Advantage: Gender, Race, and Political Success*. Austin, TX: University of Texas Press.

Caress, Stanley M., Charles Elder, Richard Elling, Jean-Philippe Faletta, Shannon K. Orr, Eric Rader, Marjorie Sarbaugh Thompson, John Strate, and Lyke Thompson. 2003. "Effect of Term Limits on the Election of Minority State Legislators." *State and Local Government Review* 35: 183–195.

Casellas, Jason Paul. 2010. *Latino Representation in State Houses and Congress*. Cambridge: Cambridge University Press.

CAWP (Center for the American Woman and Politics). 2014a. "Women in State Legislatures, 2014." Fact sheet. New Brunswick, NJ: Eagleton Institute of Politics, Rutgers University.

CAWP (Center for the American Woman and Politics). 2014b. "Women of Color in Elective Office, 2014." Fact sheet. New Brunswick, NJ: Eagleton Institute of Politics, Rutgers University.

Darcy, Robert, and Charles D. Hadley. 1988. "Black Women in Politics: The Puzzle of Success." *Social Science Quarterly* 69: 629–645.

Darcy, R., Susan Welch, and Janet Clark. 1994. *Women, Elections, and Representation*, 2nd ed. Lincoln: University of Nebraska Press.

Darcy, Robert E., Charles Hadley, and Jason F. Kirksey. 1997. "Election Systems and the Representation of Black Women in American State Legislatures." In *Women Transforming Politics: An Alternative Reader*, ed. Cathy J. Cohen, Kathleen B. Jones, and Joan C. Tronto (pp. 447–455). New York: New York University Press.

Fraga, Luis, Linda Lopez, Valerie Martinez-Ebers, and Ricardo Ramírez. 2006. "Gender and Ethnicity: Patterns of Electoral Success and Legislative Advocacy Among Latina and Latino State Officials in Four States." *Journal of Women, Politics & Policy* 28(3–4): 121–145.

García, Sonia R. 2001. "Motivational and Attitudinal Factors amongst Latinas in U.S. Electoral Politics." *NWSA Journal* 13: 112–122.

García, Sonia R., Valerie Martinez-Ebers, Irasema Coronado, Sharon A. Navarro, and Patricia A. Jaramillo. 2008. *Políticas: Latina Public Officials in Texas.* Austin, TX: University of Texas Press.

García Bedolla, Lisa, Katherine Tate, and Janelle Wong. 2005. "Indelible Effects: The Impact of Women of Color in the U.S. Congress." In *Women and Elective Office: Past, Present, and Future*, ed. Sue Thomas and Clyde Wilcox. Oxford: Oxford University Press.

Grofman, Bernard, Lisa Handley, and Richard G. Niemi. 1992. *Minority Representation and the Quest for Voting Equality.* Cambridge: Cambridge University Press.

Hardy-Fanta, Carol. 1993. *Latina Politics, Latino Politics: Gender, Culture, and Political Participation in Boston.* Philadelphia, PA: Temple University Press.

Hill, David B. 1981. "Political Culture and Female Political Representation." *Journal of Politics* 43(1): 159–168.

Hodson, T., R. Jones, K. Kurtz, and Gary F. Moncrief. 1995. "Leaders and Limits: Changing Patterns of State Legislative Leadership under Term Limits." *Spectrum: The Journal of State Government* 68: 6–15.

Hogan, Robert E. 2001. "The Influence of State and District Conditions on the Representation of Women in U.S. State Legislatures." *American Politics Research* 29: 4–24.

Jacobs, Paul. 1991. *Term Limits in America.* Washington, D.C.: Cato Press.

Kenworthy, Lane and Melissa Malami. 1999. "Gender Inequality in Political Representation: A Worldwide Comparative Analysis." *Social Forces* 78(1): 235–268.

Kurtz, Karl. 2011. "The Declining Use of Multi-Member Districts: The Thicket at State Legislatures." July 13. http://ncls.typepad.com/the_thicket/2011/07/the-decline-in-multi-member-districts.html (retrieved September 2011).

Leadership Conference on Civil and Human Rights and the Leadership Conference Education Fund. "States Affected by the Voting Rights Act." www.civilrights.org/voting-rights/vra/map.html (retrieved August 2011).

Matland, Richard E. 1998. "Women's Representation in National Legislatures: Developed and Developing Countries." *Legislative Studies Quarterly* 23(1): 109–125.

Matland, Richard E. and Deborah Dwight Brown. 1992. "District Magnitude's Effect on Female Representation in U.S. State Legislatures." *Legislative Studies Quarterly* 17(4): 469–492.

Mead, Lawrence M. 2004. "State Political Culture and Welfare Reform." *Policy Studies Journal* 32: 271–296.

Medoff, Marshall H. 1997. "The Political Implications of State Political Ideology: A Measure Tested." *American Journal of Economics and Sociology* 56: 145–158.

Moncrief, Gary, Joel A. Thompson, and Robert Schuhmann. 1991. "Gender, Race, and the State Legislature: A Research Note on the Double Disadvantage Hypothesis." *Social Science Journal* 28: 481–487.

Moore, G. and G. Shackman. 1996. "Gender and Authority: A Cross-National Study." *Social Science Quarterly* 77: 273–288.

National Association of Latino Elected Officials (NALEO) Educational Fund. 2014. "National Directory of Latino Elected Officials." February.

National Conference of State Legislatures. 2009. "The Term Limited States." www.ncsl.org/default.aspx?tabid=14844 (retrieved August 2011).

National Conference of State Legislatures. 2011. "Number of State Legislators and Length of Terms." www.ncsl.org/default.aspx?tabid=22258 (retrieved August 2011).

National Conference of State Legislatures. 2014. "2014 State and Legislative Partisan Composition." www.ncsl.org/research/about-state-legislatures/partisan-composition. aspx (retrieved February 2015).

Nechemias, Carol. 1985. "Geographic Mobility and Women's Access to State Legislatures." *The Western Political Quarterly* 38: 119–131.

Nechemias, Carol. 1987. "Changes in the Election of Women to U.S. State Legislative Seats." *Legislative Studies Quarterly* 12(1): 125–142.

Norrander, Barbara and Clyde Wilcox. 1998. "The Geography of Gender Power: Women in State Legislatures." In *Women and Elective Office: Past, Present, and Future*, ed. Sue Thomas and Clyde Wilcox. Oxford: Oxford University Press.

Norrander, Barbara and Clyde Wilcox. 2005. "Change in Continuity in the Geography of Women State Legislators." In *Women and Elective Office: Past, Present, and Future*, ed. Sue Thomas and Clyde Wilcox (pp. 176–196). Oxford: Oxford University Press.

Norris, Pippa and Ronald Inglehart. 2001. "Cultural Obstacles to Equal Representation." *Journal of Democracy* 12: 126–140.

Paxton, Pamela and Melanie M. Hughes. 2007. *Women, Politics, and Power: A Global Perspective*. Thousand Oaks, CA: Pine Forge Press.

Paxton, Pamela and Sheri Kunovich. 2003. "Women's Political Representation: The Importance of Ideology." *Social Forces* 82(1): 87–113.

Prestage, J. L. 1977. Black Women State Legislators: A Profile. In *A Portrait of Marginality: The Political Behavior of the American Woman*, ed. M. Githens and J. L. Prestage (pp. 401–418). New York: McKay.

Rule, Wilma. 1981. "Why Women Don't Run: The Critical Contextual Factors in Women's Legislative Recruitment." *Western Political Quarterly* 34(1): 60–77.

Rule, Wilma. 1987. "Electoral Systems, Contextual Factors, and Women's Opportunity for Election to Parliament in Twenty-Three Democracies." *Western Political Quarterly* 40: 477–498.

Rule, Wilma. 1994. "Women's Underrepresentation and Electoral Systems." *PS: Political Science and Politics* 27: 689–692.

Rule, W. and J. F. Zimmerman. 1992. *United States Electoral Systems: Their Impact on Women and Minorities*. New York: Praeger.

Sanbonmatsu, Kira. 2002. "Gender Stereotypes and Vote Choice." *American Journal of Political Science* 46: 20–34.

Sanbonmatsu, Kira. 2006a. "Do Parties Know That 'Women Win'? Party Leader Beliefs about Women's Electoral Chances." *Politics and Gender* 2: 431–450.

Sanbonmatsu, Kira. 2006b. *Where Women Run: Gender and Party in the American States*. Ann Arbor, MI: University of Michigan Press.

Scola, Becki. 2006. "Women of Color in State Legislatures: Gender, Race, Ethnicity, and Legislative Office-Holding." *Journal of Women, Politics, and Policy* 28: 43–70.

Smooth, Wendy G. 2006. "Intersectionality in Electoral Politics: A Mess Worth Making." *Politics & Gender* 2: 400–414.

Squire, Peverill. 1992. "The Theory of Legislative Institutionalization and the California Assembly." *Journal of Politics* 54: 1026–1054.

Squire, Peverill. 2007. "Measuring State Legislative Professionalism: The Squire Index Revisited." *State Politics and Policy Quarterly* 7: 211–227.

Tate, Katherine. 1997. "African American Female Senatorial Candidates: Twin Assets or Double Liabilities?" In *African American Power and Politics*, ed. Hanes Walton (pp. 264–281). New York: Columbia University Press.

Tate, Katherine. 2003. *Black Faces in the Mirror: African Americans and Their Representatives in the U.S. Congress.* Princeton, NJ: Princeton University Press.

Thompson, Joel A. and Gary F. Moncrief. 1993. "The Implications of Term Limits for Women and Minorities: Some Evidence from the States." *Social Science Quarterly* 72(2): 300–309.

U.S. Census Bureau. 2008–2012 American Community Survey: 5 year estimates. (retrieved February 2015).

Welch, Susan and Donley T. Studlar. 1990. "Multimember Districts and the Representation of Women: Evidence from Britain and the United States." *Journal of Politics* 52(2): 391–412.

13

THE UNIQUE CAREER PATH OF LATINA LEGISLATORS, 1990–2010

Ricardo Ramírez and Carmen Burlingame

Introduction

The Latino population has experienced dramatic growth since 1970 and edged past African Americans as the largest minority group in 2001. By 2060, it is estimated that approximately 29 percent of the population will be Latino (Colby and Ortman 2015). With continued population growth, it is believed that the size of the Latino electorate and its influence in elections will also emerge (Bowler and Segura 2012). The view that "demography is destiny" with respect to the presence of Latino voters at the polls, leads some to question whether a similar pattern will occur with increasing numbers of Latinos and Latinas in elected office.[1] Political incorporation vis-à-vis elected office, however, should not be taken for granted. If the trajectory and experience of African American political representation is instructive, both Latinos and Latinas pursuing public office may face substantial barriers that delay levels of descriptive representation (Ramírez and Fraga 2008).

While it is not clear whether the barriers faced by African Americans are directly comparable to those that Hispanic men and women face as ethnic minorities, it is important to consider structural impediments to elected office that affect multiple minority constituencies. It is also important to contemplate the factors that have affected the overall underrepresentation of women in the elected office. Change in the rate of women in elected office has shed light on the noticeable lack of consensus between earlier studies that attributed women failing to achieve parity in descriptive representation because of bias among voters and more recent studies that focus on women's lower levels of political ambition. Lawless and Fox (2010) have made the case that when women run under similar electoral conditions, they win at comparable rates as males.

202 R. Ramírez and C. Burlingame

Accordingly, women's categorical underrepresentation ensues when there are not enough women running for office to fill the political pipeline from local level politics to the national level. Lawless and Fox (2010) have contributed greatly to the body of knowledge on the role of gender and pathways to elected office through their unique panel study of potential candidates for office that emphasizes gendered differences in ambition for political office. However, as Carroll and Sanbonmatsu (2013) note, it is possible that the ambition-based model is incomplete in understanding the role that gender plays in officehold-ing. There is reason to believe that something else may be at play when consid-ering the experience of racial and ethnic minority women. This chapter, like the recent work of Carroll and Sanbonmatsu, examines successful Latina state and local office holders to trace their political careers when compared to their male counterparts.

Our interest in the career paths of Latina elected officials stems from the unique patterns of representation among Latina and Latino elected officials. While there are more Latinos than Latinas in all elected positions, evidence from the 1990s to the mid-2000s suggests that the gender disparity is less stark for Latina and Latino elected officials than among their White counterparts (Bejarano 2013; Fraga et al. 2008a; Lien et al. 2008). One possible explanation for the relatively favorable outcome for Latinas could be that they exhibit greater ambition to seek elected office and that Latinas benefit from a strategic advantage where the intersection of race and ethnicity leads to increased support for Latinas (Bejarano 2013; Fraga et al. 2008b). It is also possible that there is a greater pool of potential candidates that makes Latinas more successful, further enhanced by the geographic concentration of the overall Latino population. Over three-quarters of all Latinos are concentrated in ten states: Arizona, Cali-fornia, Colorado, Florida, Illinois, New Jersey, New Mexico, Nevada, New York, and Texas (Ramírez 2013). Fraga et al. (2008a) find that from 1990 to 2004 Latinas were more successful than White women in four of the states where Latinos constitute a larger share of the state population (Arizona, Cali-fornia, New Mexico, and Texas). Similarly, Casellas (2011) finds greater levels of success among Latinas than White women in the 2004 election. Bejarano (2013) included analysis of women in nine of these ten states in 2005 and 2009 and found similar outcomes. In addition to examining the implications of state characteristics on Latina legislative representation in two time periods, Bejarano considers case studies of California and Texas in 2004, focusing on issues of can-didate quality, further emphasizing the possibility of a "Latina advantage" when running for office. The possible "advantage" does not appear to be exclusive to Latinas. Scola (2013) finds that, relative to their respective male counterparts, "women of color" legislators have achieved greater gender parity than White women.

We expand this consideration into the top ten states where the Latino popu-lation resides in the 1990s and through the 2010 election. Does the pattern

identified by multiple scholars hold true in this expanded pool of states and the increased time period? Given the continued influx of Latinos in the population and electorate, it is important to understand whether the gendered patterns identified are election-specific or consistent across time. If things have changed, we must also understand what is changing those dynamics. Thus, we seek to provide an update to the existing research on the success of Latinas in elected office as a basis for understanding how these bourgeoning legislators may shape the nature of state legislative bodies. We expect that Latinas, given geographic concentration of their co-ethnics in ten states, will continue to do better than their female white counterparts.

For the purpose of this chapter, we want to consider whether the career paths of Latinas in state legislatures sheds light on why there appears to be a smaller representational disparity among Latinas. The remainder of the chapter is divided into four sections. The first reviews the research on women and representation as well as explanations for the patterns of Latina officeholding. The second section describes the case selection and data used for the analysis. We then discuss the patterns of representation and analyze unique career paths of Latina state legislators in the third section and the final section concludes.

Women's Historic Underrepresentation in Politics

Some studies suggest that institutional barriers impose challenging hurdles for women in the United States when compared to countries with different elect-oral processes (Norris 2006). In the United States, the lower house of Congress is elected based on a single-member district voting system, where only the top vote-getter's party receives the electoral votes for that district (Duverger 1972). This has been shown to have a significant influence on female candidates who may be a close-runner up in a district, but then ultimately have no voice after losing an election (Welch and Studlar 1990). The impact of having a proportional electoral system, as opposed to a majoritarian system (as in the United States), can double the likelihood a woman has of winning office (Norris 2006). Welch and Studlar (1990) examine women's representation in the United States in comparison with Britain while Matland and Studlar (1996) consider these trends in Canada and Norway. Both studies show that while women in the United States are at a disadvantage based on their electoral system, there are several other factors that explain their relative disadvantage to countries with multi-member districts beyond the electoral system.

In addition to structural barriers, early work on women's underrepresentation in politics focused on bias that voters may have toward female candidates (Welch and Sigelman 1982). More recent literature suggests that the explicit bias of voters has dissipated (Darcy et al. 1994; Uhlaner and Schlozman 1986). While there may not be widespread explicit bias against female candidates in the electorate, patterns of recruitment by party organizations may be a result of

existing patriarchal values that are still held by party elites (Niven 1998; Sanbon-matsu 2002, 2006). The same elite bias may be the rationale behind the explicit and continued recruitment of male candidates as opposed to potential female candidates. Lawless and Fox (2010) find that regardless of political party, female candidates are less likely to be recruited for office, recruited less intensely, or are less likely to be recruited by multiple individuals. Recruitment into office is indeed important, as it has been shown at the state level, that being asked to run for office was the reason that more than half of successful female office holders chose to begin campaigns (Carroll and Sanbonmatsu 2013). Beyond the bias that female candidates may face among the electorate and party elites, an additional attitudinal barrier remains: women's lack of ambition to seek elected office. Prospective female candidates for public office, identified through holding careers in professions most likely to produce elected officials, are much less likely to be aware of their qualifications and to consider running for public office despite having the same degree of electoral interest and involvement. As such, political ambition is more significant than having contact with women's organizations and childcare responsibilities (Lawless and Fox 2005). It is important to note that Carroll and Sanbonmatsu's analysis of the growth in the number of female state-legislative office holders between 2001 and 2008 suggests that conforming to a traditional (masculinized) pathway toward public office may be an unnecessary prerequisite for females to gain state legislative office (2013).

Intersection of Race and Gender

Challenges of racial threat may be even more severe than the biases that women either implicitly or explicitly receive as potential candidates for office. While the passage of the 15th amendment occurred 50 years prior to women receiving legal enfranchisement, Blacks and Latinos in the United States were subject to many exclusionary practices (such as Jim Crow Laws, poll taxes, and grandfather clauses) that remained in place until after the Civil Rights Era of the 1960s. As such, coupled together, there were few things in the early-mid twentieth century that could impede a successful election more than being a minority female as the intersection of their race/ethnicity and gender created multiple disadvantages for these individuals, and in fact this may remain true today. The Immigration and Nationality Act of 1965 abolished the national origins quota that was in place and led to a significant influx of immigrants from Asian and Latin America. Racial and ethnic minorities also have an increasingly hard time being elected and are significantly underrepresented when compared to their share of the population (Shea et al. 2013), yet the gender representation disparity is smaller among Blacks, Latinos, and Asian Americans than their White counterparts.

The majority of research that has been conducted on the intersection between race/ethnicity and gender has treated Latinas and Black women in the

same category with Asian women and American Indian women (Lien et al. 2008). While it might be tempting to discuss the aggregate patterns of "women of color" as a heuristic, there is some evidence that there are distinct factors such as geographic concentration that uniquely impact each of these groups to such factors as attitudinal barriers to leadership (Lien et al. 2008).

Disaggregating the gender gap of elected women beyond the categories white and "women of color" provides further rationale for studying these groups separately. While the "women of color" category showed a 12-point percentage gap above White women (proportional to their racial/ethnic group), Black women and Asian American women were more successful than Latinas; holding 38.4 percent, 36.6 percent, and 31.6 percent of their respective racial groups' elected seats (Scola 2013). The increased electoral success of Black women is especially of interest when compared to Masouka and Junn's (2013) racial hierarchy model, that makes the case that some ethnic groups are more welcome in American society. Their model, as depicted by a rhombus shape, shows Whites at the top, followed by Asian Americans, then Latinos, and finally Blacks at the least favorable position. It is quite interesting that one could make the case that the rhombus is inverted with Black women succeeding more than women of other groups, followed by either Asian American women or Latinas, and finally White women experiencing the greatest gender disparity in terms of elected office. This presents a compelling reason to study the success of Latina elected officials given that the Latino population as a whole is not as disadvantaged on a variety of socio-economic indices when compared to Blacks, but consistently are less incorporated politically in both the voting and elected office. The "women of color" term, as a category, is too expansive because it ignores the nuances of particular racial and ethnic groups, as well as further emphasizing the point that there is not one particular pipeline that leads women into successful officeholding.

Understanding the Unique Qualities of Latina Office Holders

Many of the issues that have been addressed previously pertaining to barriers that female office seekers face should have a similar impact on Latinas as they do women as a whole in the United States. While Latinas are subject to the same institutional structures that impact women as a whole, Casellas (2009) finds that term limits do not increase Latina representation, nor does having a professional legislature. Recent research on attitudes toward Latinas suggests that relative to their male counterparts, Latinas may be able to gain a strategic advantage as their gender may soften racial threat that exists, leading them to have an advantage over male Latinos (Bejarano 2013). It is also the case that the unique focus on substantive policy, their gender inclusivity, and their multiple identities create a strategic intersectionality that helps explain Latina electoral success (Fraga et al. 2008a, 158). Latinas also place greater effort on representing the interests of multiple

minority groups and building consensus in both the Latino caucus and legislature as a whole (Fraga et al. 2008b; Garcia and Marquez 2001). Consensus building, according to Carroll and Sanbonmatsu (2013), is an expectation placed on women office seekers. Paradoxically, it is possible that Latinas may be better positioned to seek public office, as evidenced by the higher candidate quality characteristics of Latina state legislative candidates (Bejarano 2013). Indeed, it appears that Latinas have great confidence in overcoming the risks (such as fundraising) when seeking office. Garcia and Marquez (2001) suggest that the greater confidence may be due to previous electoral success, but it is not clear whether Latinas who have not held previous elected office have lower levels of confidence or fundraising ability. In addition to issues of candidate-quality fundraising ability, and expectation of consensus-building, much of the extant literature focuses on the lack of recruitment to explain the underrepresentation of women in legislatures (Carroll and Sanbonmatsu 2013; Fox and Lawless 2010; Lawless and Fox 2005, 2010). Not surprisingly, Casellas (2011) finds that "none of the Latinas representing districts without a Latino majority was actively recruited by party leaders" (p. 186), thereby perpetuating the "old boys club" process of selecting and nominating potential office holders, though it is not clear if this is due to ethnicity or gender of those Latinas who represent these districts. It is important to further identify whether the particular career path of Latinas complements the existing findings that Latinas have more favorable candidate qualities and are better able to overcome fundraising challenges as a means to overcome their lack of recruitment. The fact that Latinas are successful in these electoral conditions, when they should be facing the most challenging elections, points to the need to determine what makes these office holders unique.

In addition to candidate-specific characteristics, Latinas may benefit from more recent increases in Latino electoral presence due to spatial concentration. As of the 2010 Census, 78 percent of the Latino population is concentrated in ten states ranging from 15.8 percent Latino composition in Illinois to 46.3 percent in New Mexico (Ramírez 2013). While Latino elected legislators should not be viewed monolithically (Rouse 2013), it is nevertheless evident that electoral environments with a substantial proportion of Latinos creates favorable electoral conditions for Latino legislators generally, and Latinas in particular (Bejarano 2013; Casellas 2011; Fraga et al. 2008; Scola 2013). The assumption that Latinas are prone to more sexism or *machismo* than their White counterparts does not seem to translate to comparatively greater gender inequality in elected office. In fact, while Latinas have not achieved gender parity, in 2004 Latinas were more successful than women as a whole in their respective states in Arizona, California, and Texas, and were on par with all women in New Mexico. The continued growth of the Latino population will undoubtedly impact the total number of Latino elected officials, though it is unclear whether the Latina advantage over their White female counterparts will expand to all state contexts. For additional research on the state-level implications of Latina electoral representation, see Chapter 12 by Bejarano.

Electoral Success in State Legislatures

There are a number of justifications for studying Latinas in state legislatures, as opposed to other levels of elective office. The most straightforward reason is purely based on the small number in most levels of elected office. Latinas only hold nine of the 535 seats in the 114th Congress and only 4 Latinas hold position in a statewide elected office.[2] For a more thorough analysis of statewide executive office holding, see Chapter 11 by Sanbonmatsu. Of the 100 largest cities, only two are represented by Latina mayors. The numbers are more promising in state legislatures. As of the 2014 election Latinas hold 88 state legislative seats, comprising 5 percent of all women state legislators and over 29 percent of all Hispanics elected to state legislatures. While that raw number is small, this is the area where Latinas as a percent of all Hispanic elected officials have been most successful relative to their White women counterparts. If Latinas follow similar career trajectories as White women generally, then having presence in the state legislature could be a step toward achieving higher electoral office. One important aspect of candidate-quality and the "Latina advantage" raised by Bejarano (2013) has to do with Latinas having previous political experience. However, this is measured as having run for office previously but does not test specifically for previous elected office experience for state legislators. Our primary interest is to test for the possibility of a unique Latina career path, where Latinas are distinct from their male counterparts with respect to the extent that local officeholding experience (i.e., school board, city council, and county-level office) serves as the springboard for election to the state legislature.

Data and Case Selection

As stated previously, more than 75 percent of the Latino population is concentrated within ten states: Arizona, California, Colorado, Florida, Illinois, New Jersey, New Mexico, Nevada, New York, and Texas (Ramírez 2013). More thorough analysis shows that in 1996, 98.11 percent of all male and female Latinos elected to local public office came from these ten states. Despite a slight 3 percent drop to 96.18 percent in 2006, the vast majority of all Latino local elected officials were elected in these ten states.

In order to assess the career paths of Latinas compared to their male counterparts, it is important to have information about Latina and Latino elected officials over time. This project draws on the only longitudinal database of Latino elected officials since 1990. The National Latino Legislative Database Project, 1990–2011 (Ramírez 2014) is a unique dataset that includes data of every elected Latino between the years 1990 and 2011 at every level of office ranging from local offices such as school boards to Congressional seats. While the National Roster of Elected Hispanic Elected Officials is a good baseline of

Latinos in office before 1995 and the National Directory of Latino Elected Offi-
cials provides good cross-sectional information for those in office since 1996,
the published directories are not updated retroactively. That is, there are some
instances in which someone was not included in the directory on the first year
that they were elected. By compiling information from both sources and verify-
ing them with online and print sources over time, we are able to focus on the
length of tenure in a particular elected office and also identify whether they
have held previous political office.

Extensive analysis would be required to track the political career of every
elected Latino/a for all 20 years, but selecting two years can paint a small picture
of the trends that have emerged. For this analysis we focus on the ten states
where the Latino population is concentrated, but we focus on the years 1997
and 2011. Much of the data that is included in the database comes from the
National Association of Latino Elected and Appointed Officials (NALEO). In
1996, NALEO changed the methodology for collecting data and became far
more precise, as such, using 1997 as a starting point reflects the first state legis-
lative election after the change in methodology.[3] The last election before the
most recent redistricting took place after the 2010 decennial census election is
reflected in the database in 2011. The years selected for the analysis, therefore,
ensure consistency of methodology from the original data source while concur-
rently avoiding issues in elections related to redistricting that may impact com-
parisons of career paths between Latina and Latino state legislators. The National
Latino Legislative Database Project 1990–2011 therefore allows us to identify
the number of Latinas who have been successfully elected to state legislatures
who held previous elected office, as such also identify and compare the trajec-
tory or career path of both Latina and Latino office holders. The conclusions
we draw from these analyses will help answer questions as to whether the
relative Latina success is due to a distinct path to legislative position or is com-
parable to their male counterparts.

Electoral Success in Selected Ten States Across 20 Years

In order to add context to the number of Latinas who are successful in the ten
states where the majority of Latinos live, it is first necessary to understand the
success of women as a whole in gaining elected office as well as the percentage
that Latinas constitute of Latino males and females who hold elected office
between the years of 1990 and 2010.

At no point in time do women comprise 50 percent or more of state legisla-
tors through the 20-year period. Colorado comes closest to parity, with women
comprising 41 percent of elected officials in the legislature after the 2010 elec-
tion. In nine of the ten states, the number of women elected to their respective
state legislatures grew over the 20-year span, having larger numbers of women
elected in 2010 than in 1990. The exception being Arizona, where the number

of women elected in 1990 was 34 percent, the same level as in 2010. It is possible that Arizona experienced a sort of ceiling effect due to the high number of women elected in the 1990s. Arizona was certainly exceptional at that time, as the mean percentage of women in elected office was 19 percent with states such as New Jersey having only 11 percent women elected to their state legislature. Arizona still has more women elected than New Jersey, and more women as a whole than any other of these ten states except Colorado; however Arizona's percentage of women in elected office, in 2011, was only six percentage points higher than New Jersey as compared to being over three times higher in 1990.

It is important to note that nine of the ten states also experienced an increase in the number of Latinos (both male and female) over the 20-year time span. Interestingly, Colorado, the state with the highest number of women serving in the state legislature in 2010, has the smallest number of Latinos in office. In 1990, Colorado ranked third (behind Texas and Arizona) where Latinos and Latinas comprised 11 percent of state legislators, compared to 12 percent and 14 percent in Texas and Arizona, respectively. After the 2008 election, Colorado ranked the lowest of all ten states with Latinas and Latinos comprising 4 percent of the state's legislators. While this percent increased in 2010 to 8 percent, Colorado was the only state where Latina and Latino state legislators comprised a smaller percent of the legislature as a result of the 2010 election than the percent after the 1990 election.

The main takeaway point is that there was an increase of Latino representation, albeit more gradual than the overall increase in the percentage of women state legislators. In the ten states considered in this chapter, women comprised 17.8 percent of all legislators as a result of the 1990 election and 27.5 percent after the 2010 election, where the biggest gains occurred in New Jersey, New Mexico, and Illinois. Latino and Latina legislators comprised 8.9 percent of all state legislators after the 1990 election and this grew to 14.1 percent after the 2010 election. The biggest gains were witnessed in California, Nevada, and Texas. Whereas population growth can help explain the source of gains in representation by Latina and Latina legislators in California, Nevada, and Texas, there is a less straightforward explanation about the gains among women state legislators.

In order to gain a sense of the relative experience of Latinas relative to their male Latino counterparts, we also examine how Latina legislators fare compared to male Latino legislators in their respective states. Only occasionally do Latina legislators comprise half of a state's Latina/o representatives. Nevada was the first state to have Latinas achieve electoral parity with their Latino male counterparts and they did so throughout the 1990s and New Jersey achieved gender parity between Latinos and Latinas in 1994. The significant caveat, however, is that in both New Jersey and Nevada there were only two total elected Latina/o legislators when Latinas achieved parity in either state. Therefore, this paints a more optimistic account than is warranted given that parity levels can be

achieved by the additional election of one Latina. Conversely, it must be noted that states like New Mexico have yet to achieve the 50 percent threshold, yet have had as many as 14 Latina legislators in 2004 and 2008.

Table 13.1 shows the percentages of electoral success among women as a whole, as well as the ratio of Latinas compared to the Latino elected officials across each of the ten states. Our findings concur with the analysis of Arizona, California, New Mexico, and Texas between 1990 and 2006 by Fraga et al. where they find "patterns of electoral success for women do not predict similar patterns of election for other ethnic groups" (Fraga et al. 2008a, p. 129). Not only is there a difference in how women as a whole are elected, but Latinas appear to experience an advantage from the intersection of their race and gender. Relying on the equation used in Fraga et al. (2008a), we demonstrate the Latina success by calculating ethnic-gender representation parity ratios (EGPRs) for each of the ten states; see Table 13.2 (below).

$$\text{EGPR} = \frac{\text{\# of Latina Legislators/\# Latina/o Legislators}}{\text{\# of Women Legislators/\# of total Legislators}}$$

This measure shows that for values in which the EGPR is greater than 1, the gender representation of Latinas relative to the full Latino delegation is greater than the gender parity compared to women as a whole (Fraga et al. 2008a). This table shows that the relative success of Latinas compared to other women legislators has improved since the 1990 election where the EPGR was only greater in three states, peaked at eight states after the 2004 election, and was at seven states after the 2010 election. There are some notable observations about the three states where the EPGR is less than 1. First, California historically has been the state with consistently favorable electoral conditions for Latinas compared to all other women legislators, yielding a Latina advantage beginning in 1992 with a score of 1.62 and maintaining a score greater than 1 for the next 16 years. However, in 2010, California's EGPR plummeted to a score of 0.48, the lowest of any of the ten states. Second, while New Mexico has only once achieved a score greater than 1, it has been very stable since the 2000 election and has not dropped below 0.9. Conversely, New York was consistently above 1 throughout the 1990s but has not achieved a score above 0.68 in any of the elections after 2000. California, New York, Texas, and Nevada were four states that did not have more Latinas elected to their respective ethnic cohorts in 2010 compared to where they were in 1990. Similar to California, New York and Nevada also experienced a loss during this time period, while the other eight states experienced increased EGPR scores. Nevada is unique in earning an EGPR of 2.63 (a higher score than any state achieved ever during this time period) in 1990, again likely due to the overall low number of women in elected office. Another word of caution is needed when interpreting these EGPR scores; while high numbers demonstrate having more Latinas elected proportionate to non-Latina women,

having high EGPR scores does not necessarily demonstrate Latina success in a generalized nature; it is only indicative of Latina success proportionate to non-Latina women from the same state. For example, New Jersey had the highest EGPR score in 2010 but that year there were only 30 elected women in New Jersey, while California, the state with the most dramatic drop in EGPR scores, has 34 elected women in office.

Drawing from these ten states, that together comprise more than three-quarters of the Latino population, it is clear that Latina office holders do not experience the same electoral conditions across each of these states. States that had no elected Latinas in 1990 (Florida and Illinois) have surpassed states such as California and Texas, which had notable numbers of Latina elected officials in the early 2000s. Further, states such as New York and California that had high EGPR scores throughout a majority of the 1990s and 2000s have dropped off and now have scores less than 1. Thus, electoral conditions are not equal for Latinas in the country as a whole. Further research needs to answer the question of why. We hypothesize that what drives the trend as depicted in these graphs is previous elect-oral experience. While Latinas suffer the same recruitment issues that women as a whole face, perhaps Latinas have uniquely high levels of local officeholding that would suggest their advantage in closing the gender gap relative to White women. These successful Latina office holders have already overcome the obstacles that have been known to prevent women from running for office, such as lack of ambition and scarce financial resources, thus their positive electoral history should lead to a positive trajectory as they pursue state legislative positions.

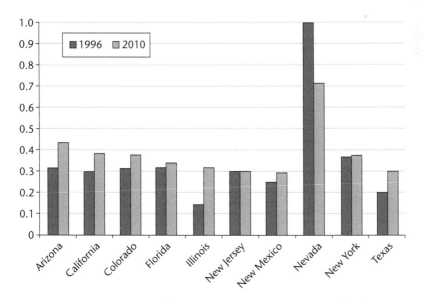

FIGURE 13.1 Percent Latina of Latino and Latina Local Elected Officials

TABLE 13.1 Gender Representation in State Legislatures, 1990–2010 (Percent)

State	1991	1993	1995	1997	1999	2001	2003	2005	2007	2009	2011
Arizona											
Women in Legislature	0.34	0.33	0.30	0.38	0.36	0.36	0.28	0.32	0.33	0.31	0.34
Latinas of Total Latina/o	0.09	0.20	0.30	0.33	0.27	0.23	0.27	0.38	0.41	0.50	0.46
California											
Women in Legislature	0.18	0.23	0.21	0.23	0.26	0.26	0.30	0.28	0.28	0.28	0.28
Latinas of Total Latina/o	0.14	0.36	0.33	0.41	0.43	0.38	0.44	0.38	0.32	0.30	0.14
Colorado											
Women in Legislature	0.31	0.35	0.31	0.35	0.34	0.34	0.34	0.33	0.34	0.37	0.41
Latinas of Total Latina/o	0.18	0.30	0.20	0.38	0.30	0.33	0.50	0.43	0.40	0.25	0.50
Florida											
Women in Legislature	0.19	0.18	0.19	0.24	0.24	0.24	0.24	0.24	0.23	0.23	0.26
Latinas of Total Latina/o	0.00	0.00	0.08	0.07	0.07	0.07	0.00	0.12	0.12	0.07	0.29
Illinois											
Women in Legislature	0.19	0.23	0.23	0.26	0.25	0.27	0.28	0.28	0.27	0.28	0.31
Latinas of Total Latina/o	0.00	0.00	0.00	0.17	0.17	0.33	0.36	0.55	0.55	0.50	0.45

New Jersey											
Women in Legislature	0.11	0.13	0.13	0.16	0.16	0.15	0.17	0.17	0.22	0.30	0.28
Latinas of Total Latina/o	0.00	0.50	0.33	0.50	0.40	0.40	0.43	0.40	0.33	0.57	0.50
New Mexico											
Women in Legislature	0.13	0.20	0.21	0.27	0.28	0.31	0.29	0.31	0.30	0.30	0.27
Latinas of Total Latina/o	0.08	0.18	0.17	0.24	0.22	0.28	0.27	0.32	0.30	0.29	0.26
Nevada											
Women in Legislature	0.19	0.27	0.35	0.33	0.37	0.35	0.29	0.33	0.30	0.32	0.29
Latinas of Total Latina/o	0.50	0.50	0.50	0.50	0.50	0.50	0.50	0.50	0.00	0.00	0.44
New York											
Women in Legislature	0.13	0.17	0.18	0.18	0.21	0.22	0.22	0.22	0.24	0.25	0.21
Latinas of Total Latina/o	0.14	0.18	0.22	0.25	0.25	0.25	0.13	0.13	0.12	0.11	0.14
Texas											
Women in Legislature	0.13	0.16	0.18	0.18	0.18	0.19	0.19	0.20	0.19	0.24	0.21
Latinas of Total Latina/o	0.20	0.28	0.25	0.29	0.24	0.23	0.22	0.25	0.19	0.32	0.21

Source: Ramirez (2014) and Center for American Women and Politics (2014).

Note

Selected years reflect the elections that occurred in the year prior (in every state except New Jersey where midterm elections are held in odd years).

TABLE 13.2 Ethnic-Gender Representation Parity

State	1991	1993	1995	1997	1999	2001	2003	2005	2007	2009	2011
Arizona	0.26	0.60	1.00	0.88	0.77	0.65	0.96	1.16	1.24	1.61	1.34
California	0.82	1.62	1.60	1.83	1.68	1.49	1.48	1.38	1.17	1.08	0.48
Colorado	0.59	0.86	0.65	1.07	0.88	0.98	1.47	1.30	1.18	0.68	1.22
Florida	0.00	0.00	0.40	0.30	0.30	0.28	0.00	0.48	0.51	0.29	1.11
Illinois	0.00	0.00	0.00	0.64	0.66	1.26	1.29	1.97	2.01	1.81	1.46
New Jersey	0.00	0.00	3.75	2.11	3.16	2.67	2.57	2.40	1.54	1.90	1.76
New Mexico	0.56	0.91	0.81	0.88	0.79	0.90	0.91	1.02	0.97	0.94	0.97
Nevada	2.63	1.85	1.43	1.50	1.37	1.43	1.75	1.50	0.00	0.00	1.56
New York	1.08	1.10	1.23	1.35	1.20	1.15	0.60	0.56	0.49	0.45	0.67
Texas	1.57	1.76	1.37	1.57	1.33	1.22	1.12	1.26	1.01	1.37	1.00

Source: Ramirez (2014).

Note
Selected years reflect the elections that occurred in the year prior (in every state except New Jersey where midterm elections are held in odd years).

Local Office Success and Career Paths

In order to compare the career paths of Latinas to their male counterparts, it is necessary to determine who has held office prior to being elected in the state legislature. This requires information about elected office experience and the distribution across the country. In both 1990 and 2010, more than 96 percent of all Latino elected officials at the local level reside in the selected ten states. If we consider the 14-year period between 1996 and 2010 the patterns are mixed, with California, Florida, Illinois, and New Jersey all having more Latino representation in 2010 than in 1996, but the remaining six states seeing losses in their share of all Latino local elected officials.

Latinas within Latinos

The story is more optimistic when looking at the growth of Latina office holders in relation to the male Latinos within the same state in 1996 and 2010.

In every state except New Jersey and Nevada, the number of Latinas who are winning local elected office is greater in 2010 than 1996 proportionate to male Latinos.

The pooled data demonstrates a significant increase in the presence of Latina and Latino elected officials, increasing from 3,252 after the 1996 election to 5,115 after the 2010 election; this translates to more than 57 percent increase. As impressive as this growth has been, the growth in Latinas in local elected office is even more noteworthy in the 14-year span, increasing from 843 to 1,737. It is clear that the faster rate of growth among Latinas means that they are the driving force behind increased presence of Latinos in local elected office.

State Legislative Growth

As was the case for local elected office, the growth of Latina legislators is notable in that they helped fuel the overall growth in Latina/Latino representation. In 2010, the number of Latinas holding state legislative office had increased by 13 women, a 47.22 percent increase relative to 1996. The aggregate number of Latino males and Latinas elected legislators also increased, but at a smaller increment (31.2 percent).

On its face, elected officials at local levels of office could provide a viable pool for state legislative office. In a traditional pipeline, the growth of Latina elected officials at the local level should help fuel the growth at the state legislative level by increasing the viable candidates at lower levels of office. However, we find that this is not the case. In fact, many of those elected to state legislatures do not have prior experience in elected office. In 1996, Latina legislators did appear to follow a pipeline from local to state legislative level pipeline more than their male counterparts. Only 9 percent of Latino legislators had previously held elected office compared to 16 percent of Latina legislators. By 2010, 17 percent of all Latina state legislators in 2010 had previous elected experience, compared to 26 percent of their male counterparts. In other words, the growth of Latino males in local level office appears to have contributed to increase in their presence in state legislatures. This is not the case for Latinas, as it appears that their path to successful election and significant growth is not dependent on their presence in lower levels office. Stated differently, Latina legislators with previous experience in the local level comprised 37.5 percent of total Latino legislators with that career trajectory in 1996. By 2010, this dropped to 20.5 percent. On its face, it could be viewed as detrimental to gender representation among Latino legislators if Latina legislators are less likely than their male counterparts to have held previous elected office before being elected to their state legislature. However, given that the proportion of Latinas among the overall level of all Latinos in state legislatures is increasing, what this suggests is that successful Latinas are not limiting their career trajectory to starting at local levels and then moving on up. Instead, they are bypassing that trajectory and getting elected directly into state legislatures. This does not preclude Latinas who opt to begin their political careers at the local level from seeking higher levels of office; it just means that they are able to do both.

Discussion and Conclusion

Through this chapter, we have offered an update to the current research on trends of Latinas officeholding within the ten most densely populated Latino states. By examining both state legislative and local level office positions, the trend is clear, Latinas are much more successful in 2010 than they were the two previous decades, but the particular reasons why is not as straightforward. This

chapter concurs with the work of Carroll and Sanbonmatsu (2013) that the career paths of Latina elected officials should not be assumed to be the same that fuels women in elected office. Our findings indicate that Latinas are indeed unique in how they have succeeded in getting elected as state legislators. Latinas are making gains relative to their Latino male counterparts and at numbers and proportions greater than non-Latina women; subsequent in-depth case studies should examine the "how" part of this conclusion, whether it is driven by particular state contexts, and whether this pattern holds for those who run and those who win state legislative races.

Notes

1 In this chapter, the terms Latina and Latino are used to refer to Hispanic women and men, respectively.
2 Diana Duran (Secretary of State for New Mexico), Catherine Cortez Masto (Attorney General of Nevada), Susana Martinez (Governor of New Mexico), and as of 2015, Evelyn Sanguinetti (Lieutenant Governor of Illinois).
3 The 1996 legislative election took place in nine of the ten states under consideration. The only exception was New Jersey as their legislature is elected in odd years.

References

Bejarano, Christina E. 2013. *The Latina Advantage: Gender, Race, and Political Success.* Austin, TX: University of Texas Press.

Bowler, Shaun, and Gary Segura. 2012. *The Future Is Ours: Minority Politics, Political Behavior, and the Multiracial Era of American Politics.* Thousand Oaks, CA: CQ Press.

Casellas, Jason P. 2009. "The Institutional and Demographic Determinants of Latino Representation." *Legislative Studies Quarterly* 34 (3): 399–426.

Casellas, Jason P. 2011. "Latinas in Legislatures: The Conditions and Strategies of Political Incorporation." *AZTLAN – A Journal of Chicano Studies* 36: 171–89.

Carroll, Susan J., and Kira Sanbonmatsu. 2013. *More Women Can Run: Gender and Pathways to the State Legislatures.* New York: Oxford University Press.

CAWP (Center for American Women and Politics) (2014). *Center for American Politics.* Retrieved December 16, 2014, from Facts on Women Officeholders, Candidates, and Voters: www.cawp.rutgers.edu/fast_facts/index.php.

Colby, Sandra L., and Jennifer M. Ortman. 2015. *Projections of the Size and Composition of the U.S. Population: 2014 to 2060.* Current Population Reports no. P25–1143, U.S. Census Bureau, Washington, D.C.

Darcy, R., Janet Clark, and Susan Welch. 1994. *Women, Elections, and Representation.* 2nd revised edition. Lincoln, NE: University of Nebraska Press.

Duverger, Maurice. 1972. *Party Politics and Pressure Groups: A Comparative Introduction.* New York: Crowell.

Fox, Richard L., and Jennifer L. Lawless. 2010. "If Only They'd Ask: Gender, Recruitment and Political Ambition." *Journal of Politics* 72 (2): 310–26.

Fraga, Luis Ricardo, Linda Lopez, Valerie Martinez-Ebers, and Ricardo Ramírez. 2008a. "Gender and Ethnicity: Patterns of Electoral Success and Legislative Advocacy Among Latina and Latino State Officials in Four States." *Journal of Women, Politics & Policy* 28 (3–4): 121–45.

Fraga, Luis Ricardo, Valerie Martinez-Ebers, Linda Lopez, and Ricardo Ramírez. 2008b. "Representing Gender and Ethnicity: Strategic Intersectionality." In Beth Reingold (ed.), *Legislative Women: Getting Elected, Getting Ahead*. Boulder, CO: Lynne Rienner.

Garcia, Sonja R., and Mariesela Marquez. 2001. "Motivational and Attitudinal Factors Amongst Latinas in U.S. Electoral Politics." *NWSA Journal* 13 (2): 112–22.

Lawless, Jennifer L., and Richard L. Fox. 2005. *It Takes a Candidate: Why Women Don't Run for Office*. Cambridge; New York: Cambridge University Press.

Lawless, Jennifer L., and Richard L. Fox. 2010. *It Still Takes a Candidate: Why Women Don't Run for Office*. Expanded edition. Cambridge: Cambridge University Press.

Lien, Pei-te, Carol Hardy-Fanta, Dianne Pinderhughes, and Christine Sierra. 2008. "Expanding Categorization at the Intersection of Race and Gender: 'Women of Color' as a Political Category for African American, Latina, Asian American, and American Indian Women." *Annual Meeting of the American Political Science Association.*

Matland, Richard E., and Donley T. Studlar. 1996. "The Contagion of Women Candidates in Single-Member District and Proportional Representation Electoral Systems: Canada and Norway." *The Journal of Politics* 58 (3): 707–33.

Masuoka, Natalie, and Jane Junn. 2013. *The Politics of Belonging: Race, Public Opinion, and Immigration*. Chicago, IL: University of Chicago Press.

Niven, David. 1998. "Party Elites and Women Candidates: The Shape of Bias." *Women & Politics* 19 (2): 57–80.

Norris, Pippa. 2006. "The Impact of Electoral Reform on Women's Representation." *Acta Politica* 41 (2): 197–213.

Ramírez, Ricardo. 2013. *Mobilizing Opportunities: The Evolving Latino Electorate and the Future of American Politics*. Charlottesville, VA: University of Virginia Press.

Ramírez, Ricardo. 2014. The National Latino Legislative Database Project, 1990–2010.

Ramírez, Ricardo, and Luis Fraga. 2008. "Continuity and Change: Latino Political Incorporation in California Since 1990." In Bruce E. Cain and Sandra Bass (eds.), *Racial and Ethnic Politics in California: Continuity and Change*, vol. 3, Berkeley Public Policy Press, Institute of Governmental Studies.

Rouse, Stella M. 2013. *Latinos in the Legislative Process: Interests and Influence*. New York: Cambridge University Press.

Sanbonmatsu, Kira. 2002. "Political Parties and the Recruitment of Women to State Legislatures." *Journal of Politics* 64 (3): 791–809.

Sanbonmatsu, Kira. 2006. "The Legislative Party and Candidate Recruitment in the American States." *Party Politics* 12 (2): 233–56.

Scola, Becki. 2013. *Gender, Race, and Office Holding in the United States: Representation at the Intersections*. New York: Routledge.

Shea, Daniel M., Joanne Connor Green, and Christopher E. Smith. 2013. *Living Democracy for Living Democracy, 2012 Election Edition*. 4th edition. New York: Pearson.

Uhlaner, Carole Jean, and Kay Lehman Schlozman. 1986. "Candidate Gender and Congressional Campaign Receipts." *The Journal of Politics* 48 (1): 30–50.

Welch, Susan, and Donley T. Studlar. 1990. "Multi-Member Districts and the Representation of Women: Evidence from Britain and the United States." *The Journal of Politics* 52 (2): 391–412.

Welch, Susan, and Lee Sigelman. 1982. "Changes in Public Attitudes Toward Women in Politics." *Social Science Quarterly* 63 (2): 312–22.

14

ASIAN PACIFIC AMERICANS IN U.S. POLITICS

Gender and Pathways to Elected Office

Nicole Filler and Pei-te Lien

Writing in the late 1980s, then school board member Judy Chu provided one of the first and only glimpses into the gendered and racial dynamics of attaining and staying in public office based on the experiences and perspectives of Asian Pacific American (APA) women in elected positions (Chu 1989). In this chapter, we extend and build upon Chu's seminal work that examines how APA women in the mid-1980s were able to overcome barriers and win election to local and state offices with a systematic analysis of both male and female APA elected officials serving at various levels of office across the United States in the second decade of the twenty-first century. In 2012, APA women made U.S. history by establishing the first female majority in a congressional delegation for a major ethno-racial group. Despite the monumental accomplishments of and the limelight on these congressional women, a decisive majority of APA women elected officials serve in subnational levels of office. In fact, five of the seven APA Congresswomen who won in 2012 started their political career in state/local offices. Holding elective offices at the subnational level appears to be a critical launching pad for national politics. Who are these APA female and male elected officials serving at national, state, and local levels offices? What are the gender differences in political pathways among them? We shed light on these questions with an original and unique dataset that includes all APAs serving in elected offices nationwide in early 2014.

Existing Approaches to the Studying of Gender and Pathways to Office

Perhaps one of the most studied topics in women and politics is the under-representation of women in public office. Extending beyond and intervening in

dominant theories, past studies have identified structural and institutional factors that systematically disadvantage women (e.g., Palmer and Simon 2006; Lawless and Pearson 2008; Welch 2008). One common approach emphasizes the acquisition and leveraging of resources and skills to advance from lower levels of office to higher ones. The underrepresentation of women, according to the traditional pipeline theory, should decrease as women become more numerous in lower levels of political office (Darcy et al. 1994). However, as more recent studies have found, not all public officials enter the office under the same circumstances or through the same channels (Mariani 2008; Carroll and Sanbonmatsu 2013). For example, Mariani (2008) finds that female legislators are older and less likely to have a background in the "springboard" professions of business or law or to advance to Congress.

Other approaches examine candidate ambition and credentials, comparing the relationship between personal and external circumstances among women and men and their interest in running for office (Burrell and Frederick 2007; Fox and Lawless 2010; Lawless 2012; Carroll and Sanbonmatsu 2013; Baer et al. 2014). Arguing against the traditional conceptualization of ambition as a relatively static and inherent characteristic, Lawless and Fox (2005) maintain that attitudinal and personal experiences also shape potential candidate ambitions. Lawless (2012) extends the idea of "nascent ambition," arguing that one's minority status defined by race and gender, as well as family dynamics, professional experiences, and political attitudes and recruitment, shape political ambition throughout one's career and lifetime. Related to external circumstances is the level of office, which has also been found to shape candidate ambition, particularly in lower levels of office (Deckman 2004, 2007; Lien and Swain 2012).

Intersecting Statuses and Identities and Pathways to Office

The majority of studies on political trajectories of public officials share a common limitation in their reliance on the perspectives and experiences of White women and men (two exceptions are Ramírez and Burlingame [Chapter 13] and Sanbonmatsu [Chapter 11]). Emerging as an intervention in dominant feminist and anti-racist discourse, intersectional scholars inform their research through the perspectives and experiences of women (and men) whose identities are marginalized across one or more axis of inequality (Crenshaw 1989; Chow et al. 1996; Collins 2000; Junn and Brown 2008; Dill and Zambrana 2009). While additive formulations are problematic in that they assume types of oppression occur dichotomously and can be ranked or understood through one category while overlooking the fluidity and mutually reinforcing aspects of identity (Hancock 2007), scholars who study electoral politics quantitatively but with an intersectional lens have retained the importance of examining the link between gender and other statuses and identities (Hardy-Fanta et al. 2006, 2007; Scola 2006, 2013; Lien et al. 2007,

2008). Brown (2014) contributes further by examining the internal dynamics within African American women in state legislatures.

These critical perspectives challenge the universalist and individualist assumptions of the underlying ideas about (formal) political leadership that perpetuate the exclusion and marginalization of non-White, non-males in popularly elected offices. Among Asian Americans, images of the "model minority" and "forever foreigner" intersect with cultural norms that influence potential candidate ambition to run and enter into the pipeline (Chu 1989; Wong 2013). Asian American women, like all women of color, face additional barriers associated with traditional gender norms and male dominance in policy-making processes (Hawkesworth 2003). Given the intersecting barriers stemming from race, ethnicity, gender, and nativity, how do APA women in mainstream electoral politics succeed? Studies that examine candidate evaluations (Sriram, Chapter 8) and political attitudes and behavior of Asian American women (Harvie, Chapter 5) demonstrate the need to consider factors unique to their positionalities across different contexts. We contribute to this growing body of research on the distinct identities of minority women, and Asian American women in particular, in U.S. politics with a systematic examination and analysis of the demographics, political socialization, and career trajectories of APA women and men currently serving in popularly elected offices nationwide. Then, we identify and analyze some broad patterns by gender and other social markers. Our findings support the idea that political trajectories for women and men of color do not follow a linear and upward pattern. We also affirm the gendered influence of personal demographic and professional factors as well as family socialization background in structuring electoral experiences of APA elected officials (EOs) in various levels of office.

Study Description and Data Collection

The collection of information about the population of APA EOs from online resources began as an undergraduate student research project through the UCSB campus-wide Faculty Research Assistance Program between January and June of 2014.[1] One of the first steps of the research process was to identify the gender and level/type of office of all APA EOs serving at federal, state, and local offices. In this research, we are only interested in those elected officials serving at federal, state, and local offices as U.S. Congress members, state governors and other statewide elective officials, state legislators, county commissioners/council members/board of supervisors, city/town or village council members, and education or school board members.

The research assistants used several leading online search engines to locate biographical information via governmental or personal websites, websites that systematically collect candidate information (e.g., smartvoter.org and zoominfo.com), and news articles. Websites that provide defined biographic information

such as Wikipedia and Ballotpedia were also consulted, though only as a last resort. Any inaccuracy in the downloaded information which was processed and then supplied to student assistants was corrected during the data collection, verification, and cleaning processes. The authors were involved in all three stages of the research process.

While the Internet and social media presented us with countless stories, perspectives, and information, there are also drawbacks to web-based data. First, not all of the requisite information is available online for all APA EOs. Even when the requisite information can be found online, there is a chance that it can be misidentified or incorrect. The ease of data gathering and the quality of the information gathered appear to correlate with the prominence of office where those serving or seeking to serve in higher levels of office usually have their own individual websites complete with biographic information and issue positions. Information regarding those serving in local offices, especially school board members in small places, is a lot more scarce and difficult to locate online. Challenges also arose when searching for specific personal information, such as ethnicity and nativity, that often required an educated guess based on a combination of information such as birthplace, membership in ethnic or other civic associations, common ethnic surnames, and official headshots extrapolated from as many sources as available online.[2]

Asian Pacific Americans in U.S. Mainstream Electoral Politics: A Demographic Profile in 2014

We collected information on the total population of Asian and Pacific Islander women and men in popularly elected offices nationwide in service between October 2013 and March 2014. Only three of the 122 political women in our database were not in service as of August 1, 2014. On the men's side, eight out of the 276 political men in our database were not in office as of August 1, 2014. There were a total of 84 APA women and 248 APA men in 2004, according to Hardy-Fanta et al. (2006, p. 15). The growth rate over the ten-year period is substantially higher for APA women (45 percent) than APA men (11 percent). In 2004, about one in four APA elected officials were women; in 2014, this gender ratio improved to 31 percent. The rapid and substantial rise of women of color elected officials within each of the non-White communities is also observed in other recent studies (Hardy-Fanta et al. 2006; Smooth 2010; Lien and Swain 2012; Lien 2014).

Current Office. As Table 14.1 shows, the highest proportion of APA women serve in municipal offices as city or town councilmembers or (vice) mayors, followed by local school board members or (vice) presidents, with the third largest proportion serving as state legislators. Compared to similar data collected in 2004 and reported in Hardy-Fanta et al. (2006), the share of female municipal offices has significantly risen (from 25 percent), while that of female school

board members has significantly decreased (from 43 percent). There is a tiny decrease in the percentage of female state legislators (from 26 percent) and county officials (from 6 percent). There were no APA women in Congress or statewide elective offices ten years ago.

For comparison purposes, Table 14.1 also provides the percentages of APA men in each level of office. Compared to their female counterparts, a higher proportion of male elected officials serve in municipal offices. A larger proportion of APA men also serve in state legislatures, while close to two in ten served on school boards. Compared to similar data collected in 2004, the share of male municipal offices has significantly risen (from 34 percent to 44 percent), while that of school board members has significantly decreased (from 33 percent to 18 percent). Unlike that among women, there is an increase in the percentage of state legislators (from 22 percent to 27 percent), but a decrease (from 10 percent to 8 percent) in percentage share of county officials. There is practically no change regarding the tiny shares of federal and statewide elective offices.

Nativity. Table 14.2 compares the percent foreign born by gender and level of office. A few conclusions can be drawn from these findings. First, unlike the general (voting age) population, the majority of APA EOs were born in the United States. Yet, the fact that at least one-third of APA women and two-fifths of APA men were not U.S. born is quite telling about the remarkable success of these immigrants in climbing the political ladder within the first generation. When analyzed by offices held, it is apparent that immigrants have much easier access to entry level school board positions. One would expect that the share of the foreign born in each level of office would decrease as we move up the political ladder. However, this appeared to be true among women until we checked the share of immigrants among congressional members where two of the seven currently in service were born in Asia. Among men, the share of foreign born among state legislators is actually higher than that among county officials, though only one of the six congressmen is foreign born. We also found

TABLE 14.1 Office

	Women		Men	
	Count	%	Count	%
Congress	7	5.7	5	1.8
Statewide	3	2.5	3	1.1
State Legislature	30	24.6	75	27.2
County	4	3.3	22	8.0
Municipal	43	35.2	120	43.5
School Board	35	28.7	51	18.1
Total N/%	122	100	276	100

Source: Asian Pacific American Elected Officials (APA EO) database, 2013–2014.

TABLE 14.2 Percent Foreign-born by Gender and Office

	Women		Men	
	Count	%	Count	%
Congress	2	29	1	17
Statewide	0	0	0	0
State Legislature	4	13	18	26
County	1	25	3	20
Municipal	14	41	44	67
School Board	16	59	15	60
Total N/%	37	34	81	40

higher percentages of the foreign born among male than female municipal officials and state legislators.

Ethnicity. Although the combined population share of Chinese and Japanese is just one-third of the U.S. Asian population in 2010, our data show that 35 percent of females and 33 percent of males were of Chinese descent, while 22 percent of females and 24 percent of males were of Japanese descent. Among the remaining females, about one-tenth each was identified as either Korean, Filipino, or Indian. Among males, slightly larger proportions were identified as Indian or Filipino, followed by Korean. There are noticeably more male than female EOs in the Asian Indian and Filipino communities. The Chinese and Japanese dominance of the APA EOs is consistent with earlier research, although there is a trend of increased diversification over recent decades (Lien 2001, 2002). In the 2006–2007 GMCL survey reported in Lien et al. (2007), about one in three of Asian respondents are of Chinese descent, 17 percent of Japanese descent, and 15 percent of Filipino descent. However, the emergence and solid presence of Korean, South Asian, and Southeast Asian refugee communities in U.S. electoral politics is equally noteworthy.[3]

Political Socialization of APA Elected Officials

Another set of indicators captures the resources and skills that APA EOs bring to elected office. In a recent study of gendered pathways to political office, Carroll and Sanbonmatsu (2013) compare the backgrounds and trajectories of male and female state legislators across two time periods (1981 and 2008). They examine four factors related to political socialization: education, occupation, family contexts, and community groups and civic organizations. We follow this approach, examining how these factors related to political socialization vary by gender.

Education (Degree and Major). We collected data for both the highest educational degrees and the specialty types of those degrees. As reported in a previous

study (Lien et al. 2008), we find APA EOs regardless of gender to be extremely well educated. As a whole, 88 percent of APA women and 85 percent of APA men in our database received a bachelor degree or more. These statistics were much higher than the educational achievement found in the general U.S. Asian population, and they are also higher than the educational achievement of other non-White elected officials found in previous studies. Further, we did not find statistically significant differences across ethnicity in the educational achievement of Asian American political elites in our data.[4] However, compared to their female counterparts, a significantly lower proportion of men received bachelor's or master's degree only. Instead, a significantly higher proportion of men than women received advanced professional degrees such as in business administration, law, and medicine.

To get a better idea about educational backgrounds, we study the breakdown by college majors, professional training, and graduate school attendance. Among female EOs, the largest group belongs to those having majored in business administration, finance, or accounting, followed by those who majored in social sciences, law, education, and urban planning or public administration. Among male EOs, law is the top major for one-fourth of them, which is much higher than that among women. About one in five men majored in business administration, finance, or accounting, which is the same as that among women. Almost twice the share of science and engineering majors are men compared to women. A higher proportion of men also majored in health and medical sciences. However, women have the edge in the social sciences, as well as education, public administration, and urban planning.

Occupation. Professional experiences might also shape the decision to run and leadership roles of elected officials. Looking at current and past occupations, we find near equal proportions of women and men who bring professional experiences in business to elective office. There are also a similar proportion of lawyers among women and men. In fact, almost one-quarter of female APA EOs come from occupations that are traditionally male dominated and commonly associated with public office. This is a departure from previous studies that find the occupational histories of majority White state legislators to reflect strong gender differences (Dolan et al. 2007; Carroll and Sanbonmatsu 2013).

We also want to highlight the role of military service, which has traditionally not been covered in the studying of occupational background. Military service is part of the experience of four APA women and 16 APA men currently holding elected positions, including several at the federal level. They include two congresswomen and one congressman; two of the three were born in Asia but moved with family to the United States during childhood. They also include four U.S-born male and one Asia-born female state legislators, as well as others serving in county and municipal councils and local school boards. These statistics suggest that being foreign-born does not necessarily create a barrier to holding higher levels of elective office for APA women and men with military

experience, but migrating early on and being raised in the U.S. context can help with their pathway to elective offices, especially for women.

Family Socialization. Chu (1989) noted that many political women did not prepare for entering politics themselves, even if they had been involved in it because of a political family. One such example in our database is Colma City, CA Mayor Joanne del Rosario, who considered herself a political neophyte and had enjoyed playing a supporting role to her brother when he was Philippine Ambassador to the United States. It was through the prodding of the Filipino American Coalition that this woman with 33 years of experience in the legal, business, and financial world finally filed her candidacy for one of the two open seats on the city council. We find close to half of APA political women grew up with a unique political socialization background that was mentioned online, mostly in their own biography or political profile posted on social media websites. Some had politically active parents or spouse. Some were from families that experienced political trauma such as internment or refugee camps. Some grew up moving around because of the military service of their father. Some were activists themselves while in college or high school. But the most common socialization background shared by 14 percent of all women is their being in the 1.5 generation, or born in Asia but growing up in the United States. A close runner-up shared by 13 percent of all women is their being born and raised entirely in the U.S. but under the influence of immigrant parents.

Perhaps in part because men were less likely than women to post information online about their political socialization experience, we were only able to identify the unique socialization background for about one-third of men in our database. Like APA women, the most common category is being in the 1.5 generation, which is shared by about one in ten of all APA men in the EO population. A distant runner-up is having been born and raised in the U.S. by immigrant parents. Almost the same percentage of men are found to grow up in families with refugee or internee background. A slightly lower percentage of them are found to participate in social movement activism while in high school or college or be active in student government. Although we do not have information on age or birth year of the EOs, those who came of age during highly politicized times might be expected to have higher levels of student activism.

Community and Organizational Involvement. Besides family socialization, another venue for political learning prior to one's first office-holding may be indicated by one's engagement in civic organizations. In Chu (1989), she found that many women began their first run for office out of a concern over their children's education and after having served on PTA/Os. Our data show that this is more common for women than for men. Compared to their female counterparts in the 2014 data, we find a higher share of male EOs' involvement in neighborhood/community organizations and pan(ethnic) organizations, as well as in business and music/arts groups. However, men's levels of involvement in PTA/Os, women's

organizations, civil rights organizations, and election campaign organizations are substantially lower. They do share with women in their top two organizations of engagement and the lack of involvement in labor unions. A somewhat similar pattern is reported in Table 4 of Lien et al. (2008).

Pathways to Elective Office

Up until this point, our study has primarily focused on the basic socio-demographic characteristics and patterns of family socialization among all currently serving APA EOs in U.S. politics. A few patterns are worthy of reviewing. First, compared to their male counterparts, a higher proportion of APA women in popularly elected offices occupy offices at lower levels of government such as local school boards. Moreover, the proportion of APA women in the most highly educated strata rival that of APA men, though the dominance of men in medicine and law seems to reflect the well-known gender bias in these fields. Reporting limitations, notwithstanding, we find a greater share of APA women than men in elective offices to come from politicized family backgrounds across nearly all indicators of political socialization. In fact, their experience as intersectionally disadvantaged women of color may figure prominently in their reasons for running for the first office. As Kaying Thao, the youngest and first Hmong American school board member in Roseville, MN and mother of three, explains:

> I was tired of reading, learning, and being a prime example of horrible policies that just did not work for the common person; so I decided to get involved to see if I could help influence and guide the decision making processes, as well as help improve and create policies to actually help mobilize people rather than keep them at the bottom. I decided on school board as the timing was perfect since there were seats opening up at the time, and, I was also encouraged to do so by colleagues who "saw" something in me, and believed in me.
>
> Sometimes I feel as if my age; my race; and sometimes gender; play a big factor in some of the situations I find myself in. I am usually the youngest or only person of color at various community meetings; and often-time, the worlds in which my colleagues and I come from are so far apart; making our ideas and understanding of education policy very different.
>
> (Doeun 2012)

Frustrations like these can be a motivation to enter public service. Turning our attention to the political trajectories of APA EOs, we use three indicators to configure the ladders and steps that may help propel our women and men in the database to enter and advance in mainstream electoral politics.

Serving in First Elective Office. Although we are aware that the reasons that APA EOs run for an elective office for the first time may not be the same for recently elected and re-elected ones, we use "first time in elective office" as a proxy to begin deconstructing the process of their entry into the electoral arena and/or the beginning of their pathways to a higher office or offices. Our data show that close to three in four women are serving in their first level of elective office, and some have been serving for quite some time.[5] School boards and municipal offices are most numerous among first timers, followed by state legislatures. Although close to half of APA women serving at this entry level of office have served in multiple positions within the board, we do not consider these changes in the current study. This is also true for three in four women in municipal governments, a slightly smaller share of APA women serving in county, stateside, and federal elective offices, and more than half of those in state legislatures.

The proportion of APA male EOs currently serving in their first level of elective office (76 percent) is only slightly higher than that found among women. Among them, about half (48 percent) are in municipal governments, 24 percent are on school boards, 19 percent are in state legislatures. As high as 98 percent of APA men on school boards are in their first level of elective office, followed by 85 percent among municipal officials, 58 percent among county officials, 53 percent among state legislators, 40 percent among congressmen, and 0 percent among statewide elected.

Same as the proportion found among women, exactly a quarter of men are currently serving for the first time in an elective office. However, in contrast to women, about three-fifths (61 percent) of the 69 males are in municipal governments, and the rest of these newly elected officials are basically divided between state legislators and school board members. Within each level of office, we find that up to 40 percent of U.S. Congressmen of APA descent, one-third of APA male municipal officials, one in five of APA male school board members, and one in ten of county officials are in their first term of their first elective office. None of the male statewide elected officials are new to an elective office.

Prior Appointed Office Holding. Because American political processes are largely male-dominated, APA women (Chu 1989) and Black women (Sanbonmatsu, Chapter 11) have found success in electoral politics after serving in an appointed position. We find evidence of a similar phenomenon in the political trajectories of APA women relative to men. Of those 33 individuals, there are roughly equal shares in municipal and schools boards and the rest serve in state legislatures. Nearly equal proportions of APA men were appointed before their first elective office. Of those 81 individuals, the majority serve in municipal offices, followed by state legislatures, and Congress.

In the GMCL survey, Asian American women are found to report a lower percentage of having prior appointments than Asian American men before

winning their current elective office. However, the reported percentage shares were a lot higher for both genders. To wit, 45 percent of Asian women and 62 percent of APA men reported having held an appointed office before their current elective office. Our web-based approach might have omitted those appointments not listed by the EOs themselves.

Prior Service as Staff. Like political appointments, having served on the staff of an elected official can be considered an important means of political socialization or learning the ropes for minority women and men before their first bid for an elective office. We observe some similar patterns with respect to gender and level of office among APA EOs who have served as staff members of public officials. Slightly over one-fifth of all APA women and men EOs have served as staff of an elected official, and for the most part, they are currently serving in state level followed by municipal level office.

Management Position(s). Holding one or more management position can be considered a proxy for possessing leadership skills that are considered a desirable quality as one contends for public office. We considered any directorship and/ or business ownership to qualify as management experience. Although equal proportions of APA women and men have held a management position before or while serving in the current office, gender differences arise in their distributions across levels of office. The highest share of female EOs with management backgrounds is found among municipal offices, followed by state/county, and congressional offices. Among APA men, the highest share of management experience is found among county officials, followed by state legislators, municipal, and statewide elected officials.

Change(s) in Office. Besides studying the personal background and socialization factors of APA EOs to gauge their separate and gendered pathways of elective office-holding, we also tried to chart their trajectories in the electoral arena in the metaphor of a political ladder among those who experienced changes in the level of elective office(s) held. Three key observations can be made from this exercise. First, slightly over one-quarter (27 percent) of all APA women EOs in 2014 had changed their elective office(s) across levels of government. Second, while all Congresswomen and county officials who have changed their first elective office did so by climbing up the political ladder, lateral career moves are more common among APA women currently serving in state, municipal, and statewide elected offices. Nearly one in five office changes happened horizontally or by moving to another office in the same level of government (e.g., from rank and file member to leadership in state legislatures, from lower to higher legislative chamber, or from elective to non-elective position), with state legislators most exhibiting this change. Third, a slightly smaller percentage changed offices by moving to a level of government that is considered lower in the political ladder. Several women in our database who were previously state legislators went on to serve in the city council. Our findings suggests that these cases may not be considered as moving down the political ladder, particularly

when the movement is one that will allow for greater influence in decision making.

Like their female counterparts, slightly over one-quarter (27 percent) of these APA men EOs have ever moved across levels of office in their political careers, so far. A much larger share of office changes among men serving in state (96 percent), county (80 percent), and statewide officials (67 percent) occurred by climbing up the ladder. A higher proportion (34 percent) of the office changes among men also happen horizontally or by moving to another office in the same level of government, with school board and municipal officials. Finally, as in the women's case, "change" did not always mean advancing to higher levels of office. There are seven (or 9.5 percent of) male EOs who moved to a position that is considered lower in the political ladder. Examples include a move from upper to lower legislative chamber, or from state legislatures or county commissions to city councils, or from city council to school board position. One case also involves a move from federal elective to statewide elective position. In other words, it is difficult to interpret the meaning and significance of changes in office in one stroke. A so-called "downward" movement in political influence might provide opportunities for political influence not available, for example, in the chambers of Congress.

Conclusion

Inspired by Chu's (1989) ground-breaking research done in the mid 1980s on APA women in mainstream politics, we created the 2014 database to study systematically the gender and ethno-racial dynamics of APA women and men elected to serve in local, state, and national governments. Our preliminary analysis of the unprecedented collection of data on the entire population of APAs in U.S. politics has produced both surprising and not so astonishing, albeit still important, findings on how women in each level of office get to where they are as compared to their male counterparts.

First, APA women EOs are part of the recent growth trend of American women of color elected officials. Their growth rate of 45 percent, compared to the 11 percent among APA men, in the past decade may not be totally unexpected for those who worked hard to achieve this progress, but it is certainly remarkable considering the humble numbers reported in Chu's research done nearly three decades ago. It is also important to note that about one-third of the APA women currently in elective offices were not U.S. born, including two at the congressional level, even if more are found at the local level.

Second, like Chu, we found well-educated women and men, especially East Asians, dominate the electoral scene. Although having a legal education helps, a lot more EOs in our database do not possess this background. Instead, many accumulated leadership skills through a variety of professional experiences. In fact, one of the surprising findings is that roughly equal portions of women and

men are associated with occupations that are traditionally male-dominated such as law and business. This contributes to the management experience found in a third of women and men currently serving.

Third, also like Chu, we found many women did not expect to enter politics early on and their being women of color and, for many, mothers of school-age children were part of the motivations to run for their first office. Having been socialized in families with various political backgrounds seems to loom larger as a factor for women than men. However, more men were engaged with neighborhood/community-based organizations, business groups, and arts/music groups than women. In reverse, more women participated in PTA/Os, women's, and civil rights organizations, which is consistent with previous studies that find family and community ties to be among the most consistent factors that explain entry and success in public office among women of color (Baca Zinn 1975; Gutiérrez et al. 2007).

Last but not least, like Chu, we found getting appointed to an office and serving as staff to an elected office to be important steps before winning an elective office. About equal shares of women and men gained prior appointments, while more women served as staff before. And whereas the majority of both women and men who changed their office did so by climbing up the political ladder, it only describes about a quarter of the trajectories. A supermajority of women and men stayed in the same entry level of office, while some of the rest changed their office holding horizontally or even downward. However, we caution against treating the horizontal and downward moves as less desirable or lower in political influence.

In the end, Chu's research and analysis of the 1984 class proves to be insightful and useful for us in appreciating the 2014 class. This is so, despite the phenomenal growth in numbers and influence of APA women and men in popularly elected positions in the present day. Looking forward, we hope to continue exploring and uncovering the intricacies regarding gendered political socializations and pathways to the first and subsequent elective offices for various groups of APA women and men in office. We shall also work to address the current data deficiencies on the men's part to allow us to do a more fair comparison on some factors.

Acknowledgments

We appreciate the very generous and invaluable research assistance provided by Tim J. Cioffi-Dinkel and Melissa N. Immel at the earlier stage of data collection. Kudos also to Rhoanne Esteban for helping gather additional data on short notice. Certainly, we are very indebted to the Asian Pacific American Institute for Congressional Studies for providing the initial roster of elected officials. All the errors and oversights are ours.

Notes

1 Students were initially supplied with a comprehensive list of APA EOs whose first and last name, state and place of office, official title, and number of legislative district were downloaded by the lead author in early February 2014 from the Asian Pacific American Institute for Congressional Studies (APAICS) Political Database available online and under constant updating. http://apaics.org/resources/political-database/.
2 Unfortunately, despite the best efforts, there are still many gaps in the database. Some information simply proved impossible to find. Perhaps the nonexistence of such information is significant, for it is quite possible that some APA EOs have political strategies for withholding certain aspects of their backgrounds. However, we argue that an examination of the available information online will provide valuable insights about what it takes for Asian Americans to be elected into office, and what the trajectories of their political careers look like.
3 Pacific Islanders were not included in the 2006–2007 GMCL Survey.
4 We suspect that, perhaps because of the extremely high overall educational achievement in the multiethnic community, a few candidates who did not score well in this category may find the need to inflate their education achievement on the campaign trail. In fact, we found this to be the case involving a female school board member in her filing data for a higher office.
5 The longest being 29 years – one is a state senator in HI, the other is a city councilwoman in CA; another woman served continuously on the same city council for 26 years; a fourth woman from MN served continuously as mayor for 20 years.

References

Baca Zinn, Maxine. 1975. "Political Familism: Toward Sex Role Equality in Chicano Families." *Aztlán: International Journal of Chicano Studies Research* 6 (1): 13–26.
Baer, Denise, Lake Research Partners, Chesapeake Beach Consulting, and Shauna Shames. 2014. *Steps to the Capitol: Women's Political Paths.* Cambridge, MA: Political Parity, a program of Hunt Alternatives.
Brown, Nadia. 2014. *Sisters in the House: Black Women and Legislative Decision Making.* New York: Oxford University Press.
Burrell, Barbara, and Brian Frederick. 2007. "Political Windows of Opportunity: Recruitment Pools, Gender Politics and Congressional Open Seats." Paper presented at the annual meeting of the Southern Political Science Association, New Orleans, LA, January 3, 2007.
Carroll, Susan, and Kira Sanbonmatsu. 2013. *More Women Can Run: Gender and Pathways to the State Legislatures.* New York: Oxford University Press.
Chow, Esther Ngan-ling, Doris Wilkinson, and Maxine Baca Zinn. 1996. *Race, Class, & Gender: Common Bonds, Different Voices.* Thousand Oaks, CA: Sage Publications.
Chu, Judy. 1989. "Asian Pacific American Women in Mainstream Politics." In *Making Waves: An Anthology of Writings By and About Asian American Women.* Asian Women United of California, ed. Boston, MA: Beacon Press, 405–21.
Collins, Patricia Hill. 2000. *Black Feminist Thought: Knowledge, Consciousness, and the Politics of Empowerment, 2nd ed.* New York: Routledge.
Crenshaw, Kimberle Williams. 1989. "Demarginalizing the Intersection of Race and Sex." *University of Chicago Legal Forum* 139: 139–67.
Dill, Bonnie Thornton, and Ruth Enid Zambrana. 2009. *Emerging Intersections: Race, Class, and Gender in Theory, Policy, and Practice.* New Brunswick, NJ: Rutgers University Press.

Darcy, Robert, Susan Welch, and Janet Clark. 1994. *Women, Elections & Representation.* Lincoln, NE: University of Nebraska Press.

Deckman, Melissa. 2004. "Women Running Locally: How Gender Affects School Board Elections." *PS: Political Science & Politics* 37 (1): 61–2.

Deckman, Melissa. 2007. "Gender Differences in the Decision to Run for School Board." *American Politics Research* 35 (4): 541–63.

Doeun, Amy. 2012. "Kaying Thao: First Hmong American Roseville School Board Member." *Hmong Times*, December 12.

Dolan, Julie, Melissa Deckman, and Michele L. Swers. 2007. *Women and Politics: Paths to Power and Political Influence.* Upper Saddle River, NJ: Pearson, Prentice-Hall.

Fox, Richard, and Jennifer Lawless. 2010. "If Only They'd Ask: Gender, Recruitment, and Political Ambition." *The Journal of Politics* 72 (2): 310–26.

Gutiérrez, José Angel, Michelle Meléndez, and Sonia Adriana Noyola. 2007. *Chicanas in Charge: Texas Women in the Public Arena.* Lanham, MD: AltaMira Press.

Hancock, Ange-Marie. 2007. "When Multiplication Doesn't Equal Quick Addition: Examining Intersectionality as a Research Paradigm." *Perspectives on Politics* 5 (1): 63–79.

Hardy-Fanta, Carol, Pei-te Lien, Dianne Pinderhughes, and Christine Sierra. 2006. "Gender, Race, and Descriptive Representation in the United States: Findings from the Gender and Multicultural Leadership Project." *Journal of Women, Politics & Policy* 28 (3/4): 7–41.

Hardy-Fanta, Carol, Pei-te Lien, Christine M. Sierra, and Dianne Pinderhughes. 2007. "A New Look at Paths to Political Office: Moving Women of Color from the Margins to the Center." Paper presented at the Annual Meeting of the American Political Science Association, Chicago, Illinois, August 30–September 2, 2007.

Hawkesworth, Mary. 2003. "Congressional Enactments of Race–Gender: Toward a Theory of Raced–Gendered Institutions." *American Political Science Review* 97 (4): 529–50.

Junn, Jane, and Nadia Brown. 2008. "What Revolution? Incorporating Intersectionality in Women and Politics." In *Women and American Democracy*, eds. Christina Wolbrecht, Karen Beckwith, and Lisa Baldez. New York: Cambridge University Press, 64–78.

Lawless, Jennifer. 2012. *Becoming a Candidate: Political Ambition and the Decision to Run for Office.* New York: Cambridge University Press.

Lawless, Jennifer, and Kathryn Pearson. 2008. "The Primary Reason for Women's Under-Representation? Reevaluating the Conventional Wisdom." *Journal of Politics* 70 (1): 61–82.

Lien, Pei-te. 2001. *The Making of Asian America through Political Participation.* Philadelphia, PA: Temple University Press.

Lien, Pei-te. 2002. "The Participation of Asian Americans in U.S. Elections: Comparing Elite and Mass Patterns in Hawaii and Mainland States." *UCLA Asian Pacific American Law Journal* 8 (1): 55–99.

Lien, Pei-te. 2014. "Reassessing Descriptive Representation by Women and Men of Color: New Evidence at the Subnational Level." *Urban Affairs Review* on-line. 51 (2): 239–62.

Lien, Pei-te, and Katie E.O. Swain. 2012. "Local Executive Leaders: At the Intersection of Race and Gender." In *Women and Executive Office: Pathways and Performance*, ed. Melody Rose. Boulder, CO: Lynne Rienner Publishers, 137–58.

Lien, Pei-te, Carol Hardy-Fanta, Christine Marie Sierra, and Dianne M. Pinderhughes. 2007. "Exploring Dimensions of Interracial Connections between Asian and other Nonwhite Elected Officials." Paper prepared for the 2007 Annual Meeting of the Association for Asian American Studies, New York, April 4–7.

Lien, Pei-te, Carol Hardy-Fanta, Dianne M. Pinderhughes, and Christine Marie Sierra. 2008. "Expanding Categorization at the Intersection of Race and Gender: 'Women of Color' as a Political Category for African American, Latinas, Asian American, and American Indian Women." Paper delivered at the 2008 Annual Meeting of the American Political Science Association, August 27–31, Boston, MA.

Mariani, Mack D. 2008. "A Gendered Pipeline? The Advancement of State Legislators to Congress in Five States." *Politics & Gender* 4 (2): 285–308.

Palmer, Barbara, and Dennis Simon. 2006. *Breaking the Glass Political Ceiling: Women and Congressional Elections.* New York: Routledge Press.

Scola, Becki. 2006. "Women of Color in State Legislatures: Gender, Race, Ethnicity and Legislative Office Holding." *Journal of Women, Politics & Policy* 28 (3/4): 43–70.

Scola, Becki. 2013. "Predicting Presence at the Intersections Assessing the Variation in Women's Office Holding across the States." *State Politics & Policy Quarterly* 13 (3): 333–48.

Smooth, Wendy. 2010. "Intersectionalities of Race and Gender and Leadership." In *Gender and Women's Leadership: A Reference Handbook*, ed. Karen O'Connor. Thousand Oaks, CA: Sage, 31–40.

Welch, Susan. 2008. "Commentary on 'Recruitment of Women to Public Office: A Discriminant Analysis,' 1978." *Political Research Quarterly* 61 (1): 29–31.

Wong, Lisa. 2013. "Support Strategies for Asian American Women Leaders in Massachusetts." Women's Pipeline for Change Project Brief 4. http://cdn.umb.edu/images/centers_institutes/center_women_politics_pipeline_project/Lisa_Wong_Final.pdf.

15

RACE, PERCEPTIONS OF FEMININITY, AND THE POWER OF THE FIRST LADY

A Comparative Analysis[1]

Andra Gillespie

First ladies have long played a pivotal role in most presidential administrations. Whether they chose to stay behind the scenes or to be active in shaping policy debates, there is no question that the women who are married to U.S. presidents wield a tremendous amount of power and influence. To be sure, some first ladies have had a difficult reception when they appeared to delve too much into the policy-making realm, but many modern first ladies (i.e., since Eleanor Roosevelt) have been very active public citizens.

Michelle Obama appears to be no different from her predecessors. She maintains an active public schedule and has adopted a number of causes to which she devotes her time and attention and for which she generates positive publicity to help affect policy change. However, in a 2015 commencement address to graduates of Tuskegee University, Mrs. Obama suggested that her experience as first lady has been different because she, unlike her predecessors, is Black. In particular, she contended that the mainstream press held her to a higher standard than other candidates' spouses in 2008 because of her race:

> As potentially the first African–American first lady, I was also the focus of another set of questions and speculations, conversations sometimes rooted in the fears and misperceptions of others.... Was I too loud or too emasculating? Or was I too soft? Too much of a mom and not enough of a career woman?
>
> (Obama, quoted in Malloy and Serfaty 2015)

This chapter seeks to empirically test Mrs. Obama's claim. Does Michelle Obama's race have any bearing on how she has been framed as first lady? Do popular depictions of Michelle Obama focus on the novelty of her being the

first Black first lady? To what extent does Mrs. Obama's race temper traditional representations of first ladies – i.e., does the press portray Mrs. Obama as a traditional homemaker-in-chief with a charity portfolio, or does her Blackness overcome the gendered circumscriptions – if at all?

In the pages that follow, I review the literature on first ladies and the literature on popular portrayals of Black women. Both literatures will help inform predictions of how first ladies are framed. I then test Mrs. Obama's hypothesis that she was treated differently using a content analysis of news profiles of her, Hillary Clinton, and Laura Bush. By comparing Michelle Obama to her immediate predecessors, we gain insight into how each first lady was popularly defined and can detect differences in media representations.

First Ladies and Advocacy

Though they serve in an unelected post, scholars of first ladies assert that these women exert a tremendous amount of power over their husband's administrations. For example, Campbell and McCluskie (2003) write that, "Although the Constitution is silent about her [the first lady], she is a prominent public figure who can, and often does, use her close proximity and indirect power to influence the president's political decisions" (169). Eksterowicz and Paynter (2003) note that since the 1930s, the first lady's duties have become more professionalized and increasingly more coordinated with the West Wing. As the federal courts noted when they granted Hillary Clinton the right to conduct private health care hearings during the 1993 reform effort, the first lady is a significant government actor (174, 225).

While the first lady is a powerful informal political actor, her role is highly gendered and circumscribed. There have certainly been first ladies who wielded a tremendous amount of political power. Edith Wilson and Eleanor Roosevelt come to mind; and in the post-World War II era, Hillary Clinton was viewed as an important policy advisor in her husband's administration, particularly as a result of her involvement in trying to overhaul the nation's healthcare system. However, Clinton received a sharp backlash for being too powerful and too involved. Myra Gutin (2003) notes that while first ladies have no formal responsibilities, their role has evolved into a highly feminized, structured, and marginal role. If first ladies appear to be too powerful or too involved in the policy process, pundits and citizens tend to think that she has violated some norm of decorum. Thus, the most powerful first ladies are the ones who can advance policy objectives without violating restrictive gender norms about women not being too pushy.

Thus, so long as a first lady operates within an admittedly gendered stylistic sphere, she may be able to use her influence to speak out on issues that may be taboo for her husband to address. Or she may be able to use a "softer touch" to advance a controversial part of her husband's agenda. Imagine that Ronald

Reagan's war against drugs would seem particularly more heavy handed had Nancy Reagan not adopted "Just Say No" as her platform. It is widely recognized that in the wake of signing the Civil Rights Act, Lyndon Johnson sent Lady Bird Johnson to campaign for him in the South. She is credited with helping her husband win half of the South in 1964 (Carlin 2004). Thus, we must consider that first ladies, so long as they stay in their prescribed gender role, may be able to make slightly more controversial aspects of a president's agenda palatable.

Race and Popular Depictions of Femininity

Clearly, traditional conceptions of gender roles define and constrain what first ladies are able to do. In many ways, the first lady epitomizes traditional notions of femininity. This is part of the reason why assertive first ladies such as Eleanor Roosevelt and Hillary Clinton were so controversial. Their independence, willingness to be opinionated, and involvement in policy debates transgressed popular expectations for how wives of presidents should behave. Despite how transgressive these first ladies were (and they were vanguard first ladies), they still may not have faced the same types of challenges that a Black consort might face. Simply put, Black women have different life experiences in the United States than White women, Michelle Obama included.

As the first African American first lady, Michelle Obama finds herself in an unprecedented position. She is one of the most high profile women in the country, and arguably, the most visible current consort in the world. She enjoys the same privileges that other first ladies enjoy (i.e., proximity to the President of the United States, staff, the profile to launch a public service platform) and has to deal with the same constraints (i.e., not having formal power, being pushed into a gendered, circumscribed role).

I contend that Michelle Obama's race adds an additional layer of complexity to her role. Because of this, it is useful to apply an intersectional framework to any analysis of Mrs. Obama's framing and impact. Patricia Hill Collins defines intersectionality as "particular forms of intersecting oppressions, for example, intersections of race and gender, or of sexuality and nation. Intersectional paradigms remind us that oppression cannot be reduced to one fundamental type, and that oppressions work together in producing injustice" (Hill Collins 2000, 18). This suggests that the sociopolitical position and perspectives of Black women may differ substantially from the perspective of White women or Black men, even though Black women share a gender identity with White women and a racial identity with Black men. Most important, the theory of intersectionality reminds us that one simply cannot double the disadvantage for Black women just because they have two marginal identities. Instead, their multiple identities can contribute to an entirely different experience (see Hancock 2007).

In her classic work, *Black Feminist Thought*, Patricia Hill Collins notes that, "The assumption on which full group membership is based – Whiteness for feminist thought, maleness for Black social and political thought, and the combination for mainstream scholarship – all negate Black women's realities" (Hill Collins 2000, 12). As such, as we examine the role and influence of Michelle Obama in her husband's administration, we must consider the possibility that her experience and influence may differ significantly from her predecessors because of her race.

Ways in Which Michelle Obama May Be Different

While all first ladies contend with the gendered constraints of their office, Michelle Obama finds herself in a unique perceptual bind. She is in one of the most gendered public roles imaginable, but it is a gendered office that until now has been exclusively defined by White standards of femininity. Hill Collins notes that "'true' [White] women possessed fours cardinal virtues: piety, purity, submissiveness and domesticity" (Hill Collins 2000, 72). Historically, Black women have been perceived as naturally lacking one or more of these traditional virtues.

There are a number of controlling stereotypes about Black women which serve to diminish their humanity and intrinsic femininity. For instance, the classic mammy stereotype is a Black female figure who is loyal to the White family she serves (usually as a domestic); however, serving her White family often comes at the expense of being available for her own family. Moreover, because the mammy is employed to engage in hard, physical household labor, she allows her White mistress the opportunity to maintain her delicacy, while the manual work negates the mammy's own femininity (Hill Collins 2000, 73–74).

In addition to the mammy figure, other stereotypes about Black women's hypersexuality, poor parenting skills, and welfare dependence persist, as well as notions that Black women dominate and emasculate their men (Hill Collins 2000, 77–79; Hill Collins 2005, 81–82, 131). Collectively, these stereotypes serve to "other" Black women and seek to deny them the status and privilege (admittedly, a highly constrained status and privilege) that is reserved for White women. In discussing the unique challenges that Black female athletes face, Patricia Hill Collins asserts that, "historically, all Black women have been deemed comparatively less feminine than white women" (Hill Collins 2005, 135).

At first glance, the fact that Black women are not perceived as passive or in need of protection could seem to be a blessing. However, the othering of Black women in this fashion has had serious social and policy consequences. This kind of stereotyping has been used in the past to justify the sexual exploitation of Black women (Hill Collins 2000, 81) and the circumscription of social welfare benefits to poor Black women in particular (see Hancock 2004).

In addition, these stereotypes have elicited a unique, classed reaction from middle class Black women attempting to overcome the stereotypes. Much of

what we define as the politics of respectability is motivated by a feminist desire for Black women to be treated as equally feminine to White women (Hill Collins 2005, 71). Lakesia Johnson uses the iconic image of Sojourner Truth wearing a bonnet and shawl while holding a Bible to illustrate the somewhat counterintuitive inclination for some Black women to embrace traditional, White femininity as a way of reclaiming their womanhood. She argues:

> For example, photographs of famous abolitionist Sojourner Truth played an important role in her work to uplift the race and to counter existing discourses about the immorality of Black women. Truth fashioned herself as a respectable, middle-class lady in order to prove her humanity to whites.
>
> (Johnson 2012, 8)

Professional, middle-class Black women have found themselves in an extremely tenuous social situation. As much as they try to use their accomplishments and class status to overcome negative stereotypes about Black women, they find themselves constrained by reincarnations of the old stereotypes. Patricia Hill Collins notes that, "Images of middle class Black femininity demonstrate a cumbersome and often contradictory link between that of modern mammy and Black lady" (Hill Collins 2005, 139). These Black women wish to represent the politics of respectability and virtue, yet they lack the wealth that would allow them to be ladies of leisure. Moreover, many professional Black women find themselves in the position of having to prove their loyalty to their employers at the expense of their personal lives, thus reproducing the mammy stereotype in a modern, more educated form (Hill Collins 2005, 139–141).

Using the example of the fictional character Claire Huxtable (of the 1980s sitcom *The Cosby Show*), Patricia Hill Collins argues that middle class Black women can either be Black ladies (which they usually cannot afford to do) or educated Black mammies, but they cannot be both. On paper, Huxtable was a smart, successful attorney with a solid marriage and five loving children. However, most scenes on *The Cosby Show* portrayed Mrs. Huxtable engaged in reproductive labor. She was raising children, keeping house, or canoodling with her husband. Hill Collins argues that Huxtable was rarely shown in a professional setting because, "Doing so would introduce the theme of her sexuality into the workplace, and exploring those contradictions apparently were beyond the skills of the show's writers" (Hill Collins 2005, 140). Ironically, though, Claire Huxtable would have likely needed to work outside the home in order for her and her husband to provide so comfortably for their family, despite her husband's lucrative and high status job as an obstetrician. Hill Collins juxtaposes the character of Claire Huxtable with the character of Lt. Anita Van Buren of *Law and Order*, an educated Black mammy. Lt. Van Buren's character was devoted to her job and her detectives, but seemingly devoid of a personal life (Hill Collins 2005, 139–142).

Since being a Black lady in the truest sense of the word was economically out of reach for most Black women, Hill Collins contends that a new stereotype of Black women emerged in the late twentieth century: "the educated Black bitch" (Hill Collins 2005, 145). The educated Black bitch is the foil to the modern, educated mammy. Like the educated mammy, she is smart, hardworking, and financially independent. However, she is competitive, aggressive, sexually assertive, and disloyal. For these reasons, Hill Collins argues that the deployment of the educated Black bitch stereotype can be used to undermine claims for the acceptance of middle class Black women on the basis of their respectability. Their competitiveness and aggressiveness undermines their intrinsic femininity and, for many, explains their perpetually single marital status (Hill Collins 2005, 145–146).

Related to the notion of the educated Black bitch is the general stereotype of Black women as angry. Rooted in classic Sapphire (named for the wife of one of the title characters in *Amos n' Andy*) stereotypes, "Black women's anger ... is seen as a pathological, irrational desire to control Black men, families and communities. It can be deployed against African American women who dare to question their circumstances, point out inequities, or ask for help" (Harris-Perry 2011, 95). Melissa Harris-Perry notes the political and social consequences of portraying Black women as angry. She contends that the stereotype of the angry Black woman has allowed Black women to be blamed for poverty and the disintegration of the Black family. Moreover, the angry Black woman never needs to be protected, and her alleged hostility negates the need to examine whether her underlying grievances have merit or can be addressed and ameliorated (Harris-Perry 2011, 86–96).

The notion of the educated Black bitch also correlates highly with the notion of Black women as preternaturally strong. Harris-Perry notes that Black women embrace the notion of strength to counter negative stereotypes. However, such a posture may not be healthy. She writes, "While this attachment to strength may be adaptive, it also creates dangerous exposure for Black women – routine human weakness and fragility are potential sources of shame" (Harris-Perry 2011, 186). Harris-Perry likens the pressure for Black women to be superwoman to John Henryism, a phenomenon epidemiologist Sherman James discovered among Black men. In response to racism, some Black men strove to work harder, ignoring their health. The end result was higher rates of cardiovascular disease hypertension among Black men (Harris-Perry 2011, 186–187; see also James 1994).

Michelle Obama as a Black First Lady

The office of first lady in many ways represents the pinnacle of traditional American womanhood. For Michelle Obama to be in this position of the standard American, feminine ideal is notable. The question arises, though, as to whether the stereotypes of Black women being less appropriately feminine

actually undermine Mrs. Obama's ability to garner the same type of recognition for and leverage from her role as first lady, as gender circumscribed as the role is.

Certain aspects of Michelle Obama's biography evince her susceptibility to common stereotypes about Black women. By virtue of the race and class status into which she was born (Mrs. Obama's mother worked as a homemaker when she was growing up, but her father supported the family in a blue-collar occupation), she does not automatically fit common perceptions of women in the elite classes. And while she and her husband were comfortably affluent and pedigreed by the time her husband ran for president, she might find herself stuck between the mammy and Black lady stereotypes. She could either be portrayed as a competent, loyal professional, or she could be portrayed as an upper class woman without a professional identity. Moreover, if her professional carriage offered any hint of being assertive or opinionated, she could be susceptible to charges that she is an educated Black bitch.

Popular renderings of Michelle Obama suggest a potential susceptibility to common stereotypes about Black women. As her husband was being introduced to the American electorate, certain narratives emerged about Michelle Obama which are arguably stereotypical. For instance, when Michelle Obama jokingly introduced her husband as her "baby daddy" at a rally in 2008, Fox News referred to Michelle Obama as "Obama's Baby Mama" in its RSS scroll, implying that she was an unwed mother (see Gillespie 2008). When she remarked that "for the first time in my adult lifetime, I am really proud of my country," she was accused of being both angry and unpatriotic (Johnson 2012, 109). *National Review* even labeled her "Mrs. Grievance" on the cover of its April 21, 2008 issue.

Hypotheses, Data, and Methods

The question underlying this chapter is to what extent does race popularly define Michelle Obama's tenure as first lady? Because of her unique role as first lady, I would expect that journalistic renderings of Mrs. Obama would fixate on her race and racially stereotypical depictions of her (such as being angry), while Laura Bush would be portrayed more as a traditional first lady. While I anticipate that media coverage of Hillary Clinton would cast her in a non-traditional role, I expect that Mrs. Clinton would be depicted differently than Mrs. Obama because of the racial difference.

To empirically test these hypotheses, I, similar to Ward (2016), conducted a comparative content analysis of news profiles of Michelle Obama and Mmes. Clinton and Bush as first lady. I chose to compare Mrs. Obama to her two immediate predecessors for a number of reasons. First, Michelle Obama, though significantly younger, is considered by some demographers to be a generational peer of Laura Bush and Hillary Clinton. They are certainly generational peers in

terms of the timing of their White House service. They are also the only three first ladies who have advanced degrees. Thus, their attitudes and general cultural perspectives, particularly on the role of women in modern society, may be shaped by some of the same cultural reference points that would not resonate if I compared Michelle Obama to Jackie Kennedy or Eleanor Roosevelt, who served in periods where women's roles were more rigidly defined. Second, I wanted to compare Mrs. Obama to both a Democratic and a Republican predecessor to control for any potential differences in party. If Mrs. Obama is depicted similarly to Mrs. Clinton, then partisanship may explain the similarity. Similarly, if Mrs. Clinton and Mrs. Bush received similar treatment, then race may explain that similarity.

To conduct this comparison, I compiled a dataset of news profiles featuring the three first ladies from Lexis Nexis Academic Universe. Going into this study, I supposed that news profiles were more likely to concentrate on first ladies themselves. For this chapter, I focus on campaign season depictions of Mrs. Clinton, Bush, and Obama. The dataset includes coverage of the years their husband stood for election (both first and second terms). It also includes the immediate post-election period (November to January). This allows me to examine inauguration coverage of the first ladies, which may be more likely to discuss each first lady's service platform or fashion choices. As such, the years covered in the database include January 1, 1992 to January 31, 1993; January 1, 1996 to January 31, 1997; January 1, 2000 to January 31, 2001; January 1, 2004 to January 31, 2005; January 1, 2008 to January 31, 2009; and January 1, 2012 to January 31, 2013. The dataset was restricted to articles listed in Lexis Nexis that could be described as profiles and biographies or interviews, and I only looked at U.S. newspapers and magazines. During the coding process, I found that some of the articles originated in foreign magazines. Those were subsequently excluded from the database. I also excluded articles that only mentioned first ladies in captions or links but did not mention the first lady in the text. I did include articles that only briefly mentioned the first lady as some of those articles and snippets often did include relevant information.

In total, the dataset includes 349 articles, all of the articles which met the selection criteria specified above. It is clear from the outset that Michelle Obama and Hillary Clinton generated far more media attention than Laura Bush. Mrs. Bush was mentioned in only 26 articles during and immediately after the 2000 campaign and in 45 articles during and immediately after the 2004 campaign season. In contrast, Mrs. Clinton was mentioned in 117 articles (76 during and immediately after the 1992 campaign; and 41 during and immediately after the 1996 campaign); and Mrs. Obama was mentioned in 161 articles (98 articles during and immediately after the 2008 campaign season and 63 articles during and immediately after the 2012 campaign). First ladies were rarely the subject of the articles or snippets[2] included in the database. For instance, Laura Bush was a primary subject of only 18 articles compiled in this dataset (25.4 percent).

Hillary Clinton was a primary subject in 35 articles (29.9 percent); and Michelle Obama was a primary subject in 54 articles (33.5 percent).

After determining the number of articles and coding them for year, I then coded the articles for content. I was particularly interested in how first ladies were depicted in the articles. Were they depicted in the context of their family roles or as highly credentialed professional women? Did the stories revolve around their roles as traditional consorts (i.e., advocating for a charitable or social cause, accompanying their husbands on diplomatic trips, hosting state dinners), or did they focus on the role of the first lady in advocating for a specific policy (i.e., things that actually become law through legislation or executive order)? Did articles focus on the first lady's role as a chief campaign surrogate, or did they focus just on her clothes?

With this in mind, I coded each article based on how authors characterized first ladies in each article.[3] I coded each characteristic as a binary variable (1 if the characteristic was represented in the article; 0 if it was not). The relevant characteristics are as follows:

- **FLOTUS Contrast:** Does the article mention other first ladies or presidential or vice-presidential candidates' spouses?
- **Policy Advocate:** Does the article describe the first lady engaging in a policy discussion?
- **Campaigner:** Is the first lady participating in campaign activities?
- **Scandal Context:** Does the article mention a scandal that involves the first lady or her husband?
- **Emasculating FLOTUS:** Does the article portray the first lady as being domineering toward her husband?
- **Influential/Ambitious FLOTUS:** Does the article portray the first lady as seeking to influence her husband's administration?
- **Complementarian FLOTUS:** Does the article portray the first lady as being a complement to her husband?
- **Good Marriage:** This variable queries whether news reports explicitly describe the president and first lady's marriage as healthy.
- **Mother:** Does the article mention the president and first lady's children or refer to the first lady as a mother?
- **Homemaker:** Does the article depict the first lady engaging in reproductive work separate from rearing her own children?
- **Consort Activities:** Does the article depict the first lady as engaging in activities that we consider traditional first lady activities?
- **FLOTUS as Regular Person:** Does the article depict the first lady engaging in normal activities?
- **FLOTUS as Role Model:** Does the article imply that the first lady is or should be a role model?
- **Education:** Does the article discuss the first lady's educational background?

- **FLOTUS as Professional:** Does the article talk about the first lady's professional career?
- **FLOTUS as Feminist:** Does the article describe the first lady as a feminist?
- **FLOTUS Appears Before Women:** This variable captures instances where news articles depict the first lady appearing before primarily female audiences.
- **FLOTUS as Black:** Does the article mention that Michelle Obama is Black?
- **FLOTUS Appears Before Minorities:** Does the article depict the first lady appearing before a minority audience or working in a minority space?
- **FLOTUS Appears Before Blacks:** Is the first lady depicted appearing before or working with a largely African American constituency?
- **Angry FLOTUS:** Is the first lady is described or depicted as angry in the article?
- **Middle Class FLOTUS:** This variable is coded as 1 if the article claims that the first lady has a middle class or small town (i.e., middle America) background.
- **Working Class FLOTUS:** Does the article imply that the first lady pulled herself up from a working class background?
- **Fashionable FLOTUS:** Does the article mention the first lady's clothing or describes her physical bearing or beauty?

Findings

Table 15.1 outlines the bivariate analysis of how the last three first ladies have been depicted in feature journalism coverage during the years their husbands ran for president (both first and second elections). This allows for a comparative analysis to see if all three first ladies were depicted similarly in the national press. The p-values listed in the table are from chi-square analysis of the cross-tabulations.

The bivariate findings indicate that some representations of first ladies were portrayed with relatively equal frequency across the three administrations. For instance, all three first ladies' children were mentioned in the articles about 25 percent of the time. There were some variations in the discussion of some characteristics that were not statistically significant. For instance, articles were more than twice as likely to mention that Michelle Obama and Laura Bush had strong marriages than Hillary Clinton. While this is not surprising given widespread discussion of the strains in Bill and Hillary Clinton's marriage, this difference is not statistically significant, in large part because very few articles explicitly described any of these presidential marriages as strong. Similarly, while Laura Bush was more likely to be described as engaging in reproductive labor (i.e., cleaning house, cooking, gardening, or casual entertaining), she was described in that manner in less than 20 percent of the articles which mentioned her.

TABLE 15.1 Article Framing of First Ladies, Hillary Clinton to Michelle Obama

FLOTUS described:	Clinton	Bush	Obama	p-value
In contrast to other political spouses	43 (36.8%)	23 (32.4%)	32 (19.9%)	0.006
As a policy advocate	28 (23.9%)	8 (11.3%)	13 (8.1%)	0.001
As a campaign surrogate	35 (29.9%)	13 (18.3%)	57 (35.4%)	0.033
In the context of a political scandal	43 (36.8%)	7 (9.9%)	24 (14.9%)	0.000
As softening POTUS's rough edges	4 (3.4%)	7 (9.9%)	4 (2.5%)	0.033
As seeking/having influence in POTUS's administration	22 (18.8%)	0 (0.0%)	13 (8.1%)	0.000
As having a good marriage	4 (3.4%)	6 (8.5%)	13 (8.1%)	0.236
As a mother	29 (24.8%)	20 (28.2%)	43 (26.7%)	0.870
Engaging in domestic activity	12 (10.3%)	13 (18.3%)	15 (9.3%)	0.124
Carrying out traditional FLOTUS duties	25 (21.4%)	28 (39.4%)	33 (20.5%)	0.005
Doing regular activities	13 (11.1%)	11 (15.5%)	9 (5.6%)	0.045
As role model	7 (6.0%)	2 (2.8%)	21 (13.0%)	0.018
As being educated	9 (7.7%)	11 (15.5%)	20 (12.4%)	0.232
As having a career	31 (26.5%)	15 (21.1%)	20 (12.4%)	0.011
As a feminist	30 (25.6%)	3 (4.2%)	4 (2.5%)	0.000
Appearing in feminine spaces	5 (4.3%)	0 (0.0%)	10 (6.2%)	0.099
As Black	0 (0.0%)	0 (0.0%)	23 (14.3%)	0.000
Appearing in minority spaces	2 (1.7%)	2 (2.8%)	7 (4.3%)	0.454
Appearing in Black spaces	2 (1.7%)	0 (0.0%)	6 (3.7%)	0.190
As angry	15 (12.8%)	0 (0.0%)	17 (10.6%)	0.009
As middle class	2 (1.7%)	3 (4.2%)	4 (2.5%)	0.570
As a working class triumph	0 (0.0%)	0 (0.0%)	15 (9.3%)	0.000
In terms of clothes/attractiveness	16 (13.7%)	4 (5.6%)	18 (11.2%)	0.226
Positive portrayal of fashion/beauty	6 (5.1%)	4 (5.6%)	8 (5.0%)	0.978
Negative portrayal of fashion/beauty	5 (4.3%)	0 (0.0%)	3 (1.9%)	0.146
TOTAL	117	71	161	

Source: Author's compilation.

Articles covering Laura Bush and Michelle Obama were more likely to mention their educational credentials than articles covering Hillary Clinton. However, the differences were not statistically significant. In a similar vein, Michelle Obama and Hillary Clinton were more likely – but not significantly more likely – to appear before female, minority, or African American audiences or to be perceived as trying to appeal to these groups. Mrs. Bush was never depicted appearing in a female space or all Black space in the articles in this database; however, Mmes. Clinton and Obama were only rarely depicted reaching out to female, minority, or Black constituents.

There were differences in how the first ladies were objectified in terms of their fashion choices or general attractiveness. Hillary Clinton's physical bearing was proportionately discussed most (nearly 14 percent, compared to 11 percent for Michelle Obama and 6 percent for Laura Bush). However, again, because those discussions were rare in this universe of articles, the differences were not statistically significant. I did sub-code the fashion/appearance variable to account for positive or negative depictions of the first ladies, anticipating that Hillary Clinton would have been subject to more criticism (there were some neutral fashion depictions). I found, though, that overall those frequencies were so small that any distinctions were statistically insignificant.

There were many dimensions on which first ladies experienced statistically significant differences in media coverage. For instance, articles discussing Michelle Obama were significantly less likely to mention other first and second ladies and gentlemen (both real and potential). This could imply that Michelle Obama is treated as a unique consort. It could also suggest that Hillary Clinton, because of her role in attempting to draft a healthcare plan, drew greater comparisons with her more traditional counterparts.

It was perhaps not surprising that the data support the common narrative of Hillary Clinton being a substantively trailblazing, potentially polarizing first lady. Clinton was more than twice as likely than Laura Bush and nearly three times as likely as Michelle Obama to be depicted advocating for policy. In addition, nearly 40 percent of articles discussing Hillary Clinton mentioned some type of scandal, whether it was about her husband's infidelity or their ethical and financial dealings while Bill Clinton was Governor of Arkansas. Mrs. Clinton was also significantly more likely to be depicted as a feminist (25 percent, compared to 4 percent for Laura Bush and 3 percent for Michelle Obama). There were also stark contrasts in how her ambitions were portrayed. Nearly 19 percent of articles discussing Hillary Clinton discussed the fact that she either sought or had substantive influence in her husband's administration, even going so far sometimes as to report that Clinton was compared to Lady Macbeth of Shakespearean lore. In contrast, none of the articles about Laura Bush mentioned such ambitions, while only 8 percent of articles about Michelle Obama portrayed her as seeking power.

The data also support the common perception that Laura Bush was a traditional first lady. She was far less likely to be depicted campaigning for her

husband (18 percent of articles, compared to 30 percent of articles for Hillary Clinton and 35 percent of articles for Michelle Obama); but, she was far more likely to be portrayed engaging in traditional first lady activities[4]: reading to school children, participating in events which highlight her platform, hosting guests at the State of the Union Address, etc. In addition, Laura Bush was three to four times as likely as Hillary Clinton and Michelle Obama, respectively, to be described as rounding out her husband's rough edges or serving as his conscience or ego check.

There were some ways in which discussions of Hillary Clinton and Laura Bush were significantly different from discussions of Michelle Obama. For instance, Hillary Clinton and Laura Bush were respectively two to three times as likely as Michelle Obama to be depicted doing regular things (i.e., going to plays, having lunch with friends and family, having birthday celebrations, discussing favorite foods). Mmes. Clinton and Bush were also significantly more likely to have their career choices discussed than Mrs. Obama. Despite the fact that Laura Bush had quit her job nearly 20 years before her husband ran for president, articles were 70 percent more likely to mention her career background than they were to mention Michelle Obama's career (even though she worked outside of the home until her husband ran for president). Similarly, Hillary Clinton's career background was discussed more than twice as often as Michelle Obama's, despite the fact that they are both lawyers.

Perhaps not surprisingly, race and class figure prominently in depictions of Michelle Obama. While there was no statistical difference in the frequency of the depiction of the first ladies as being middle class, Michelle Obama was described as having worked her way up from a working class background. Some of this reflects the reality of her background. Hillary Clinton and Laura Bush came from more economically comfortable families, so it is not surprising that they were never described as working class. It is also not surprising that only Michelle Obama was ever described as Black; after all, neither Hillary Clinton nor Laura Bush identifies as African American.

What might be surprising, though, is the depiction of Michelle Obama vis-à-vis her predecessors as a role model. Thirteen percent of the articles mentioned Mrs. Obama's capacity to be an exemplar – these articles included interviews with third parties who claimed her as a role model or editorials which argued that Michelle Obama should be a role model. Only two articles about Laura Bush mentioned her in the context of being a role model, while seven articles about Hillary Clinton mentioned something about her capacity to be a role model.

Because of existing stereotypes about angry Black women, Michelle Obama may be particularly vulnerable to media discussions of her being angry. As expected, Michelle Obama was significantly more likely than Laura Bush to be portrayed as angry. These depictions usually discussed her comments about being proud of her country or the 2008 *The New Yorker* cover which portrayed

her as a gun-toting, Afro-wearing radical. Laura Bush was never portrayed as angry. However, Hillary Clinton was equally likely to be portrayed as angry (in general, I coded the infamous "I could have stayed home and baked cookies" and "I'm not standing by my man like Tammy Wynette" comments as connoting anger (and feminism)).

To be sure, depictions of anger could be deployed in different ways against first ladies depending on other characteristics. Thus, it is important for us to consider the ways in which race intersects with gendered depictions of anger to portray first ladies in different ways. To that end, I created interaction terms to see if Hillary Clinton was more likely to be portrayed as both angry and feminist (a negative stereotype in its own right) in the same article and if Michelle Obama was likely to be described as angry and Black in the same article.

Table 15.2 presents the cross-tabulations for the interactions of anger depictions with depictions of the first lady as feminist or Black. Since Michelle Obama is the only Black first lady, it is not surprising that she is the only first lady described as angry and Black. Seven articles described her as angry and mentioned her race, compared to 17 articles which described her as angry and 23 articles which mentioned her race. In contrast, only two articles simultaneously described her as a feminist and angry (four articles described Obama as a feminist). Not surprisingly, Hillary Clinton was most often described in the same article as being angry and feminist. Twelve articles described Clinton as an angry feminist (that is more than one-third of the 29 articles which described Clinton as a feminist and all but one of the articles that described her as angry).

In Table 15.2, I also present correlations between discussions of Hillary Clinton and Michelle Obama as feminist and angry and Michelle Obama as angry and Black. I did not assume normal distribution and used Kendall's Tau B

TABLE 15.2 Depictions of First Ladies as Angry Feminists or Angry Blacks, by First Lady

FLOTUS Characteristic	Clinton	Bush	Obama	p-value
Feminist	30 (25.6%)	3 (4.2%)	4 (2.5%)	0.000
Black	0 (0.0%)	0 (0.0%)	23 (14.3%)	0.000
Angry	15 (12.8%)	0 (0.0%)	17 (10.6%)	0.009
Angry*Feminist	12 (10.3%)	0 (0.0%)	2 (1.2%)	0.000
Angry*Black	0 (0.0%)	0 (0.0%)	7 (4.3%)	0.015
TOTAL	117	71	161	
Correlations				
Angry* Feminist	0.477**	–	0.205**	
Angry* Black	–	–	0.264**	

Source: Author's Compilation.

Notes
** $p \leq 0.05$, two tailed test.

correlations, but I also ran Spearman's Rho correlations and Pearson's correlations as a robustness check and got nearly identical results.

As the bottom of Table 15.2 shows, the correlations between depictions of selected first ladies as being angry and Black and/or feminist are significant. There were significant correlations between depictions of both Hillary Clinton and Michelle Obama as being angry and feminists. The relationship was much stronger for Hillary Clinton, though; while the correlation between depictions of Michelle Obama as being angry and feminist was a weak-to-moderate 0.2, the correlation between depictions of Hillary Clinton as being angry and feminist was a comparatively stronger 0.48. Indeed, when Clinton was described as angry, she was almost always portrayed as a feminist as well.[5]

While the correlation between explicit depictions of Michelle Obama as being angry and Black was significant, the relationship is a weak to moderate 0.26. While Michelle Obama's race or perceived anger was often mentioned in articles, they were not mentioned together a majority of the time. It should be noted that one could argue that one need not explicitly mention Mrs. Obama's race to prime stereotypes of the angry Black woman. While that may be true, it cannot be empirically tested using content analysis of text only. An experimental approach employing pictures would be more appropriate to answer that question.

Analysis/Conclusion

The content analysis above confirms Mrs. Obama's suspicions in part. There are ways in which media coverage distinguishes her from her two immediate predecessors. Media reports did seize upon the novelty of Michelle Obama's race, and it was explicitly mentioned in about one in seven articles. Mrs. Obama was also significantly less likely to be mentioned in the context of discussions about other first ladies and candidates' spouses.

In many ways, the unique backgrounds of each of the three first ladies led to distinct media treatment. Laura Bush, arguably the most traditional first lady of the three studied here, received less media coverage and was less likely to be covered explicitly campaigning for her husband. While she was not portrayed as seeking to influence her husband's administration, she was more likely to be portrayed as her husband's moral compass and carrying out traditional first lady duties.

In contrast, Hillary Clinton and Michelle Obama were portrayed in ways consistent with popular conceptions of them. These conceptions support the idea that gender and race intersect in ways that produce meaningful differences in the treatment of Black and White women. Hillary Clinton was portrayed in ways that could be construed as consistent with popular understandings of second-wave feminism. She was most likely to be portrayed as a feminist, more likely (than Michelle Obama) to be portrayed as a career woman, and most likely to be portrayed as wanting to vie for power in her husband's administration.

Michelle Obama, whose résumé is as equally impressive as Hillary Clinton's, occupies an interesting middle space. She was not significantly more or less likely to be portrayed as a mother or housewife, nor were her educational credentials touted more or less than the others. She, like Laura Bush, was significantly less likely to be portrayed as a feminist and as a career woman, though. And while there has been a lot of popular attention given to Mrs. Obama's wardrobe and physique, in this dataset, her clothes and appearance were not more scrutinized than the other first ladies.

Mrs. Obama was more likely to have her working class roots discussed in articles than Hillary Clinton and Laura Bush's middle class roots. Often, Mrs. Obama was depicted as a modern day Horatio Alger. In addition to her working class roots, articles were more likely to describe Michelle Obama as a role model. Sometimes, this was a normative framing, with an op-ed writer declaring that Mrs. Obama should be a role model. Other times, interview subjects claimed Mrs. Obama as their role model.

Both Hillary Clinton and Michelle Obama were portrayed as angry. However, the angry frames used to describe Clinton and Obama were different and racialized. When she was portrayed as angry, Hillary Clinton was portrayed as an angry, implicitly White feminist. Occasionally, when Michelle Obama was portrayed as angry, she was explicitly described as Black.

These findings suggest that race and gender do intersect to create unique opportunities and challenges for Michelle Obama. While she has had to contend with accusations that she is an angry Black woman, she also bears the burden that reporters are more likely to depict her as a role model who pulled herself up by her bootstraps. So, not only is she racialized and gendered, she is also classed.

In addition, the findings corroborate the Black feminist literature that suggests that professional Black women contend with stereotypes that deny them their full femininity. Compared to Laura Bush and Hillary Clinton, Michelle Obama was equally likely to be portrayed as a homemaker, mother, stylish, or in a good marriage. However, she was significantly less likely than Laura Bush, the supposedly traditional first lady, to be portrayed engaging in traditional consort duties or even having a career. Obama is certainly portrayed as more traditional than Hillary Clinton, but she is portrayed as less traditional than Laura Bush, despite the fact that both women are equally less likely to be described as feminist and about equally less likely to be portrayed in a policy advocacy role compared to Hillary Clinton.

I should point out that this study is only generalizable for election year, print profile coverage of first ladies. A more extensive universe of articles might generate different findings. Future studies should examine profile coverage of first ladies across all eight years of their husbands' terms. Scholars might also want to consider a study of news section coverage of first ladies to determine if the coverage differs when the story is a hard news story versus a human interest piece. Future work should also consider an examination of the relationship between article themes and the tone of media coverage of the first lady.

To conclude, Michelle Obama may have had a point when she said that she was held to a different standard than other candidate wives. Nearly a quarter of the articles mentioning her explicitly referenced her race, and there was a moderate correlation between articles mentioning her race and describing situations which portrayed her as angry. In addition, she, unlike her predecessors, was held up as a role model and an example of someone who had pulled herself up by her bootstraps. Aside from the angry characterization, these distinctions may seem benign. However, even the flattering characterizations can be constraining, because they place undue pressure on Black women to be super-human (see Harris-Perry 2011, 216, 218). As the most high profile woman in America, many people already project unrealistic expectations onto her. As the most high profile Black woman in America, Mrs. Obama has to contend with additional pressures that other Black women face to project a highly gendered sense of perfection while still contending with a pervasive but evolving set of pernicious stereotypes which diminish the contributions of Black women on a daily basis.

Appendix available online at www.routledge.com/9781138958845.

Notes

1 The author would like to thank Ife Odelugo, Elvin Ong, Kirsten Widner, and Lizzy Wiener for their research assistance with this project. An earlier version of this chapter was presented at the annual meeting of the Southern Political Science Association.
2 I define a snippet article as an article that is a compilation of news briefs. A first lady might be the subject of one of the brief articles that is aggregated into a full column. If a first lady is the subject of one of these brief articles, then I code her as being the focus of the article, as I am only focused on the section of the column that pertains to her. Snippets also include rankings lists, community calendars, and television schedule guides. Sometimes those articles are mere listings, but it is not uncommon for those listings to be annotated and to contain substantive information. For this reason, I decided to include the whole class of articles in the database.
3 Student researchers conducted an inter-coder check on a random selection of 41 articles. We all agreed on 74.5 percent of the codes. The first inter-coder check was conducted before revising the code fields to include the scandal, emasculating, influential/ambitious, complementarian, good marriage, angry, middle class, working class, and positive/negative fashion variables. The variables noting appearances in predominantly Black and female audiences was also reconfigured after the inter-coder check as well. Another student researcher conducted an inter-coder check with the new codes. Our individual coding decisions agreed at least 77.8 percent of the time. After this, I then modified the angry and feminist codes to designate nearly all of Hillary Clinton's references to baking cookies and Tammy Wynette as being angry and feminist.
4 This is largely due to the fact that articles covering Mrs. Bush often referenced the work she did while she was First Lady of Texas.
5 It should be noted that this is largely driven by the discussion of the baking cookies and Tammy Wynette comments.

References

Campbell, Colton and Sean McCluskie. 2003. "Policy Experts: Congressional Testimony and Influence of First Ladies." In *The Presidential Companion: Readings on the First Ladies*. Robert Watson and Anthony Eksterowicz (Eds.). Columbia, SC: University of South Carolina Press. 169–191.

Carlin, Diana B. 2004. "Lady Bird Johnson: The Making of a Public First Lady With Private Influence." In *Inventing a Voice: The Rhetoric of American First Ladies of the Twentieth Century*. Molly Meijer Wertheimer (Ed.). New York: Rowman and Littlefield. 273–296.

Eksterowicz, Anthony and Kristen Paynter. 2003. "The Evolution of the Role and Office of the First Lady: The Movement Toward Integration with the White House Office." In *The Presidential Companion: Readings on the First Ladies*. Robert Watson and Anthony Eksterowicz (Eds.). Columbia, SC: University of South Carolina Press. 210–230.

Gillespie, Andra. 2008. "The Michelle Obama Drama." *Atlanta Journal-Constitution*. July 20.

Gutin, Myra. 2003. "Hillary's Choices: The First Ladyship of Hillary Rodham Clinton and the Future of the Office." In *The Presidential Companion: Readings on the First Ladies*. Robert Watson and Anthony Eksterowicz (Eds.). Columbia, SC: University of South Carolina Press. 273–288.

Hancock, Ange-Marie. 2004. *The Politics of Disgust*. New York: New York University Press.

Hancock, Ange-Marie. 2007. "When Multiplication Doesn't Equal Quick Addition: Examining Intersectionality as a Research Paradigm." *Perspectives on Politics*. 5(1): 63–80.

Harris-Perry, Melissa V. 2011. *Sister Citizen: Shame, Stereotypes and Black Women in America*. New Haven, CT: Yale University Press.

Hill Collins, Patricia. 2000. *Black Feminist Thought*. Revised Tenth Anniversary Edition. New York: Routledge.

Hill Collins, Patricia. 2005. *Black Sexual Politics*. New York: Routledge.

James, Sherman A. 1994. "John Henryism and the Health of African Americans." Culture, Medicine and Psychiatry. 18 (2): 163–182.

Johnson, Lakesia. 2012. *Iconic: Decoding Images of the Revolutionary Black Woman*. Waco, TX: Baylor University Press.

Malloy, Allie and Sunlen Serfaty. 2015. "Michelle Obama Says She Was Held to a Different Standard in '08 Campaign Due to Her Race." CNN.com. May 11. Retrieved from www.cnn.com/2015/05/09/politics/michelle-obama-commencement-tuskegee-university/index.html. May 15, 2015.

Ward, Orlanda. 2015. "Media Framing of Black Women's Campaigns for the U.S. House of Representatives." In *Distinct Identities: Minority Women in U.S. Politics*. Nadia Brown and Sarah Roberts Allen Gershon (Eds.). London: Routledge.

16

TO BE YOUNG, GIFTED, BLACK, AND A WOMAN

A Comparison of the Presidential Candidacies of Charlene Mitchell and Shirley Chisholm

Christina Greer

In 1968, a young 38-year-old activist and member of the Communist Party, Charlene Mitchell, decided to run for the President of the United States. Mitchell did not fit the profile of a U.S. presidential candidate. For starters, she was young, Black, and a woman.

Charlene Mitchell did not make a significant "dent" in the campaigns of the three leading candidates, Richard Nixon (Republican Party), Hubert Humphrey (Democratic Party), or George Wallace (American Independent Party), and her campaign is often dismissed if not completely erased from the history books. Some would consider her run for the presidency, which garnered just over one thousand votes, an abject failure. Mitchell, however, was the first ever African American woman to run for the presidency of the United States. Her run, as far-fetched as it may have seemed in 1968, helped pave a portion of the stony road Shirley Chisholm faced in 1972 when she announced her candidacy for president of the United States on the Democratic Party ticket just four years later. A 48-year-old Shirley Chisholm was a seasoned state legislator turned U.S. Congresswoman from New York. Both Mitchell and Chisholm were significantly younger than the average white male politician in their race. The average age for the party nominee in the Republican Party from 1960 to 1980 was 58 years old and for the Democratic Party it was 52 years old. The U.S. Constitution states that citizens running for the presidency must be 35 years or older. However, due to the skills and requirements necessary for successful campaign-fundraising, feeder occupations, and name recognition – often candidates much older than 35 years old emerge as leaders in a presidential election. Their race and gender were more significant determinants for their collective electoral fates than their age differences, when compared to their white male competitors [See Appendix A].

In charting Mitchell and Chisholm's campaigns, some may think that the two candidacies have little in common beyond the fact that both candidacies involved Black women. Indeed, at first glance these two candidacies may not appear to share much in common. However, we must remember that there would be no Barack Obama without the courage of Jesse Jackson (F. Harris 2014). There would be no Jesse Jackson without the bravery of Shirley Chisholm. And there is no audacious campaign of Shirley Chisholm without the beginning foundation of Charlene Mitchell. We know that many women who worked on Chisholm's failed 1972 campaign later became active participants in Democratic Party politics on local and state levels, most notably Congresswoman Barbara Lee (D-CA) who worked as a volunteer on Chisholm's campaign for the presidency. The election of the first Black president is a result of the electoral successes and failures of his predecessors, all of them, not just the one or two Democratic candidates that scholars and mainstream popular narratives choose to acknowledge.[1]

How was Mitchell able to introduce the concept of a Black woman running for the presidency? And, perhaps most importantly, what can we learn from the campaigns of Mitchell and Chisholm and how can we apply these lessons to twenty-first century intersectional politics, campaigns, and elections? If the reality of a Black woman in executive office is the goal, what lessons from Mitchell and Chisholm should we consider in order to assist future potential Black female candidates? In this chapter, I examine the presidential runs of Mitchell and Chisholm as Black and female candidates for the U.S. presidency. Using the growing literature on Chisholm in particular, I find that while Mitchell did not significantly alter the political landscape in 1968, her candidacy begins a long legacy of Black females running for the presidency, registering new Black voters into the electoral system, and ultimately helping to contribute to the elusive "golden prize" for Black Americans, the election of Barack Obama as the first African American president of the United States in 2008. More importantly though, Mitchell's often forgotten candidacy contributes to the growing conversation pertaining to the contributions of Black female candidates to electoral and partisan politics for Blacks in America, as well as the necessity for a political pipeline for Black female candidates to statewide office.

Beginning with Mitchell, Black women continue to run for the presidency on alternative parties, but are still largely underrepresented in national level politics as representatives of one of the two dominant political parties. Black women are highly participatory as voters in American politics (primarily as Democrats) and are increasingly representing diverse offices on local levels and in state houses across the country, and even across dominant party lines. For example, almost all Black female members of the Congressional Black Caucus (CBC) began their start in politics in local and state-wide electoral politics. Black women are serving as mayors in second and third tier population cities, as members of state houses, and the U.S. Congress. And the success of Mia Love

(R-Utah) represents a possible new trend of Black women elected for higher office on the Republican Party line. However, with the exception of former U.S. Senator Carol Moseley Braun (D-IL), Black women have not been able to attain positions as U.S. senators or as governors, positions that often catapult one into the national spotlight and lay the foundation for a credible presidential run. Without Black women in these pipelines, the road to the White House for African American women remains an elusive prize. The 2016 California Senate race with Kamala Harris (Democrat) may represent a possibility for the advancement of a Black female elected to statewide office who could be considered as a legitimate candidate for executive office. However, she must first win statewide election and build coalitions across several demographic groups, something that has been especially difficult for Black women seeking state-wide office.

Black women consistently lead the African American community in participation in electoral politics, yet their advancement into executive level politics has not been commensurate with their overwhelming participation rates. When observing the data on Black women on local levels, they show a consistent increase of Black female representation in various levels of political office (Brown 2014b; Dolan 2005; Gamble 2010), but beyond the one Black female who chooses to run for the presidency every four years on an alternative party platform, there has not been a significant campaign waged by an African American female candidate within the Democratic or Republican Party since 1972 (Lynch 2004). Despite this reality, the candidacies of Black women, although not at the numbers or candidate selective processes as they could or should be in the twenty-first century, still represent contributions to the larger Black political consciousness. No, these candidacies have not yielded a Black female president. However, they have introduced other Black women to electoral politics and the descriptive significance of a Black woman running for office. When Black women run for lower offices, they can and do win (Smooth 2006b; Williams 1989).

So why did Mitchell run? And what is the significance of her candidacy on the executive political contributions of Shirley Chisholm on the successes of Jackson and Obama? The role of Mitchell and Chisholm's candidacies on Black electoral politics, for modern day Black female candidates, is of great importance as we develop theories of intersectionality for twenty-first century American politics. Their candidacies were not just significant for the candidacies of Jackson and Obama decades later. Their campaigns also served as vehicles of participation for Blacks who would later run for local level offices. In particular, what can we learn from these "failed" campaigns? I find that both Mitchell and Chisholm laid a foundation for future Black candidates, both male and female. They also laid a foundation for candidates not just in the Democratic Party, but for African American candidates representing diverse independent parties. Specifically, Mitchell and Chisholm as Black and female candidates have contributed to the larger political development of African American presidential scholarship in ways still being felt today on the local, state, and national levels.

In subsequent pages, I present a brief overview of the theories of candidate selection, scholarship on Black female candidates, and the application of those theories to the candidacies of Mitchell and Chisholm. Using pre-existing scholarship, I show the Mitchell and Chisholm created a "snowball effect" for electoral success on the national level that ultimately culminated in the election of Barack Obama, the first African American president. I also argue that the lack of a sustained dominant party pipeline for Black female electeds has prevented Black women from attaining statewide office and ultimately the presidency.

The Limitations of Leaders

In 1968, Charlene Mitchell as a little known African American member of the Communist Party decided to run for the presidency. The only two women who had previously set sights on the presidency were white women, Victoria Woodhull in 1872 and Belva Ann Lockwood in 1884 and 1888.[2] Both Woodhull and Lockwood ran before women received the franchise in 1920 through the passage of the 19th Amendment. To be clear, the passage of the 19th Amendment largely affected the lives of white women. Although "Blacks" were granted the franchise through the passage of the 15th Amendment, ostensibly that franchise was granted largely to Black men. And due to Reconstruction and the subsequent emergence of Jim Crow laws, full Black enfranchisement did not occur until 1965 with President Lyndon Johnson's passage of the Voting Rights Act (VRA). Even then, the full franchise took additional years to implement in several areas of the country, primarily in the U.S. South. Therefore, when assessing the electoral inclusion of African Americans, Blacks have only been fully included in the franchise for 50 years. Although Mitchell ran after the passage of the 15th and 19th Amendments, allowing Blacks and women the franchise, Blacks in America had not been given full and fair treatment under the law in regards to the electoral process due to Draconian local and state laws and Jim Crow efforts that prohibited full inclusion as citizens and voters. Mitchell's run for the presidency is often regarded (if it is regarded at all) as the equivalent of a small pebble falling into a vast ocean. Unlike most accounts that omit Mitchell's candidacy all together, I argue that her campaign is representative of the first African American woman who ran for presidency, and was a small pebble that sets forth an avalanche of electoral progress for African American women (and men), which is felt almost a half of a century later.

Given the extremely small number of votes garnered by Mitchell during her presidential run, 1075 votes to be exact, it is understandable for some to believe Mitchell's efforts were in vain or not even worthy of note. Instead, I argue we must view Mitchell as a necessary pioneer for all African American candidates and elected officials, especially Shirley Chisholm, who is often heralded as the first African American woman who had the audacity and courage to run for the presidency. Mitchell's party affiliation is just one of the contributing factors in

her lack of electoral success. The Democratic and Republican Parties have solidified their dominance in the electoral sphere and have left little to no room for alternative party success (Milkis 1993; Sundquist 1983). Mitchell's candidacy on the Communist Party line and her direct philosophical and intellectual links between the Communist Party and the African continent placed her within a party and an electoral message that was not mainstream, even for Black American voters. Therefore, Chisholm's decision to run for the presidency, in a crowded Democratic Party field, while refusing to be pushed to the margins to an alternative party (even when it was clear she would not have the support of a vast majority of Black male leaders within the Democratic Party), is indicative of her understanding of the American voters' ability to recognize individuals they deemed as "serious" candidates. For voters, one of the primary and baseline indicators of a potential legitimate presidential candidate is the decision and ability to run within the two-party system (Sundquist 1983).

There are inherent limitations of America's dominant two-party system for African American candidates, as well as both the importance and limitations of the effects African American third-party candidates have had, and can have, on that system (F. Harris 2014). There is value in the existence of alternative parties and symbolic candidates within the American polity. The dilemma for the African American electorate, is that it must either: 1) work within a dominant two-party system that is designed to disappoint, and thus potentially lead to African Americans' alienation and withdrawal; or 2) not work within that system and guarantee their alienation as a consequence of that withdrawal (Hamilton 1973). Thus by participating in the two-party system, in which roughly 90 percent of African American voters have supported the Democratic Party and have voted almost unanimously in recent history, African Americans are seeking to *protect* their interests, but at the price of a decreased ability to *advance* their interests (Dawson 1994; Hamilton 1973; Walters 1988).

Why the Campaigns of Charlene Mitchell and Shirley Chisholm Largely Got Ignored

In the mid-1960s there was great turbulence within the Black community in the form of protest politics as well as revolutionary politics on local, state, and national levels (Tate 1993). Many politicians argued for institutional change within the American political system, while others argued that change in the American political system was not possible, and ultimately, the American political system was impervious to change (Tate 1993; Turé and Hamilton 1967). Therefore, some opted to abstain from the political system altogether. We must remember that the franchise was not fully and uniformly extended to African Americans until the passage of the 1965 Voting Rights Act. Therefore, the presidential campaign of Charlene Mitchell in 1968 on the Communist Party ticket is seen as both a version of protest politics and institutional politics intersecting

at once. The late 1960s and early 1970s were a time of great political awakening for Blacks in electoral politics. The elections of Black women in statehouses across the country introduced a new era of race and gender politics for Black female electeds [See Appendix B]. The landmark election of Shirley Chisholm to Congress as the first Black woman, followed by Barbara Jordan's (D-TX) election just four years later as the first Black woman from the U.S. South marked a new era of Black politics (Fraser 2014).[3]

Using an intersectionality framework to analyze the experiences of African American women political elites on the presidential level is informed by the significant scholarship which analyzes Black women on local and state levels (Brown 2014a; Smooth 2006a; Stokes-Brown and Dolan 2010). Crenshaw (1989) argues that the intersectionality of race and gender must be analyzed when assessing women of color in American politics. Similarly, Collins (2000) says the cultural patterns of oppression for Black women are interrelated. The bond between race and gender is consistently influenced by oppressive structures of society. As Black politicians and the political activities of Black voters moved into mainstream political conversations, Mitchell, as a third-party candidate, and Chisholm, as the Democratic Party candidate, were both ignored by the larger media, political operatives, and the parties that they represented. I call Mitchell and Chisholm political elites because they ran for the presidency of the United States, the highest office in American politics. Therefore their classification as elite level operatives must be noted.

When observing the candidacies of Mitchell and Chisholm it is clear that Black women experienced both race and gender simultaneously. As scholars have often observed on local and state levels, these two experiences are often inseparable (Brown 2014a; Hawkesworth 2003). As Githens and Prestage (1977) argued, Black women are the double disadvantage being, in that they are a part of the non-majority racially and part of the non-dominant group in their gender. In 1968 and 1972 Mitchell and Chisholm did not experience what the research of Smooth (2006a) and Philpot and Walton (2007) found. They argue that minority female candidates appeal to a broader range of voters both female and communities of color. However, Mitchell was not a member of a dominant party and therefore her candidacy in the Communist Party did not include the support of Blacks or women. Chisholm could not get Blacks or women to support her candidacy on a wide scale level. Essentially, elite level Blacks and leaders within the Black community wanted a Black man as their ultimate representative on the national level (Johnson 2007).

Timing, Campaigning, and the Competition: The Work of Mitchell and Chisholm

Contextualizing the significance of Mitchell's 1968 campaign in a larger Black radical tradition was unlike Chisholm who later represented what some would

consider assimilationist electoral politics. Mitchell, her identity with the Communist Party, and her bold candidacy as a Black woman for the presidency on an alternative party line represented a stark contrast to her all white male competition, as well as previous notions of Black leadership, Black radical politics, and electoral chances.

In 1968 when Mitchell ran against Richard Nixon (Republican), Hubert Humphrey (Democrat), and George Wallace (American Independent), she faced, within her own party, the barriers to her electoral ambition. The roles women are assumed to play within social movements often did not include visible leadership roles. And even within progressive politics, men were presumed to be the progressive leaders and thinkers, while women's roles were relegated to nurturing and supportive helpmate roles in nature (Taylor 1999).

Mitchell's political leanings also did not represent mainstream Democratic Party politics. However, her ability to link the Civil Rights struggles in the U.S. to larger African independence and liberation movements became her driving mission. What is so fascinating about the Civil Rights struggles at this moment in time is that, on the one hand, many African Americans are solidly aligning themselves with the Democratic Party – the party that began to recruit African Americans under the leadership of Franklin D. Roosevelt in the 1940s, and whose relationship was further solidified under the leadership of John F. Kennedy and Lyndon B. Johnson in 1960 and 1964 respectively. However, on the other hand, African American alignment at this time was also very solidly cognizant of the various Civil Rights efforts waged by groups as diverse as the SCLC, SNCC, Black Panthers, the Socialist Party, and others. Therefore, Mitchell's candidacy does not necessarily represent a contradiction to mainstream Black American politics. Rather, her candidacy represented a non-dominant party version of the myriad of discussions and concerns being waged within the Black community at the time. As a candidate, she articulated her support of the American Civil Rights Movement, but expressed her disagreement with the capacity of a capitalist U.S. system to ever support (or tolerate) economic ambitions of the Black underclass (Cullen and Wilkinson 2010). Mitchell's message of economic liberation was a perfect complement to many within the Civil Rights Movement who believed that true equality and freedom must be attained not only at the ballot box, but in the banks as well. Drawing from Malcolm X's April 3, 1964 speech "The Ballot or the Bullet" in Cleveland, Ohio, Mitchell was keenly aware of Malcolm X's philosophy pertaining to the link between capitalism, racism, and power. In his speech he stated, "It's impossible for a white person to believe in capitalism and not believe in racism." (Goldstone 2010, p. 80). Mitchell was keenly aware of how race, economic liberation, and policy were intertwined in American politics and elections.

The Civil Rights Movement was waged after decades of Jim Crow oppression and began as early as the 1930s and 1940s (Johnson 2010). However, the height of the Black Power Movement was set in the 1960s and a prime opportunity for Mitchell to capitalize on Black feelings of disenfranchisement within the American

political system and inequality compared to their white counterparts. Mitchell took her message to groups like the Black Panthers, who were sympathetic to the larger goals of racial equality, economic stability, and greater political visibility. Largely due to her extensive travels throughout the continent of Africa, her knowledge and understanding of the continent and its liberation struggles proved to be an invaluable resource to the Black Panthers and other Black radical political movements being waged in the U.S. Mitchell's involvement in African and American political unity, equality, and enfranchisement is indicative of the larger diasporic linkages present between African Americans and their African counterparts (Hayes and Greer 2013). As groups like the Southern Nonviolent Coordinating Committee (SNCC) removed white participants from its membership because they felt the needs of African Americans must be addressed by African Americans and that the larger society needed to address Black inequality when compared to whites (Cullen and Wilkinson 2010), Mitchell campaigned primarily across the northeastern section of the United States and spoke primarily on college campuses. Although only on the ballot in four states, her sojourn remains significant, as Mitchell was the first African American woman nominated by a political party and placed on the ballot for the presidency.

Mitchell's bid for the presidency in 1968 was also significant because the Communist Party had not run any candidates for national office from 1948 to 1964. Due to the McCarran Internal Security Act of 1950 and the Communist Control Act of 1954, the Communist Party consisted largely as an organization that existed in the shadows of American democratic politics (Lipset 1978). Due to her race, gender, and party affiliation, she was largely ignored by the larger Black and white communities.

Chisholm's presidential fate was largely sealed by the lack of Black male leadership support during the secret 1971 meeting of Black political leaders in Northlake, IL. The all-male leadership gathered to decide whether they would support a white candidate in the 1972 presidential election or run one of their own Black (implied male) leaders. During the meeting, various levels of elected officials were present as well as leaders who represented the vast geographic interests of Blacks in America. When Shirley Chisholm suggested that she be considered as a presidential contender in 1972, the Black male leadership demurred, arguing that their reluctance to support Chisholm had nothing to do with her gender. Rather, they argued, it was her brash style that contributed to their reticence. Julian Bond, at the time a Georgia state legislator recalled,

> There was anger against her.... She thought that by virtue of announcing the candidacy we would fall in line. I remember enormous resentment at this idea. Politicians like to be asked. She would put it down to sexism, and there was some of that, but I don't think her gender had as much to do with it as her style.
>
> (Richardson 1996, p. 194)

Black leaders gathered once again in 1972 for the Black National Convention in Gary, IN. The various factions of Black political leadership did not succeed in endorsing a single candidate. Rather, the political needs, wants, and priorities were so diverse among the groups, an agreement was not reached pertaining to a presidential candidate endorsement. This included the non-endorsement of the sole African American in the race, Shirley Chisholm. Robnett (1996, p. 1688) argues that, "Gender exclusion was particularly useful because the movement could draw upon the resources of well-educated and/or articulate women to act as carriers, as cultivators of solidarity." Shirley Chisholm did not want to solely serve as a "cultivator of solidarity" or as a mediator of conflicts. It was in Miami Beach, FL at the 1972 Democratic National Convention that Chisholm witnessed Black male leadership act like, "old fashioned politicians in the pursuit of power" (Richardson 1996, p. 210). Chisholm was well aware of the difficulty in gaining the support of Black male leaders. During her transition from state legislator to U.S. Congresswoman she later reflected,

> [It] came through to the community that the organization could not bring itself to endorse me because I would not submit to being bossed by any of them ... even among themselves, they never questioned my competence or dedication. What they said was always that I was "hard to handle."
>
> (Chisholm 1970, pp. 83–4)

Similarly, women (read white women) in the women's rights and equality movements wanted essentially a white woman as evidenced by the scores of white feminists who ultimately could not bring themselves to support Chisholm's candidacy. Not only did the 1972 Black Freedom Delegates meeting in Ohio vote not to support Chisholm, leading white female feminists such as Gloria Steinem and Bella Abzug failed to back Chisholm as well. Often when one is tasked to think about women running and women winning, the process is largely about white women (Junn and Masuoka 2014).

In 1968, when the country was still very much divided along racial lines, women's equity had yet to be fully recognized, and the Civil Rights Act and Voting Rights Act were barely in their implementation phases, the candidacy of Mitchell, and the subsequent candidacy of Chisholm just four years later, did not yield a broad range of voters, both female and in communities of color.[4]

The trend of Black voting in presidential elections has steadily increased over the past four decades, as has the percent of female voters (Cole and Stewart 1996; M. Harris 2014). Therefore, on local levels, Black female candidates have been able to find success in state houses in primarily Black districts and local elections in diverse locales (Sanbonmatsu 2002). However, many Black female candidates also find that party leaders often assume voters are more willing to support white female candidates over Black female candidates in particular

circumstances and districts, especially for state house positions. Therefore, party leadership does not readily, or easily support the candidacies of Black women (Sanbonmatsu 2006b).

What it's Like to Run on a Third Party … or to Run Within the Dominant Party and Get Treated Like a Third Party Candidate

Although Black women have long been silent leaders within the Black political community, Black women have largely been absent from the larger discussions of the past regarding emerging post-Civil Rights leadership (Gamble 2010). King (1995) argues, "Black women often confront multiple oppressions and systemic discrimination, they have also always resisted those oppressions" (p. 294). Black women are more politically engaged than Black men (Cole and Stewart 1996; Tate 1993) even though they consistently struggle to resist subordination and marginalization. Despite the dual marginalization many Black women have faced, they overwhelmingly supported Barack Obama's 2008 and 2012 candidacies at roughly 65 percent of the entire Black community (M. Harris 2014).

Given the high levels of Black female involvement in local, state, and national politics, why do their presidential contributions seem almost invisible when comparing them to their Black male counterparts? There are institutional and systemic barriers that Black women have faced (and continue to face) when seeking executive office in the U.S. and these constraints are directly affected by the intersectionality of race and gender identity for Black female politicians. Robnett (1996) argues that Black women were often excluded from the institutional and/or interpersonal networks necessary to build successful movements. Because of this exclusion, they therefore served as "bridge builders" and thus initiated ties between the social movement and the community, but were not considered movement leaders.

As we begin to analyze how Mitchell influenced the candidacy of Chisholm, how Mitchell has been largely ignored by the political discourse surrounding Black females and the presidency, and how Chisholm influenced the presidential candidacies of roughly 20 African American women following her failed 1972 presidential run, we must remember the constraints placed on African Americans in the electoral sphere. Black female candidates and voters consistently face institutional and structural barriers and additional obstacles to political success. For example, child care and parent care obligations, inflexible occupational statues, and a lack of resources to make voting a priority (Jordan-Zachery and Wilson 2014). Therefore, the significance of Mitchell and Chisholm, Black women daring to run for the presidency during the height of civil unrest, the vestiges of White supremacy as evidenced by George Wallace's presidential run, and widespread inequities, is the physical manifestation of their attempts to face institutional barriers of executive level electoral politics head on.

Mitchell, Chisholm, and So Many Others: Ambition without Institutional Support

When investigating the significance of race and gender for Black women running for the executive office, it is necessary to investigate why these Black women decided to become candidates for the highest office in American democracy, and what factors affected their decisions and ultimate outcomes. Candidate ambition and subsequent factors associated with highlighting issues important to women and Blacks directly affect an individual's decision to run for office.

Many of the factors that influence candidate ambition do not necessarily coincide with the literature on candidate emergence and selection. Candidate ambition is the decision for an individual to run for an elected office. However, candidate emergence and selection are often times influenced by factors such as income, education, wealth, and previous occupation in order for parties and larger political institutions to select the most "electable" candidate to recruit to run (Darcy et al. 1994, p. 105; Gamble 2010, p. 295). Herrnson (2012) details how candidates are often selected by parties. It is the larger party institutions that often select individuals to financially support, promote, train, and assist in getting elected. Unlike Mitchell, who was not a member of one of the larger dominant two parties, Chisholm was. As a sitting member of the U.S. Congress she possessed the minimum requirement many party officials implore when selecting a candidate to support. She had twice previously been elected. And although she was not a member of the legal profession or business community, occupations often chosen by party leaders because of their access to financial resources, Chisholm's political networks as an elected official could have been utilized by party leaders as an electoral asset.

When reviewing all possible candidates from the 1968 and 1972 presidential elections, Mitchell and Chisholm were the only women who emerged as candidates. There were no white female candidates in either election year. In 1968, 65 percent of voting eligible women voted in the presidential election and 62 percent voted in 1972, even with a woman on the ballot (U.S. Census Bureau). Women had received the franchise in 1920 with the passage of the 19th amendment. However, due to the limited gains of African Americans in electoral politics, and only the recent passage of the 1964 Civil Rights Act and the 1965 Voting Rights Act, it is fair to say that female advancement in an electoral space was often limited to the expansion of white women's progress.

Candidate ambition theory suggests that the desire to run has always been present (Black 1972). However, candidate eligibility theory explains how this ambition is often overturned by the candidate selection process. Because women, especially Black women, have been grossly underrepresented in occupations which serve to elevate individuals into eligible candidates supported by

party institutions, their underrepresentation can be explained more succinctly. Although in the twenty-first century, many of the past theories are being challenged, the underrepresentation of women in elite level politics persists.[5]

Implications and Conclusions: Creating the Opportunity

What is abundantly clear is that the next step(s) are to get more women to run and stay in the political pipeline so that even higher executive offices may be attained (Gamble 2010). Sanbonmatsu (2002, p. 793) has suggested in her analysis of the role of political parties in shaping female representation across the U.S., "The pattern of women in the state legislature has implications for women's election to statewide and federal office since female state legislators may run for higher office." This present work illustrates the importance of descriptive representation of past Black female candidates, but also the necessity for an increase in the pipeline for Black female candidates. When reviewing the names of the roughly 20 Black women who have run for executive office in the U.S., none were as successful as Chisholm in 1972 [See Appendix C]. For example, although women like Senator Carol Moseley Braun (D-IL) and Congresswoman Cynthia McKinney (D-GA) ran for the presidency over three decades after Chisholm, their presidential campaigns did not galvanize voters or mobilize supporters as seen by Chisholm in 1972. This suggests that the problem is largely twofold. Either comprehensive candidate recruitment and training have not been present, or the institutional barriers present for Black women at the national level have become more calcified, even as opportunities are expanding for Black women on the local and state house levels. While Black female candidates on alternative party lines have served a necessary function to increase Black female leadership, networks, strengthen alternative party frameworks and institutions, and increase organizational efforts on a myriad of levels, the alternative candidacies do not contribute to the goal of a Black *female* executive.

So why did Mitchell run? And what is the significance of her candidacy as we think more critically about the inherent political limitations of statewide or national Black female leadership? In order to fully understand the magnitude of Mitchell's run and the courage it took to wage a presidential campaign in 1968, we must look at the legacy her initial run set forward. Mitchell and Chisholm's attempts at the presidency provide an overview of African American contributions to the institution of the executive office. Although the participation of African American candidates on the national level may have seemed like far-flung and self-serving endeavors for many third-party and independent candidates, important institutional mechanisms arose from their inclusion into the electoral system at this elite level. These candidates implemented grass roots organizing on local levels in diverse locales, questioned pre-existing party rules, and groomed local campaign workers for local level and state wide offices. Their quest for the executive office not only contributed to an increase in African American elected officials on local

levels, but also directly and indirectly enabled the success of Jesse Jackson in 1984 and 1988. Their efforts, both descriptively and substantively, also directly contribute to the successes of the Obama campaign some 40 years after Mitchell's name first appeared on a presidential ballot.

Although Mitchell and Chisholm were the first African American women to run for the presidency, they were not the first African Americans to seek executive office. For Black women seeking the presidency, especially Chisholm, the intersection of race and gender proved to be a barrier that white women and Black men could not (or would not) overcome. The lack of Black female candidates representing one of the two dominant parties has also created a "corrosive effect" in the pipeline for executive office. If Sanbonmatsu (2002) is correct and lower offices for women, and especially women of color, are necessary to attain greater elected status, the lack of Black female governors and U.S. senators should raise further questions pertaining to the weight of intersectionality for Black women on statewide levels.

That there has only been one Black female senator, and no Black female has ever been elected as a governor of one of the 50 U.S. states, is indicative of a lack of statewide political infrastructure for Black female candidates. In reviewing the various failed campaigns of Black women who have run for the presidency, what is even more stark is that there have been far fewer Black women to ever run for senate or governor in the U.S., when compared to white women and Black men. The lack of Black females entering into "feeder" occupations for national level office helps explain the dismal numbers of Black women who ever run for the presidency on a dominant party line. Black women occupy a political space in a context still largely dominated by wealthy white males and, therefore, Black female candidate ambition is often trumped by a white candidate's abilities to raise more significant amounts of capital and thereby eliminating competition before it even has time to germinate. It is only in hindsight that we can observe the necessary elections of Black women who dared to run for the highest office in U.S. politics, and how those failed candidates often inspired and motivated other Black women to run for local office. It is the lack of pipeline from local to statewide elected office that continues to limit the possibility of one day having a president who just happens to be young, gifted, Black, and a woman.

Appendix tables available online at www.routledge.com/9781138958845.

Notes

1 In other works, I explore the significance of all 55 African Americans who have run or been nominated for the U.S. presidency from 1872 to 2012. See Greer, Christina. 2015. African-American Candidates for the Presidency and the Foundation of Black Politics in the Twenty-first Century. *Politics, Groups, and Identities.*
2 Woodhull chose Frederick Douglass as her Vice Presidential running mate. Ultimately, he declined to accept the nomination.

3 The 1974 landmark election of Yvonne Brathwaite Burke (D-CA) as the third Black American woman elected to U.S. Congress is often overlooked. However, her success in CA politics opened several doors for Black women in state level offices as well as Congress. Currently Kamala Harris and the dozens of Black female elected officials across the state of California owe a debt to Brathwaite Burke.

4 The U.S. Census Bureau Current Population Surveys 1968–2008, Trends in Voter Turnout. Figures 2–4 show the presidential election voting percentages from 1964 to 2008. Figure 2.1 compares all citizens to Black citizens. Observing the presidential years 1968 and 1972 when assessing the entire citizenry, the voting percentages were 68 percent and 62 percent respectively. During those two elections, Blacks voted in fewer numbers than the overall citizenry at roughly 58 percent and 51 percent respectively. The subsequent tables show the voter turnout of all citizens compared to male citizens (Figure 3.1) and to female citizens (Figure 4.1). In 1968 and 1972, the percentage of the male citizenry voted at 2 percent and 1 percent higher than the rates of the national citizenry and women voted at rates of 2 percent and 1 percent less than the national citizenry.

5 See Carroll and Sanbonmatsu (2013) for further discussion. Some factors that influence women's ambition to run for elected office are recruitment and family involvement and obligations within the home (Burrell 1994; Herrnson 2012). However, many theories that attempt to explain female involvement in politics often focus on local and state level female activity (Brown 2014b; Smooth 2006b).

Bibliography

Black, Gordon. 1972. A Theory of Political Ambition: Career Choices and the Role of Structural Incentives. *APSR* 66(1): 144–59.

Brown, Nadia. 2014a. *Sisters in the Statehouse: Black Women and Legislative Decision Making*. New York: Oxford University Press.

Brown, Nadia. 2014b. Black Women's Pathways to the Statehouse: The Impact of Race/Gender Identities. In *Black Women in Politics: Identity, Power, and Justice in the New Millennium*. Eds. Michael Mitchell and David Covin. *National Political Science Review*, Volume 16, New Brunswick, NJ: Transaction Publishers.

Burrell, Barbara. 1994. *A Woman's Place is in the House: Campaigning for Congress in the Feminist Era*. Ann Arbor, MI: University of Michigan Press.

Carby, Hazel. 1998. *Race Men*. Cambridge, MA: Harvard University Press.

Carroll, Susan. 1994. *Women as Candidates in American Politics*. Bloomington, IN: Indiana University Press.

Carroll, Susan, and Kira Sanbonmatsu. 2013. *More Women Can Run: Gender and Pathways to the State Legislatures*. New York: Oxford University Press.

Chisholm, Shirley. 1970. *Unbought and Unbossed*. Washington, D.C.: Take Root Media.

Cole, Elizabeth R., and Abigail Stewart. 1996. Meanings of Political Participation among Black and White Women: Political Identity and Social Responsibility. *Journal of Personality and Social Psychology* 71: 130–40.

Collins, Patricia Hill. 1990. *Black Feminist Thought: Knowledge, Consciousness, and the Politics of Empowerment*. Boston, MA: Unwin Hyman.

Crenshaw, Kimberle Williams. 1989. Demarginalizing the Intersection of Race and Sex: A Black Feminist Critique of Antidiscrimination Doctrine, Feminist Theory, and Anti-Racist Politics. In *Feminist Legal Theory: Readings in Law and Gender*. Eds. K. T. Bartlett Kennedy and R. Kennedy, 57–80. San Francisco, CA: West View Press.

Cullen, David, and Kyle Wilkinson. 2010. The Communist Party of the United States

and African American Political Candidates. In *African Americans and the Presidential Road to the White House*. Eds. Bruce Glasrud and Cary Wintz. New York: Taylor and Francis.

Dawson, Michael. 1994. *Black Visions: The Roots of Contemporary African-American Political Ideologies*. Chicago, IL: University of Chicago Press.

Darcy, R., and Charles Hadley. 1988. Black Women in Politics: The Puzzle of Success. *Social Science Quarterly* 69: 629–45.

Darcy, R., Charles Hadley, Susan Welch, and Janet Clark. 1994. *Women, Elections, and Representation*. 2nd Ed. Lincoln, NE: University of Nebraska Press.

Dolan, Kathleen. 2005. How the Public Views Women Candidates. In *Women and Elective Office: Past, Present, and Future*, 2nd ed. Eds. Sue Thomas and Clyde Wilcox, 41–59. New York: Oxford University Press.

Duke, Lois Lovelace (Ed.). 1996. *Women in Politics: Outsiders or Insiders?* 2nd ed. Englewood Cliffs, NJ: Prentice-Hall.

Fraser, Zinga. 2014. *Catalysts for Change: A Comparative Analysis of Barbara Jordan and Shirley Chisholm*. Ph.D. Dissertation at Northwestern University, Department of African American Studies.

Gamble, Katrina. 2010. Young, Gifted, Black, and Female: Why Aren't There More Yvette Clarks in Congress? In *Whose Black Politics?* Ed. Andra Gillespie, 293–308. New York: Routledge.

Githens, Marianne, and Jewel Prestage. 1977. *A Portrait of Marginality: The Political Behavior of the American Woman*. New York: Longman.

Goldstone, Dwonna. 2010. The Socialist Workers Party and African Americans. In *African Americans and the Presidential Road to the White House*. Eds. Bruce Glasrud and Cary Wintz. New York: Taylor and Francis.

Hamilton, Charles. 1973. *The Black Experience in American Politics*. New York: Putnam Publishing Group.

Harris, Fredrick. 2014. *The Price of the Ticket: Barack Obama and the Rise and Decline of Black Politics*. New York: Oxford University Press.

Harris, Maya. 2014. *Women of Color: A Growing Force in the American Electorate*. Washington, D.C.: Center for American Progress. 1–13.

Hayes, Robin J., and Christina M. Greer. 2013. The International Dimensions of Everyday Black Political Participation. *Journal of African American Studies*: 1–19.

Hawkesworth, Mary. 2003. Congressional Enactments of Race-Gender: Toward a Theory of Raced-Gendered Institutions. *American Political Science Review* 97 (4): 529–50.

Herrnson, Paul S. 2012. *Congressional Elections: Campaigning at Home and in Washington*. Washington, D.C.: CQ Press.

Johnson, Cedric. 2007. *Revolutionaries to Race Leaders: Black Power and the Making of African American Politics*. Minnesota, MN: University of Minnesota Press.

Johnson, Kim. 2010. *Reforming Jim Crow: Southern Politics and State in the Pre-Brown South*. New York: Oxford University Press.

Jordan-Zachery, Julia, and Salida Wilson. 2014. Talking about Gender While Ignoring Race and Class: A Discourse Analysis of Pay Equity Debates. In *Black Women in Politics: Identity, Power, and Justice in the New Millennium*. Eds. Michael Mitchell and David Covin. *National Political Science Review*, Volume 16, New Brunswick, NJ: Transaction Publishers.

Junn, Jane, and Natalie Masuoka. 2014. *Gender Gap or Race Gap? Women Voters in U.S. Presidential Elections*. APSA Paper.

King, Deborah K. 1995. Multiple Jeopardy, Multiple Consciousness: The Context of

Black Feminist Ideology. In *Words of Fire*. Ed. Beverly Guy-Sheftall, 294–318. New York: New Press.

Lipset, Seymour. 1978. Marx, Engels, and America's Political Parties. *The Wilson Quarterly* (1976–) 2(1) (Winter): 90–104.

Lynch, Shola. 2004. *Chisholm '72: Unbought and Unbossed*. Documentary Film.

Milkis, Sydney. 1993. *The President and the Parties: The Transformations of the American Party System since the New Deal*. New York: Oxford University Press.

Mitchell, Michael, and David Covin. 2014. Black Women in Politics: Identity, Power, and Justice in the New Millennium. *National Political Science Review*, Volume 16, New Brunswick, NJ: Transaction Publishers.

Philpot, Tasha S., and Hanes Walton, Jr. 2007. One of Our Own: Black Female Candidates and the Voters Who Support Them. *American Journal of Political Science* 51: 49–62.

Richardson, James. 1996. *Willie Brown: A Biography*. Berkeley, CA: University of California Press.

Robnett, Belinda. 1996. African American Women in the Civil Rights Movement, 1954–1965: Gender, Leadership, and Micromobilization. *American Journal of Sociology* 101(6): 1661–93.

Sanbonmatsu, Kira. 2002. Political Parties and the Recruitment of Women to State Legislatures. *Journal of Politics* 64(3): 791–809.

Sanbonmatsu, Kira. 2006a. Gender Pools and Puzzles: Charting a "Women's Path" to the Legislature. *Politics and Gender* 2: 387–400.

Sanbonmatsu, Kira. 2006b. Do Parties Know That "Women Win"? Party Leader Beliefs about Women's Electoral Chances. *Politics and Gender* 2: 431–50.

Sigelman, Carol, Lee Sigelman, Barbara Walksoz, and Michael Nitz. 1995. Black Candidates, White Voters: Understanding Racial Bias in Political Perceptions. *American Journal of Political Science* 39: 243–65.

Smooth, Wendy. 2006a. Intersectionality in Electoral Politics: A Mess Worth Making. *Politics and Gender* 2: 400–14.

Smooth, Wendy. 2006b. African American Women in Politics: Journeying from the Shadows to the Spotlight. In *Gender and Elections in America: Shaping the Future of American Politics*. Eds. Susan Carroll and Richard Fox, 117–42. New York: Cambridge University Press.

Stokes-Brown, Atiya, and Kathleen Dolan. 2010. Race, Gender, and Symbolic Representation: African American Female Candidates as Mobilizing Agents. *Journal of Elections, Public Opinion, and Parties* 20: 473–94.

Sundquist, James. 1983. *Dynamics of the Party System*. Washington, D.C.: Brookings Institute.

Tate, Katherine. 1993. *From Protest to Politics: The New Black Voters in American Elections*. Cambridge, MA: Harvard University Press.

Tate, Katherine. 2003. *Black Faces in the Mirror: African Americans and their Representatives in the U.S. Congress*. Princeton, NJ: Princeton University Press.

Taylor, Una. 1999. "Read[ing] Men and Nations": Women in the Black Radical Tradition. *SOULS* 1(4): 72–80.

Turé, Kwame, and Charles Hamilton. 1967. *Black Power: The Politics of Liberation*. New York: Vintage.

Walters, Ronald W. 1988. *Black Presidential Politics in America: A Strategic Approach*. New York: State University of New York Press.

Williams, Linda. 1989. White/Black Perceptions of the Electability of Black Political Candidates. *National Political Science Review* 2: 45–64.

17

RAISING THEIR VOICES IN TRIBAL POLITICS

Indigenous Women Leaders in Arizona and
New Mexico

Diane-Michele Prindeville and Lawrence Broxton

> ...as the first Councilwoman ... I remember ... this elderly lady came and she gave me a hug and said "My child, my child be strong" because I guess in the [pueblo] way they were saying that a woman's heart is not strong enough to be on the Council.
>
> (Rose M.)

Purpose and Value of Research

This chapter is about the experiences of a few Native American women in tribes with political systems ranging from highly participatory and democratic to authoritarian, elitist, and downright hostile to women. To illustrate: "After I was hired [to work in the pueblo administration] ... when I came here, there was some writing on my door ... it had 'Welcome to hell, come on in.'" (Betty H.)

American Indian women active in grassroots and electoral politics are motivated by, and build their political agendas around, their traditional culture and gender. They seek to maintain tribal sovereignty, preserve their indigenous language, battle racism, empower women, and improve the quality of life in their communities (Prindeville 2003; cojmc.unl.edu/nativedaughters/leaders/native-women-move-to-the-front-of-tribal-leadership). Native women serving in tribal and grassroots politics adapt mainstream feminist ideologies to analyze and address their communities' needs while considering traditional cultural values and beliefs (Prindeville 2004a). "Women leaders from 21 tribes representing different forms of government all expressed the value and necessity for women's participation in tribal governance and policymaking" (Prindeville 2004b).

Drawing on the personal stories of 14 Native leaders from 12 Indian Nations[1] in Arizona and New Mexico, we examine how culture and gender roles influence whether, and to what extent, women may participate in the politics

and governance of their tribe. By this we mean exercising legitimate authority in the leadership of their sovereign nation, creating policy, deciding on the distribution of resources, and conducting affairs of state. The purpose and value of this research is to increase our understanding of and add new knowledge to the extremely limited scholarship devoted to Native American politics and governance, and to indigenous North American women's political leadership. There is much that we can learn from them and their cultures.

> I think women bring a different perspective, and women can definitely ... make positive contributions on how they see things happening, whether it's at the local level, or at their homes, or in the schools.... Looking out for the children, or looking out for your parents and your elders, women have a lot to say.
>
> (Melanie D.)

This growing body of knowledge shatters stereotypes and provides empirical support for the influential role of Native women in tribal and non-tribal governance, political activism, and public policy-making (Prindeville 2003, 2004a, 2004b).

Similar to the findings in several of the chapters in this volume, Native women also face structural, institutional, and cultural barriers to achieving political leadership. Sanbonmatsu (in this volume) finds that women of color often lack the opportunities to serve in higher political office. In this chapter I illustrate these particular difficulties for Native women and their experiences in serving in political leadership in tribal governments. Whereas the Ramírez and Burlingame (in this volume) and Filler and Lien chapters (also in this volume) demonstrate that women of color serve in a myriad of political offices, we offer new evidence of where and how Native women engage with electoral politics. Lastly, this chapter provides fresh empirical knowledge of the kinds of political cultures that allow Native women leadership in tribal politics. These findings are similar to those of Bejarano (in this volume) who finds that there are particularized conditions in which women of color are most likely to be elected. In sum, while some Native women face distinct cultural barriers to achieving political participation, the experiences that we detail in this chapter elucidate the similarities faced by women of color who seek a place in political life.

Research Methodology

Using a snowball sampling technique I conducted candid face-to-face interviews in 2001 and 2007 with 14 Native American leaders from 12 tribes in Arizona and New Mexico. The majority of the leaders were elected to office by enrolled members of their tribe at the time of their interview with the exception of three. One of these women had long been involved politically, starting in her

TABLE 17.1 Position Held by Leaders

Leadership Position	# of Leaders	State	Govt.
Tribal Administrator (Staff)	2	NM	TRAD'L.
Council Member	1	AZ	IRA
Secretary	3	AZ/NM	HYBRID
Treasurer	2	NM	HYBRID
Chairwoman	2	AZ	IRA
Vice-President	1	AZ	IRA
Governor	1	NM	HYBRID
President	1	NM	IRA
State Legislator*	1	NM	IRA

Notes
Forms of Government
Trad'l. – Traditional/Theocratic
Hybrid – Transitional/Hybrid
IRA – Constitutional/IRA
* Leader ran for highest tribal office while in state government.

village then moving from county commission to state legislature to campaigning for leader of her tribe. The other two women held top administrative positions in traditional theocratic pueblos which banned women and laymen from political leadership. Their knowledge, competency, and professional expertise, however, enabled them to have a positive influence in their communities.

The tribes operated under one of the following systems of governance: traditional theocratic, transitional/hybrid, and constitutional or IRA (stands for Indian Reorganization Act, which will be explained below).

My personal interviews with leaders, which were conducted in different venues, varied in length with most lasting between one and a half to two hours. I used a digital recorder and took handwritten notes during and after our meeting to ensure accuracy. Because I employed active interviewing techniques, study participants were free to guide the conversation and wander off topic, which is how some of the richest data emerges. Because of the potential for political and personal retaliation against the participants of this study, I took precautions to keep secret the leaders' identities by using pseudonyms and avoiding any mention of their personal characteristics. Finally, I offered the leaders the opportunity to review our transcript for errors, misrepresentations, and misunderstandings so these could be corrected.

Background

Puebloan and historically nomadic tribes in Arizona and New Mexico differ in culture, religion, and governing structure. Pueblos were established agrarian

TABLE 17.2 Tribes and Their Form of Government

Indian Nation	Peoples	Govt.	State
Acoma Pueblo (1)*	Pueblo	TRAD'L.	NM
Ak Chin (1)	Ak Chin	IRA	AZ
Fort McDowell Yavapai (1)	Yavapai/Mohave/Apache	IRA	AZ
Hopi Nation (1)	Pueblo	HYBRID	AZ
Jicarilla Apache Nation (1)	Apache	IRA	NM
Navajo Nation (2)	Diné (Navajo)	IRA	AZ/NM
Pascua Yaqui (1)	Yoeme (Yaqui)	IRA	AZ
Pojoaque Pueblo (2)	Pueblo	HYBRID	NM
Pueblo of Isleta (1)	Pueblo	HYBRID	NM
Pueblo of Zuni (1)	Pueblo	HYBRID	NM
Salt River Pima-Maricopa Indian Community(1)	Pima/Maricopa	IRA	AZ
San Felipe Pueblo (1)	Pueblo	TRAD'L.	NM

Notes
This table indicates the name of the tribe, the ethnicity of the people residing there, the tribe's form of government, and the state in which that Indian Nation is located.
Forms of Government
Trad'l. – Traditional Theocratic
Hybrid – Transitional/Hybrid
IRA – Constitutional or IRA
* Number of Leaders Interviewed from that nation.

communities comprised of multi-level, multi-family dwellings built around a plaza that functioned as the center of social and religious life. Religious beliefs and practices infused all aspects of life from cultural norms to gender roles to governance (Ortiz 1979).

While pueblo people speak different languages and exercise tribal autonomy, they share similar creation stories and core values. These include such fundamental beliefs as the importance of family, and by extension the community, and the need for maintaining balance in all things. The All Indian Pueblo Council, comprised of all 19 New Mexico pueblos, is the oldest such association of governments in North America (Sando 1992). In contrast to the loosely organized nomadic bands that attacked pueblos, Spanish, Mexican, and later American settlements, the pueblo tribes were considered "civilized" by the U.S. government (Dutton 1983).

The Indian Nations, now restricted to reservations in Arizona and New Mexico, were historically small bands of nomadic hunter-gatherers that travelled the Southwest following the herds and raiding other tribes and colonial settlements for resources (Dutton 1983). Their harsh migratory lifestyle made it necessary to establish winter and summer camps to hunt game and forage for seasonal foods. Connected by kinship and clan, these autonomous bands were bound by a

common objective: survival. With little need for a formal system of governance, leadership and participation in decision-making was determined largely by one's wisdom, skillfulness as a hunter or warrior, ability to heal others and interpret the spirit world, and mastery of strategizing, building alliances, and peace-making.

Many Southwest native cultures were traditionally matrilineal meaning that property and land were passed through the woman's side of the family, and matrilocal in that the husband, upon marriage, joined the wife in her mother's home (Ortiz 1979). Similarly, upon divorce, the wife maintained control over her children, property, and land. The importance of the feminine as an expression of life, wisdom, and strength is evidenced by the many female deities in Native American religious beliefs. Particularly significant is the Corn Mother icon, an indigenized Mary, mother of Jesus, which symbolizes both Native religious elements such as sacred corn pollen and fertility as well as Christian notions of "correct" feminine behavior (Gutierrez 1991).

Whether in pueblos or nomadic bands, gender roles were generally determined by need or practicality and custom. While men and women might have separate religious duties, for example, these were equally valued as essential to the well-being of the community. We see how this remains relevant today:

> I think for pueblo women, especially [here] they participate in a lot of things that the men put off. No matter if cattle owner or sheep owner, it's usually the women that handle a lot of the things that comes with ranching. Usually the men would be the ones having jobs or they have other things to do like religious activities, and that's when the women play the major role in a lot of things … I would say that the women were the backbone and … traditionally we're there to support the men, our husbands.
>
> (Vickie I.)

Other roles might be shared. Activities such as hunting, raiding, or childcare might also be open to both sexes based on the competence, health, and physical ability of the individual. Similarly, in societies that recognized two-spirits,[2] gendered roles were fluid and might be easily adopted to fit the life of what we now call a lesbian, gay man, or transgendered individual. Underlying such a social system is a basic respect by men, women, and third-gendered[3] people for one another's contributions to community life. European contact brought Christianity, patriarchy, a cash-based economy, and the colonization of Native peoples. Other consequences included the influence of patriarchy on religion and culture, a principal effect of which was the subjugation and devaluing of women (Gutierrez 1991).

Following the U.S. Civil War, when the federal government rounded up and forcibly removed the Western nomadic peoples to reservations, the military often split communities relocating them to unfamiliar territory where they had to share limited resources with other tribes, in some cases former enemies. This

strategy of "divide and conquer" was employed to weaken and demoralize Native peoples who had fought the U.S. government to preserve their freedom. The now subdued bands, which had been fiercely independent, had to organize and collaborate to survive in an alien and hostile environment. Indigenous religious practices were suppressed, traditional structures of authority were lost, and social roles were increasingly defined by gender (Dutton 1983). Despite the seemingly hopeless conditions the people found themselves in, they drew strength from their culture. The words of a contemporary Navajo[4] leader interviewed for this study are just as applicable today as they would have been for her great grandparents on their return to Dinétah (Navajo land) in 1866 from captivity at Fort Sumner:

> Our culture is slowly changing. Our way of life, our ceremonies are changing. And they will continue to change. We're losing the real traditional practices but there's something that will not change. Our songs are strong and beautiful and how we hold that within us. Those will never change ... our prayers are beautiful; [they] will sustain us...
>
> (Lucy M.)

The history of genocide and of cultural and religious oppression by first the Spanish-, then the Mexican-, and finally the United States government continues to be deeply felt among Native people in the West (Dutton 1983; Sando 1992). Many middle-aged individuals continue to carry the scars, both physical and psychological, of their childhoods in missionary-run Bureau of Indian Affairs (BIA) boarding schools, of violence, and of racism. The resulting social problems faced by most if not all Native communities are well-documented (alcoholism, domestic violence, chronic unemployment, suicide), and extremely difficult to overcome because they are passed from one generation to the next (cojmc.unl.edu/nativedaughters/leaders/native-women-move-to-the-front-of-tribal-leadership). The traumatic intergenerational experience of indigenous peoples is referred to as "historical trauma."

Many of the leaders interviewed for this study referred to "living in two worlds." This balancing act requires them to successfully assimilate into the dominant culture while sustaining their indigenous culture, language, and religious practices. As one woman stated:

> I lost my mother a couple of months ago, and she basically told us, "You guys are not Indian anymore." She said, "You learned the white man's ways and that's the customs you follow." And it's true. "You speak the language, you do everything as such," she said. "You've lost your identity." And that's basically true. Our children don't have the slightest idea who they are.
>
> (Carmen W.)

Despite differences in their language and culture, the previously nomadic tribes built informal alliances against a common enemy: the federal Indian Agent who controlled their access to basic resources including food, medicines, housing, and clothing. Their intertribal alliances established a framework for what would later become self-governing tribal councils. In 1934 the U.S. Congress passed the Indian Reorganization Act (IRA) to create a uniform system of governance for Indian reservations and pueblos based in part on the federal constitution and on a corporate business model. Indigenous peoples across Indian Country were strongly urged by the Department of Interior to create tribal councils or governing boards that would function under a constitution, articles of incorporation, or a similar medium.

Arguably, such a system of governance would facilitate the ease with which BIA officials could pressure puppet tribal IRA governments to negotiate below-market leases on valuable natural resources and tribal lands. While this proved to be the case in some instances, in others, adoption of a constitution, articles of association, or a governing code facilitated women's official and legal participation in tribal politics. As one leader of an IRA-style tribe stated: "We are one of the few [pueblos] that will let women participate in the council or offices, for that matter. Three of the four elected [council members] right now are women" (Shannon D.). On the other hand, in pueblos which have not adopted any written regulations or laws for governing, both women and laymen remain excluded from de facto participation in the politics and governance of their tribe.

Forms of Governance

The three forms of government found among the tribes of Arizona and New Mexico are traditional theocratic, transitional/hybrid, and IRA or constitutional (Prindeville and Braley Gomez 1999). Traditional theocratic systems, common to the majority of pueblos in New Mexico, have exclusively male leaders who, based on their clan and membership in all-male religious societies, are appointed for life, in secret, by religious officials called *caciques*. The appointees are usually given religious roles and responsibilities as part of their governing duties. Elections do not exist.

As a project participant from a traditional theocratic pueblo stated: "I think the only way that women would actually really ever play a role in tribal government is, if we had a constitution, and if we were allowed to vote" (Betty H.). Women and laymen[5] are barred from attending regular council meetings – most of which are conducted in the indigenous language. Many theocratic pueblos hold occasional "General Meetings" that are open to the community and allow enrolled tribal members, including women, to attend. These may be in English but may or may not be regularly scheduled, as they are held at the will of the tribal council. Even then, the presence of women is not always welcome:

...one of the tribal officials made a comment to me, and he told me that it was not appropriate for a [pueblo] woman to be so vocal at general meetings.... And I told him "No one, no single man or woman ever told us that we could not be at general meetings and that we did not have a voice."... You look at the attendees at the community meetings, and who are they? The majority of them are women.

(Betty H.)

As the regular council meetings are closed to the majority of enrolled members, the council's decision-making process is unclear and few outside the "inner circle" of religious and appointed political leaders know exactly how their pueblo government operates.

Few governing procedures, rules, regulations, or policies are written, although this differs among pueblos. Whether a policy document such as the budget is available, depends on the Pueblo Governor's decision. The tribal council, which may be very large because leaders are appointed for life, may serve as the executive, legislative, and judicial branch of government. The lack of a separation of powers endows the Governor, Lieutenant Governor, religious leaders, and other key officials with tremendous power and little if any oversight. As one administrative official from a very traditional theocratic pueblo stated:

The tribal council represents ... the voices of the community and, ideally, that's how it should work. But sometimes it doesn't. Unfortunately, tribal councilmen come with their own personal agendas ... that may not be for the betterment ... of all people.... How do I remind my leaders of their purpose here? How do I get across to them that the decisions that they make really affects everyone, from our elders to the unborn?

(Melanie D.)

Transitional/hybrid governments are essentially defined as pueblos that have transitioned from politically conservative theocracies to increasingly open systems that demonstrate some of the characteristics of classic liberal republics. For example, these pueblos tend to hold regular elections and open meetings, written (or electronic) records are kept, decision-making by the political leadership is transparent, and a separation of powers exists. While the tribal council are elected by enrolled members of the pueblo eligible to vote, the offices of Governor, Lieutenant Governor, Secretary, and Treasurer are either nominated and elected by the sitting council or selected based on the number of votes accumulated by each winning candidate. None of the 40 or so Southwestern tribes that I have studied sanction political parties although some authorize a very limited amount of campaigning. Pueblos do not allow either parties or campaigning.

Transitional or hybrid forms of governance maintain some traditional traits, such as combining important religious and cultural practices with affairs of state.

For example, a key role of the Governor and Council is to lead the procession of dancers[6] into the plaza on ceremonial occasions. This particular responsibility might prove difficult for women leaders to meet if their pueblo culture excludes females from traditionally male religious societies. As one leader explained: "I feel that women ... can do just as good as men and make decisions. I feel that we're just as equal in terms of tribal government.... I'm not talking about the religious aspects. That's different" (Marsha G.). Most important for women is the existence of a constitution or articles that codify women's right to participate in their pueblo's governance.

A study of the policy preferences of Native women leaders in New Mexico found that gender is a major factor influencing their decisions. This finding was explained largely by the differences between constitutional or IRA-style tribal governments and the traditional theocratic pueblos of New Mexico, which exclude women and laymen from political participation (Prindeville and Braley Gomez 1999). This is powerfully illustrated by an administrator from a traditional theocratic pueblo who described working conditions for women there:

> ...they did have a female that was a Tribal Secretary ... [the council] obliterated the position, or any opportunities for any other women to serve in that capacity, because I guess she couldn't hack the pressures from the men ... there was a lot of sexual harassment stuff going on back then. They would tease her and make comments that would belittle her, so she got frustrated and just quit.
>
> (Betty H.)

Constitutional or IRA governments tend to be structured similarly to the United States government with open elections, separate branches, checks and balances, due process, and written codes and procedures. Having a constitution does not guarantee a democratic government, however (cojmc.unl.edu/nativedaughters/leaders/native-women-move-to-the-front-of-tribal-leadership). One leader described how she was ousted from office by the council in violation of the tribal constitution because there was no system of checks and balances among the three branches:

> ...It's bad here in Indian Country. But I think that one of the things that needs to happen ... is that we have to go back to the [tribal] constitution and we have to educate ourselves on it, and read it very carefully and ask questions if you don't understand certain areas.
>
> (Carmen W.)

In functioning constitutional governments, both men and women are eligible to participate in politics and hold office at all levels. Professionalism and fairness are favored over kinship and membership in men's or women's societies. However,

even in constitutional or IRA tribes there may not be a clear distinction between religious matters and governance:

> ...we had the dance over at another village across from where I live. I came back to work and a person came up to me and said, "I didn't know you played such an important role in this dance" because I had to lead the women into the plaza. I said, "Yes, that's my other duty..."
>
> (Marsha G.)

For the past decade or so, numerous Indian Nations have been working to integrate traditional cultural values and ways of leading into their existing constitutional style governments. Some of these pre-conquest values include participatory forms of governance such as gender equity, collaborative decision-making, and restorative (or reparative) justice. For example, the Navajo Nation, the largest tribe in the United States, have integrated *The Fundamental Laws of the Diné* into the Navajo Nation Code to better protect and maintain their culture and traditions:

> The Navajo Nation Council and the Diné recognize that the Diné Life Way is a holistic approach to living one's life ... In order to live the Beauty Way ... all elements of the government must learn, practice and educate the Diné on the values and principles of these laws.
>
> (www.nativeweb.org/pages/legal/navajo_law.html)

While the *Fundamental Laws* illustrate examples of appropriate thinking and behavior, *The Beauty Way* is a model for living by maintaining harmony with all things. These lessons, which take the form of songs, prayers, and ceremonies, identify ideal behaviors for Navajo men and women, for the treatment of children, elders, others, animals, and the natural environment. Children are valued, elders are venerated, and women are honored. Leaders, whether women or men, are held to the same high standards.

Throughout the world, women give life, provide care, introduce language, and pass culture on to children: "whether or not we continue to flourish as a tribe is dependent on the women.... It's through the women that our children learn a lot of things, even about our culture" (Betty H.). Socializing and educating each new generation is absolutely essential to the sustainability of a society. Nevertheless, this traditionally female role is rarely acknowledged, especially in patriarchies, which constitute the overwhelming majority of human communities. In fact, very few cultures either reward or accord any special status to women for the part they play in ensuring the propagation of humankind. At least one exception to this seems to have been the matrilocal and matrilineal tribes of the Southwest prior to European contact and the introduction of patriarchy and Catholicism (Gutierrez 1991; Sando 1992). Even so, women's current status and treatment is not consistently egalitarian across tribes, as was previously noted.

While the preponderance of Southwest tribes now residing in Arizona and New Mexico are historically matrilocal and/or matrilineal, the most conservative of the traditionally theocratic pueblos appear to be the most patriarchal and exclusionary of women in political leadership. This irony is not lost on members of these pueblos who refute the *caciques'* claims that women's participation in pueblo governance violates religious and cultural traditions. On the contrary, they point out that prior to Spanish contact and the introduction of patriarchy by the Catholic Church, women played an equally significant role to that of men in social and religious life. The remnants of these traditions are evidenced in female religious deities, women's societies, the role of women in dances, the importance of the matriarch, and matrilineal and matrilocal customs (Gutierrez 1991; Prindeville 2004b). While religious and political officials of some of the all-male theocratic pueblos have remained steadfast in refusing access to governance by women and laymen, others have opened the way to change: "Ever since I was growing up, in my teenage years, my mom was in office so I would see her going [to council meetings]. She was a good role model to us" (Karen G.).

As early as 1934, theocratic pueblos such as Hopi, Isleta, Pojoaque, and Zuni began adopting constitutional forms of government, which permitted political participation by women and laymen while preserving religious and cultural practices essential to the tribe. These pueblos created their own form of transitional/hybrid governance by, arguably, combining what they believed to be the most desirable features of their own ancient customs, the Spanish colonial systems, and U.S. political systems. These transitional changes did not happen overnight. In fact Zuni, the largest of the pueblos, did not transition to a hybrid until 1970. Even then, not all political positions were open to women immediately. Even with adoption of a constitution, bylaws, or code, successfully entering politics required that women demonstrate a commitment to their culture and customs thereby reassuring tribal members that women's participation in tribal governance did not break with tradition:

> I got on [council] and then my mother was very supportive ... When the inauguration came I said "How am I going to dress?" She told me to dress traditional because that's what they want to see. And so she told me to go talk to an elderly person, my father's auntie ... our matriarch.... She said "You're going to dress in a manta [shawl]." And she was the one who helped me through...
>
> (Rose M.)

Even when women purportedly have full access to politics because their tribe has an IRA-style government, Native women leaders face stereotypes and sexism, just as non-native women do. In many instances, indigenous women in office are not given the same respect as their male colleagues (cojmc.unl.edu/nativedaughters/leaders/native-women-move-to-the-front-of-tribal-leadership). This happens when

women are relatively new actors to tribal politics and/or their culture maintains strong remnants of colonization and patriarchy (Prindeville 2004a, 2004b). The result is that women are not seen as legitimate leaders:

> ...I served with another young lady ... we were serving on Council with three older gentlemen. We had all these new innovative ideas ... they laughed at us and we said "...we've got to convince the Council that we need to go this route. Let's do it in a way that we're not going to attack them; we have to strategize." ... we survived and we got some points across.... We have to have the opportunity to ... voice [our opinions] without retaliation.
>
> (Gladys C.)

"Gladys" and her colleague recognized that they were unwelcome on the previously all-male council. However, they found ways of being heard and, if not welcomed, at least tolerated until they were accepted by the other tribal leaders. By appearing non-threatening and deferential to the male council members, they were able to raise important issues to the policy agenda.

Even in matrilineal and matrilocal tribes where women are esteemed for achieving the status of matriarch, they still bear the double burden of working women. Despite changes in the roles of father-as-breadwinner and mother-as-homemaker, mothers are often judged more harshly than fathers. Consequently, women in politics often feel guilty about their absence from family when their governing responsibilities require their attention:

> ...women have to have ... the support of your family, otherwise you'll go down the drain. There are times that I feel guilty that I've neglected, or felt like I've neglected ... my children. But I think, now that we're all older, we see where we were at and where we're at today...
>
> (Margie M.)

In the case of "Margie," seeing the positive achievements resulting from her years in tribal leadership made her time in government worthwhile. She went on to say that her family is proud of her and that, as matriarch, she has earned the respect of others, including tribal elders. The concern over balancing family obligations with the duties of public service is a sentiment seldom expressed by males, even when they have spent their entire career in politics. In contrast, it is a burden that women bear and a standard by which mothers, in particular, are measured.

Conclusion

By studying the experiences of 14 Native American leaders from 12 Indian Nations we have gained a bit more insight into how gender roles and culture

influence whether, and to what extent, women are able to participate in the politics and governance of their tribe. A culture comprised of beliefs and practices that value women is more likely to produce attitudes that promote gender equity in all aspects of life, including leadership. In this type of society, all individuals are more likely to be respected, whether women, men, two-spirits, or third-gendered and their contributions to the community, similarly welcomed. While the type of government is a critical factor in determining whether women and men may participate in politics, a constitution or code does not guarantee democracy. On the other hand, a political system that provides structural opportunities for change empowers tribal members to decide for themselves issues such as who may marry, and whether women should hold the same leadership positions as men.

Stereotypes endure unless evidence is consistently available to demonstrate clearly that they are false. Strong and courageous women have demonstrated competent leadership and provided role models, spurring growing numbers of Native women to engage in governance. Even among pueblos currently unwilling to permit women's and laymen's participation, there is hope that women will reclaim their place in tribal politics. Professional women with college degrees heading households are becoming more common across Indian Country. Further, women are increasingly independent and vocal, and they are raising the next generation of leaders. Eventually, young members of traditional theocratic pueblos will question the logic of excluding women – over half of the community's talent, expertise, and wisdom – from participation in decisions about the wellbeing and future of their people. Native Americans have persevered by adapting, yet maintaining core values. There are plenty of examples of effective tribal leaders who are women, as well as prosperous Indian Nations, which maintain their cultural integrity and are governed by women. As long as indigenous women persevere in the struggle to achieve social justice for their people, they will continue to enlarge the pool of capable Native leaders and advance the cause of gender equity across Native America.

Notes

1 Academics refer to indigenous North American people as "indigenous" or "First Nations." The vast majority of Native people I have interviewed identify by their specific tribe or as Native American, American Indian, or simply as "Indian" when speaking to non-native people. Therefore, I use these commonly used terms interchangeably throughout the chapter.
2 In the simplest terms: a "Native LGBTQ person." www.nativepeoples.com/Native-Peoples/May-June-2014/Two-Spirit-The-Story-of-a-Movement-Unfolds/.
3 Encompassing both feminine and masculine. In modern terms, a transgendered individual. Ibid.
4 The Navajo call themselves *Diné*, meaning *The People*.
5 By "laymen" I mean male tribal members who are excluded from religious and political leadership because they do not belong to certain religious societies or elite clans.
6 Dance is a form of prayer fundamental to many Native American religions.

Bibliography

Dutton, Bertha P. 1983. *American Indians of the Southwest*. Albuquerque, NM: University of New Mexico Press.

Gutierrez, Ramon A. 1991. *When Jesus Came, the Corn Mothers Went Away*. Stanford, CA: Stanford University Press.

Ortiz, Adolfo. 1979. *Pueblos: Introduction. Handbook of North American Indians: Southwest*. Washington, D.C.: Smithsonian Institution.

Prindeville, DM. 2003. "'I've Seen Changes:' Perceptions of Political Efficacy Among American Indian and Hispanic Women Leaders." *Women & Politics* 25, 1/2: 89–113.

Prindeville, DM. 2004a. *On the Streets and in the State House: American Indian and Hispanic Women and Environmental Policymaking in New Mexico*. Routledge Dissertation Series: "Indigenous Peoples and Politics," F. Wilmer, ed., Routledge.

Prindeville, DM. 2004b. "Feminist Nations? A Study of Native American Women in Southwestern Tribal Politics." *Political Research Quarterly* 57, 1: 101–112.

Prindeville, DM. and T. Braley Gomez. 1999. "American Indian Women Leaders, Public Policy, and the Importance of Gender and Ethnic Identity." *Women & Politics* 20, 2: 17–32.

Pullin, Zachary. 2014. "Two Spirit: The Story of a Movement Unfolds." *Native Peoples*. May–June. www.nativepeoples.com/Native-Peoples/May-June-2014/Two-Spirit-The-Story-of-a-Movement-Unfolds/.

Sando, Joe. 1992. *Pueblo Nations: Eight Centuries of Pueblo Indian History*. Santa Fe, NM: Clear Light Publishers.

Transcript of the Fundamental Laws of the Diné. No. CN-69–02. Amending Title 1 of the Navajo Nation Code to Recognize the Fundamental Laws of the Diné. www.nativeweb.org/pages/legal/navajo_law.html.

Young, Molly. "Native Women Move to the Front of Tribal Leadership." *Native Daughters*. Lincoln: University of Nebraska. cojmc.unl.edu/nativedaughters/leaders/native-women-move-to-the-front-of-tribal-leadership.

18

WHY ARE YOU UNDER THE SKIRTS OF WOMEN?

Race, Gender, and Abortion Policy in the Georgia State Legislature

Tonya M. Williams

Introduction

On February 21, 2012, State Representative Yasmin Neal (D-Jonesboro), an African American[1] female state lawmaker in the Georgia House of Representatives, sponsored "HB 1116." The legislation, if enacted into law, sought to "...prohibit the performance of vasectomies in Georgia." Providing a sarcastic justification for the regulation, the bill read: "It is the purpose of the General Assembly to assert an invasive state interest in the reproductive habits of men in this state and substitute the will of the government over the will of adult men."[2] Neal's symbolic legislative proposal to usurp the reproductive decision-making of men was intended to demonstrate how the state uniquely leverages its regulatory power to routinely intervene in the reproductive decision-making of women. The first term state representative lamented, "If we legislate women's bodies, it's only fair that we legislate men's. There are too many problems in the state. Why are you under the skirts of women? I'm sure there are other places to be."[3] Although the incidence of legislative proposals regulating the reproductive decision-making of men may be infrequent and unconventional, Neal's provocative legislative action was not isolated to the statehouse. Bemoaning what they claimed was the Republican-controlled state legislature's systematic "war on women," every female state senator in the Democratic conference walked out of the Senate chamber on the last day of the legislative session protesting anti-abortion legislation. Every woman in the delegation that vacated the chamber in protest was African American except one. What do we make of this exceptional legislative action and symbolic manifestation of political and ideological contestation over abortion orchestrated by a cadre of predominately Black female state legislators in the Georgia General Assembly? Furthermore, to

what degree does gender influence the legislative behavior of Black state lawmakers on abortion related policy?

Political science research examining the distinct forms of intersectional representational activities and legislative decision-making of African American legislators, particularly among Black women at the state level, has proliferated over the last two decades or so (Adams, 2007; Barrett, 1995; Bratton and Haynie, 1999; Bratton et al., 2007; Brown, 2014a, 2014b; Brown and Hudson Banks, 2014; Githens and Prestage, 1977; Orey and Brown, 2014; Orey et al., 2006; Smooth, 2001, 2006). Few studies, however, have explored race, gender, and legislative decision-making on one of the most provocative subjects in American politics: abortion. Building upon the tradition of what Black feminist political scientist Evelyn Simien describes as "Black women studies in political science" literature (Simien, 2006), this study seeks to understand whether and how African American women state lawmakers express distinctive legislative behavior from their Black male co-partisans on abortion policy in the Georgia statehouse. This study draws from data on bill sponsorship and roll call voting data during the 151st and 152nd Georgia General Assembly. Results should indicate the degree to which these aforementioned symbolic demonstrations were emblematic of a broader ideological and substantive policy commitment to safeguarding abortion rights (and more broadly, reproductive health) by Black female legislators in the Georgia statehouse. Additionally, this case study should concomitantly reveal the extent to which those sentiments were shared, if at all, and/or to what degree, by their Black male counterparts. Although political science research revealing the "distinctive policy niche(s)" constituted by Black state lawmakers (Orey et al., 2006) and Black women, in particular, is developing, studies have yet to yield a satisfactory answer to the questions that shape and inform this study.

Since the landmark *Roe* v. *Wade* (1973) decision enshrining the right to abortion, political science research examining the political behavior of the myriad political actors dedicated to preserving abortion rights has ostensibly been associated with the political agenda of the (white) women's and reproductive rights movement(s) (Roberts, 1997; Ross, 1998; Simien and Clawson, 2004) in partnership with the legislative priorities of white feminist-minded lawmakers. However, the aforementioned vignette describing the legislative behavior by Black women lawmakers in the Georgia state legislature suggests a more complicated picture largely unaccounted for in the extant literature on women of color in legislative studies, and more broadly, Black politics. This shortcoming in the existing literature may in part be predicated on the view that championing abortion rights is not a politically salient policy concern for the Black electorate, activist Blacks, and/or Black political elites concerned with social justice and progressive racial policy, and therefore does not merit sustained political inquiry. Nevertheless, what is clear is that much of political science scholarship on Black politics has provided little intellectual space to

explore the politics associated with the reproductive experiences of Black women and girls nor their myriad roles as political actors in the contentious political terrain of reproductive politics. Black feminist activist intellectual Loretta J. Ross provides this astute explanation that may account for, in part, the inclination towards intellectual obscurity with regard to Black women and reproductive politics:

> The Black feminist commitment to reproductive rights has remained buried for at least three important reasons. First, the movement for abortion rights is erroneously seen as belonging to the predominately white women's movement.... Second, the struggle for reproductive rights is not commonly perceived as a part of the civil rights movement, although in fact it was part of the movement until after World War III ... a third reason that the Black feminist tradition has been obfuscated is that racist and sexist assumptions held by population experts, feminists, or the African American community itself ignore our power as African-American women to make responsible reproductive and political decisions ourselves.
>
> (Ross, 1998, pp. 162–163)

Nonetheless, a substantive body of research has emerged documenting the complexities of Black women's intersectional identities, reproductive experiences, and feminist/womanist political activism in the formation of anti-racist and anti-sexist politics within the domain of "reproductive justice" from "sister disciplines." Much of this research has found that the American historical landscape is littered with examples of state-sponsored and/or privately financed *interventions* premised on the derogatory social construction of Black female sexuality, fertility, and mothering as dangerous, pathological, and requisite of state surveillance, regulation, and deprivation of reproductive autonomy. In fact, Black feminist political advocacy on abortion, while generally unaccounted for in political science research beyond public opinion research on intra racial group attitudes, has been extensive particularly over the last four decades (Nelson, 2003; Silliman et al., 2004; Solinger, 1998). In fact, multidisciplinary bodies of literature reveal that any serious discursive treatment of the political contestation over the expression of women's agency to exercise control over their own fertility in the history of American politics must be contextualized through the experiences, ideological lenses, and political activism of Black women (Cade-Bambara, 1970; Luna, 2009, 2010; Nelson, 2003; Nixon, 2007; Roberts, 1997; Ross, 1998; Silliman et al., 2004; Smith, 2005; Springer, 1999). Black feminist legal scholar Dorothy Roberts, in *Killing the Black Body: Race, Reproduction, and the Meaning of Liberty*, concludes, in fact "the control of Black women's reproduction has shaped the meaning of reproductive liberty in America" (Roberts, 1997, p. 6). Additionally, African American women at the elite and grassroots levels have

lent their political capital to the preservation of abortion rights and ostensibly transformed the reproductive rights movement into a social justice movement that locates the reproductive experiences of intersectionally marginalized communities at the center of their politic and activism (Nelson, 2003; Silliman et al., 2004). Consequently, the emergence of the reproductive justice movement encapsulates this ideological rupture and political transformation from single axis analyses of women's reproductive lives to an intersectional one. This intersectional approach remains cognizant of the extent to which race, gender, class, sexual orientation, gender identity, and/or other identities of social construction serve to shape, inform, and offer meaning to who does and does not have the power and resources to make decisions pertaining to reproduction and more broadly, bodily autonomy.

To that end, the investigation proceeds as follows: Prior to providing an overview of political science research on race, gender, and political representation through the theoretical lens of intersectionality, I will review literature exploring the raced-gendered dimensions of abortion that has decidedly focused on one particular dimension of the polemic: comparative mass public opinion research disaggregated by race and gender (in addition to other contextual factors). Next, I will consider the state-specific institutional setting in Georgia within the social and political milieu of abortion politics. The data and methods section will follow. Finally, the study concludes with a discussion of the findings, a summation of the research, and implications for future research.

Race, Gender, and the Politics of Abortion: An Overview of the Literature

Abortion remains distinct from other social problems, in that, according to Carter et al. (2009), "Despite this trend toward liberalization" on myriad other politically contentious policy issues, "there is little evidence of a convergence or liberalization in abortion attitudes in recent decades" (p. 2). Thus, the politics associated with the reproductive decision-making of women has spurned the emergence of a diverse set of ideological actors, interests, and coalitions committed to shaping public opinion and mobilizing sympathetic adherents for political action from electoral politics to sustained social movement activism (Goggin, 1993; Jelen and Wilcox, 2003; Luker, 1984; Wolbrecht, 2000), with an eye towards appropriating political power through the democratic process to advance their particular policy prerogative. Forty years after the landmark ruling on abortion, the polemic persists unfettered by time or judicial fiat. Understanding the contemporary landscape of American politics, the ideological sorting of the political parties and hyper partisanship over the last 30 years cannot be told without incorporating the politics of abortion (Wolbrecht, 2000).

A sizeable body of social science literature on abortion exists. However, studies that center on whether and how the intersection between race and

gender are considered within the landscape of the abortion polemic have a decidedly unidirectional emphasis: comparative mass public opinion research. Previous research has considered whether and how variables such as race and, more recently, gender interact with other salient demographic, contextual, and social factors to influence and structure political attitudes on elective abortion within and between racial groups (Carter et al., 2009; Clawson and Clark, 2003; Combs and Welch, 1982; Dugger, 1991; Hall and Ferree, 1986; Secret, 1987; Wilcox, 1990). In a classic work building upon the research of Combs and Welch, Hall and Ferree, and Secret, Clyde Wilcox examines comparative public opinion data on elective abortion disaggregated by race-gender subgroups using data obtained from the General Social Survey of 1988 (Wilcox, 1990). Wilcox maintains that while "racial differences on abortion attitudes are declining," the findings reveal that gender differences in Black support for abortion are prevalent, with Black women more supportive and Black men significantly less so (p. 254). Wilcox, informed by Petchesky (1990), pontificates that the gender differentiation in abortion attitudes amongst Black respondents may reflect, on the one hand, Black males' suspicion of abortion as an instrument of genocide and, on the other, Black women's desire to exercise agency over their reproductive decision-making. He concludes, however: "More research is needed, using better measures of black family structure, culture and perceptions of the politics of abortion" (p. 255). Although Wilcox documents the decline in racial differences on abortion attitudes, he also finds that Black women are more supportive of elective abortion than white women. Evelyn Simien and Rosalee Clawson's (2004) "The intersection of race and gender: An examination of Black feminist consciousness, race consciousness, and policy attitudes" proves instructive given its attention to the intersection between Black feminist and race consciousness with regard to the raced-gendered dimension of Black mass public attitudes on abortion. Drawing from the 1993 National Black Politics Survey, the study's findings conclude that the lived experiences of Black males can and are structured by their support for "Black feminist ideals" and "that a commitment to Black feminist principles does not detract from racial solidarity" (Simien and Clawson, 2004, p. 808). Although the existing research suggests that feminist beliefs remains a determinative factor in support for abortion (Fine, 2006), Simien and Clawson (2004) conclude that Blacks, irrespective of gender, who embrace distinctly Black feminist sentiments (rather than association with mainstream feminism) are more likely to be "pro-choice." Concomitantly, they find that if race consciousness, rather than Black feminist consciousness, is the principle organizing ideological predisposition for individuals, even for Black women, in shaping abortion attitudes, support diminishes (Simien and Clawson, 2004). They conclude: "these particular Black women may perceive abortion as a population control policy that undermines reproductive freedom, that is, the freedom to have children rather than the freedom not to have children" (Simien and Clawson, 2004, p. 806).

Consequently, the "abortion (and contraception) as genocide ideologies," a belief in state-sponsored population control measures intended to diminish and/ or exterminate Blacks (Cade-Bambara, 1970; Caron, 1998; Cohen, 2003; Darity and Turner, 1972; Woolford and Woolford, 2007; Wright, 1978) alluded to in Clawson and Simien's (and Wilcox's) work serves an important conduit to understanding the differentiation in Black mass public attitudes on abortion. Additionally, their research reveals that irrespective of gender and depending upon factors such as social milieu and ideological orientation, Blacks may be predisposed toward formulating oppositional attitudes on abortion premised on their awareness and/or experience with the practice of racialized reproductive oppression in America (Roberts, 1997; Ross, 1998; Silliman et al., 2004). Carter et al.'s (2009) "Trends in abortion attitudes by race and gender: A reassessment over a four decade period" provides the most comprehensive, intersectional evaluation of trends in abortion attitudes over time to date. The research findings here suggest that a racialized gender gap exists most notably between Black men and women on abortion attitudes with Black men conveying a more traditional orientation on the procedure than Black women and white women and men. By the 1990s, argue Carter et al. (2009), in fact, "Black males show significantly more conservative attitudes than Black females" (p. 13), and while the gap remains, it has declined since the 2000s.

Race, Gender, Political Representation, and Legislative Behavior

Building upon political science literature on Black politics and women (of color) in politics literatures, scholars have sought to explore the myriad ways in which race and gender (in addition to other categories of social location) function interactively to inform and influence political attitudes, policy preferences, and types and levels of political participation and legislative behavior amongst Black officeholders. This emergent body of political science research, recognizing the transformation of the milieu of American politics after the enactment of the Voting Rights Act of 1965, were also compelled to ask new questions and develop differential methodological approaches in order to reconsider political representation and legislative decision-making from an intersectional perspective (Barrett, 1995; Bratton and Haynie, 1999; Bratton et al., 2007; Brown, 2014b; Brown and Hudson Banks, 2014; Githens and Prestage, 1977; Hawkesworth, 2003; Orey and Brown, 2014; Orey et al., 2006; Preuhs, 2006; Smooth, 2001). Wendy Smooth, one of the principal intellectual architects of Black women in legislative studies research, chides scholars espousing conventional interpretations of the Voting Rights Act of 1965 exclusively "as a racial policy" and the implications therein, arguing that "After all, it is not until the passage of this legislation that African American women are first extended a modicum of citizenship in the United States" (Smooth, 2006, p. 401). Thus, incorporating intersectionality as an analytical framework obligates scholars to interrogate and

critique established theoretical paradigms and analytical preoccupations that structure our understanding of political behavior along exclusively gendered or raced lines or ignored altogether. Under the auspice of this conceptual framework, intersectionally marginalized groups, such as Black women, garner heightened visibility and are no longer exclusively secondary or tangential subjects of empirical investigation in legislative studies.

Political science research on African American women in state legislative bodies and Congress have yielded significant findings, demonstrating that their representational activities and policy prerogatives are distinctive, unusually ideologically coherent, and warrant sustained political evaluation in relationship to and independent of other race-gender groups. Drawing from Prestage and Githens's (1977) groundbreaking manuscript, *A Portrait of Marginality: The Political Behavior of the American Woman*, Edith Barrett, one of the first scholars to explore the raced-gendered dimension of legislative decision-making, found that collectively, these intersectionally marginalized legislators were more ideologically coherent in their policy preferences and their legislative behavior, revealing a greater degree of uniformity than their peers in the representative bodies which they served (Barrett, 1995). A decade later, King-Meadows and Schaller reaffirmed those findings (King-Meadows and Schaller, 2006). Orey et al.'s (2006) results are also instructive as their research on political representation in Mississippi concludes that the agenda setting behavior of Black women is dissimilar in meaningful ways from not only white men and women but their Black male co-partisans as well. The authors reveal that

> ...when we disaggregated African American men and women, we find that a progressive bill is more likely to be introduced when a Black woman serves as the primary sponsor. Arguably, because African American women are "doubly disadvantaged," as a result of racism and sexism, they possess unique perspectives when compared to their peers, which informs their legislative agendas.
>
> (Orey et al., 2006, p. 112)

Evaluating agenda setting behavior through bill sponsorship of Black female and male state lawmakers and white female state lawmakers, Adams (2007) demonstrates that Black and women state lawmakers vary markedly from their white peers in terms of agenda setting behavior, legislative agenda priorities, and bill passage rates (based on race and gender). Her study revealed that while "African American female legislators as a group, [were] less likely to achieve passage of the legislation they introduced" (p. 78), white women "were as likely as were male legislators to secure passage of the legislation they introduced" (p. 78). Beyond studies exploring the degree to which African American women possess the requisite institutional power and influence to shape legislative agendas and advance their respective policy proposals within a given legislative settings, research also indicates that Black

women officeholders center the interests of groups oftentimes excluded from the accumulated benefits of privilege, power, and wealth. Brown and Hudson Banks (2014) assert that Black women, in fact, "use their intersecting raced and gendered identities to advocate for the needs of racial/ethnic minorities, women, and especially minority women" (p. 166). Despite data showing that Black women continue to be significantly underrepresented in state legislative bodies (Orey and Brown, 2014), this distinct racial-gender subgroup has accounted for the "increase in the number of African American elected officials" over the last 25 years and "data from the Center for Women and Politics (2013) indicate that African American women state legislators are at an all-time high" (p. 144). Consequently, no serious analytical survey of Black politics or women (of color) in politics scholarship can occur without meaningful consideration of the distinct ways in which Black women lawmakers engage in representational activities in legislative institutions, particularly those holding office in the South where the majority of Black people and officeholders live and serve, respectively. Despite the proliferation of literature since Prestage and Githens's (1977), Barrett's (1995), and Smooth's (2001) landmark studies exploring the legislative behavior of Black women, we know very little about this racial subgroup's legislative priorities and voting behavior on abortion policy, nor that of their Black male co-partisans for that matter.

The Political Setting: Reproductive Politics in the Peach State

Georgia offers an optimal legislative setting to undertake this case study on the gendered implications of Black legislative behavior on abortion policy for several reasons. Certainly, examining the legislative behavior of this distinct racial-gender group on abortion policy, situated within the political-cultural milieu of one southern state does not lend itself towards broad regional generalization (Orey et al., 2006), the study does serve to oblige scholars in Black legislative studies to consider whether and how reproductive politics fit within the scope of Black state lawmakers' legislative agendas and representational activities (if at all). The Peach State, itself, benefits from the largest state legislative Black caucuses in the country according to their website (Georgia Legislative Black Caucus, www.galbc.org/home/) in addition to the disproportionate representation of Black state lawmakers in the Democratic Caucus of the Georgia General Assembly. The most recent membership profile indicates the Black legislators comprise 47 members (out of 180 members) in the state House of Representatives and 13 members in the 56-member state Senate. Although African American state lawmakers continue to be underrepresented in legislative institutions at the state and federal levels, under the racially polarized political party regime that has emerged in the South, Black state lawmakers in the statehouse comprise 47 out of the 60 members of the Democratic Party's legislative caucus during the 152nd Georgia General Assembly (www.gahousedems.com/#!caucus-members/c1ql4). This a significant increase in political representation, in terms of rate of representation and proportion of the

Democratic Party caucus, given that in 1982, African Americans only held 23 seats in the lower house of the Georgia General Assembly (Middlemass et al., 2010, p. 105). African American female state lawmakers comprise nearly half of this racial affinity group's legislative caucus according to the Center for American Women and Politics ("State Fact Sheet-Georgia") and hold strategic positions of leadership in the Black Caucus and in the Democratic Party's legislative delegation, albeit as the minority party. To be sure, as is documented in national trends, the election of Black women to state legislative bodies is in large measure responsible for hastening the transformation of the racial and gender composition of this southern state legislature and increasing gender parity. In fact, according to a study published by the Center for American Women and Politics for Higher Heights Leadership Fund (Dittmar, 2014), African American female lawmakers in Georgia not only comprise "75% of the Democratic women in the Georgia state legislature" (p. 15), but they are uniquely overrepresented in the terms of political representation comprising more than one-third of Democratic lawmakers while only making up 14% of the general population" (pp. 14–15).

Over the last two decades, Georgia state politics has undergone a significant political transformation resulting in a twenty-first-century legislative body where Democratic state legislators are predominantly comprised of African Americans and white women and a Republican caucus that is overwhelmingly white and male (Bullock and Gaddie, 2010). The partisan realignment shifting longstanding institutional power and influence from one-party Democratic rule to one-party Republican control means, according to David Bositis, that in real terms "there is strong statistical evidence that politics is resegregating, with African Americans once again excluded from power and representation," whereby "virtually all black elected officials in the region are outsiders looking in" (Bositis, 2011, Introduction). Consequently, the partisan reconfiguration of the Georgia General Assembly has resulted in a more socially conservative governing majority that is also hostile to abortion rights. Although Bullock and Gaddie (2010) conclude that nearly "all Republican legislators are economic conservatives, not all suburban members are social conservatives" (p. 69), the arc of the regulatory regime on abortion has curved towards one that is more restrictive. In fact, Bullock and Gaddie posit that when Republicans seized control over the state legislature and governor's mansion in 2004 with the election of Sonny Perdue, abortion was "At the top of the list of priorities of religious conservatives" and "the new Republican leadership rewarded the Religious right" (pp. 162–163) with the enactment of abortion restrictive legislation.

Further rounding out the idyllic nature of the political setting for this investigation, the Peach State has also been demarcated as a state "hostile to abortion" (Nash et al., 2014, para. 3), according to the Guttmacher Institute.

Benefiting from an extensive body of research on state level abortion policy, we know that state variability in abortion laws can be accounted for by considering a confluence of political, ideological, cultural, and religious factors that

dictate whether and how states regulate the procedure. These factors range from interest group behavior (particularly the presence of "anti-abortion" and "abortion rights" groups), the presence of female state lawmakers, partisan and ideological configurations of state legislative bodies and executives, religious composition and religiosity of individual states and lawmakers, in addition to mass level public opinion (Halva-Neubauer, 1990; Wetstein, 1996). Although the Peach State has never been a bastion of political liberalism and concomitant toleration for liberalized abortion laws, it has not generally been ranked amongst the states most inhospitable to abortion particularly in a region known for being so. In one of the first studies of its kind, Glen Halva-Neubauer's "Abortion Policy in the Post-Webster Age" catalogues individual states' regulatory regimes on abortion restrictive policy classifying Georgia as a "codifier state." A "codifier" regime is classified as one which is conservative in its policy orientation towards abortion but not as antagonistic as a "challenger state" espousing vociferous opposition while erecting and cultivating a regulatory regime that challenges and ultimately seeks to dismantle the precedent established under Roe (Halva-Neubauer, 1990). The Guttmacher Institute, a reproductive and sexual health organization that supports abortion rights, that periodically evaluates state regulatory regimes on abortion policy concludes that a marked variation in state level opposition to abortion has emerged since 2000 and a demonstrable increase in abortion restrictive legislative proposals and laws implemented at the state level since 2010 (Nash et al., 2014). In part, the proliferation of state level anti-abortion laws was accentuated by an intense ideological and (intra) partisan contestation over abortion access under healthcare reform, resulting in a political compromise that empowered states to restrict access to the procedure in state health exchanges and private insurance plans in addition to the 2010 midterm election outcomes that sent vociferously anti-abortion lawmakers to state and federal legislative bodies (Nash et al., 2014; Sonfield and Pollack, 2012). Although Georgia remained an outlier relative to its southern neighbors (MS, LA, and SC) that were classified as "hostile to abortion" in 2000, the state would eventually meet the requisite threshold for this demarcation by 2010, along with the rest of the southern states (www.guttmacher.org/media/infographics/2000–2014-maps-states.html; Nash et al., 2014).

Assessing Black State Lawmakers' Views of Abortion Policy

I expect that Black female lawmakers will be more likely than their Black male co-partisans to champion reproductive rights and oppose legislative proposals that restrict access to abortion. Although few studies have considered the degree to which the intersection between race and gender identities of lawmakers inform legislative behavior on abortion policy, "Black women's policy agendas," according to Brown and Hudson Banks (2014) "are informed by liberal progressive politics ... as well as support for traditional Black and feminists political

interests" (p. 166). Thus, support for abortion rights policy would likely be consistent with the "political interests" and progressive legislative orientation of Black female lawmakers accounted for in earlier intersectionality informed legislative studies on Black women. In fact, Black women in political leadership, from Black sororities to Black female elected officials to Black feminist inspired healthcare workers, organizations, and activists, have embodied a distinctively Black feminist ethos that has consistently articulated and demanded the right to exercise agency over their reproductive lives whilst unapologetically demanding the requisite resources to ensure the human right to healthcare including reproductive health in addition to access abortion and contraceptive services (Ross, 1998). Interestingly and contextually significant with respect to Georgia and reproductive politics, state Representative "Able" Mable Thomas (D-56), a member of the Georgia statehouse representing Atlanta, was one of the original members of a group called "Women of African Descent for Reproductive Justice." Founded in 1994, this cadre of Black feminist leaders originated in part to provide a voice for intersectionally marginalized women during the Clinton era healthcare reform policy deliberations (Ross, 1998). In a statement addressed to members of Congress, published in the *Washington Post*, the would-be architects of the nascent reproductive justice movement articulated a set of political expectations that called into question any legislative reform that was not comprehensive and inclusive of reproductive health services including the liberalization of abortion restrictive policy that denied poor and working class women access to abortion. The statement, a contemporary black feminist healthcare manifesto situated within an intersectional praxis, argues:

> Black women have unique problems that must be addressed while you are debating health care reform legislation. Lack of access to treatment for diseases that primarily affect Black women and the inaccessibility of comprehensive preventive health care services are important issues that must be addressed under reform. We are particularly concerned about coverage for the full range of reproductive services under health care reform legislation.
>
> (Women of African Descent for Reproductive Justice, 1994)

Although few studies have sought to interrogate the extent to which safeguarding reproductive rights constitutes as a "distinctive policy niche" of African American female state lawmakers, findings from primary and secondary sources documenting the political and policy activism of Black women in the domain of reproductive politics suggests further political science research on the subject is warranted.

The legislative behavior of Black state lawmakers in the Georgia statehouse was examined using bill sponsorship and roll call voting data on abortion related legislation from the 2011/2012 and 2013/2014 regular legislative sessions.

Traditional and non-binding resolutions were evaluated. This study draws upon a combination of what Adams refers to as "proactive" indicators (i.e., as bill sponsorship) and "reactive" indicators (i.e., roll call voting) of legislative behavior (Adams, 2007). We do so in order to evaluate whether and to what degree there are discernible distinctions in the legislative behavior between this racial subgroup on abortion policy. Data secured from bill sponsorship will likely determine the degree to which abortion is a legislative priority for Black women as illustrated in the aforementioned legislative scenarios in Georgia during the 2011–2012 legislative sessions. Bratton and Haynie (1999) contemplate the relative significance of bill sponsorship, as an evaluative measure of lawmakers' policy priorities compared to roll call voting, maintaining:

> Agenda setting in the form of bill sponsorship demands a relatively high level of support, commitment, awareness of, and expertise on policy areas (Tamerius 1995). Furthermore, though opportunity costs are present (Schiller 1995), legislators have more freedom at this state to express their interests and satisfy important constituencies than at the roll call voting stage, when they are limited to declaring preferences regarding a pre-established set of choices.
>
> (p. 661)

Consequently, a combination of these two indicators of legislative behavior should yield a more accurate representation of the legislative priorities and policy preferences of African American state lawmakers. Participant observation, semi-structured elite interviews, and/or survey research with Black state lawmakers would be an ideal complement to this study. These methodological approaches provide important qualitative information about how lawmakers' lived experiences, identities, and personal values and belief systems structure their policy attitudes and ultimately impact their legislative agendas and voting preferences that cannot be extrapolated through using exclusively quantitative measures (Brown, 2014b). However, given the exploratory nature of the study, these two conventional measures of legislative behavior are sufficient for a preliminary analysis. Certainly, incorporating one or more of the aforementioned supplemental methodological approaches would contribute to future studies on the subject and will likely offer findings that cannot be accounted for in this case study. In addition to evaluating traditional bills, non-binding resolutions – legislative action not characteristically included in evaluations of legislative behavior and lawmaking processes – were considered as well. This type of legislative action allows for lawmakers to symbolically express their policy preferences on matters that may be unlikely to secure the requisite legislative and/or executive support to successfully navigate the traditional, oftentimes arduous, lawmaking process given institutional restraints and partisan configuration, in this case. Resolutions that assumed an unambiguous ideological position, in

support of or in opposition to abortion were included for consideration in order to clearly ascertain the legislator's policy preference on the matter. Records of legislative action from the state House of Representatives were obtained from the Clerk of the Georgia House of Representatives' official webpage (www.house.ga.gov/clerk/en-US/default.aspx). The race and gender of the lawmakers were determined by reviewing individual lawmakers' biographies and photos from their official webpages. Data were analyzed in order to determine the degree of variability in the legislative behavior between Black state lawmakers.

Abortion restrictive policies were coded as laws that created institutional, financial, and/or logistical barriers to accessing elective abortion within a given jurisdiction. Many of these legislative proposals, according to the Guttmacher Institute, take the form of targeted regulation of abortion providers (TRAP) laws, which establishes "limits on the provision of medication abortion, bans on private insurance coverage of abortion and bans on abortion at 20 weeks from fertilization" (Boonstra and Nash, 2014). Abortion supportive policies were coded as laws and/or resolutions that expressed support for, increased access to, and/or resources for the provision of reproductive health services and/or elective abortion, in particular.

Results

Data on roll call voting and bill sponsorship was retrieved from the Georgia General Assembly website. During the 2011–2012 legislative sessions, 1372 bills, a combination of traditional bills and resolutions, were introduced.[4] Throughout the following 2013–2014 legislative session, 1276 bills were introduced.[5] The research parameters yielded four abortion relevant legislative proposals during the 2011–2012 legislative sessions. During the 2013–2014 legislative sessions, there were three abortion related bills introduced in the 152nd Georgia General Assembly that were evaluated for this study.

The results indicated in Table 18.1 show bill sponsorship data for the four legislative proposals on abortion during the 2011–2012 legislative session disaggregated by gender of Black state lawmakers. The four legislative proposals included bills that: would designate abortion as "pre-natal" murder, prohibit abortion after a fetus reaches gestational age where lawmakers determined they would be pain capable, prohibit abortion after 20 weeks with an exemption for a "medically futile" pregnancy, and proscribe the reproductive decision-making of men by regulating vasectomies. Three of the legislative proposals were designated as abortion restrictive while the "vasectomies bill" was coded as abortion supportive given the sponsoring lawmakers expressed intent.

During the 151st Georgia General Assembly, "HB 954," a bill prohibiting abortion after 20 weeks, was passed by a margin of 106 to 59. It was the only abortion restrictive bill enacted during this legislative session. Table 18.2 shows the roll call voting behavior of Black state lawmakers on abortion related

TABLE 18.1 Content Analysis of Legislative Bill Sponsorship on Abortion by Gender (2011–2012)

Bill/Content	Supportive or Restrictive	BFL N = 15	BML N = 19	Enacted
(Traditional bill) HB 1 Pre-Natal Murder	Restrictive	0	0	No
(Traditional bill) HB 89 Pain-Cable Unborn Child Protection	Restrictive	0	0	No
(Traditional bill) HB 954 20-Week Abortion Ban	Restrictive	0	0	Yes
(Traditional bill) HB 1116 Prohibition of Vasectomies	Supportive	4	0	No

Source: Georgia General Assembly, 2011–2012 Legislative Session: www.legis.ga.gov/Legislation/en-US/Search.aspx.

Note
Black Female Lawmakers (BFM) and Black Male Lawmakers (BML).

legislative proposals disaggregated by gender. Not accounting for those members that were excused or non-voting on the legislation or the lone Republican, every Black state lawmaker opposed the law indicating the Caucus's collective objection to abortion restrictive legislation irrespective of gender.

The results from the data, shown in Table 18.2, indicate that Black women were more likely to sponsor abortion supportive legislative proposals (traditional bills and resolutions) than their Black male counterparts. Black state lawmakers did not co-sponsor any abortion restrictive legislative action during the 151st session.

During the 2013–2014 legislative sessions, there were three abortion related bills out of 1276 bills introduced in the statehouse of the 152nd Georgia General

TABLE 18.2 Roll Call Voting of Black State Representatives, on HB 954, by Gender (2011–2012)

	Voting Behavior HB 954		
	No	Yes	Total
BFL	15	0	15
BML	19	0	19
Total	34	0	34

Source: Georgia General Assembly, 2011–2012 Legislative Session: www.legis.ga.gov/Legislation/en-US/vote.aspx?VoteID=9450.

Note
Black Female Lawmakers (BFM) and Black Male Lawmakers (BML).

Assembly. HB 1066, an abortion restrictive legislative proposal, would have prohibited the provision of elective abortion services in health insurance plans for state employees.[6] The latter two legislative proposals, HB 3 and HB 914, were non-binding resolutions that affirmed support for the expansion of reproductive health services including elective abortion. The data provided in Table 18.3 show that Black female lawmakers were more likely than their Black male co-partisans in the statehouse to express support for safeguarding abortion in their agenda setting behavior as indicated by bill sponsorship.

Concomitantly, data reveal that no Black lawmakers sponsored abortion restrictive legislation in the statehouse during the designated legislative session. Drawing from roll call voting data on abortion restrictive legislation, Table 18.4 shows that Black male lawmakers are just as likely to oppose abortion restrictive policies as Black women refuting, to a degree, my aforementioned expectation

TABLE 18.3 Content Analysis of Legislative Bill Sponsorship on Abortion by Gender (2013–2014)

Bill/Content	Supportive or Restrictive	BFL N = 19	BML N = 24	Enacted
(Resolution) HB 3				
Policy Resolution on Reproductive Rights	Supportive	5	0	NA
(Resolution) HB 914	Supportive	4	1	No
(Traditional Bill) HB 1066	Restrictive	0	0	No
(Traditional Bill) SB 98				
Federal Abortion Mandate Opt-out Act	Restrictive	0	0	Yes

Source: Georgia General Assembly, 2013–2014 Legislative Session: www.legis.ga.gov/Legislation/en-US/Search.aspx.

Note
Black Female Lawmakers (BFM) and Black Male Lawmakers (BML).

TABLE 18.4 Roll Call Voting of Black State Lawmakers, on SB 98, by Gender (2013–2014)

	Voting Behavior SB 98		
	No	Yes	Total
BFL	18	1	19
BML	24	0	24
Total	42	1	43

Source: Georgia General Assembly, 2013–2014 Legislative Session: www.legis.ga.gov/Legislation/en-US/vote.aspx?VoteID=11948.

Note
Black Female Lawmakers (BFM) and Black Male Lawmakers (BML).

about the gendered influence in legislative behavior. Nevertheless, SB 98: "Federal Abortion Mandate Opt Out Act," legislation that prohibited abortion services in state healthcare exchange plans and state employee health plans, was enacted during the legislative session. It passed by a margin of 105 to 64.

Moving beyond "reactive" legislative behavior such as roll call voting, data on bill sponsorship of non-binding resolutions reveal that Black women were more likely to demonstrate their support for abortion rights through their agenda setting behavior than their Black male colleagues in the lower chamber. Thus, the preliminary findings suggest that Black women are more likely to advocate for abortion rights than their Black male counterparts, but Black lawmakers in Georgia, irrespective of gender, oppose abortion restrictive policy.

Findings and Conclusion

This research considers whether and to what degree, if any, African American women state lawmakers in Georgia demonstrate distinctive legislative behavior from their Black male colleagues on state level abortion policy. This study produced two distinct findings. First, analyzing roll call voting on abortion restrictive legislation, we find that there is no variation in the voting behavior of Black state lawmakers during the observed legislative sessions. Analyzing roll call voting data, we find that Black male state lawmakers were just as likely to oppose abortion restrictive legislative proposals as Black women. This finding is particularly significant given the expectation that gender would mitigate, to some degree, the voting behavior of Black state lawmakers with Black women more likely to oppose abortion restrictive policy than Black males. Consequently, this study, while limited to the Georgia statehouse and by two consecutive legislative sessions, likely reaffirm Brown and Hudson Banks's conclusion that "black men are partners in furthering legislation that assists Black women and minorities, women and low-income individuals. In this regard, African American men are willing and necessary supporters of issues that concern Black women" (p. 178). Moreover, and perhaps most interesting, is that variability in legislative behavior between Black female state lawmakers, that was revealed, is limited to their agenda setting behavior in the form of bill sponsorship on abortion policy. The study found that Black women in the statehouse were more likely to sponsor legislation and resolutions that sought to safeguard abortion access, expand reproductive health services, and express opposition to abortion restrictive legislative proposals, in particular ways that are not consistently accounted for when analyzing bill sponsorship data of their Black male co-partisans. Black women legislators' inclination towards sponsoring progressive social policy on abortion, in both real and symbolic terms, in a deeply conservative legislative setting amidst adversarial institutional conditions, reveals the extent to which they champion abortion rights as opposed to tacitly supporting them. These results build upon Brown and Hudson Banks's (2014) claim that:

> African American women legislators do not need to hold large numbers in the statehouse to push legislation that matters most to them. Having high numbers of presumed allies, for instance White women and Black men, does not affect Black women's legislative behavior.
>
> (p. 177)

Subsequently, the findings here suggest that researchers on Black women in legislative politics should consider whether the level of support for abortion rights demonstrated in this case study by Black women state lawmakers reflects a legislative commitment, or "policy niche," that merits further interrogation in other legislative settings. Although the established research indicates that Black women are amongst the most progressive lawmakers in legislative bodies, it falls silent on the extent to which support for reproductive rights is a part of this distinct racial subgroup's policy agenda. Thus, if the findings of the study are replicated in other legislative settings and/or in Georgia over several legislative sessions, then we may conclude that advocating for the protection of abortion rights in legislative policymaking cannot be exclusively confined to the policy agendas of feminist-inspired white female lawmakers. In fact, the findings support previous social science research by scholars that Black women, at the elite and grassroots level, have perceived reproductive politics and the distinct ways in which reproductive oppression has impacted the lived experiences of Black women, as a policy and political prerogative, that merits sustained social movement mobilization and legislative action. In this case, African American female state lawmakers may recognize abortion policy as both a raced and gendered issue, signaling their willingness to champion a policy choice that is reflective of their intersectional identities and thus, experiences of their constituents and themselves. Nevertheless, it is certainly worth reiterating that irrespective of the social policy under investigation, "that without Democratic majorities, African American legislators do not attain the formal leadership positions that provide the means to offset bias and marginalization in Southern legislatures" (Preuhs, 2006, p. 598). Although the vast majority of literature exploring social policy and Black legislative behavior has not meaningfully interrogated abortion policy to the extent observed in this investigation, the same political axiom articulated by Preuhs remains pertinent in this study. Finally, the results, while significant, could not ascertain when and under what circumstances the findings observed materialized in the legislative behavior of Black state lawmakers nor the gendered variability in legislative behavior, if any, in previous decades and/or sessions. Subsequently, this study could not adequately explain whether and to what degree the indisputable support for "abortion rights" by Black state lawmakers and Black female legislators, in particular, demonstrated here emerged and under what circumstances.

Future Research

Given the political, cultural, and chronological limitations associated with this study, one cannot extrapolate that these findings will be duplicated in other southern legislative settings and, thus, are not generalizable beyond Georgia. Consequently, research on this subject would benefit from a larger representative sample of southern states, incorporating comparative, multi-year state level analysis of abortion policy over several legislative sessions with both Black and white state lawmakers. For example, a comparative study of the legislative behavior of Black state lawmakers in Alabama, Georgia, Mississippi, and Louisiana on abortion policy would be an ideal complement to this exploratory investigation given that these states are classified as either "hostile to abortion" or "extremely hostile to abortion." In addition, African American women state lawmakers are significantly represented in legislative bodies comprising "half of all women legislators" in these states (Dittmar, 2014, p. 14). Further empirical investigation will likely uncover whether the legislative behavior of Black state lawmakers in Georgia demonstrated in this study is an anomaly in the region or possibly reflective of a broader trend that is unaccounted for in studies of southern Black lawmakers' legislative agendas. Moreover, to what degree, if at all, does abortion supportive legislation constitute a "policy niche" for Black female lawmakers in other southern legislatures as demonstrated in Georgia. Future research would also benefit from utilizing a mixed methods approach, incorporating quantitative and qualitative methods tasked with analyzing the myriad dimensions of legislative behavior beyond bill sponsorship and roll call voting in addition to lawmakers' perceptions of their role as policy entrepreneurs on abortion policy. This study provides an answer to whether and to what degree Black state lawmakers support abortion rights; however, the research falls short of exploring why and how Black women legislators in the most conservative region of the country have come to champion abortion rights in their agenda setting behavior. Nevertheless, myriad unanswered questions remain and are fertile ground for future research. Given the persistent moral and political polemic associated with abortion and entrenched interests on both sides of the issue, lawmakers particularly in conservative states "hostile to abortion" will likely remain "under the skirts of women" and thus, opportunities to explore these questions will persist.

Notes

1 For the purpose of this study, African Americans and Blacks as designations for a racial subgroup will be used interchangeably.
2 Georgia General Assembly, Legislative Record for HB 1116. Available from: www.legis.ga.gov/Legislation/20112012/122141.pdf.
3 Georgia General Assembly, Legislative Record for HB 954. Available from: www.legis.ga.gov/Legislation/20112012/127778.pdf.

4 http://news.blogs.cnn.com/2012/02/21/georgia-democrats-to-propose-limitations-on-vasectomies-for-men/.
5 www.house.ga.gov/clerk/HouseCalendars/20112012/HComposite.pdf.
6 www.house.ga.gov/clerk/HouseCalendars/20132014/HComposite.pdf.

Bibliography

Adams, K. S. (2007). Different faces, different priorities: Agenda-setting behavior in the Mississippi, Maryland, and Georgia state legislatures. *Nebula*, 4(2), 58–81.

Barrett, E. J. (1995). The policy priorities of African American women in state legislatures. *Legislative Studies Quarterly*, 29(2), 223–247.

Barrett, E. J. (2001). Black women in state legislatures: The relationship of race and gender to the legislative experience. In S. J. Carroll (Ed.), *The impact in public office* (pp. 185–204). Bloomington, IN: Indiana University Press.

Boonstra, H.D. and Nash, E. (2014). *A surge of state abortion restrictions puts providers – and the women they serve – in the crosshairs.* Guttmacher Institute. Retrieved from: www.guttmacher.org/pubs/gpr/17/1/gpr170109.html.

Bositis, D. A. (2011). Resegregation in southern politics? *Joint Center for Political and Economic Studies.* Research Brief.

Bratton, K. A., and Haynie, K. L. (1999). Agenda-setting and legislative success in state legislatures: The effects of gender and race. *Journal of Politics*, 61(3), 658–679.

Bratton, K. A., Haynie, K. L., and Reingold, B. (2007). Agenda setting and African American women in state legislatures. *Women, Politics, and Public Policy*, 29 (Summer/Fall), 71–96.

Brown, N. E. (2014a). Black women's pathways to the statehouse: The impact of race/gender identities. In Michael Mitchell and David Covin (Eds.), *Black women in politics: Identity, power, and justice in the new millennium. National Political Science Review, 16.* New Brunswick, NJ: Transaction Publishers.

Brown, N. E. (2014b). *Sisters in the statehouse: Black women and legislative decisionmaking.* New York, NY: Oxford University Press.

Brown, N., and Hudson Banks, K. (2014). Black women's agenda setting in the Maryland state legislature. *Journal of African American Studies*, 18, 164–180.

Bullock, C., and Gaddie, R. (2010). *Georgia politics in a state of change.* Boston, MA: Pearson Education, Inc.

Cade-Bambara, T. (1970). The pill: Genocide or liberation? In T. Cade-Bambara (Ed.), *The black woman: An anthology.* New York, NY: New American Library.

Caron, S. M. (1998). Birth control and the black community in the 1960s: Genocide or power politics? *Journal of Social History*, 31(3), 545–569.

Carter, J. S., Carter, S., and Dodge, J. (2009). Trends in abortion attitudes by race and gender: A reassessment over a four-decade period. *Journal of Sociological Research*, 1(1).

Clawson, R. A., and Clark, J. A. (2003). The attitudinal structure of African American women party activists: The impact of race, gender, and religion. *Political Research Quarterly*, 56(2), 211–221.

Cohen, C. (2003). A portrait of continuing marginality: The study of women of color in American politics. In S. J. Carroll (Ed.), *Women and American politics: New questions, new directions* (pp. 190–213). New York, NY: Oxford University Press.

Combs, M., and Welch, S. (1982). Blacks, whites, and attitudes toward abortion: A research note. *Public Opinion Quarterly*, 46(4), 510–520.

Darity, W. A., and Turner, C. B. (1972). Family planning, race consciousness and the fear of race genocide. *American Journal of Public Health*, 62(11), 1454–1459.

Dittmar, K. (2014). *The status of black women in American politics: A Report by the Center for American Women and Politics for Higher Heights Leadership Fund.* Retrieved from http://d3n8a8pro7vhmx.cloudfront.net/themes/51c5f2728ed5f02d1e000002/attachments/original/1404487580/Status-of-Black-Women-Final-Report.pdf?1404487580.

Dugger, K. (1991). Race differences in the determinants of support for legalized abortion. *Social Science Quarterly*, 72(3), 570–587.

Fine, T. S. (2006). Generations, feminist beliefs and abortion rights support. *Journal of International Women's Studies*, 7(4), 126–140.

Githens, M., and Prestage, J. (1977). A minority within a minority. In J. L. Prestage and M. Githens (Eds.), *A portrait of marginality: The political behavior of the American woman.* New York, NY: David McKay.

Goggin, M. (Ed.). (1993). *Understanding the new politics of abortion.* Newbury Park, CA: Sage.

Hall, E., and Ferree, M. (1986). Race differences in abortion attitudes. *Public Opinion Quarterly*, 50, 193–207.

Halva-Neubauer, G. (1990). Abortion policy in the post-Webster age. *Publius*, 20, 27–44.

Hawkesworth, M. (2003). Congressional enactments of race-gender: Toward a theory of raced-gendered institutions. *American Political Science Review*, 97(4), 529–550.

Jelen, T. G., and Wilcox, C. (2003). Causes and consequences of public attitudes toward abortion: A review and research agenda. *Political Research Quarterly*, 56, 489–500.

King-Meadows, T., and Schaller, T. F. (2006). *Devolution and black state legislators: Challenges and choices in the twenty-first century.* New York, NY: State University of New York.

Luker, K. (1984). *Abortion and the politics of motherhood.* Berkeley, CA: University of California Press.

Luna, Z. T. (2009). From rights to justice: Women of color changing the face of US reproductive rights organizing. *Societies without Borders: Human Rights and the Social Sciences*, 4, 343–365.

Luna, Z. T. (2010). Marching toward reproductive justice: Coalitional (re)framing of the march for women's lives. *Sociological Inquiry*, 80(4), 554–578.

Lynxwiler, J., and Gay, D. (1996). The abortion attitudes of black women: 1972–1991. *Journal of Black Studies*, 27(2), 260–277.

Middlemass, K. M., Menfield, C. E., and Wielhouwer, P. (2010). African Americans in the Georgia General Assembly: Agents for change? In P. Ford (Ed.), *African Americans in Georgia: A reflection of politics and policy in the new south.* Macon, GA: Mercer University Press.

Nash, E., Gold, R. B., Rathbun, G., and Vierboom, Y. (2014). *Laws affecting reproductive health and rights: 2014 state policy review.* Guttmacher Institute. Retrieved from www.guttmacher.org/statecenter/updates/2014/statetrends42014.html.

Nelson, J. (2003). *Women of color and the reproductive rights movements.* New York, NY: New York University Press.

Nixon, L. (2007). The right to (trans)parent: A reproductive justice approach to reproductive rights, fertility and family-building issues facing transgender people. *William and Mary Journal of Women & Law*, 36(1), 5–21.

Orey, B. D., and Brown, N. (2014). Black women state legislators electoral trend data 1995–2011. In Michael Mitchell and David Covin (Eds.), *Black Women in Politics: Identity, Power, and Justice in the New Millennium. National Political Science Review, 16* (pp. 143–147). New Brunswick, NJ: Transaction Publishers.

Orey, B. D., and Latimer, C. (2008). The role of race, gender and structure in state policymaking. *Journal of Race and Policy*, 4(1).

Orey, B. D., Smooth, W., Adams, K. S., and Harris-Clark, K. (2006). Race and gender matter: Refining models of legislative policy making in state legislators. *Journal of Women Politics and Policy*, 28(3), 97–119.

Petchesky, R. P. (1990). *Abortion and woman's choice: The state, sexuality and reproductive freedom*. Boston, MA: Northeastern University Press.

Prestage, J. L., and Githens, M. (Eds.) (1977). *A portrait of marginality: The political behavior of the American woman*. New York, NY: David McKay.

Preuhs, R. R. (2006). The conditional effects of minority descriptive representation: Black legislators and policy influence in the American states. *The Journal of Politics*, 68(3), 585–599.

Roberts, D. (1997). *Killing the black body: Race, reproduction and the meaning of liberty*. New York, NY: Pantheon.

Ross, L. (1998). African American women and abortion. In R. Solinger (Ed.), *Abortion wars: A half century of struggle, 1950–2000*. Berkeley, CA: University of California Press.

Simien, E., and Clawson, R. (2004). The intersection of race and gender: An examination of Black feminist consciousness, race consciousness and policy attitudes. *Social Science Quarterly*, 85(3), 793–810.

Scola, B. (2006). Women of color in state legislatures: Gender, race, ethnicity and legislative office holding. *Journal of Women Politics and Policy*, 28(3), 43–70.

Secret, P. E. (1987). The impact of region on racial differences in attitudes toward legal abortion. *Journal of Black Studies*, 17(3), 347–369.

Silliman, J., Fried, M. G., Ross, L., and Gutierrez, E. R. (2004). *Undivided Rights: Women of Color Organize for Reproductive Justice*. Cambridge, MA: South End Press.

Simien, E. M. (2006). *Black feminist voices in politics*. Albany, NY: State University of New York Press.

Simien, E. M., and Clawson, R. (2004). The intersection of race and gender: An examination of black feminist consciousness, race consciousness, and policy attitudes. *Social Science Quarterly*, 85(3), 793–810.

Smith, A. (2005). Beyond pro-choice versus pro-life: Women of color and reproductive justice. *NWSA Journal*, 17(1), 119–140.

Smooth, W. (2001). *African American women state legislators: The impact of gender and race on legislative influence*. Ph.D. diss. University of Maryland.

Smooth, W. (2006). Intersectionality in American politics: A mess worth making. *Politics and Gender*, 2, 400–414.

Smooth, W. (2014). African American women and electoral politics: Translating voting power into officeholding. In S. J. Carroll and R. L. Fox (Eds.), *Gender and elections: Shaping the future of American politics* (3rd ed.). New York, NY: Cambridge University Press.

Solinger, R. (Ed.) (2008). *Abortion wars: A half century of struggle, 1950–2000*. Berkeley, CA: University of California Press.

Sonfield, A., and Pollack, H. (2012). The Affordable Care Act and reproductive health: Potential gains and serious challenges. *Journal of Health Politics, Policy and Law*, 38(2).

Springer, K. (1999). *Still lifting, still climbing: African American women's contemporary activism*. New York, NY: New York University Press.

Walters, R. (1974). Population control and the black community. *Black Scholar*, 5(8), 45–51.

Weisbord, R. G. (1975). *Genocide? Birth control and the black American*. Westport, CT: Greenwood Press.

Wetstein, M. (1996). *Abortion rates in the United States: The influence of opinion and policy.* Albany, NY: SUNY Press.

Wilcox, C. (1990). Race differences in abortion attitudes: Some additional evidence. *Public Opinion Quarterly*, 54, 248–255.

Wilcox, C. (1992). Race, religion, region and abortion attitudes. *Sociological Analysis*, 53(1), 97–105.

Wolbrecht, C. (2000). *The politics of women's rights: Parties, positions, and change.* Princeton, NJ: Princeton University Press.

Women of African Descent for Reproductive Justice (WADRJ). (1994). Black Women on Universal Healthcare Reform. *Washington Post*. Retrieved from: https://bwrj.wordpress.com/category/wadrj-on-health-care-reform/.

Woolford, J., and Woolford, A. (2007). Abortion and genocide: The unbridgeable gap. *Social Politics: International Studies in Gender, State and Society*, 14(1), 126–153.

Wright, G. (1978). Racism and the availability of family planning services in the United States. *Social Forces*, 56(4), 1087–1098.

PART V

Conclusions

19

AFTERWORD

Reflection and Future Directions

Nadia E. Brown and Sarah Allen Gershon

> I came along at a time when there was a demand to give men greater visibility and opportunity. In White society they were saying, "Women can't do it." In Black society, they were saying, "Women do too much." It's a diabolical situation.
>
> Rep. Yvonne Braithwaite Burke (D-CA)

Yvonne Braithwaite Burke, the first Black woman elected to the California State Assembly and the first African American to represent the West Coast in Congress, notes that minority women walk a delicate line in American society. As the first Black woman chair of the Congressional Black Caucus, Braithwaite Burke was confronted by Black male peers who felt as if she spent too much time advocating for women's issues and informed her that she was not elected to create the Black Women's Congressional Caucus (Oral History, C-SPAN Archives). As the first Congresswoman to give birth and to be granted maternity leave while in Congress, Braithwaite Burke unapologetically embraced this "dubious honor"[1] and balanced the demands of motherhood, while representing parts of southern California. Proving that Congresswomen could take on serious committee assignments, Braithwaite Burke was appointed to the Appropriations Committee. At the same time, she asserted the institutional place of women in Congress by taking on the unpopular position of chair of the Select Committee on the House Beauty Shop – which was viewed as a frivolous and self-serving women's committee at the time. Her actions provide a glimpse into Braithwaite Burke's representational style that simultaneously advocated for racial/ethnic minorities, women, and minority women.

As expressed in the epigraph, Braithwaite Burke notes that minority women are often placed in lose-lose situations. However, this precarious position does not stop minority women in politics from achieving their political goals. Rep. Braithwaite Burke's quote and actions epitomize the dedication, convictions, and personal fortitude of the minority women in politics that have been highlighted in this edited volume. In a society where women of color often receive mixed messages about their proper role in American political life, these brave women unabashedly dare to run for office, hold distinct political views, challenge long-held norms, and confront stereotypes that seek to pigeonhole them. Like Braithwaite Burke, the studies in this volume have shown that minority women push society (mainstream American – i.e., White as well as her particularized ethnic/racial group) to rethink the limitations, expectations, and boundaries placed on women of color.

Reflections on Chapter Contributions

The contributors to this volume have each portrayed the uniqueness and salience of studying women of color in American politics. The theoretical and pragmatic contributions and implications derived from the essays in this volume are multilayered and multifaceted. Each chapter presents readers with new and innovative research on minority women's politics. By centering the experiences, policy preferences, stereotypes, and political behavior of minority women in U.S. politics, this volume provides scholars with new perspectives that may enhance scholarly research projects. Each chapter convincingly makes the case that minority women are vital political actors whose experiences should be incorporated into mainstream studies of political science.

The use of both qualitative and quantitative methodological techniques in this volume showcases the numerous ways scholars can approach intersectionality centered research projects. While intersectionality scholars have long debated the methodological tenets involved in measuring this construct (Brown 2014; Brown and Gershon, forthcoming; Hancock 2007; Jordan Zachery 2007; Garcia Bedolla and Scola 2006; Orey et al. 2006), this volume contributes to a small but growing body of empirical studies that utilize an intersectional analysis through quantitative *and* qualitative data. The work in this book employs large-N survey data, detailed case studies, content analysis and experimentation, demonstrating the value of different methodologies in studying race, gender, and political behavior in the U.S. context. Thus, our chapters illustrate the many issues that policy makers, scholars, and practitioners will grapple with in the future, as well as the tools we can use to approach these challenges.

The key themes of political representation and participation are explored within this volume in a refined and nuanced manner to shed new light on how minority women operate within the U.S. political system. For instance, Mirya Holman's chapter illustrates that the traditional factors that drive political

participation operate differently for minority women. In this chapter, she forcefully argues that scholars should disavow themselves of a one-size-fits-all model of political participation. Similarly, Jeanette Yih Harvie's chapter illustrates that immigration and naturalization is a significant contributing factor to Asian American women's political participation and policy preferences. The chapter by Pearl Ford Dowe also demonstrates that Southern Black women's experiences remain an impactful force in American politics by illustrating their policy preferences.

The chapters in this volume convincingly argue women of color who are political elites must confront unique stereotypes that often influence or shape their achievements. In this manner, Ivy Cargile's chapter showcases the prevalence of gender and ethnicity based stereotypes that voters continue to hold when assessing Latina candidates. Orlanda Ward demonstrates that stereotypes of Black women impact media's coverage of candidates, which may in turn impact electoral prospects. Similarly, Andra Gillespie's chapter provides empirical evidence to show that the media places Michelle Obama into gender- and race-based constraints in their assessment of her performance as First Lady. Jessica Johnson Carew examines Black women candidates, demonstrating that stereotypical views of this group work in tandem with colorism to provide lower candidate evaluations. Sriam's research indicates that Asian Pacific American voters are more supportive of co-ethnic women candidates and that religion plays an important role in candidate evaluations.

Focusing more broadly on political representation, select chapters in this volume powerfully exhibit the role of minority women as political actors with distinctive policy preferences. For example, the chapter by Tonya Williams systematically examines the legislative behavior of Black women in the Georgia statehouse to argue that this population has distinct views on abortion policy vis-à-vis other legislators of varying races and gender. Similarly, Rachel Van Sickle-Ward and Adrian Pantoja reveal that Latinas have distinct foreign policy preferences, which separate them from their male counterparts. K. Juree Capers and Candis Watts Smith find significant variance in linked fate among Black men and women, which in turn shapes their policy preferences.

The unique political behavior and attitudes of minority women highlighted by several chapters in this volume underscore the importance of having minority women in government. As a group with unique interests, descriptive representation is critical to ensure that this population's preferences are articulated and heard. Yet, as the chapter by Kira Sanbonmatsu shows, women of color have difficulty achieving statewide executive office. Christina Greer also explores the failed candidacies of Charlene Mitchell and Shirley Chisholm to offer race- and gender-based strategies of Black women who sought the American presidency. Furthermore, the chapter by Ricardo Ramírez and Carmen Burlingame provides empirical evidence to illustrate that Latinas have different pathways to elected office because of their ethnicity and gender. Similarly, Christina Bejarano's chapter tracks the effectiveness of Latina candidates and where they successfully run.

Taken as a whole, the chapters in this volume have offered an opportunity to reflect upon the political insights derived from a close examination of the lived experiences of minority women in the American political system. Each chapter allows readers to delve more fully into the complexities, challenges, and opportunities that minorities face as political actors and citizens.

Future Directions

The authors in this volume demonstrate the importance of critical analysis within intersectionality research by including various identities of political importance. Intersectionality scholars have advocated that research must move beyond the "holy trinity" of race, class, and gender to examine other salient identities that impact the lives and politics of minority women (Baca Zinn and Dill Thornton 1996; Brown 2014; Smooth 2006). Indeed, Wenshu Lee (2012) advocates for critical intersectionality that will include other variables such as religiosity, party identification, and ideology. This analytical move exposes the ways in which the extant studies of identity are woefully under-theorized when it comes to minority women (Nash 2008). This critical approach actively engages with meaning-making processes that allow for the possibilities of social and political transformation. Indeed, calling into question power relations among groups within any given identity-based category necessitates that analytical complexity be afforded to the study of minority women in a manner that asks deep questions and requires rigorous considerations. This move pushed beyond the theories of double and triple marginalization to tell a more complete story of minority women in politics. Furthermore, this added complexity exposes both the challenges and opportunities that minority women face in American politics. As such, there is significant potential for this type of research to transform both the self and society.

For example, the authors in this volume move the study of intersectionality research forward by complicating the identities of women of color, exploring issues such as immigrant, partisan, and religious identity (e.g., Capers and Watts Smith; VanSickle-Ward and Pantoja; Yih Harvie; Sriram). We encourage other scholars to take such bold steps in their own research rather than uncritically assuming that race, gender, and class are the most paramount factors that shape the political lives of women of color.

By highlighting the differences and similarities among women of color, this volume showcases how the subfields of women and politics and race/ethnic politics fail to fully recognize the politics of women of color. Intra-group and inter-group analyses provide new insights into the distinctiveness and parallels between minority women as women and as racial/ethnic minorities. These comparisons showcase parallels and disunities amongst and between groups that often reify systems and social structures that are important in minority women's political lives. This both/and approach significantly expands scholars' analytical

tools for examining minority women. Many of the studies featured in this work are exemplars of innovative intersectionality research, moving beyond the inter- sectional holy trinity. As comprehensive as the chapters in this volume are, many subjects linked to minority women in America remain understudied. In particular, the experience of LBGTQ and differently abled women of color need to be further examined. These understudied populations are not included in this volume, yet are necessary vantage points for expanding critical intersec- tional scholarship on women of color.

Lastly, we implore scholars to critically engage with the social and historical factors that have shaped categories of difference rather than merely taking race, class, and gender as a priori. Instead, this proposition is built on the lived realties of women of color who have differing relationships with the American polity. Masuoka and Junn (2013) powerfully argue that the American racial hierarchy was crafted via immigration and citizen law and legal classifications of race, which formed the basis of American political belonging. We encourage scholars to use a similar perspective to explore gender-based social stratification. For example, gender has been used to structure political belonging to the American polity. America's national identity is derived from shared values that have deemed certain groups inferior and superior. In a patriarchal society, women have subordinate social standing. This diminished social status further complicates the racial order of non-White Americans as reified in the law. As such, it is imperative that scholars recognize how race-gender identities fit into the American racial (and gendered) hierarchy. For instance, the Immigration Act of 1924 established national quotas for immigration (namely from Europe) but women were not afforded equal status until 1952. This Act created long-term effects of who could be allowed into the country and rightfully claim American citizenship. Another example of women's precarious relationship to the American polity is readily seen *partus sequitur ventrem* – meaning, that which is brought forth follows the womb, legal doctrine in which enslaved status was passed from mother to child. For Black women, their (re)pro- duction and bodies were intimately tied to a racial hierarchy that through capit- alism linked Blacks as property, laborers, and inherently second-class humans (Brown and Young, forthcoming). These historical examples continue to shape how minority women operate within the American polity. As Harvie and Wil- liams do in their respective chapters, future research needs to incorporate these historical events into their theoretical and empirical frameworks.

We can also follow the recommendations set forth by Masuoka and Junn (2013) to employ a comparative relational analytical approach, which suggests scholars estimate models by racial groups that take into account the distinct historical factors that shaped the development of the group *prior* to analyzing the results across groups. As such, scholars must take seriously the conditions in which each group of minority women have been created and maintained. Path- dependent historical processes, such as barriers to legal immigration and slavery, are constantly being (re)defined and shaped as new meanings play out in

American politics for minority women. Raced/gendered categorization of women of color continues to have political significance as seen in group-based stereotypes, policy preferences, and political behavior. For example, chapters by Yih Harvie and Prindeville and Broxton highlight the usefulness of including a historical perspective to examining how Asian American women and Native women express present-day political belonging. These chapters demonstrate how minority women's current politics are a direct consequence of race/gender-based exclusion, which in turn look different from co-ethnic males, White women, and other minority women.

Conclusion

We end this chapter similarly to how it began – by heeding the wisdom of Rep. Yvonne Braithwaite Burke. Her illustrative quote summarizes the challenges faced by minority women in politics, yet her life's work is a stellar example of minority women advancing key principles of American democracy. Braithwaite Burke's ability to transcend barriers, work with reluctant colleagues, achieve her policy goals, as well as balance motherhood and work showcase the limitless possibilities of minority women in politics. This unique population is well poised to make monumental changes to American politics vis-à-vis electoral representation and political participation. It is our goal to feature these possibilities in this volume in hopes that both scholars and the broader society will recognize the unique contributions this group makes to American politics. As with all feminist scholarship, we seek to add new knowledge to the discipline *and* transform society through our academic contributions. Our hope is that this volume upholds this feminist mission and both advances the field as well as moves American society one step closer to recognizing the full humanity and abilities of women of color as political actors.

Note

1 "Rep. Burke: 'A Dubious Honor,'" 5 July 1973, *Washington Post*: C7; "7–lb. 9–oz. Girl for Rep. Burke," 24 November 1973, *New York Times*: 19.

References

Baca Zinn, Maxine, and Bonnie Thornton Dill. 1996. "Theorizing Difference from Multiracial Feminism." *Feminist Studies* 22: 321–31.

Brown, Nadia. 2014. *Sisters in the Statehouse: Black Women and Legislative Decision Making*. New York, NY: Oxford University Press.

Brown, Nadia, and Sarah Allen Gershon. Forthcoming. "Intersectional Presentations: An Exploratory Study of Minority Congresswomen's Websites Biographies." *Du Bois Review*.

Brown, Nadia, and Lisa Young. Forthcoming. "Ratchet Politics: Moving Beyond Black Women's Bodies to Indict Institutions and Structures." *National Political Science Review*.

Garcia Bedolla, Lisa, and Becki Scola. 2006. "Finding Intersection: Race, Class, and Gender in the California Recall Vote." *Politics and Gender* 2 (1): 5–27.

Hancock, A.-M. 2007. "When Multiplication Doesn't Equal Quick Addition: Examining Intersectionality as a Research Paradigm." *Perspectives on Politics* 5: 63–79.

Jordan-Zachery, Julia. 2007. "Am I a Black Woman or a Woman Who Is Black? A Few Thoughts on the Meaning of Intersectionality." *Politics and Gender* 3 (2): 254–63.

Lee, Wenshu. 2012. "For the Love of Love: Neoliberal Governmentality, Neoliberal Melancholy, Critical Intersectionality, and the Advent of Solidarity with the Other Mormons." *Journal of Homosexuality* 59 (7): 912–37.

Masuoka, Natalie, and Jane Junn. 2013. *The Politics of Belonging: Race, Public Opinion, and Immigration*. Chicago, IL: University of Chicago Press.

Nash, Jennifer. 2008. "Rethinking Intersectionality." *Feminist Review* 89: 1–15.

Orey, B., W. Smooth, K. S. Adams, and K. Harris-Clark. 2006. "Race and Gender Matter: Refining Models of Legislative Policy Making in State Legislatures." *Journal of Women, Politics, & Policy* 28 (3/4): 97–119.

Smooth, Wendy G. 2006. "Intersectionality in Electoral Politics: A Mess Worth Making." *Politics and Gender* 2 (31): 400–14.

CONTRIBUTORS

Editors

Nadia E. Brown is Associate Professor of Political Science and African American Studies at Purdue University where she specialized in American politics with a distinct focus on Black politics as well as women and politics. She is the author of *Sisters in the Statehouse: Black Women and Legislative Decision Making* (2014, Oxford University Press). Dr. Brown is the author of numerous articles focusing on Black women's politics.

Sarah Allen Gershon is Associate Professor of Political Science at Georgia State University. She received her Ph.D. from Arizona State University in 2008. Dr. Gershon's research interests include Media and Politics, Gender Politics, and Race and Ethnicity. Her research has been published in several academic journals, including: *Political Communication*; *Political Research Quarterly*; the *Journal of Women, Politics and Policy*; *Social Science Quarterly*; and the *Journal of Politics*.

Contributors

Christina E. Bejarano is Associate Professor of Political Science and Undergraduate Director of Political Science at the University of Kansas. The center of her research explores the dynamics of intersectionality of race/ethnicity and gender, for both minority female political candidates and voters. She is the author of *The Latina Advantage: Gender, Race, and Political Success* (University of Texas Press, 2013) and *The Latino Gender Gap in U.S. Politics* (Routledge Press, 2014).

Lawrence Broxton's career includes public and private sector economic development and workforce development experience. He is co-owner of Trego Community Partners, a minority and women-owned business specializing in services to Native American governments and entrepreneurs. The firm's most recent projects were rural economic development and youth leadership initiatives in the Navajo Nation.

Carmen Burlingame is a Ph.D. student at the University of Notre Dame, after receiving both her M.A. in Political Science and M.P.A. from Central Michigan University. Her previous research has been focused on women's influence in deliberative settings and the role of deliberation in the cultivation of a civic identity in young citizens. At Notre Dame, Carmen is studying American and Comparative Politics with a specific focus on identity politics and behavior across multiple segments of the population.

K. Jurée Capers is Assistant Professor in the Department of Public Management and Policy at the Andrew Young School of Policy Studies of Georgia State University. She received her Ph.D. in Political Science from Texas A&M University and holds a Bachelors of Arts degree in Political Science and Psychology from Winthrop University. A scholar of public administration and public policy, she often addresses questions related to policy implementation and outcomes within the governance framework. Her research examines how governance in the broad sense affects each phase of policy – from agenda setting and policy design to policy outputs and outcomes. Substantively, her research centers on social policy issues, particularly k-12 education, as it relates to racial and ethnic minorities and underrepresented groups. Her recent work combines theories of bureaucratic representation, public management, and structure to understand the politics of school desegregation and its effect on student outcomes.

Jessica D. Johnson Carew is an Assistant Professor of Political Science and Policy Studies at Elon University. She earned her M.A. and Ph.D. in Political Science from Duke University in 2008 and 2012, respectively, and attended Yale University where she earned a B.A. in Political Science in 2004. While studying at Duke, she served as a Graduate Fellow in the Center for the Study of Race, Ethnicity, and Gender in the Social Sciences and was awarded The JoAnn Gibson Robinson Dissertation Writing Award by the Association for the Study of Black Women in Politics in 2012. Dr. Carew has co-authored the following works: "Group Membership, Group Identity, and Group Consciousness: Measures of Racial Identity in American Politics?" in *Annual Review of Political Science* and "Intergroup Relations in Three Southern Cities: Black and White Americans' and Latino Immigrants' Attitudes" in *Just Neighbors?: Research on African American and Latino Relations in the United States* (2011, Russell Sage Foundation).

Ivy A. M. Cargile is an Assistant Professor of Political Science at California State University, Bakersfield. Broadly, her research interests are in American political behavior. She explores both elite and voter behavior with an emphasis on the Latino community. Regarding voter behavior, she is interested in how Latino voters are influenced across various domains such as candidate evaluations, public opinion about immigration policy, as well as the context in which political learning occurs. In regards to elite behavior, her interests focus on how Latina political actors, as well as other politicians of color, represent their constituents, and their influence on policy outcomes. Her work has appeared in *Political Research Quarterly*, as well as in multiple books on the topics of immigration, and Latina/o politicians.

Pearl K. Ford Dowe is an Associate Professor of Political Science at the University of Arkansas and is affiliated with the African and African American Studies Program. She has published numerous articles and book chapters that have appeared in journals such as the Journal of African American Studies, Political Psychology, and, Social Science Quarterly. She is currently researching political attitudes, behaviors, and campaign challenges of African American women. Her most recent book, co-authored with her mentor, the late Hanes Walton, Jr. and Josephine Allen, *Remaking The Democratic Party: Lyndon B. Johnson As A Native-Son Presidential Candidate* is forthcoming fall 2016 from University of Michigan Press.

Nicole Filler is a fourth year graduate student in the Department of Political Science at the University of California, Santa Barbara. Her dissertation research will focus on civic identity and citizenship among first and second generation Asian American women living in Los Angeles, CA. Nicole is also pursuing a doctoral emphasis in feminist studies.

Andra Gillespie is Associate Professor of Political Science at Emory University in Atlanta, Georgia. Her research and course offerings include political participation and racial and ethnic politics generally; however, she devotes most of her attention to studying "post-racial" African American leadership. Andra is the editor of and contributor to *Whose Black Politics? Cases in Post-Racial Black Leadership* (2009, Routledge) and the author of *The New Black Politician: Cory Booker, Newark, and Post-Racial America* (2013, New York University Press).

Christina Greer is an Associate Professor of Political Science at Fordham University – Lincoln Center campus. Her research and teaching focus on American politics, Black ethnic politics, urban politics, Congress, the presidency, New York City and New York State politics, campaigns and elections, and public opinion. Prof. Greer's book *Black Ethnics: Race, Immigration, and the Pursuit of the American Dream* (2013, Oxford University Press and winner of the WEB du

Bois Book Award in 2014 from the National Conference of Black Political Scientists) investigates the increasingly ethnically diverse Black populations in the U.S. from Africa and the Caribbean. She finds that both ethnicity and a shared racial identity matter and also affect the policy choices and preferences for Black groups. Prof. Greer is currently writing her second manuscript on the history of all African Americans who have run for the executive office in the U.S. Roughly 60 African Americans have run for or been nominated for the executive office since 1872. She investigates the role of symbolic candidacies and alternative parties as sources for increased democratic and Democratic participation for Blacks in America. Her research interests also include mayors and public policy in urban centers.

Jeanette Yih Harvie is a post-doctoral research fellow at the Center for Taiwan Studies, University of California, Santa Barbara (2015–2016). She is also a lecturer in the Department of Political Science at California State University, Los Angeles. Dr. Harvie received her Ph.D. in Political Science from the University of California, Santa Barbara in 2014. Her current research focuses broadly on the politics of race and ethnicity in the U.S., specifically, the process of political incorporation for Asian Americans.

Mirya R. Holman is Assistant Professor in the Political Science department at Tulane University. She received her Ph.D. from Claremont Graduate University in American Politics and Public Policy. Her research interests focus on women and politics, local politics, research methods, and environmental politics. Her book, *Women in Politics in the American City* (2014, Temple University Press) is a comprehensive evaluation of the effect of gender on the behavior of American mayors and city council members. Dr. Holman has current projects on gender and political ambition, the use and activation of gender stereotypes in political campaigns, religion and political identity, as well as a variety of other research interests.

Pei-te Lien is a Professor of Political Science at the University of California, Santa Barbara. Most of her recent work examines the intersection of race, ethnicity, gender, and nativity in political behavior, both of the elites and the mass. She is a co-principal investigator of the Gender and Multicultural Leadership project.

Adrian D. Pantoja is Professor in Political Studies and Chicano Studies at Pitzer College. Prior to his appointment at Pitzer College, Pantoja was a professor at Arizona State University and the University of Connecticut. He received his Ph.D. in Political Science from the Claremont Graduate University in 2001. His research has appeared in numerous books and academic journals including *Political Research Quarterly*, *Political Behavior*, *Social Science Quarterly*, and *American Behavioral Scientist*.

Diane Michele Prindeville is co-owner of Trego Community Partners, LLC, a minority and woman-owned business providing culturally appropriate training and technical support to tribal governments. In addition, Dr. Prindeville designs and delivers professional development courses to public officials through the New Mexico Certified Public Manager program, and teaches Political Science as an adjunct professor at the University of New Mexico. Her most recent study, coauthored with C. D. La Tour, "Cultural Diplomacy: New Mexico's Collaboration between Tribal and State Governments" appeared in *Cultural Competency for Public Administrators* (K. Norman-Major and S. T. Gooden, eds., 2012, M. E. Sharpe).

Ricardo Ramírez is Associate Professor of Political Science at the University of Notre Dame and a faculty fellow in the Institute for Latino Studies. His broad research interests include political behavior, state and local politics, the politics of race and ethnicity, and immigrant politics. His research is geared to understanding the transformation of civic and political participation in American democracy by focusing on the effects of political context on participation, the political mobilization of and outreach to Latino immigrants and other minority groups, and the causes and consequences of increasing diversity among elected officials. He is author of *Mobilizing Opportunities: The Evolving Latino Electorate and the Future of American Politics* (2013, University of Virginia Press).

Kira Sanbonmatsu is Senior Scholar at the Center for American Women and Politics (CAWP) at the Eagleton Institute of Politics and Professor of Political Science at Rutgers University. She received her Ph.D. from Harvard University. Before joining Rutgers, she taught at The Ohio State University. She studies gender, race/ethnicity, parties, public opinion, and state politics. Among other publications, she is the author of *Democrats, Republicans, and the Politics of Women's Place* (2004, University of Michigan Press) and *Where Women Run: Gender and Party in the American States* (2006, University of Michigan Press). Her articles have appeared in such journals as *American Journal of Political Science*, *Politics & Gender*, and *Party Politics*. Her current research concerns attitudes toward women's descriptive representation; gender stereotypes; women's recruitment to elective office; and the relationship between party representation and women's representation.

Candis Watts Smith is an Assistant Professor of Public Policy at UNC-Chapel Hill. Her research is primarily concerned with the ways in which political attitudes and behaviors intersect with and are contextualized by identity. She specializes in American politics, with an emphasis on race and ethnicity. Her current research agenda addresses how demographic changes influence American politics. This agenda includes her first book, *Black Mosaic: The Politics of Black Pan-Ethnic Diversity*

(2014, NYU Press), which is a comparative analysis of African Americans' and Black immigrants' identities, attitudes, and behaviors. It examines the ways in which the boundaries of Black identity and the contours of Black politics are shaped by the increased ethnic diversity among Blacks in the United States.

Shyam K. Sriram is a doctoral student in the Department of Political Science at the University of California, Santa Barbara. His research interests lie primarily in American politics with a focus on Asian Pacific Americans, but he is also focused on the politics of South Asia. He received his B.A. in Political Science from Purdue University and his M.A. in Political Science from Georgia State University. He has taught at Georgia Perimeter College, Georgia Highlands College, and Morehouse College.

Rachel VanSickle-Ward is an Associate professor of Political Science at Pitzer College in Claremont, California. Her research interests include public policy, public law, and gender and politics. She has published work on the politics of statutory language, gender and political ambition, and administrative law. Her first book, *The Devil is in the Details: Understanding the Causes of Policy Specificity and Ambiguity* (SUNY Press, 2014), explores the impact of political and institutional fragmentation on policy wording, focusing on the dynamics of social policy construction in the states. Her writing has appeared in *Talking Points Memo and The Washington Post* (The Monkey Cage). She was named the 2012 Pitzer College Scholar in Residence for her research on contraception politics and policy, and is currently working on a book on the subject.

Orlanda Ward is a Teaching Fellow in Research Methods and an ESRC-funded Political Science Ph.D. candidate. She holds a Masters in Gender Studies from UCL. Orlanda has previously worked for a frontbench MP and for several NGOs focusing on gender issues. Orlanda's research focuses on the intersection of "race"/ ethnicity and gender in news coverage of U.K. and U.S. elections.

Tonya Williams, Ph.D., joined the faculty in the Department of Social and Behavioral Sciences at Johnson C. Smith University as a visiting assistant professor of political science in Fall 2011. She is a graduate of the University of California, Davis and Clark Atlanta University in Political Science. Dr. Williams' interdisciplinary scholarship broadly interrogates the intersection between race, gender, class, and public policy while incorporating discourse from international human rights law. Currently, she is investigating race, region, and reproductive public policy formation on the state levels in the U.S. South. She is a former New Voice Gulf Coast Transformation Fellow, 2007–2010, previously serving as a research associate, campaign director, and program director at two Atlanta based non-profit organizations where she edited two popular education social justice publications.

INDEX

Page numbers in *italics* denote tables, those in **bold** denote figures.